FASHION IMAGES DE MODE

EDITED BY LISA LOVATT-SMITH INTRODUCTION BY RANKIN
ART DIRECTION AND DESIGN BY MATHIEU TRAUTMANN

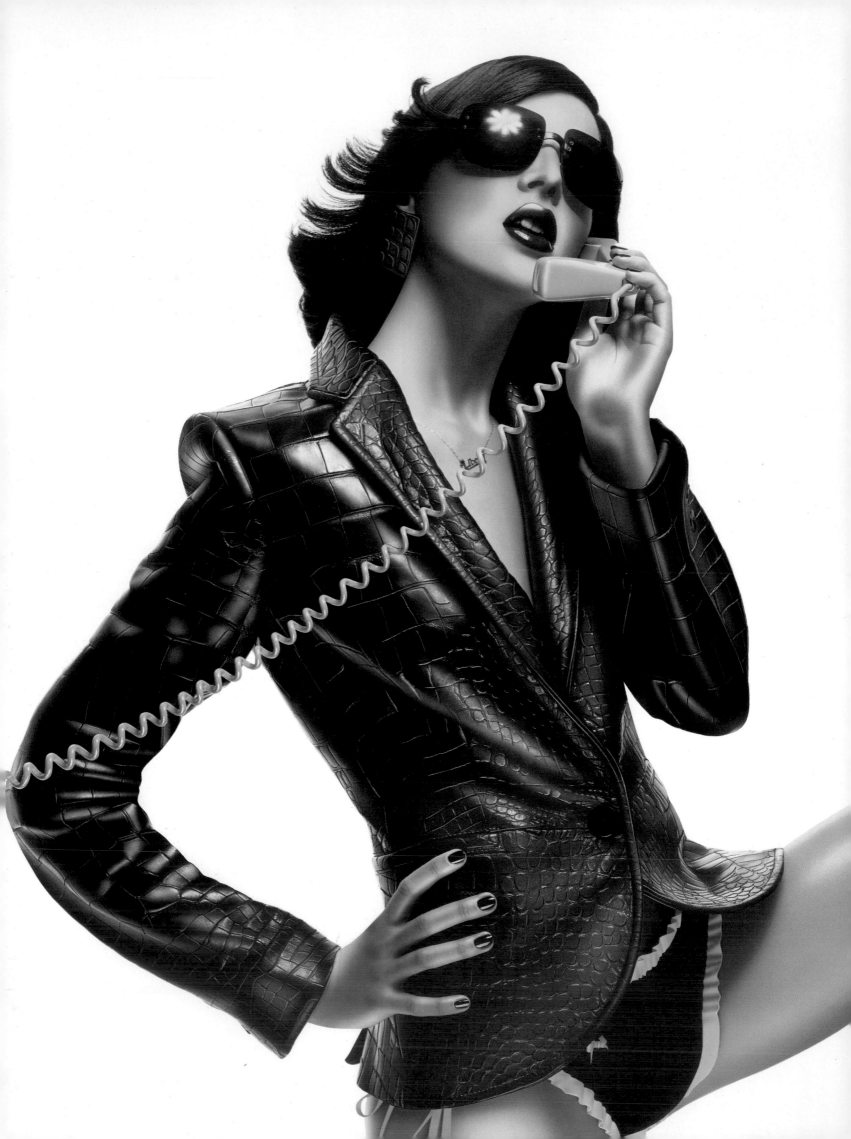

CONTENTS SOMMAIRE

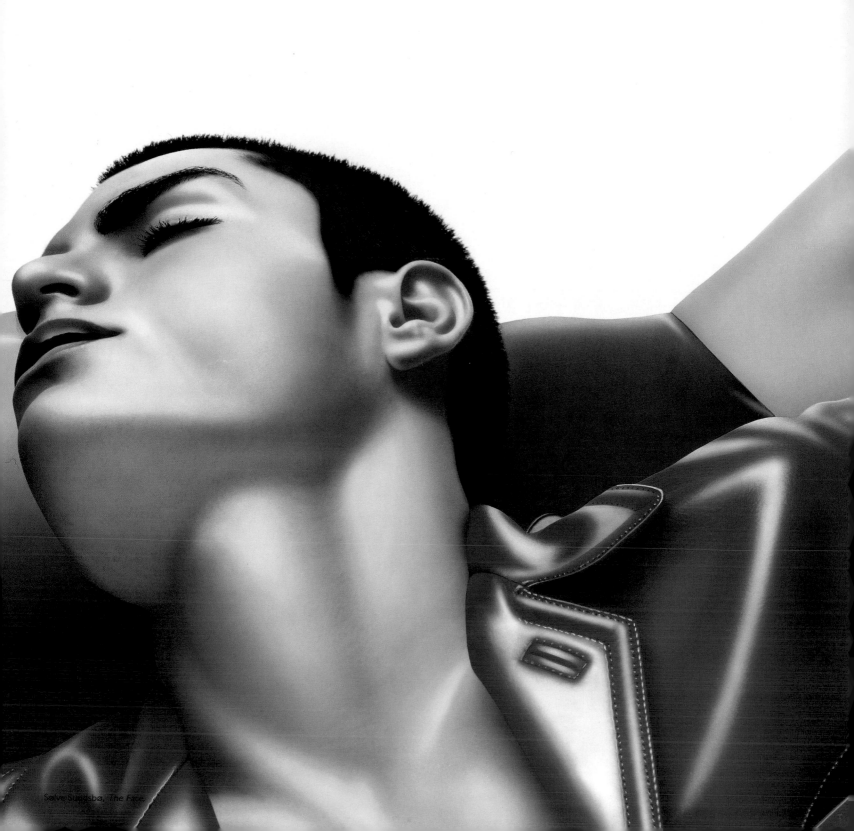
Sølve Sundsbø, The Face.

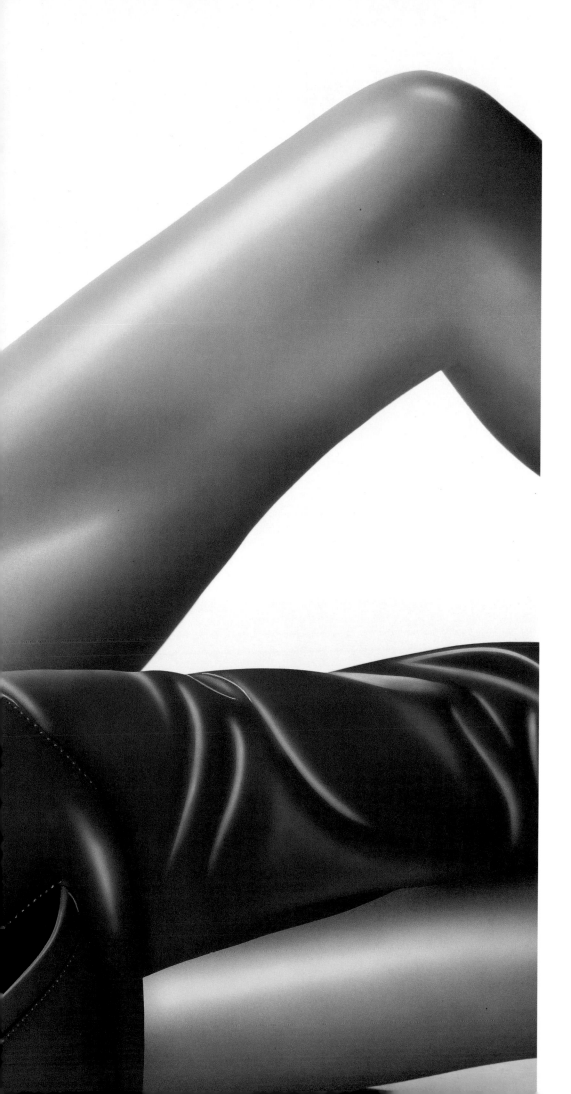

FEATURED PHOTOGRAPHERS PHOTOGRAPHES VEDETTES

John Akehurst
Miles Aldridge
Anette Aurell
Clang
Karen Collins
Elaine Constantine
Philip-Lorca diCorcia
Horst Diergerdes
Warren du Preez
and Nick Thornton-Jones
Sean Ellis
Jerome Esch
David Ferrua
Andrea Giacobbe
Nathaniel Goldberg
Frederike Helwig
Steve Hiett
Bettina Komenda
Nick Knight
David LaChapelle
Serge Leblon
Kevin Mackintosh
Marcus Mâm
Melodie McDaniel
Michel Momy
John Midgley
Platon
Phil Poynter
Terry Richardson
Christophe Rihet
Luis Sanchis
Sinisha
Oliver Spies
Antonio Spinoza
Steen Sundland
Sølve Sundsbø
Mike Thomas
Donna Trope
Javier Vallhonrat
Jonathan de Villiers
Tim Walker

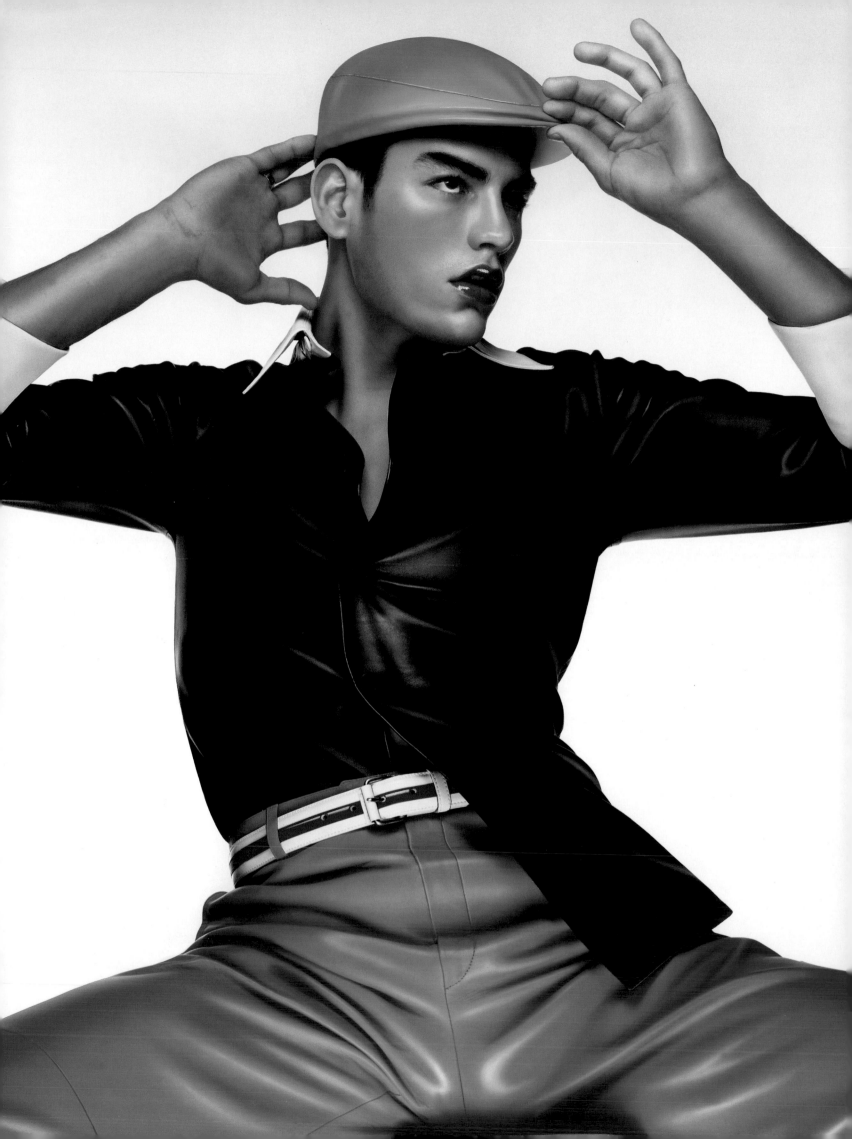

LISA LOVATT-SMITH

We used to talk about the *fashion* industry. Fashion photography was simply a part of it, cut out of *papier couché* rather than silks and satins, but still part of that particular enterprise. The point was the clothes. Photography was deferential and dependent, showing the style, the fabric, the idealized, fleshed-out projection of the client; and the ego-building, flattering mirror image of the potential customer. It was pure money-making logic. It was about product placement, making the clothes sublime. It had a role, a place in the scheme of things. Most of all, it was about removing the finished garment as far as possible from the stink of wet wool and shearing, or murdered silk moths, or sweaty cotton pickers, and into the tea rooms and dance halls of the twentieth century in the Western world. That is precisely what the fashion photography of the great magazines set out to do, in the 1940s and 1950s, through the lenses of Penn, Horst, Beaton, Avedon and many more. It has succeeded rather too well. In our (young) lifetimes it has become an industry of its own, filling hundreds of pages each month, moving billions. And it doesn't even show the clothes any more. 'Show the clothes' was the unavoidable magazine editor's battle cry, heard at its loudest and most insistent in the 1980s; but it is now barely a whisper, an embarrassed squeak. When did the attitude take over from the function, when did the purpose of serving the fashion industry disappear? When did the clothes become just an accessory to the art of picture-making? When did the public begin to buy magazines to look at the photographs instead of the clothes? Magazines such as *Rank*, *Big* or the granddaddy of them all, *Egoïste*, which work mainly with fashion photographers, are not about fashion. Not at all. They are about a contemporary vision of the world, call it applied art or what you will. *Fashion Images de Mode* is the modern history of a service industry, elevated – through the personal, un-analysable creative talent of its artisans – to a contemporary cult. Jeanloup Sieff, who died last year, was an acute observer of this phenomenon, and his long career straddled four decades. *Fashion Images de Mode* will miss his finely tuned sense of irony, which you can appreciate in the portfolio of his work which appears in this volume. He was kind enough to encourage us from the beginning, and he will be much missed.

Nous avions l'habitude de parler de l'industrie de la mode. La photographie de mode en faisait tout simplement partie, se profilant sur du papier couché plutôt que sur des soieries ou du satin, mais partie intégrante de cette singulière entreprise. Pleine de déférence et respectueuse, révélant les styles et les matières, elle était la projection idéalisée et enrobée du client, l'image que reflète le miroir flattant l'égo du consomateur potentiel. La photographie de mode avait un rôle, une place dans cet ordre de choses. Pure logique permettant de faire de l'argent. Il s'agissait d'écouler un produit en proposant de sublimes vêtements. Il fallait, avant tout, tenir le vêtement éloigné de l'odeur nauséabonde de la laine mouillée, de la tonte, du massacre des vers à soie ou encore des cueilleurs de coton en sueur pour proposer ces habits dans les salons de thé et les salles de bal du monde industrialisé du XXe siècle. C'est précisément ce que la photographie de mode des meilleures revues a cherché à faire dans les années 40 et 50, grâce aux objectifs de Penn, Horst, Beaton, Avedon, Sieff et bien d'autres encore. Cela a presque trop bien marché. Tout au long de nos jeunes années, la photographie de mode est devenue une industrie à part entière, remplissant des centaines de pages par mois et déplaçant des milliards. Mais elle ne cherche même plus à montrer de vêtements à la mode. «Montrer des

vêtements» était le cri de guerre obligé de tout éditeur de revue de mode, proclamé haut et fort dans les années 80 pour n'être plus maintenant qu'un murmure ou un vagissement déconcerté. Quand la pose a t-elle remplacé la fonction? Quand le propos de servir l'industrie de la mode a t il disparu? Quand les vêtements sont-ils devenus un simple accessoire de l'art de faire de belles images? Quant le public a t il commencé à acheter des revues de mode pour regarder des photographies et non plus des vêtements?

Des publications telles que Rank, Big, ou leur ancêtre, Egoïste, qui travaillent essentiellement avec des photographes de mode, ne parlent plus de mode. Plus du tout. Elles proposent une vision contemporaine du monde, qu'on dénomme art appliqué ou autre. Fashion Images de Mode est l'histoire moderne d'une activité de service, élevée au culte contemporain grâce au talent créatif personnel et non analysable de ses artisans. Jeanloup Sieff, décédé l'an dernier, était un fin observateur de ce phénomène et sa longue carrière a porté sur plus de quatre décennies. Fashion Images de Mode gardera la nostalgie de son sens aigu de l'ironie que l'on peut apprécier dans le cahier de ses oeuvres à l'intérieur de ce recueil. Il a toujours cherché à nous encourager, et nous le regretterons infiniment.

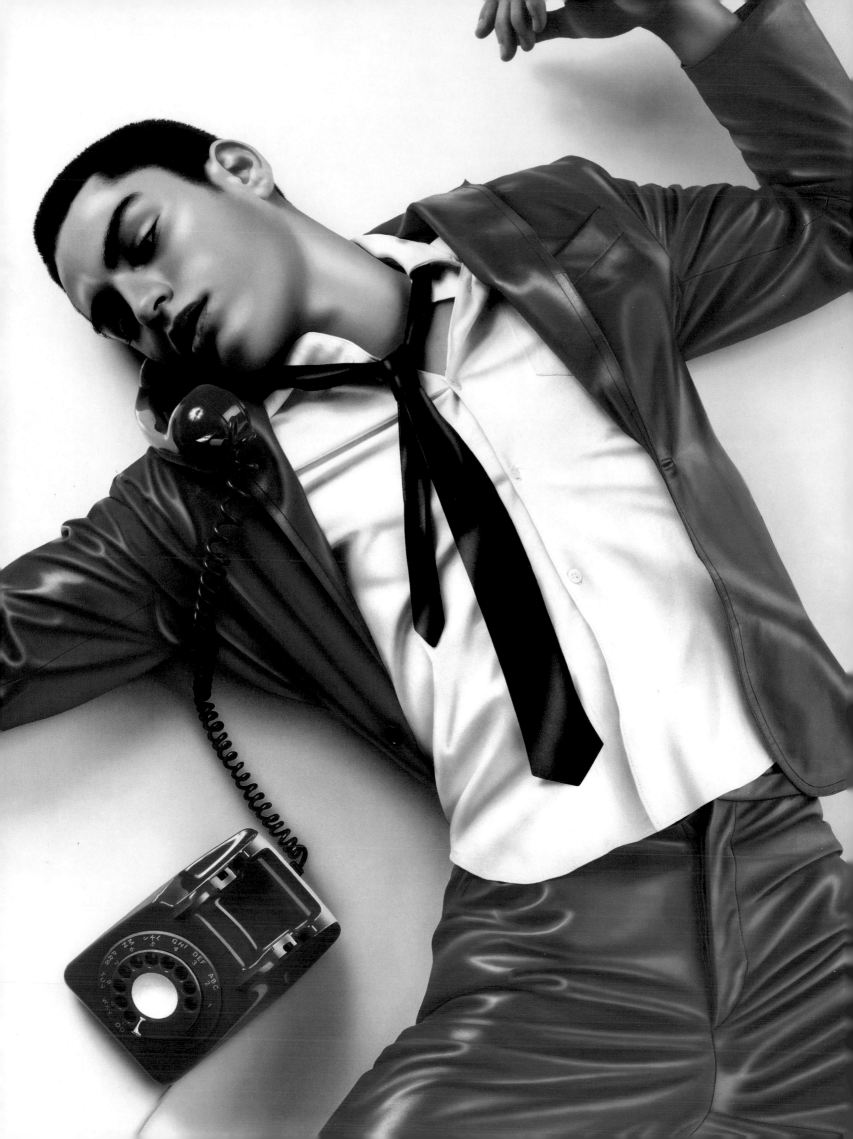

INTRODUCTION BY RANKIN

When I first saw *Fashion Images de Mode 1* I didn't really like it. I thought it was elitist and unrepresentative of what was going on in cutting-edge fashion photography. Phil Poynter, who was the photo editor of Dazed & Confused at the time, and I had laughed at its exclusion of the most innovative work, which we saw as being represented by us and our magazine. And they'd even asked us to review it, the cheek of it! I told Phil to send it back with some expletive inscription but of course, being more level-headed than me, he kept the copy in the office. In truth, we were probably half-bitter and half-guilty of our own elitism, and Phil was more temperamentally inclined to acknowledge this than me. I guess what I really wanted was to be in it.

The reality was that this was the first compendium to actually take fashion photography seriously, maybe even as an art form, and its imitators (of which there have been many) have fallen short in their understanding of what all of us (the photographers, fashion editors and stylists) are trying to achieve. Lisa Lovatt-Smith's understanding is inherent. When you look closely at any of the five previous books, it is impossible to miss this empathy and love for the medium.

Fashion Images de Mode's regularity and quality of contributors only enhanced its reputation further in my opinion. I was finally included within its pages in issue 3, by which point I'd been humbled into accepting *Fashion Images de Mode* as the industry standard. Last year, to my surprise, I was offered the chance to publish what has become fashion photography's yearbook and jumped at the chance. After meeting Lisa I realised we had shared the same passion for fashion photography all of the time - maybe I was just becoming less cynical!

So here is *Fashion Images de Mode 6*, brilliant as always. And this time I'm the one who has been able to be elitist and unrepresentative. I hope you like the work included; as with most photography I love it – but this work I love just a little bit more.

Lorsque j'ai vu pour la première fois le livre Fashion Images de Mode 1, *il ne m'a pas beaucoup plu. Je l'ai trouvé élitiste et peu représentatif des tendances les plus pointues de la photographie de mode. Avec Phil Poynter, qui était à l'époque le directeur artistique de Dazed & Confused, nous avions même trouvé assez drole le fait que le travail le plus innovateur, c'est à dire celui que nous faisions avec Dazed, en était exclu. Et ces petits coquins avaient osé nous demander d'en faire la chronique ! J'avais dit à Phil de renvoyer le livre avec une note d'insulte, mais faisant preuve de son bon sens habituel, il en avait gardé un exemplaire au bureau. En vérité, je pense que nous étions envieux mais aussi coupables d'un certain élitisme par rappord à notre propre travail. La nature de Phil est telle qu'il l'avait compris bien avant moi, qui aurait simplement voulu figurer dans ce premier volume.*

Le fait est que Fashion Images de Mode 1 a été la première collection à considérer la photo de mode comme une forme d'art, chose que ses nombreux imitateurs n'ont pas réussi à comprendre. Lisa Lovatt-Smith a un sens inné de ce que nous tous, phtotographes, rédacteurs de mode et stylistes, essayons de faire. En regardant les cinq volumes précédents, cet amour est évident.

L'apparition ponctuelle et la qualité des participants n'ont fait que contribuer à la bonne réputation de Fashion Images de Mode. J'ai finalement eu la chance de voir mon travail figurer parmi les pages du numéro 3, ayant bien eu le temps de changer d'avis sur ce projet d'envergure. L'année dernière, à ma grande surprise, on m'a proposé de publier ce livre qui fait aujourd'hui figure d'annuaire dans le monde de la photographie de mode. En rencontrant Lisa, je me suis aperçu que nous avions depuis toujours la même passion pour la photo de mode. Peut-être que je devenais juste un peu moins cynique! Voici donc Fashion Images de Mode 6, brillant comme à son habitude. Et cette fois ci, c'est sur moi que tomberont toutes les accusations d'élitisme. J'espère que vous allez aimer les images que nous avons choisies. Moi qui adore tout ce qui touche à la photographie, je les aime tout particulièrement.

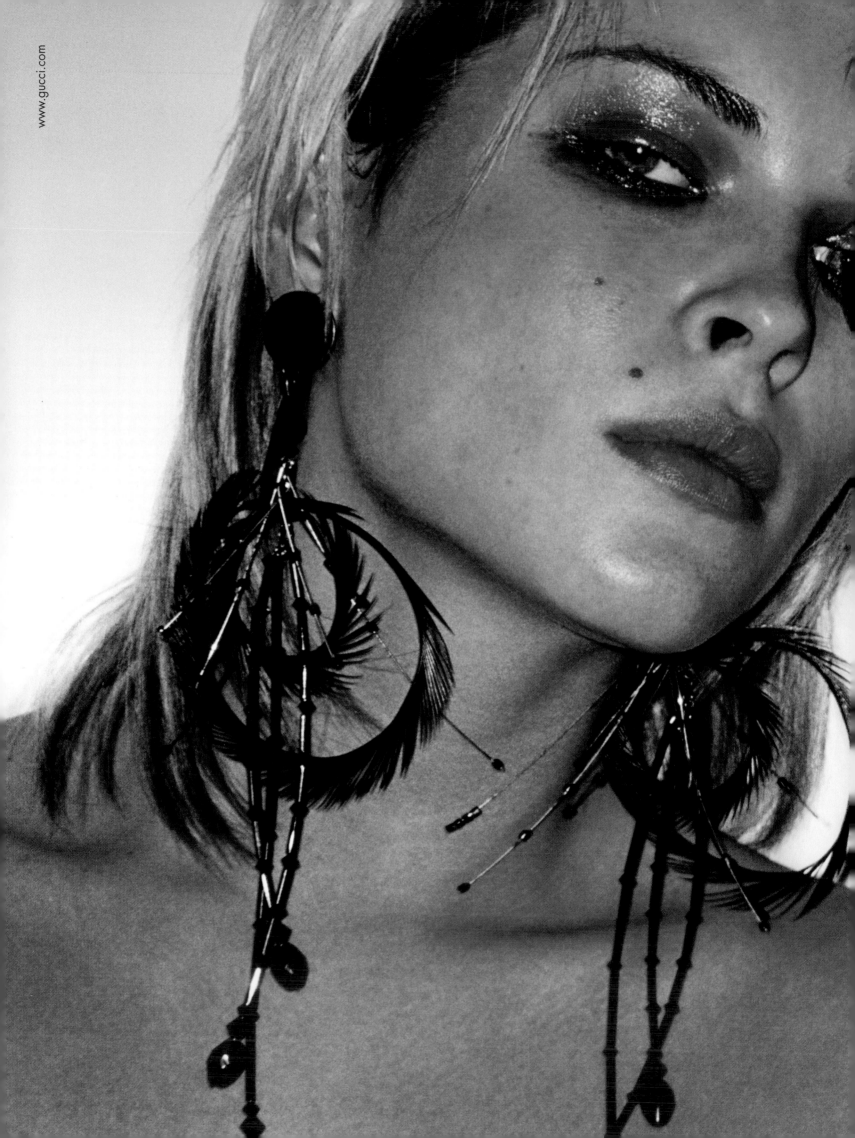

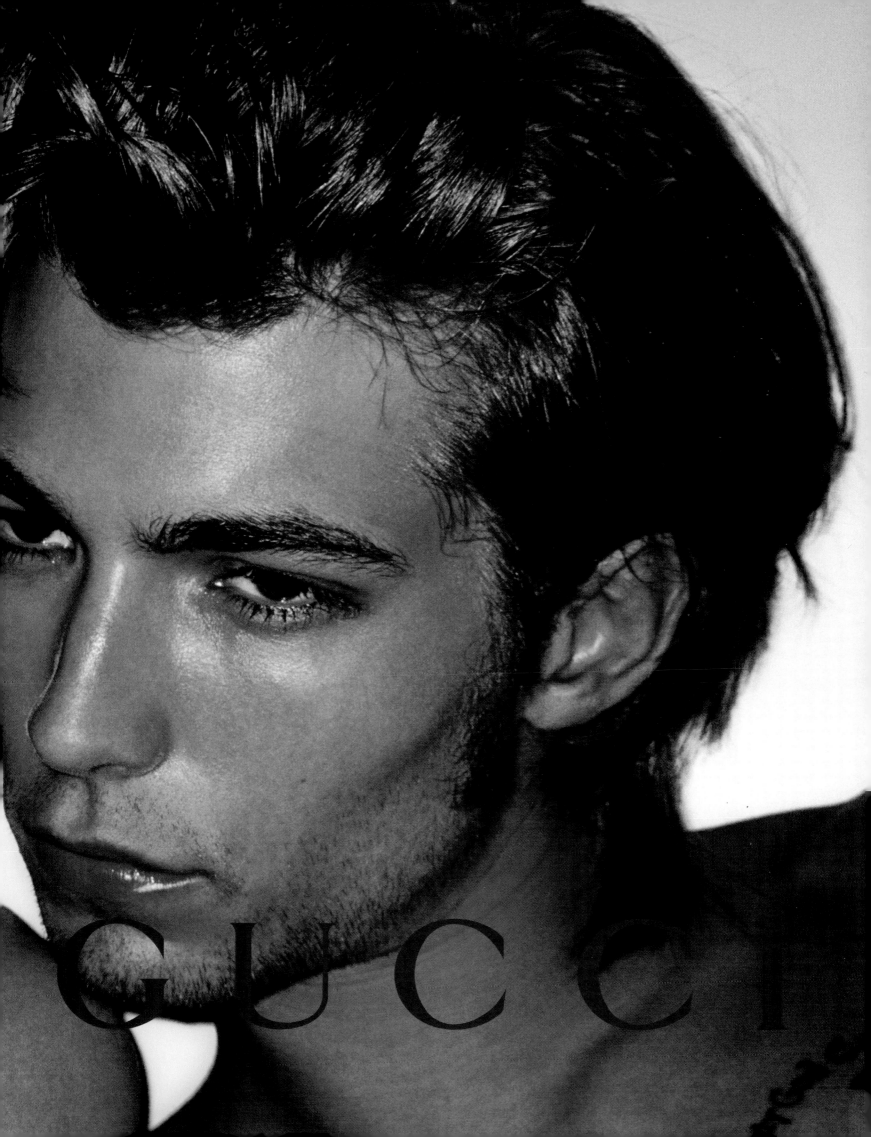

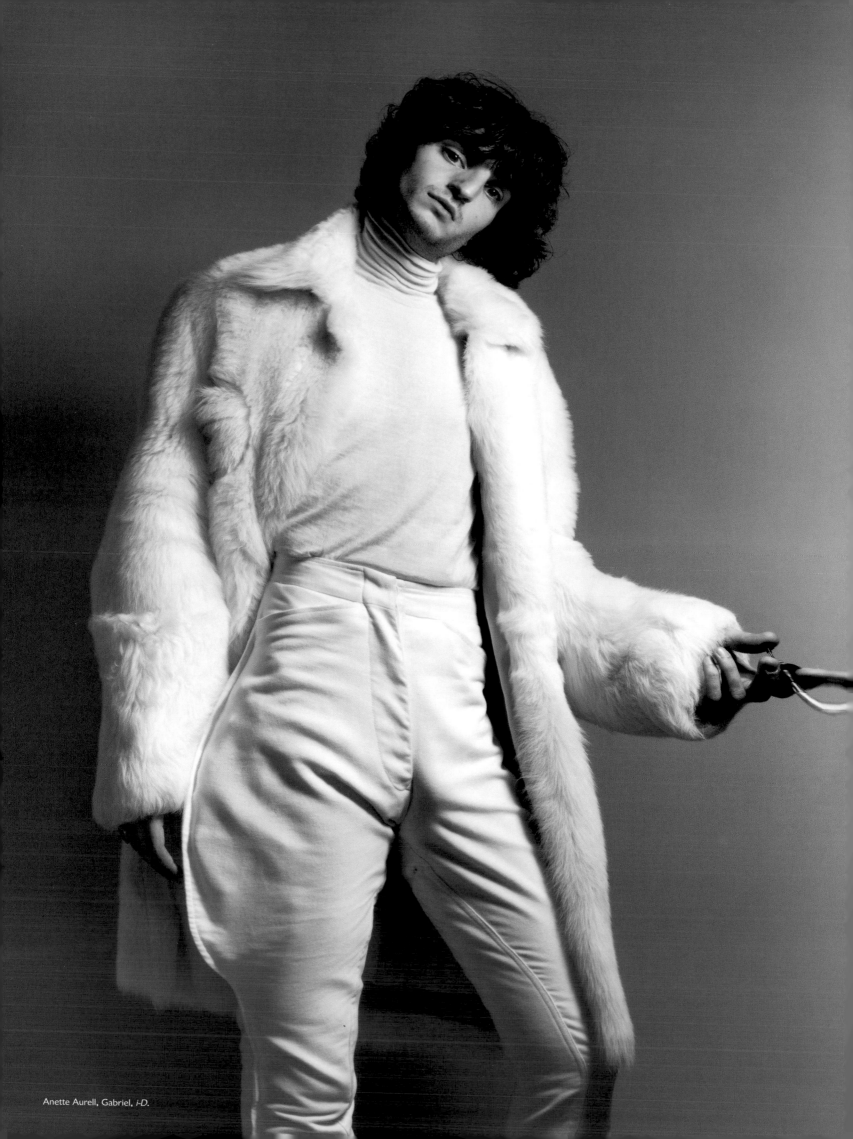

Anette Aurell, Gabriel, *i-D*.

AMBIGUOUS IDENTITY

THE FINE ART OF ANDROGYNY BY MARIUCCIA CASADIO WITH A PORTFOLIO BY ANETTE AURELL

The cultures of ancient India, Egypt and classical Greece have left us with a rich repertoire of images in which the exceptional qualities of divine or earthly personalities are expressed through the aesthetic interaction of masculine and feminine anatomies and physical features. Androgyny is one of the most perturbing and seductive representations of the transhuman or superhuman essence. Throughout history and across different territories it has marked the mythological identity of existing or imaginary creatures: entities invented to exalt forms of faith, collective convictions, or impressions of human culture and history. Symbolically neither man nor woman, creature of a mysterious eros, alien to the codified schemes of sexuality, and in an eternally marginal position, the androgynous condition has long paid a price for its uniqueness. Confined to the outer limits of the real and the possible, it has nevertheless always been part of the collective image bank.

Androgyny had to wait until the turn of the nineteenth century, however, to become an inseparable part of human culture, with the status of a condition of the mind and the spirit. The late 1800s and early 1900s saw the first individual forms of rebellion against bourgeois society and the consequences of industrial culture. In the footsteps of figures such as George Sand and Oscar Wilde there soon came a host of individual voices – Marquise Luisa Casati, Tamara de Lempicka, Baron Von Gloeden, Coco Chanel, Nijinski and Jean Cocteau, to name just a few – and androgyny became a major protagonist in art and literature, poetry and fashion, music and photography.

From the late nineteenth century on, then, it became possible to defy, in different ways, moralism and arrogance, predictability and atrophy. Ushering in a form of artistic practice that trespassed into the territory of lifestyle – a subversive form of narcissism that was destabilizing and insidious for the existing, collectively legitimized moral values and social priorities – the debut of androgyny in mass culture coincided perfectly with that of the dandy. This unique social figure manufactured an original, hybrid and provocative concept of virility, rejecting the gloomy distinction of the male bourgeois uniform in favour of a wardrobe that featured pastel tones, lace, ribbons and other pretty affectations of feminine dress, seasoned with aristocratic eccentricities of bearing and behaviour, alongside whimsical hairstyles, powder and rouge. This was a historical and linguistic passage that, in its opposite form, led women like George Sand to choose an explicitly male name and way of dressing, triggering that breakdown of sexual boundaries that was to lead, throughout the twentieth century, to admirable effects and spectacular consequences.

Ancient myth has invaded the modern and the contemporary icon. It has become a metaphor for a radical revolution of sentiment, for a self-awareness that has modified appearance and essence, anatomical characteristics and physiognomy, the ethics and aesthetics of eroticism and sexuality. Androgyny has gradually become a true cultural product, a linguistic and visual mode of representing the relationship between identity and history, between the personal and the social, between introspection and observation of one's time, between art and life. It offers a mirror to what can justifiably be called the mutation of subjective attitudes and interpersonal communications that has been set in motion by progress – a mutation that began with the dawn of the industrial era, evolved in the West during the years of economic growth and expansion, and subsequently those of the youth culture revolution; and has now reached the age of information and post-technological communication.

Apollo and Narcissus, Janus, Diana the Huntress, Cupid: the figures of classical culture may recur in different aesthetic registers but they can never be separated from their historical context; instead, they gradually give rise to forms of androgyny consistent with the needs and stimuli of the times, offering

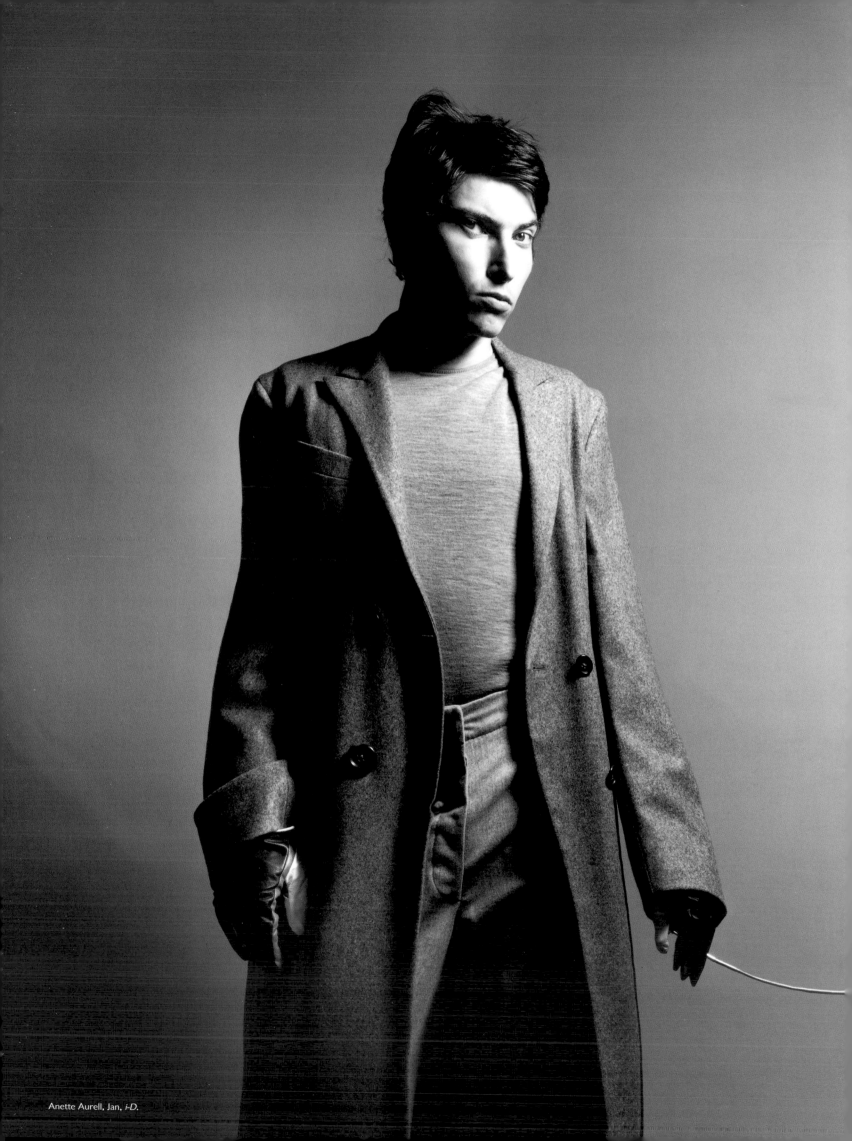

Anette Aurell, Jan, *i-D.*

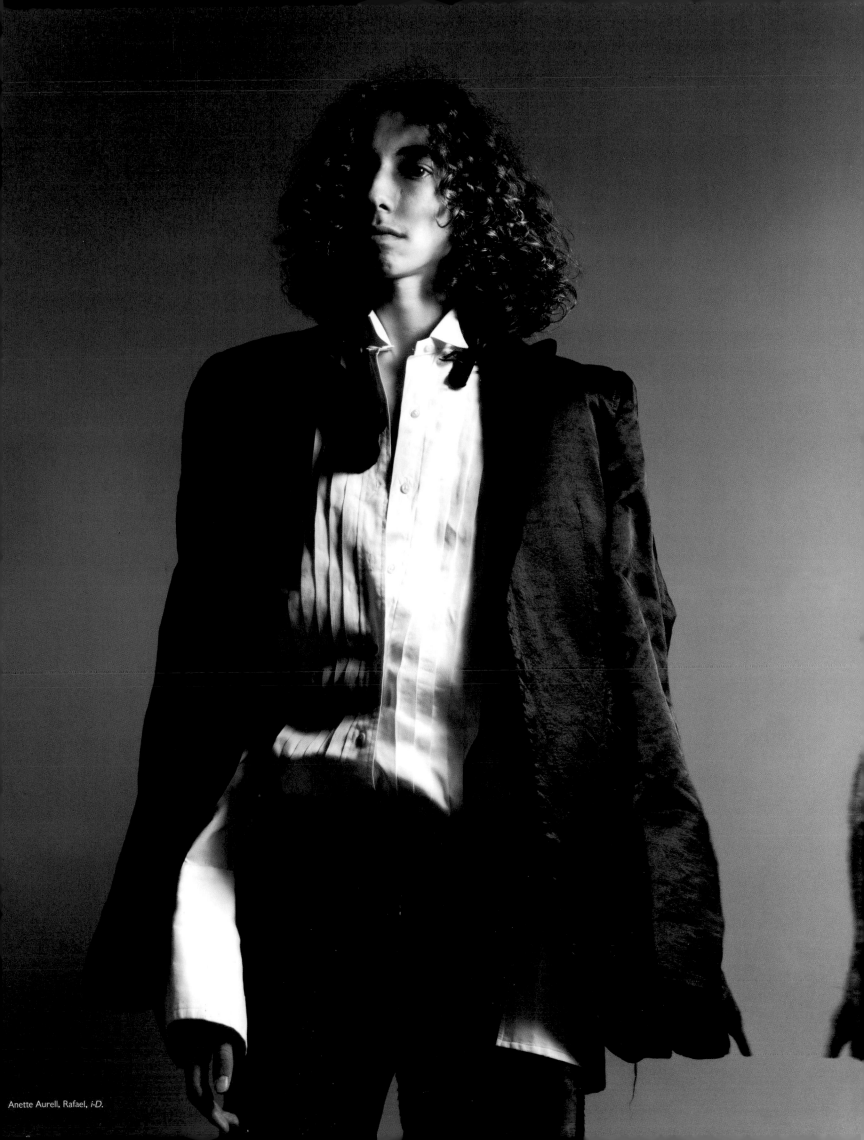

Anette Aurell, Rafael, *i-D*.

an added possibility for comprehension of different epochs and contexts. Marcel Duchamp puts a moustache on Leonardo's *Mona Lisa*; or becomes Rrose Sélavy, his 'female' self-portrait functioning as a label for a work in the form of a perfume bottle. With such gestures, and in tune with the spirit of the twentieth century, Duchamp opened the way for reflection on art that is no longer painting, or sculpture, or even an object, but rather a parody of the products made for consumption.

It is the quality of the social and cultural context that legitimizes (or otherwise) the artistic value of an idea or a creative sign. After all, during the same period we can observe interactions between art and fashion, poetry and production, and between the establishment and the avant-garde; leading to unprecedented collaborations and unexpected affinities between, for instance, Chanel and Cocteau, Schiaparelli and Dalí, Gertrude Stein and Picasso. And androgyny, as the perfect metaphor for the role of art, became the vehicle for a changing conception of the artwork – as the celibate machine; as excellent merchandise, but with no useful value, in a historic and social framework tirelessly centred on the recognizability and reproducibility of ideas and products. Thus the androgynous physiognomy began to appear in artworks and fashion trends; in music and film personalities; and in photographic subjects, theatrical themes and advertising illustrations. Just as Surrealism shed light on the feminine part of the male and the masculine part of the female, the same awareness influenced the choices of the new image-protagonists in terms of dress and style. The aesthetic results were so extraordinary that they were able to inspire original forms of film stardom, different ways of approaching the photographic subject, even different ways of thinking about the character of communication itself.

The 'à la garçonne' cuts of the 1920s, or the women in masculine clothing à la Marlene Dietrich in the 1930s, were only the beginning of a long litany of icons. Starting with the female/male self-portraits of artists such as Frida Kahlo, it extends to contemporaries such as Cindy Sherman, Morimura and Ugo Rondinone. Along the way it passes through other forms of self-representation on the part of artists such as Urs Lüthi, Luigi Ontani, Francesco Clemente and McDermott & McGough, via the *sui generis* contributions of personalities like Andy Warhol and his muse Edie Sedgwick; models like Veruschka in the 1960s, and 'living sculptures' like Leigh Bowery, who, along with Boy George, was one of the main protagonists of the London nights of the 1980s.

While the 1940s and 1950s witnessed an entrenchment of the artist behind the artwork, during the 1960s androgyny resurfaced with force. The younger generation's rejection of the value and consumption systems of mass culture led to a need to express new ways of thinking, dressing, acting and, basically, being. There developed an urgent desire to be free from any type of restriction, including that of gender. Sexuality was transformed into a free, unconditioned expression of the body, its sensations and sentiments. Androgyny became a

new chapter in fashion at this time: thanks to fashion designers like Rudi Gernreich, it dared to attempt unprecedented aesthetic communions, stylistic and behavioural interactions of male and female character. Ambiguity and ambivalence were attitudes that found the perfect environment in which to put down roots and survive – in large part due to the world of pop music, with figures such as David Bowie, Mike Jagger, Lou Reed, Alice Cooper or Brian Eno. At the same time the arrival of fashion models like Veruschka and Donyale Luna caused a radical turnaround of the standard concept of feminine grace. Another potent influence in this direction came in the 1960s and 1970s from designers such as Yves Saint Laurent, creator of the longest-lasting, most modern concept of the tuxedo and the pantsuit for women. The fashion photographer Helmut Newton also contributed to this process of change, representing – perhaps in an even more radical and iconoclastic way – a strong, butch woman, as erotically ambiguous as she is feminine.

In the most recent representations of androgyny, collages of different perceptual inputs – interweavings of anatomies and features, of familiar images and new sensations – make man and woman, art and fashion, past and future coexist. The overlapping of male and female has now become an accepted style icon, the leitmotiv for experiences of photography and Photoshop, the protagonist of much of the imagery seen in fashion publications and art shows; it alludes to a mutation that is already in progress. What was the exception has become the norm; what was episodic has become recurrent: time has transformed the finest of all hybrids into an inexhaustible source of visual motifs and themes. While the artist Cindy Sherman enters and exits, thanks to the use of theatrical and cinema make-up, personalities of different genders and periods, Morimura applies a narcissistic identification with different Hollywood divas to his photographic work, and Ugo Rondinone uses a computer to superimpose his own facial features, complete with moustache, over those of fashion models in the images of Juergen Teller or Mario Testino. These photographers, together with others such as Peter Lindbergh, Steven Meisel, Bruce Weber and Paolo Roversi, are the makers of a new concept of androgyny in fashion. And although they operate in two different linguistic territories, artists and fashion photographers are not really that far apart. In fact, more than ever before they seem to be accomplices in the development of the same message, authors of a new mythology of beauty in a vast, contradictory key. It is a beauty that is human but also unreal; feminine but masculine, masculine but feminine; marvellous yet monstrous; original yet resembling something else; in orbit between past and future, between attraction and provocation, between uniformity and uniqueness. And both sexes, anyhow and always, implicitly or explicitly, are present.

Mariuccia Casadio is an art critic and curator interested in the interactions between art and fashion. She is arts consultant to Italian *Vogue* and a member of the advisory board for the Nicola Trussardi Foundation. Mariuccia Casadio also teaches history of fashion and fashion photography at the European Institute of Design in Milan.

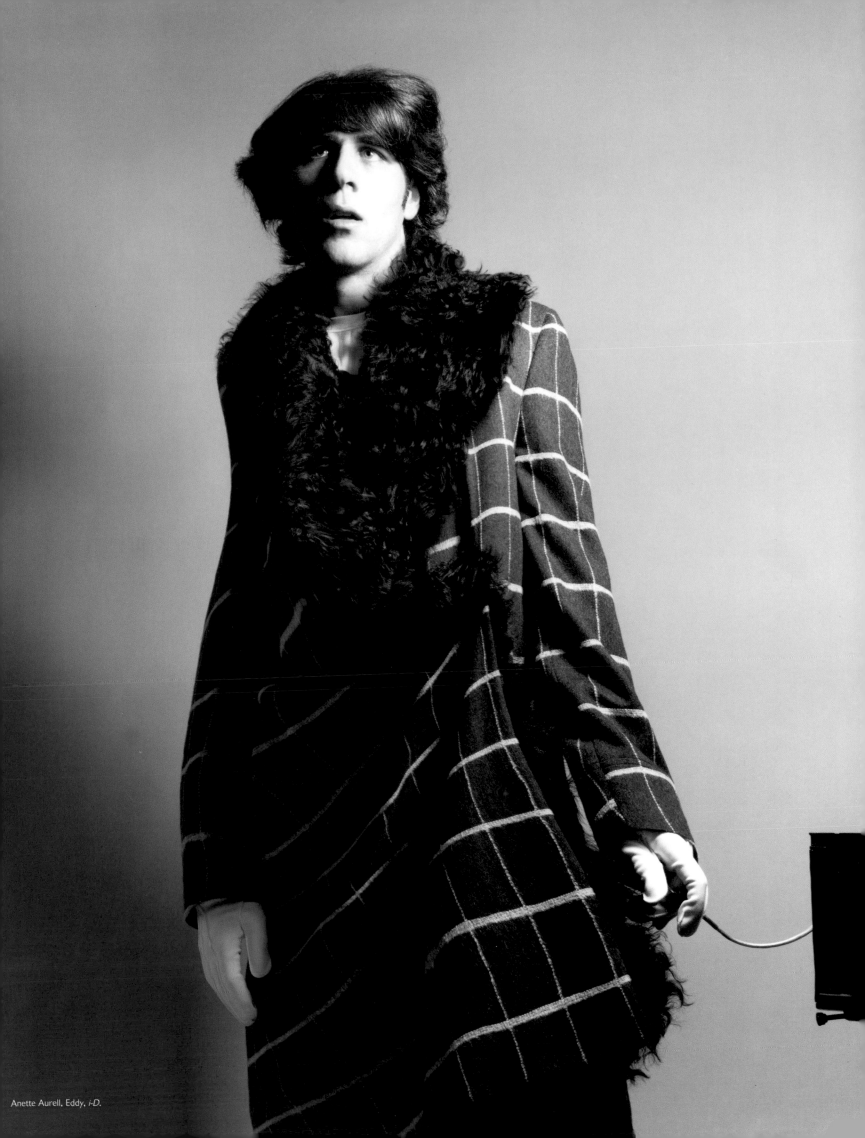

Anette Aurell, Eddy, *i-D.*

IDENTITE AMBIGUE: L'ART PLASTIQUE DE L'ANDROGYNIE

Les cultures de l'Inde, de l'Egypte ancienne et de la Grèce classique nous ont légué un vaste recueil d'images figurant les qualités exceptionnelles de personnages divins ou terrestres par le biais d'une interaction très esthétique entre des anatomies masculines et féminines et leurs caractéristiques physiques. L'androgynie est l'une des représentations les plus troublantes et séduisantes de l'essence suprahumaine ou transhumaine. Tout au long de l'histoire et dans différents domaines, elle a marqué l'identité mythologique de créatures divines ou réelles : entités inventées afin d'exalter certaines formes de foi, diverses convictions collectives ou expressions de culture et d'histoire humaine. Symboliquement, ni homme ni femme, créature d'un mystérieux éros, étrangère aux modèles codifiés de la sexualité, en éternelle situation marginale, la condition androgyne a longtemps payé le prix de sa singularité. Bien que confinée aux limites externes du réel et du possible, elle a toujours fait partie de la banque d'images collectives.

L'androgynie doit attendre le début du XIXe siècle, cependant, pour devenir partie indissociable de la culture humaine, avec son statut d'état mental et psychique. Avec la fin du XVIIIe et le début du XIXe, on assiste aux premières formes individuelles de rébellion contre la société bourgeoise et les premières conséquences de la culture industrielle. Sur les traces de personnalités telles que George Sand et Oscar Wilde, une cohorte de personnages divers élève bientôt la voix : la Marquise Luisa Casati, Tamara de Lempicka, le Baron Von Gloeden, Coco Chanel, Nijinski et Jean Cocteau, pour n'en citer que quelques-uns. L'androgynie se pose alors comme un important protagoniste de l'art et de la littérature, de la poésie, de la mode, de la musique et de la photographie.

Dès la fin du XIXe siècle, il devint possible de défier, de différentes façons, le moralisme et l'arrogance, la prévisibilité et l'étiolement de l'esprit. En s'annonçant comme une pratique artistique qui empiétait sur le style de vie, une forme subversive de narcissisme apparaît, déstabilisante et insidieuse pour les valeurs morales et les priorités sociales existantes et collectivement légitimées. Ce début de culture populaire de l'androgynie coïncida parfaitement avec celle du dandy. Cette caractéristique sociale unique a fabriqué un concept original, hybride et provocateur de virilité, rejetant la terne distinction de l'uniforme de l'homme bourgeois en faveur d'une garde robe qui se déclinait en tons pastel, dentelles, rubans et autres joliesses du vêtement féminin, agrémentée d'excentricités aristocratiques de port et de conduite, le tout accompagné de coiffures capricieuses, de poudre à joues et de rouge à lèvres. Ce fut un passage historique et linguistique qui, à l'inverse, put également conduire des femmes comme George Sand à choisir explicitement un nom et un style masculins, provoquant l'effondrement des limites sexuelles qui devait mener, tout au long du XXe siècle, à d'admirables effets et des conséquences spectaculaires. L'ancien mythe a envahi les icônes modernes et contemporaines. Il est devenu la métaphore d'une révolution radicale des sentiments, d'une prise de conscience qui a modifié l'apparence et l'essence, les caractéristiques anatomiques et la physionomie, l'éthique et l'esthétique de l'érotisme et de la sexualité. Peu à peu, l'androgynie est devenue un véritable produit culturel, un mode linguistique et visuel représentant la relation entre l'identité et l'histoire, entre ce qui est du domaine personnel et du domaine social, entre l'introspection et l'observation d'une époque, entre l'art et la vie. Elle offre un miroir de ce que l'on peut appeler, à juste titre, la mutation d'attitudes subjectives et de la communication interpersonnelle déclenchée par le progrès, une mutation qui a commencé à l'aube de l'ère industrielle, a évolué en Occident pendant les années de croissance et d'expansion économique, puis avec la révolution de la culture de la jeunesse pour parvenir maintenant à l'âge de l'information et de la communication post-technologique.

Apollon et Narcisse, Janus, Diane la Chasseresse, Cupidon : les personnages de la culture classique peuvent apparaître sur différents registres esthétiques mais ne peuvent jamais être séparés de leur contexte historique; en fait, ils donnent lieu, peu à peu, à des formes d'androgynie en accord avec les besoins et impulsions de leurs temps, et offrent une nouvelle manière d'appréhender différentes époques et contextes. Marcel Duchamp dessine une moustache sur la Jaconde de Leonardo; ou devient Rrose Sélavy, son auto-portrait féminin servant d'étiquette pour un travail artistique sur des flacons de parfum. Avec de tels gestes en harmonie avec l'esprit du XXe siècle, Duchamp a tracé la voie pour une réflexion sur l'art qui n'est plus de la peinture, de la sculpture ou même un objet, mais plutôt la parodie de produits conçus pour la consommation.

C'est la qualité du contexte social et culturel qui légitime la valeur artistique d'une idée ou d'un signe créatif. Après tout, au cours de cette même période, on peut observer diverses interactions entre l'art et la mode, entre la poésie et la production, ou entre l'establishment et l'avant-garde, conduisant à des collaborations sans précédent et des affinités inattendues entre, par exemple, Chanel et Cocteau, Schiaparelli et Dali, Gertrude Stein et Picasso. Et l'androgynie, en tant que parfaite métaphore du rôle de l'art, est devenue le véhicule d'une conception évolutive du travail artistique comme un célibat,

comme une excellente marchandise mais sans aucune valeur utile, dans un cadre historique et social inlassablement centré sur la reconnaissance et la reproductibilité des idées et des produits. Ainsi, la physionomie androgyne a commencé à apparaître dans les oeuvres d'art et les tendances de la mode, avec les vedettes de la musique et du cinéma, les sujets photographiés, les thèmes de pièces de théâtre et les illustrations publicitaires. De même que le Surréalisme a mis en lumière la partie féminine de l'homme et la partie masculine de la femme, cette même prise de conscience a influencé les choix des nouveaux protagonistes de l'image dans leur style et leur habillement. Les résultats esthétiques étaient si extraordinaires qu'ils furent à même d'inspirer des formes originales de célébrité cinématographique, différentes façons d'aborder le sujet photographique, et même différentes manières de concevoir les caractéristiques de la communication en soi.

La coupe à la garçonne des années 20, ou les femmes en habits masculins à la Marlène Dietrich dans les années 30, n'étaient que le début d'une longue litanie de symboles. Depuis les autoportraits féminins/masculins d'artistes tels que Frida Kahlo, jusqu'aux portraits contemporains de Cindy Sherman, Morimura et Ugo Rondinone, en passant par d'autres formes d'auto-représentation conçues par des artistes tels que Urs Lüthi, Luigi Ontani, Francesco Clemente et McDermott & McGough, avec des contributions sui generis de personnalités telles que Andy Warhol et sa muse Edie Sedgwick, de mannequins comme Veruschka dans les années 60, et les «sculptures vivantes» comme Leigh Bowery, qui, avec Boy George, était l'un des principaux protagonistes des folles soirées de Londres dans les années 80.

Tandis que les années 40 et 50 marquèrent une époque de retranchement de l'artiste derrière son oeuvre, c'est au cours des années 60 que l'androgynie refait surface en force. Le rejet par la plus jeune génération des systèmes de valeurs et de consommation de la culture de masse, donne lieu à l'expression de nouvelles façons de penser, de s'habiller, de se comporter et, en fin de compte, d'être. C'est ainsi que surgit un irrésistible besoin de se libérer de tout type de restriction, y compris l'identité sexuelle. La sexualité s'est transformée en une expression libre et non conditionnée du corps, des sensations et des sentiments. L'androgynie est devenue un nouveau chapitre de la mode de l'époque: grâce à des grands couturiers tels que Rudi Gernreich, elle s'est aventurée vers une communion esthétique, stylistique et comportementale sans précédent, avec des interactions de caractère masculin et féminin. L'ambiguïté et l'ambivalence finirent par trouver un parfait environnement où prendre racine et purent survivre en grande partie grâce au monde de la pop music, avec des personnages tels que David Bowie, Mike Jagger, Lou Reed, Alice Cooper ou Brian Eno. En même temps, l'arrivée de mannequins de mode comme Veruschka et Donyale Luna ont signifié un changement radical du concept classique du charme féminin. Une autre

influence considérable et semblable a surgi dans les années 60 et 70 avec de grands couturiers tels que Yves Saint Laurent, créateur du concept le plus moderne et le plus perdurable du smoking et du tailleur-pantalon pour femme. Le photographe de mode, Helmut Newton, a également contribué à cette évolution, en représentant la femme, peut-être d'une manière encore plus radicale et iconoclaste, sous un aspect robuste et homasse, aussi érotiquement ambigüe que féminine.

Avec les représentations les plus récentes de l'androgynie, des collages de perceptions différentes, des entrelacs d'anatomies et de caractéristiques diverses, d'images familières et de nouvelles sensations, permettent à l'homme et à la femme, à l'art et à la mode, au passé et au futur de coexister. L'intime juxtaposition de l'homme et de la femme est maintenant devenue un symbole stylistique accepté, le leitmotiv pour des expériences de photographie et de Photoshop, le protagoniste de nombreuses images de publications de mode ou d'expositions artistiques. Elle fait allusion à une mutation déjà en cours. Ce qui était l'exception est devenue la norme; ce qui était épisodique est devenu récurrent: le temps a transformé le plus subtil de tous les hybrides en une source inépuisable de motifs et de thèmes visuels. Tandis que l'artiste Cindy Sherman fait son entrée et sa sortie en parvenant à représenter, grâce au maquillage propre au théâtre et au cinéma, des personnalités de sexe et d'époque différentes, Morimura applique une identification narcissique à son oeuvre photographique avec différentes divas d'Hollywood, et Ugo Rondinone a recours à l'ordinateur pour surimposer les traits de son visage, moustache comprise, sur les visages de mannequins figurant sur les images de Juergen Teller ou de Mario Testino. Ces photographes, et d'autres comme Peter Lindbergh, Steven Meisel, Bruce Weber et Paolo Roversi, sont les créateurs de ce nouveau concept d'androgynie dans le monde de la mode. Et bien qu'ils évoluent dans deux domaines linguistiques différents, les artistes et les photographes de mode ne sont pas très éloignés les uns des autres. En fait, plus que jamais, ils semblent être complices de l'évolution d'un même message, les auteurs d'une nouvelle mythologie de la beauté avec des accords pleins et contradictoires. Il s'agit d'une beauté qui est humaine tout en étant irréelle; féminine tout en étant masculine, merveilleuse et pourtant monstrueuse; originale, tout en ressemblant à autre chose; en orbite entre le passé et le futur, entre l'attraction et la provocation, entre l'uniformité et la singularité. Tandis que les deux sexes sont toujours et de toutes façons, implicitement ou explicitement présents.

Mariuccia Casadio est critique d'art et conservateur de musée. Elle s'intéresse aux interactions entre l'art et la mode. Consultant artistique auprès de Vogue édition italienne et membre du Conseil Consultatif pour la Fondation Nicola Trussardi, Mariuccia Casadio enseigne également l'histoire de la mode et la photographie de mode à l'Institut Européen du Design à Milan.

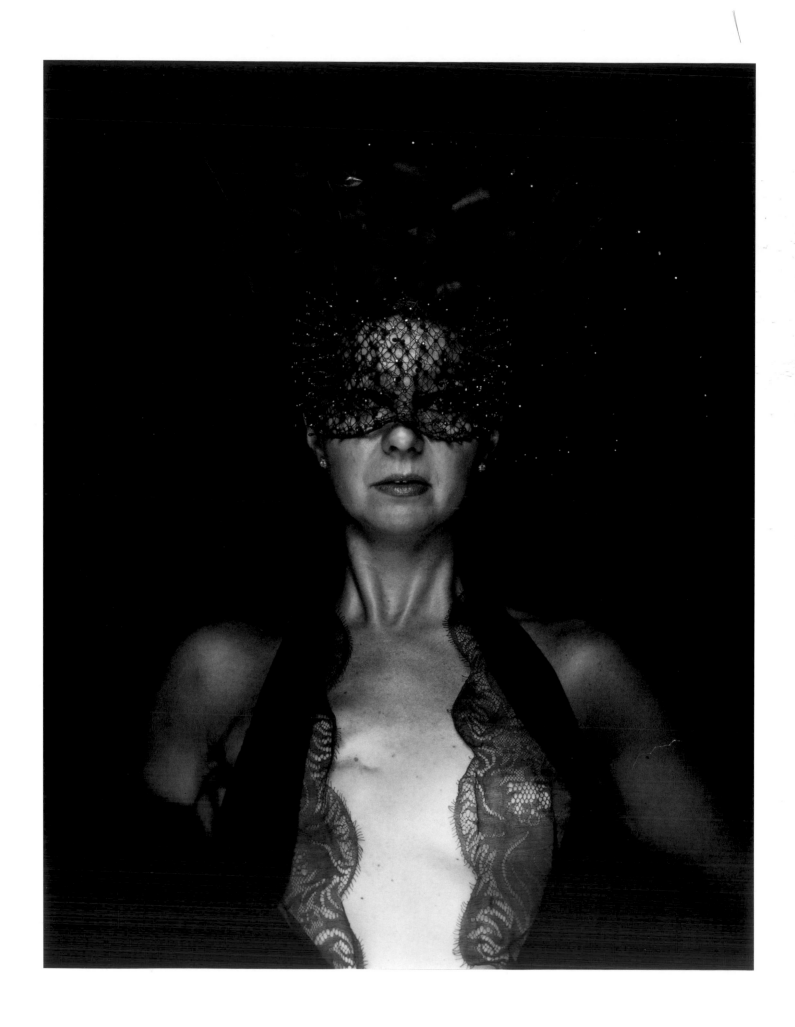

Nick Knight, Liz Bellamy, *Showstudio.com.*

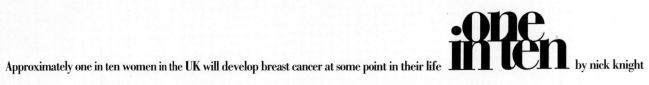

Approximately one in ten women in the UK will develop breast cancer at some point in their life **·one in ten** by nick knight

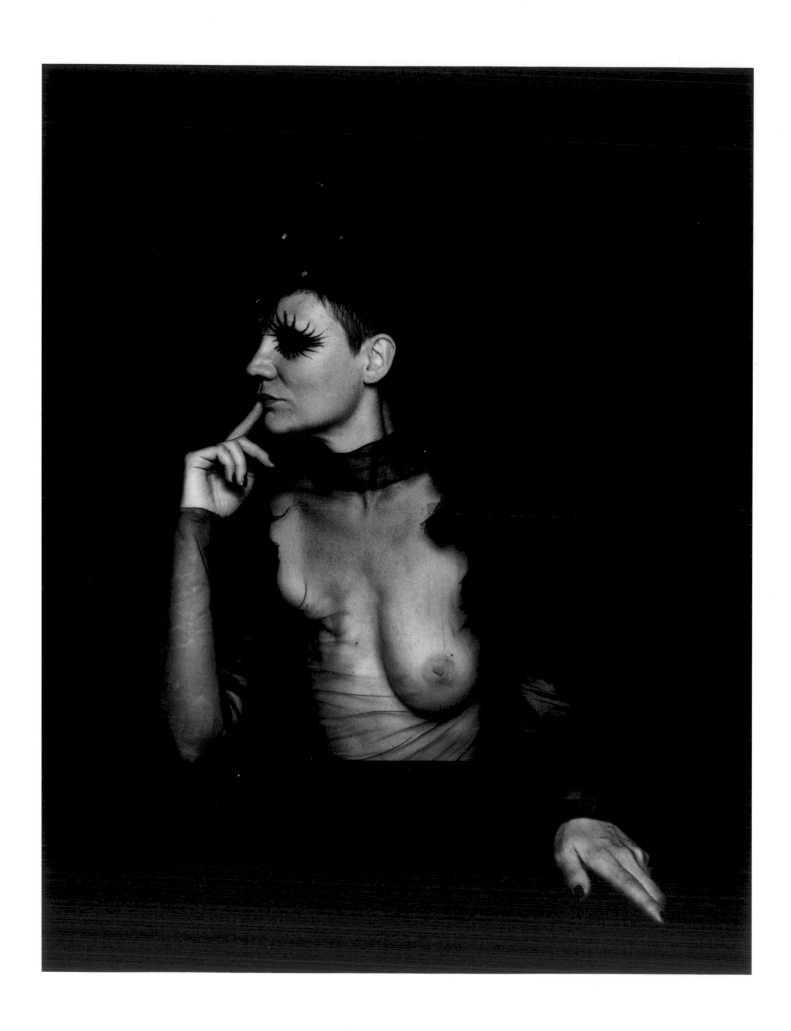

Nick Knight, Matuschka, *Showstudio.com*.

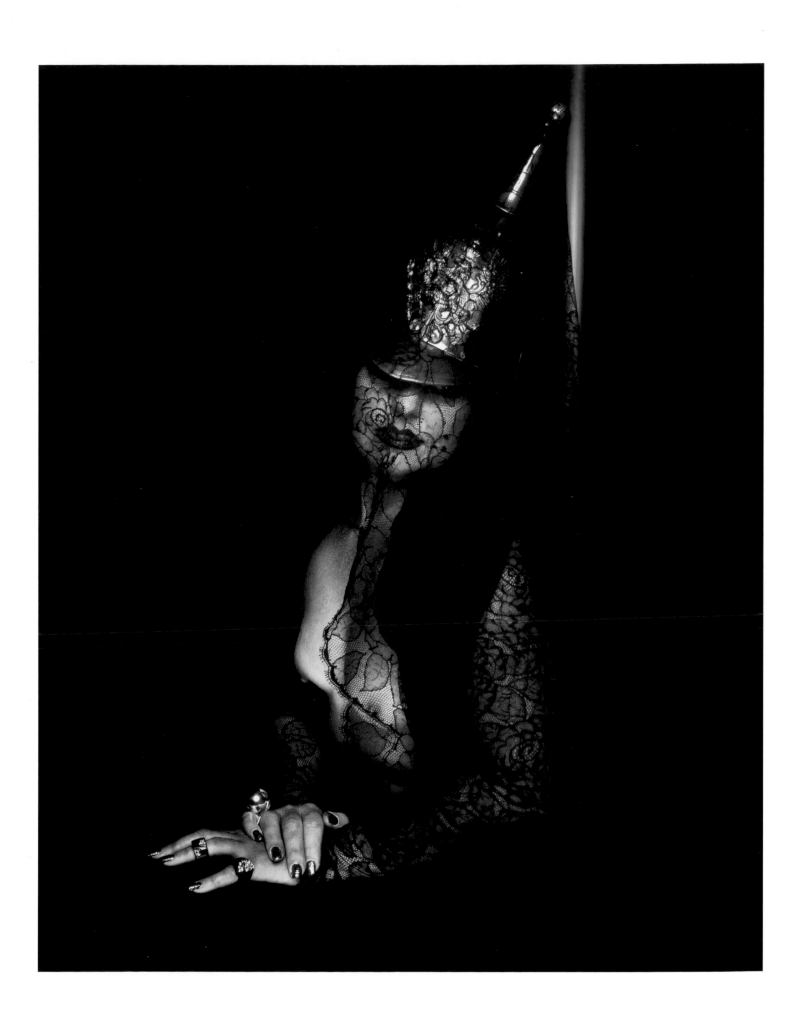

Nick Knight, Sue Loosely, *Showstudio.com.*

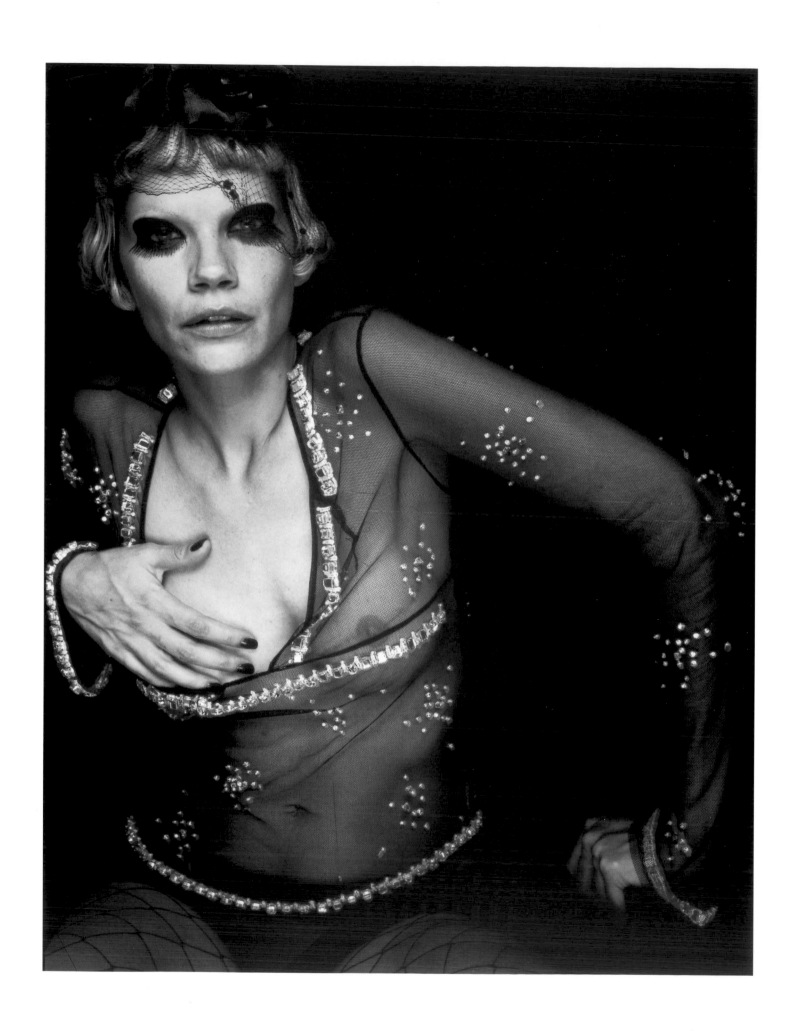

Nick Knight, Nikki Umberti, *Showstudio.com.*

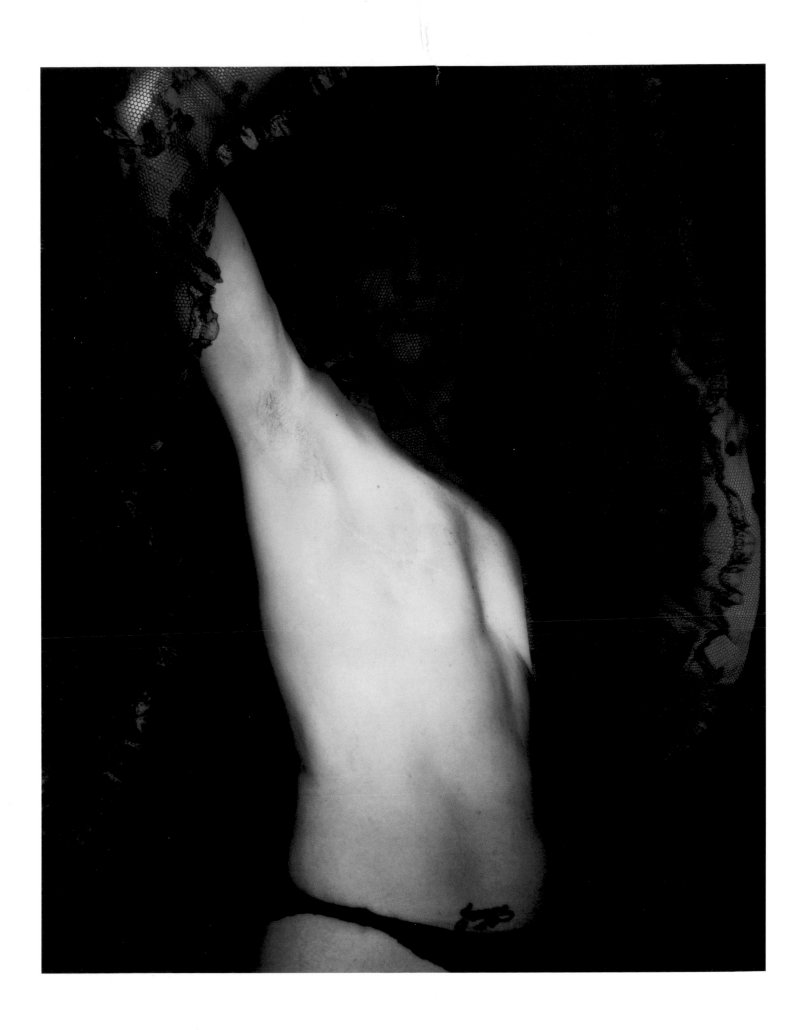

Nick Knight, Matuschka, *Showstudio.com*.

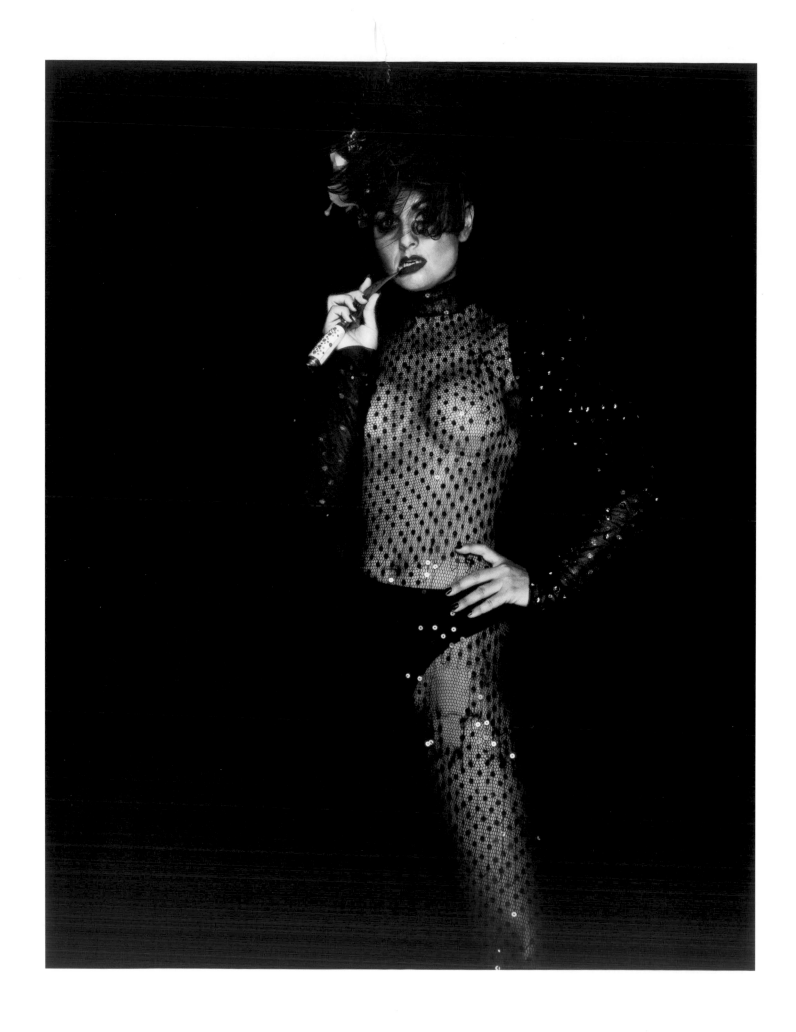

Nick Knight, Miranda Vicente, *Showstudio.com.*

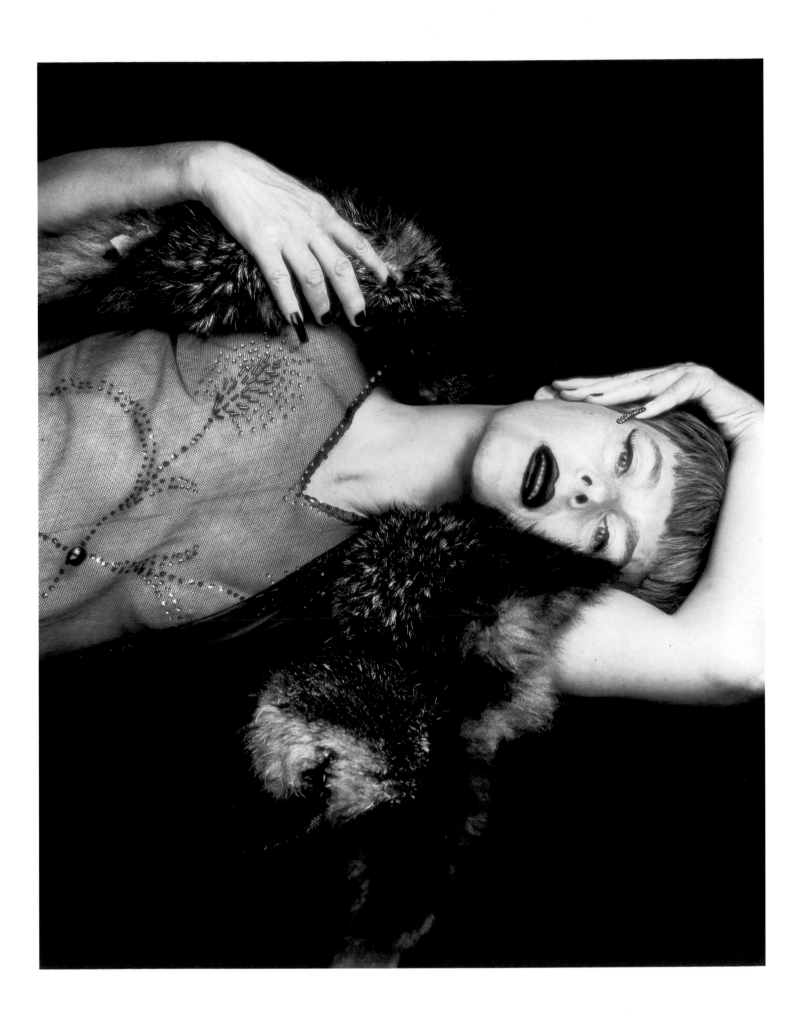

Nick Knight, Ann Stansell, *Showstudio.com*.

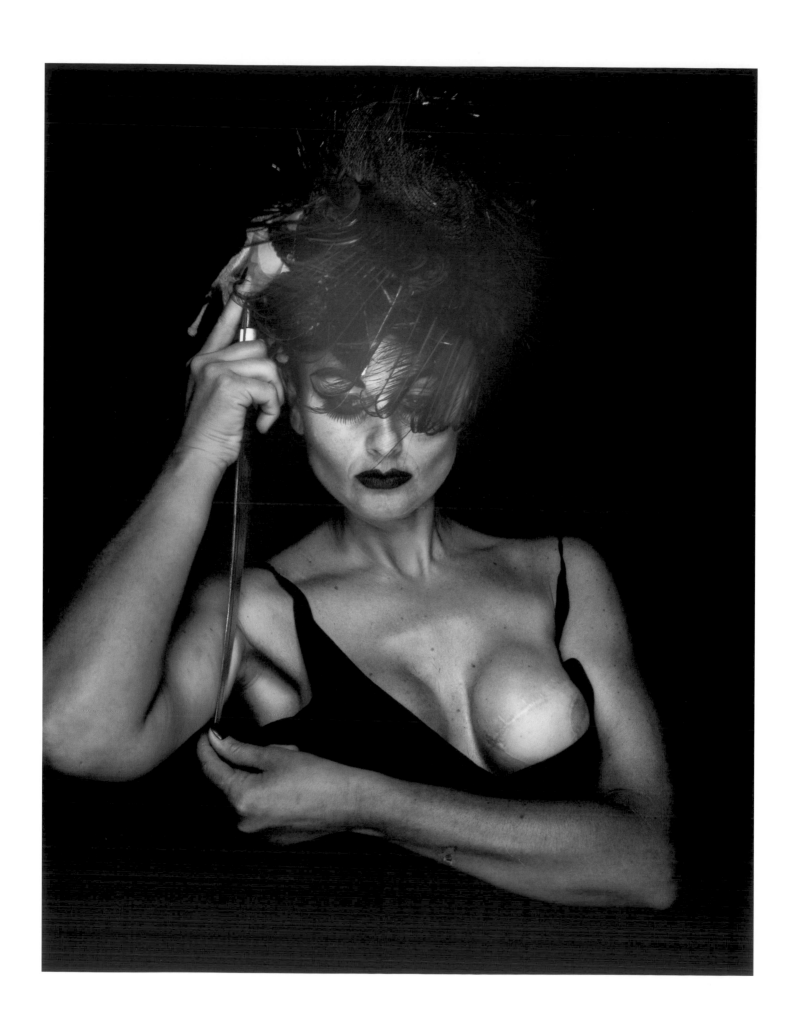

Nick Knight, Miranda Vicente, *Showstudio.com*.

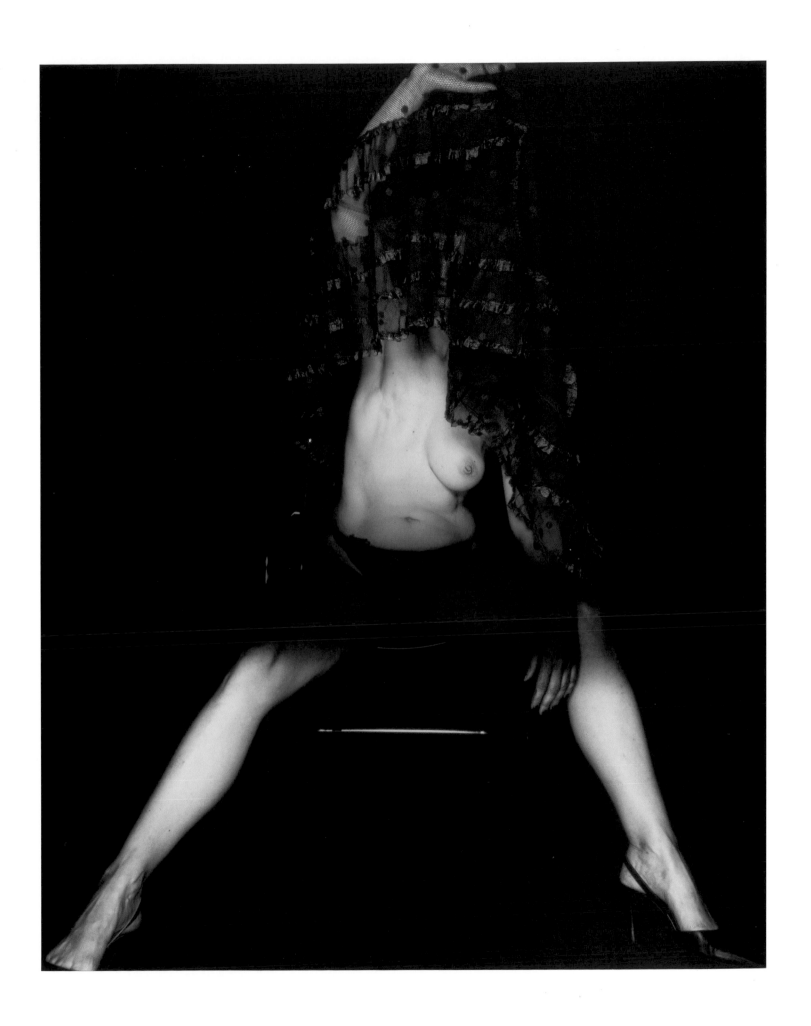

Nick Knight, Matuschka, *Showstudio.com.*

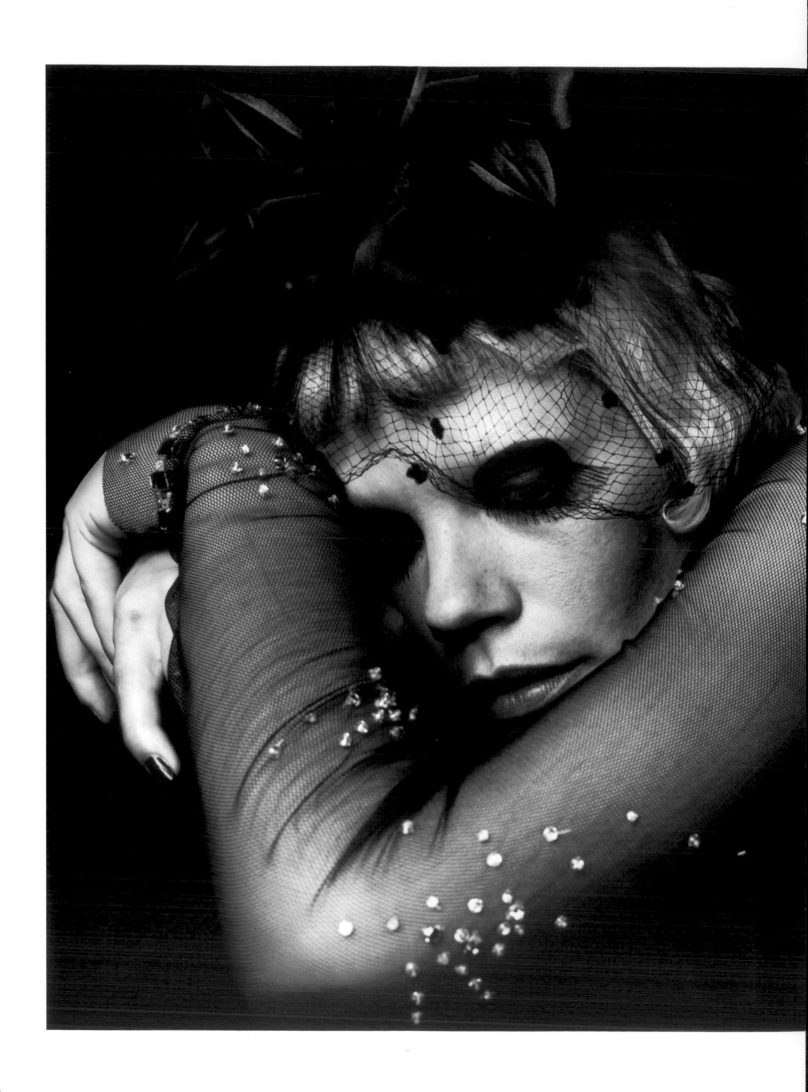

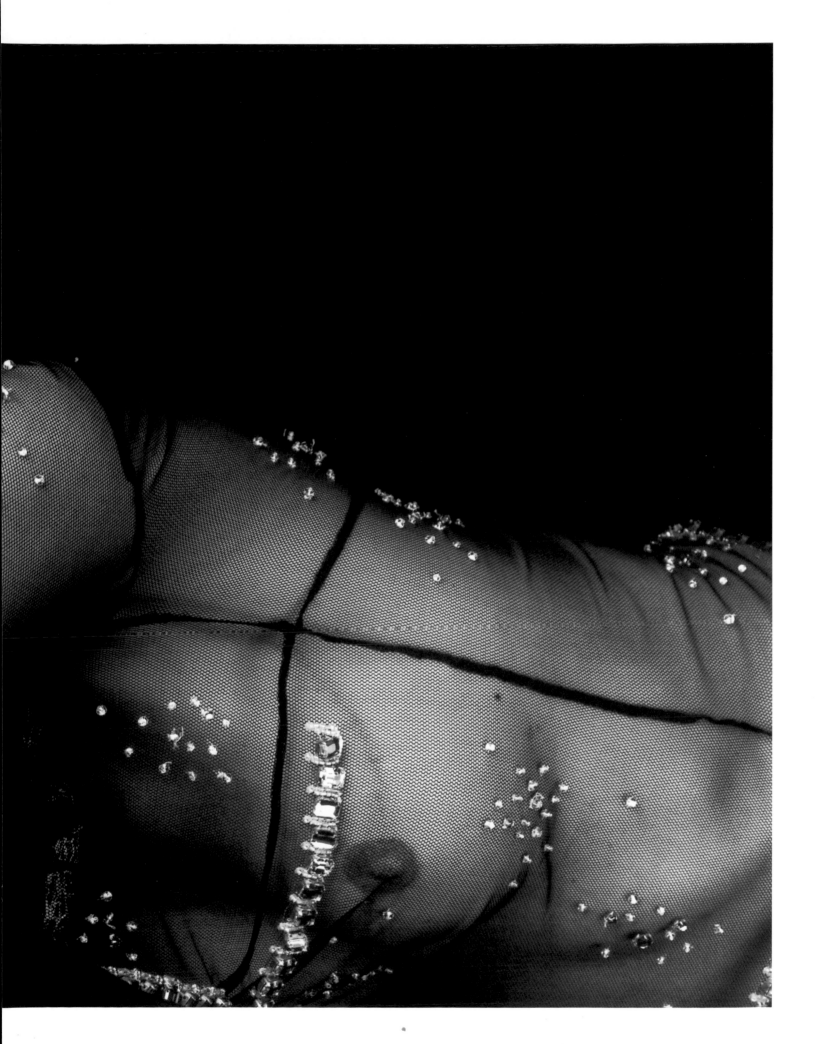

Nick Knight, Nikki Umberti, *Showstudio.com.*

NARRATIVE PHOTOGRAPHY

BY AVIS CARDELLA WITH A PORTFOLIO BY PHILIP-LORCA DICORCIA

September 2000: the fall fashion issue of *W* magazine is chunky and jam-packed with advertising and editorial pages. Nestled within the well of the glossy tome is a twenty-four-page spread titled 'Stranger in Paradise' which, thanks to the keenly focused lens of photographer Philip-Lorca diCorcia, captures a *mise en scène* that appears to question the very values the magazine tends to endorse. Within the borders of each thoughtfully constructed frame a story is played out, cinematic and smoky-hued. Characters, ranging from beaming blond socialites and their tuxedoed escorts to an army general and a mysterious 'boy', are seemingly attending the same cocktail party. This, as each carefully chosen detail will attest, is a rarefied world of money and privilege. But something is amiss. This world of exclusion has somehow been permeated. Turn the page and the buff, translucent-skinned boy is naked, centre stage in this theatre of manners, enclosed in a glass shower. Turn the page again and he is sprawled on a sofa, flanked by two willow-limbed and carefully coiffed socialites. The threesome is then caught sharing lunch, his plate of overflowing fries and goo-goo grin in sharp contrast to their designer salads, rail-straight posture and 'oops, you caught me' smirks. While the editorial copy speaks of 'impeccably tailored suits' and 'elegant evening dresses', it's easy to forget that this is a fashion spread constructed within the commercial codes of a fashion magazine. The fashion appears almost incidental. Welcome to the world of narrative fashion.

In explaining his construction of these images diCorcia says: 'At first I thought the class exploitation and decadence thing was a little predictable but then I decided that it was important for me to maintain a critique of the medium in which I was working, which I have consistently tried to do. I saw the characters as both models of production and consumption at a time in the US when big money and rampant materialism were so all-pervasive as to have become applaudable to most.' Is this the fashion photograph that *Vogue* editor-in-chief Anna Wintour speaks of in the preface to the book *The Idealizing Vision*, where she writes: 'Our needs are simple. We want a photographer to take a dress, make a girl look pretty, give us lots of images to choose from, and not give us any attitude'? Or do diCorcia's images fall more in line with the observation of novelist and essayist Susan Sontag, who writes: 'The greatest fashion photography is more than the photography of fashion'? Sontag could have easily been making reference to diCorcia's 'Stranger' as well as a large portion of the fashion imagery produced over the past year. The actual fashion – the very thing that calls a fashion photograph into being – has taken a back seat in photographs that create deliberate fictions rife with symbolism and innuendo, constructed realities with social signifiers that affront the viewer.

Just as documentary-style 'realism' was appropriated in fashion's vocabulary in the 1990s, so have narrative, staged scenarios and cinematic views – which have gained legitimate approval in the fine-art world over the past decade – evolved and been adopted by fashion in parallel. As Elliott Smedley points out in an essay entitled 'Escaping To Reality: Fashion Photography in the 1990s': 'Periodically, there is an attempt by the fashion world to shed what it perceives as an overly commercial image – and its search for something new results in flirtation, even courtship, between fashion and the art world.' The art presently involved in this flirtation is narrative. And the flirtation has been realized via the crossover of fine-art talent (the aforementioned diCorcia, and Nan Goldin, for example) into the fashion arena, as well as via the appearance of imagery produced for commercial fashion purposes on gallery and museum walls. Naturally, the resulting images attempt to do more than simply show pretty girls in pretty dresses. More often than not they imbue style and fashion with allegory and expression, connecting with the viewer on social, psychological and emotional levels.

But employment of a narrative and vernacular image in fashion photography is not an entirely contemporary phenomenon. Stirrings of the genre's desire to do more than simply show clothing can be seen in the 1950s within the work of Richard Avedon and Irving Penn. Avedon's penchant for capturing mannerisms and gestures from real life, and Penn's utilization of sociological and anthropological elements, made the point that a model is more than the clothing she carries on her back. Yet, it is the introduction of filmic techniques in the 1960s and 70s that led to clothing becoming more incidental in the fashion photograph. Two names that immediately come to mind are Helmut Newton and Guy Bourdin, who both reworked fashion images into complex documents encoded with erotic hieroglyphics. Suddenly, a Bourdin photo wasn't about high-heeled shoes but became a commentary about the type of woman who wears them. Newton hadn't simply photographed an Yves Saint Laurent suit but had embarked on an exploration of the delicate balance between male and female roles in the era of the 'liberated woman'.

A seminal narrative construct comes via the lens of Bob Richardson, who in 1967 produced a series of photographs for French *Vogue* set on a Mediterranean beach. The lone female model, dark-haired and with an anxious, feral expression in her eyes, sits in a café inhabited only by men, whose gazes are eerily reflected in a mirror or caught in the blurry gauze of the flattened background. The sequence follows her to a rocky beach where she sits alone, smoking a cigarette and rolling pebbles in her palms, while in another frame she reclines in the sand, her head propped on the spine of her lover. Apparently uninterested, he looks out into the horizon as a single tear rolls down her cheek. Again, Richardson's series is remarkable not so much for the fashion it features but for its observations about the woman who may wear it. Unlike much of the fashion photography produced until then, these images embraced themes of melancholy and despair and brooked questions about the

artificial nature of fashion photography itself. Although not realist in their actual style, their realistic nature departed from fashion photography's unattainable ideal and set the stage for future imagery to comment honestly about cultural and social themes beyond the scope of fashion.

In the ensuing years fashion photography has continued to show that it can reflect the spirit of a time. Narrative has been a vehicle to do so. Image-makes such as Bruce Weber, with his high contrast black-and-white Americana, created photographic stories throughout the 1980s that presented a dichotomy of old-fashioned apple pie values and an increasingly sexualized male. And, on the heels of an era of glamour and supermodeldom, narrative returned in the early 1990s in the form of documentary-style realism. The storylines here often reflected urban isolation, anomie, and a suggestion of the pervasiveness of drug culture. Photographers who made these the conscious subjects of their narratives included Corinne Day, Juergen Teller and Nan Goldin, with Goldin being especially noteworthy because she exemplifies the cross-fertilization of the fine-art photography and fashion photography worlds. While Goldin was solidly recognized as a fine-art talent she seamlessly stepped into the fashion world, ultimately producing advertising images for designers such as Helmut Lang and Matsuda.

Today's narrative trend comes into focus as a representation of the multi-tentacled creature that fashion photography has become: selling clothing, being auctioned as art, addressing complex social issues. It accepts itself as a soldier of commerce, yet often becomes so loaded with drama and innuendo that it threatens to burst from its glossy walls. Stylized fictions can act as an escape route for fashion's commercial aspirations, especially when created by fine-art photographers. The boundaries between both worlds becomes further blurred, begging the question: Can art look like fashion, fashion like art? Such as is the case with diCorcia's 'Stranger'. diCorcia states that he stopped doing cinematic narratives in his personal work back in 1994. Yet the fashion world was still clamouring for a narrative style in 2000 and fashion photographers appeared anxious to further explore the theme.

The past year has seen new talent emerge, often published by smaller 'couture' magazines such as Spoon, Numéro, Flaunt and Dutch, which have adopted a style of 'staged fashion photography'. Richard Mistri, for example, takes the trappings of American pop culture, particularly the idiosyncrasies of Southern California, and creates unsettling scenes that often parody the excesses of the culture's incessant focus on appearance. Jerome Esch creates fashion photographs that incorporate themes of infrastructure, 'how things are put together'. In the 'Terra Nova' issue of Spoon, Esch creates a thematic fashion story that explores the pervasive and silent presence of big corporations in all our lives. While the 'fashion' is present in each photo, he injects a sinister sense of corporate

culture sterility by interspersing frames of models wearing hard hats and trendy clothing with frames of the naive, happy, park-like atmosphere of a gated community. Esch succeeds in achieving an eerie balance between a place that is both beautiful and horrible. As the photographer explains: 'Just beyond the frame are the dangers, the bad guy lurking just past the protective fence.'

What makes these images new and noteworthy is not only the open-ended storylines but their attempt to connect with the viewer on a deeper psychological level through them. In doing so they further challenge fashion's ability to transcend itself, to move beyond the built-in obsolescence of its subject matter. Fashion has velocity. But now that images such as those produced by Guy Bourdin for French Vogue in 1981 are sold at Pace MacGill Gallery in New York for tens of thousands of dollars, can we say that the fashion image is on its way to being stopped in its tracks? What is clear is that the image of the pretty girl in the pretty dress will not be able to transcend its sell-by date. But perhaps fashion with a narrative can. As art photography is gaining respect in the art world, wouldn't fashion photography care to garner some of the same respect?

In the premier issue of British magazine The Fashion, photographer Jonathan de Villiers produced a fashion editorial set in an art auction house. As de Villiers explains: 'The auction house shoot came about because the evaluation, promotion and selling of art objects is a lovely way of tackling the issues surrounding both the wider selling machine that fashion is a part of, and the art/commerce dynamic that everyone who works in an industry like fashion has to fret over.' de Villiers creates a photographic story crammed with 'a lot of stuff'. While fashion is its starting point, by virtue of its setting and publication, the photos also include images by both Thomas Struth and Nan Goldin up for sale in the auction room, alongside Philippe Garner (one of the world's foremost photographic print experts) assessing a Bill Brandt (who, according to de Villiers, 'decisively influenced 60s fashion photography') and the Sotheby's in-house photographers shooting a silver dress. The dress, says de Villiers, 'is a nice metaphor for the transformation of the ephemeral and diaphanous into hard precious metal'. Another metaphor to be found in LeVillers' multi-layered document has to do with fashion photography's recent trend for narrative. His positioning of art within fashion within art exemplifies the inspiration that fashion has taken from fine-art photographers over the past years, the movement of fine-art photographers into fashion photography, and the continued need for both to find new and exciting outlets for their ideas and stories.

Avis Cardella is a former model who worked in the US and throughout Europe before becoming a freelance journalist and novelist. Her work has appeared in Marie Claire, Picture, Frank and Sexual Health among other publications. She is currently working on a book about identity as it relates to our perception of ourselves in photograph.

Septembre 2000. La revue de mode W, dans son numéro de mode d'automne, est saucissonnée et bourrée de publicité et de pages d'articles. Inséré à l'intérieur de cette revue luxueuse, on trouve un reportage de 24 pages intitulé «Stranger in Paradise» qui, grâce à l'objectif parfaitement maîtrisé du photographe Philip Lorca diCorcia, propose une mise en scène semblant remettre en question les valeurs mêmes que la revue préconise. Chaque image soigneusement construite, évoque une histoire qui se déroule dans des teintes fumées et un style cinématographique. Divers personnages, allant de la starlette blonde et pétillante, escortée de son cavalier en smoking, au général en uniforme, jusqu'à un étrange «garçon», tous semblent se divertir dans le même cocktail. Comme le suggère la recherche dans le détail, l'ambiance est très raffinée, un monde où abondent les privilèges et l'argent. Il y a cependant quelque chose d'étrange. On dirait qu'on s'est infiltré dans ce monde très exclusif. En tournant la page, on s'aperçoit que le jeune homme à la peau lisse et bronzée, personnage principal de ce théâtre de moeurs, est nu derrière un pare-douche vitré. A la page suivante, on le retrouve affalé sur un sofa, flanqué de deux minettes impeccablement coiffées, aux jambes longues et souples. On les retrouve plus loin tous les trois, un sourire béat aux lèvres, lui une assiette débordant de frites à la main contrastant avec les salades design des filles qui se tiennent droites comme des ifs, et «oui vous nous avez bien eu», petits sourires. Alors que le texte parle «de costumes impeccablement coupés» et «d'élégantes robes du soir», on oublie facilement qu'il s'agit d'un reportage de mode tout à fait dans les normes commerciales de la revue. En fait, la mode y semble presque accessoire.

Bienvenue dans ce monde de la mode narrative.

Cherchant à expliquer la construction de ses images, diCorcia commente : «Au début, je croyais que l'exploitation des classes et le phénomène de décadence étaient assez prévisibles mais il m'a semblé ensuite plus important pour moi de faire une critique du moyen d'expression avec lequel je travaillais, ce que j'ai ensuite immanquablement cherché à faire. J'ai considéré les personnages comme des modèles de production et de consommation à la fois, à une époque où aux Etats-Unis, l'argent et le matérialisme étaient partout devenus les valeurs que tout un chacun applaudissait.» S'agit-il du photographe à la mode que cite le rédacteur en chef de Vogue, Anna Wintour, dans la préface du livre The Idealizing Vision où elle écrit «Ce que nous recherchons est très simple. Nous voulons qu'un photographe prenne de belles photos de robes sur de jolies filles et nous propose un grand choix d'images afin que nous puissions retenir les meilleures, mais sans aucune prétention»? ou bien est-ce que les images de diCorcia sont plus dans la ligne de la romancière et essayiste, Susan Sontag, lorsque celle ci constate : «La très belle photographie de mode est bien plus que la photographie de la mode»? Sontag aurait facilement pu se référer à «Stranger» de diCorcia ainsi qu'à une grande partie des images de mode produites l'an dernier. La mode véritable, celle qui définit l'existence même d'un photographe de mode, est passée à l'arrière plan de photographies qui, à dessein, créent des fictions pleines de symboles et d'allusions, réalités construites avec des signifiants sociaux qui interpellent le spectateur.

De même que le réalisme de style documentaire est devenu un terme du vocabulaire de la mode, dans les années 90, de même les scénarios, mises en scène narratives et vues cinématographiques qui ont gagné leurs lettres de noblesse dans le monde des beaux arts au cours des 10 dernières années, ont évolué et été adoptés parallèlement par la mode. Comme le signale Elliott Smedley dans un essai intitulé «Escaping to Reality: Fashion Photography in the 1990s» : «On constate régulièrement dans le monde de la mode une tentative faite pour rejeter ce qui est perçu comme une image par trop commerciale et la recherche d'autre chose qui donne le flirt, voire une cour en bonne et due forme, entre le monde de la mode et celui de l'art. L'art impliqué dans ce flirt est narratif. Et le flirt se matérialise par la rencontre de talents artistiques (tels que diCorcia et Nan Goldin par exemple) sur la scène de la mode et l'apparition d'images de mode produites à des fins commerciales sur les murs des galeries d'art et de musées. Bien sûr, les images en question font autre chose que de montrer de jolies filles dans de jolies robes. La plupart du temps, elles mêlent au style et à la mode des allégories et expressions qui renvoient le lecteur au plan social, psychologique et émotionnel.

Mais le recours à une image narrative et vernaculaire pour la photographie de mode n'est pas un phénomène entièrement contemporain. On retrouce des prémisses du genre, ce désir de faire autre chose que de montrer simplement des vêtements, dans les années 50 avec l'œuvre de Richard Avedon et Irving Penn. Le penchant d'Avedon pour saisir les gestes et les poses dans la vie réelle, laisse à penser qu'un mannequin représente bien plus que les vêtements qu'il ou elle peut porter. Toutefois, c'est l'introduction de techniques cinématographiques dans les années 60 et 70 qui ont fait du vêtement quelque chose d'accessoire pour le photographe de mode. Deux noms nous viennent aussitôt à l'esprit : Helmut Newton et Guy Bourdin, car tous deux ont retravaillé les images de mode en documents complexes codés avec des hiéroglyphes érotiques. Soudain, une photo de Bourdin ne montrait plus des chaussures à talons hauts mais devenait un commentaire sur le type de femme qui les portait. Newton ne photographiait pas simplement un tailleur d'Yves Saint Laurent mais explorait l'équilibre délicat qui existait entre les rôles féminins et masculins à l'époque de la femme libérée.

Une construction narrative qui fait école, émerge de l'objectif de Bob Richardson qui, en 1967, a produit une série de photos pour Vogue, édition française, sur une plage méditerranéenne. Le seul mannequin féminin aux cheveux bruns, à l'expression dure et au regard anxieux, est assise dans un café empli d'hommes dont le regard se reflète mystérieusement dans un miroir ou dans le halo d'un fond d'image assez flou. On la retrouve ensuite seule, assise sur une plage rocheuse, en train de fumer une cigarette et de lisser des galets dans sa main, tandis que dans une autre séquence, elle est allongée sur le sable, la tête appuyée sur le dos de son amant. L'air indifférent, celui-ci a le regard tourné vers l'horizon tandis qu'une larme coule le long de la joue de son amie. La série de Richardson est remarquable, non tant pour la mode qu'il présente mais pour les connotations sur la femme qui peut porter cette mode. Contrairement à la photographie de mode produit

jusqu'alors, ces images évoquent la mélancolie et le désespoir et suscitent des questions sur la nature artificielle de la photographie de mode. Bien que non réaliste dans leur style, la nature réalistique découle de cet idéal inaccessible de la photographie de mode et plante le décor de futures images pour d'authentiques commentaires sur des sujets culturels ou de société n'appartenant plus au domaine de la mode.

Au cours des années suivantes, la photographie de mode a continué à montrer qu'elle pouvait refléter l'esprit d'une époque. Avec comme vecteur, le style narratif. Des images telles que celles de Bruce Weber, avec son grand contraste noir et blanc Americana, ont créé des récits photographiques tout au long des années 80 qui intégraient la dichotomie des anciennes valeurs américaines traditionnelles et l'homme de plus en plus sexualisé. Et dans le sillage d'une époque de glamour et de supermannequins, la narration est revenue, au début des années 90, au réalisme de style documentaire. Les histoires évoquent alors l'isolation urbaine, l'anomie et suggèrent l'infiltration de la culture de la drogue. Parmi les photographes qui ont consciemment choisi ces thèmes pour leurs récits, citons Corinne Day, Juergen Teller et plus particulièrement Nan Goldin, car elle illustre le fertile croisement de la photographie d'art et de la photographie de mode. Alors que Goldin était reconnue pour son talent artistique, elle s'est peu à peu acheminée vers le monde de la mode pour récemment produire des images pour des designers tels que Helmut Lang et Matsuda.

La tendance narrative, aujourd'hui, est le reflet de la créature tentaculaire qu'est devenue la photographie de mode, cherchant à vendre des vêtements, se mettant aux enchères comme une œuvre d'art, et répondant à des questions sociales complexes. Elle s'accepte comme un soldat du commerce tout en devenant à ce point chargée de drame et d'allusions qu'elle menace d'exploser hors de sa cage dorée. Des fictions stylisées peuvent servir de dérivatif pour les aspirations commerciales de la mode, surtout lorsqu'elle est le fait de photographes d'art. Les limites entre les deux mondes s'estompent de plus en plus et posent la question de savoir si l'art peut ressembler à la mode et la mode à l'art. C'est le cas avec «Stranger» de diCorcia qui affirme avoir cessé toute narration cinématographique dans son œuvre personnelle depuis 1994. Pourtant, le monde de la mode se réclamait encore du style narratif en l'an 2000. Et les photographes de mode semblaient toujours désireux d'explorer le sujet.

De nouveaux artistes talentueux sont apparus l'an dernier, souvent publiés par des revues de haute couture de moindre tirage telles que Spoon, Numéro, Flaunt et Dutch, et ils ont adopté le style photographie de mode mise en scène. Richard Mistri, par exemple, reprend les décors de la culture pop américaine et plus encore les particularités propres à la Californie du Sud pour créer des scènes étranges qui bien souvent parodient les excès de cette continuelle importance accordée à l'apparence. Jerome Esch propose des photographies de mode basées sur des thèmes d'infrastructure, «comment les choses peuvent s'assembler». Dans un numéro de Spoon, Esch crée une histoire de mode thématique qui explore la présence silencieuse et envahissante des

grandes sociétés dans notre vie. La mode est bien là sur chaque photo, mais une sensation sinistre de stérilité de culture d'entreprise est donnée, intercalant des images de mannequins portant chapeau et vêtements à la dernière mode avec des photos d'une société ingénue s'amusant follement et renfermée sur elle-même. Esch parvient à trouver un équilibre troublant entre un lieu à la fois splendide et horrible. Comme il l'écrit : «Les dangers guettent derrière le bord de l'image et le laron est là aux aguets derrière la photo et son encadrement.»

Ce qui rend ces images nouvelles et remarquables, c'est non seulement la narration sans conclusion mais également la tentative faite pour relier le spectateur à un plan psychologique plus profond. Ainsi, remettent-elles en question la capacité de la mode à se transcender, à aller au delà de l'obsolescence inhérente à son sujet. La mode est aussi évanescence. Mais maintenant que des images telles que celles produites par Guy Bourdin pour la revue Vogue, édition française, en 1981, sont vendues à la Galerie Pace MacGill, à New York pour des dizaines de milliers de dollars, peut-on dire que l'image de mode est sur le point d'être figée dans le temps? Ce qui est clair c'est que l'image d'une jolie fille dans une jolie robe ne pourra pas transcender sa date de péremption. Mais par contre, la mode narrative peut y parvenir : de même que la photographie d'art gagne respect et reconnaissance dans le monde de l'art, la photographie de mode ne pourrait-elle pas recueillir aussi une partie de ce respect ?

Dans le premier numéro de la revue britannique The Fashion, le photographe Jonathan de Villiers propose un reportage de mode avec pour décor une salle de vente aux enchères. Et il explique : « L'idée de la salle de vente m'est venue en pensant à l'estimation, la promotion et la vente d'objets d'art, un formidable moyen pour traiter les questions concernant à la fois la vaste machine à vendre dont fait partie la mode et la dynamique du commerce de l'art qui inquiète tous ceux qui travaillent dans un domaine comme celui de la mode.» de Villiers a créé une histoire photographique bourrée «d'un tas de trucs». Alors que la mode est son point de départ, en vertu même du décor et de la publication, les photos incluent aussi des images de Thomas Struth et Nan Goldin sur le point d'être vendues aux enchères, avec Phillippe Garner (l'un des plus célèbres experts en photographie) évaluant un Bill Brandt (qui, selon de Villiers, «a influencé de façon décisive la photographie de mode des années 60») et les photographes de Sotheby en train de photographier une robe en argent. La robe, dit de Villiers, «est une métaphore de la transformation de ce qui est éphémère et diaphane en métal précieux». Une autre métaphore que l'on trouve dans le document de de Villiers porte sur la tendance récente de la photographie de mode à devenir narrative. Son positionnement de l'art dans la mode dans l'art, montre bien l'inspiration que la mode a su trouver auprès des photographes d'art ces dernières années, et le mouvement des photographes d'art vers la photographie de mode, avec le besoin constant pour les uns et les autres de trouver de nouveaux débouchés pour leurs idées et leurs récits.

Avis Cardella fit une carrière de mannequin aux Etats Unis et en Europe avant de devenir journaliste free-lance et écrivain. Ses travaux ont notamment été publiés dans Marie Claire, Picture, Frank et Sexual Health. Elle rédige actuellement un livre sur l'identité et son influence sur la perception que nous avons de nous-mêmes sur les photographies.

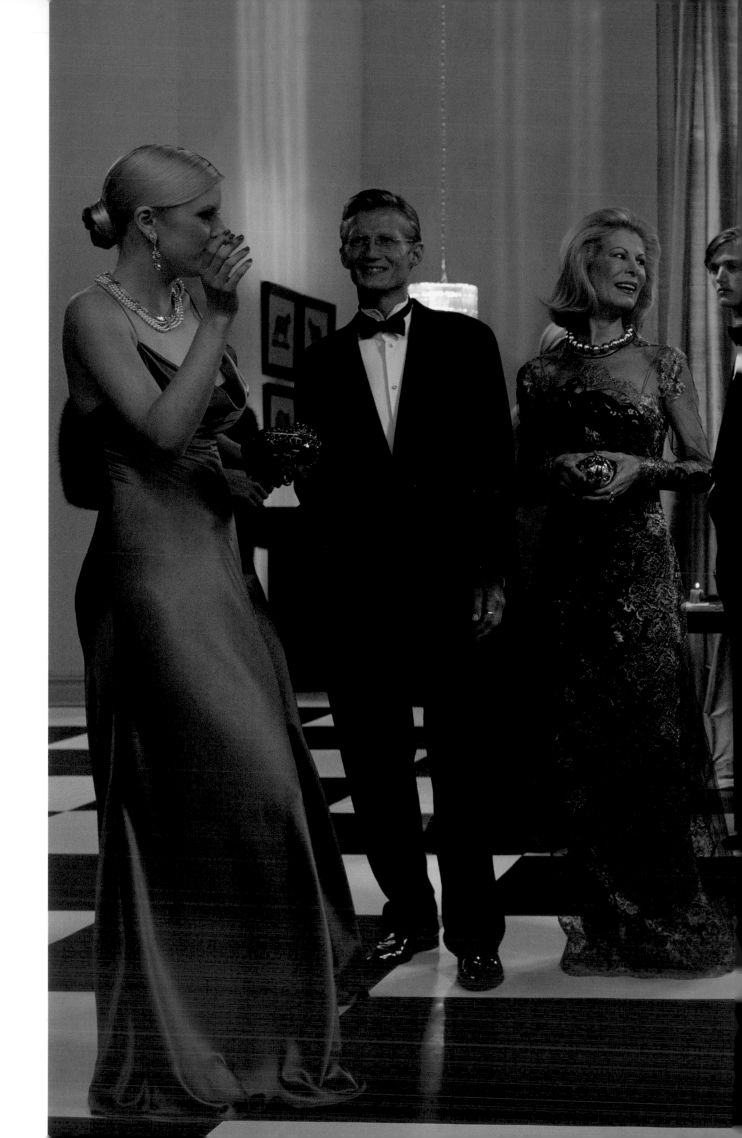

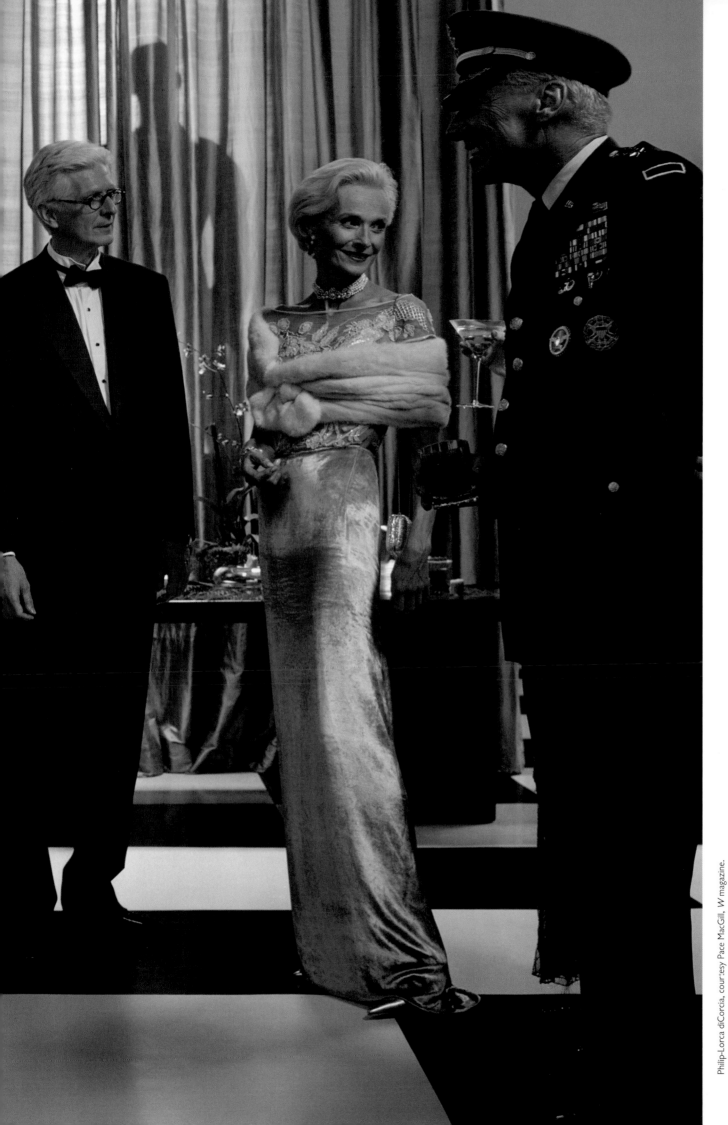

Philip-Lorca diCorcia, courtesy Pace MacGill, W magazine.

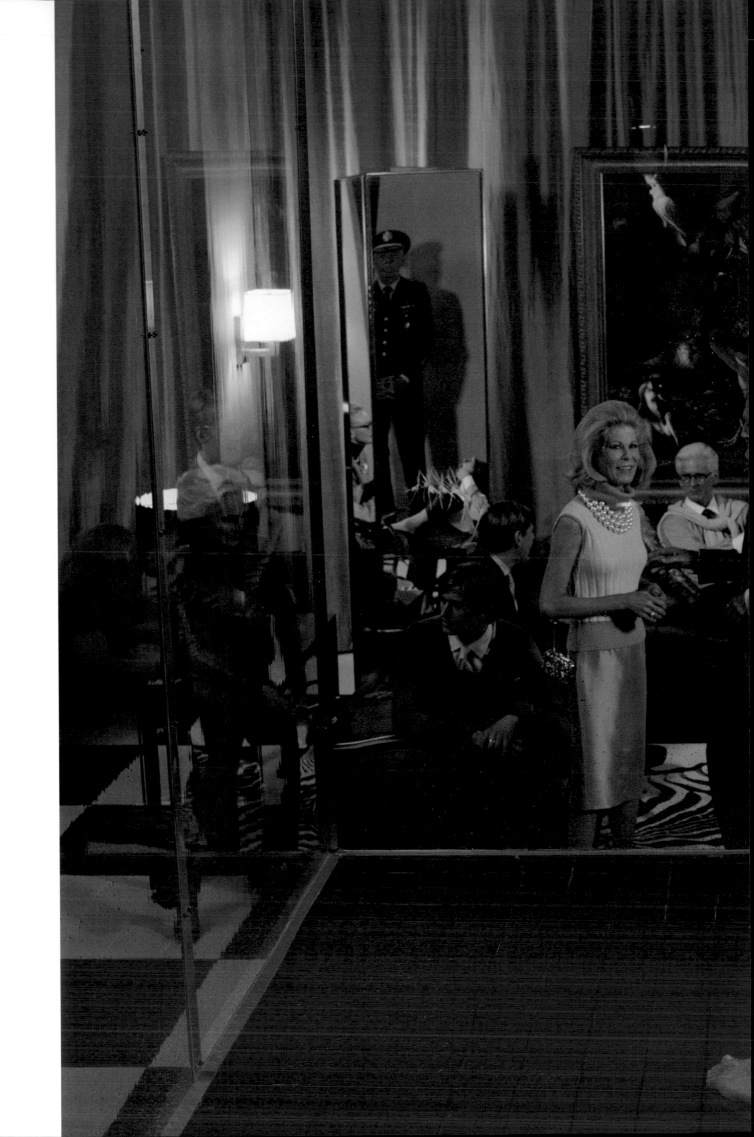

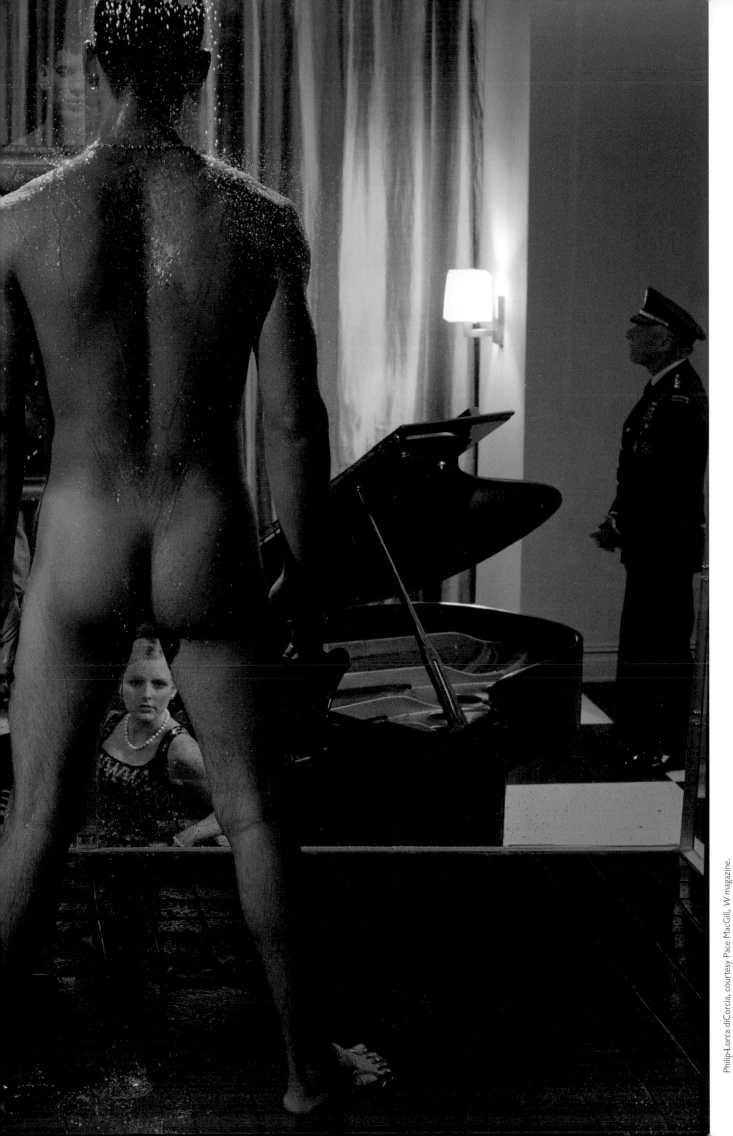

Philip-Lorca diCorcia, courtesy Pace MacGill, *W magazine.*

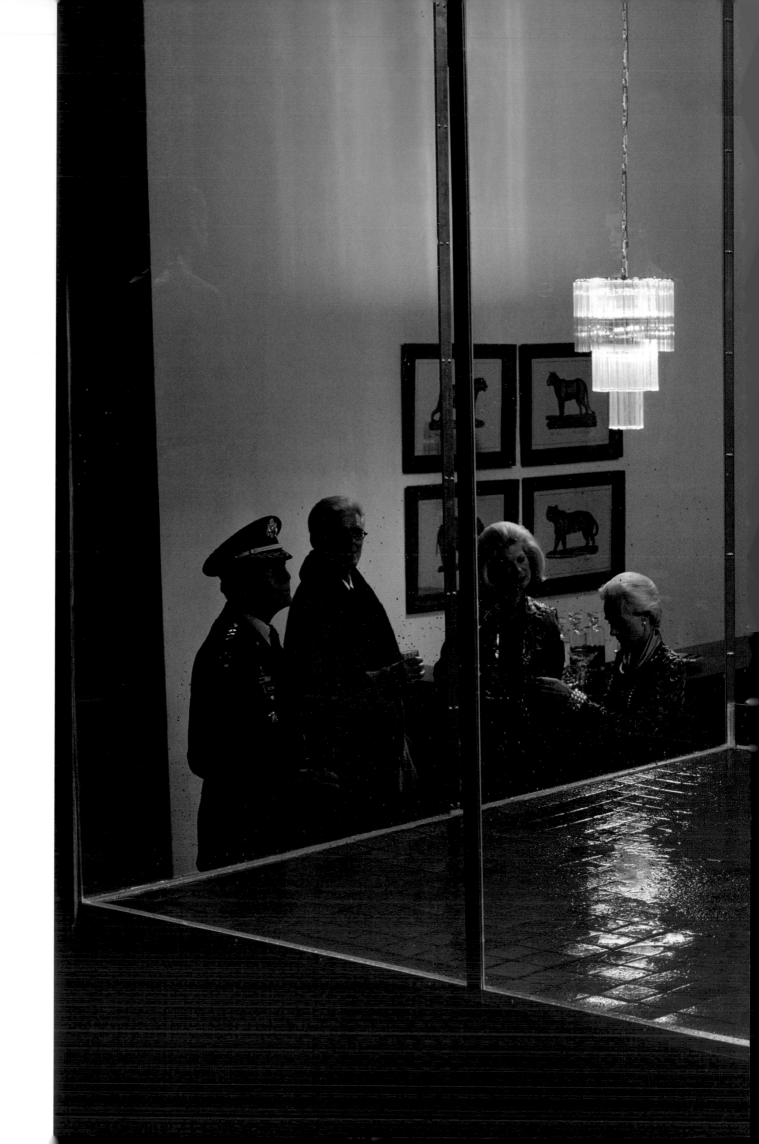

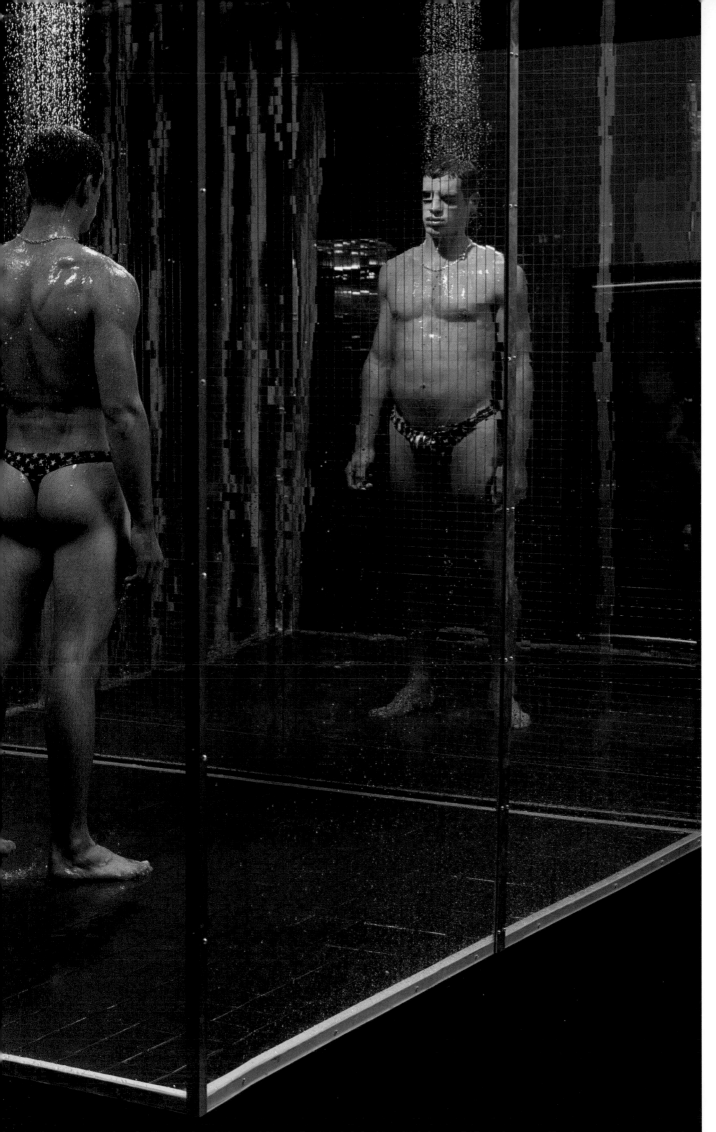

Philip-Lorca diCorcia, courtesy Pace MacGill, W magazine.

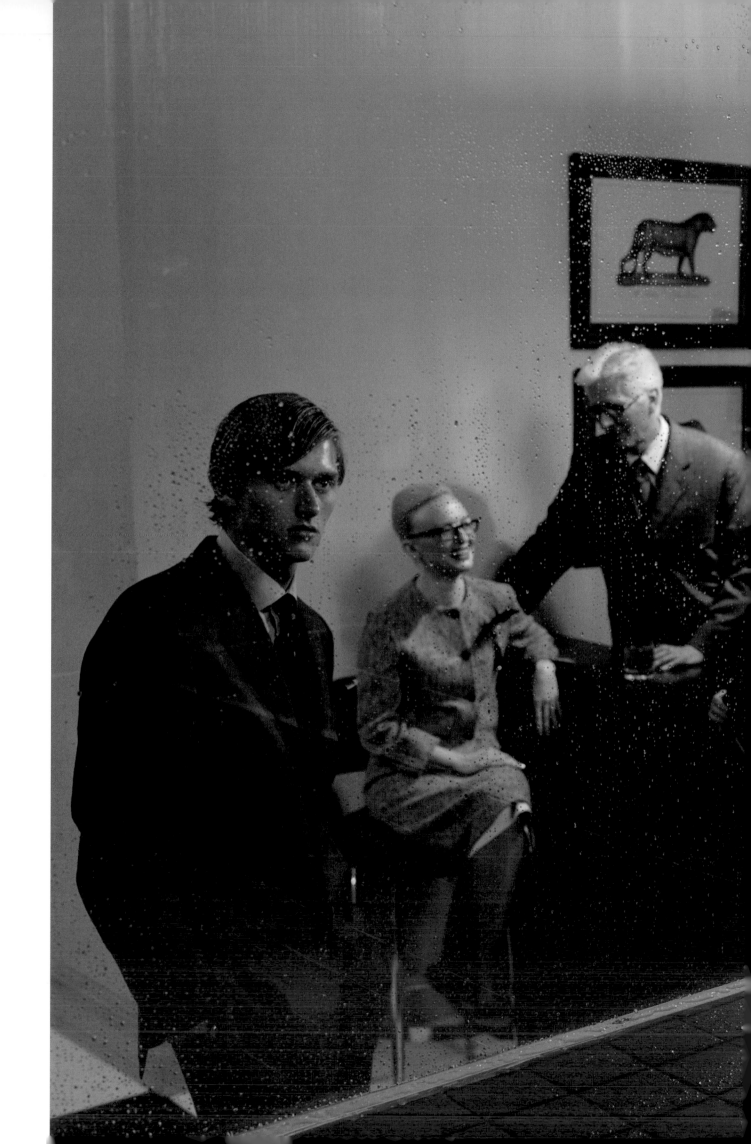

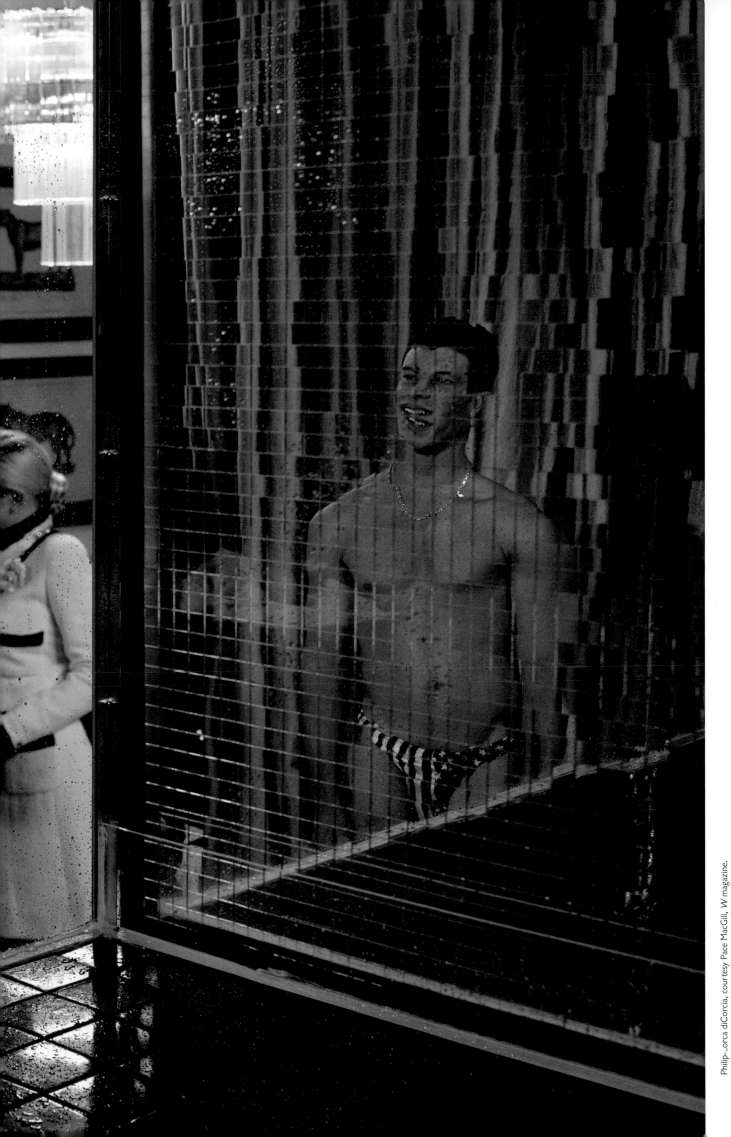

Philip–orca diCorcia, courtesy Pace MacGill, W magazine.

Philip-Lorca diCorcia, courtesy Pace MacGill, *W* magazine.

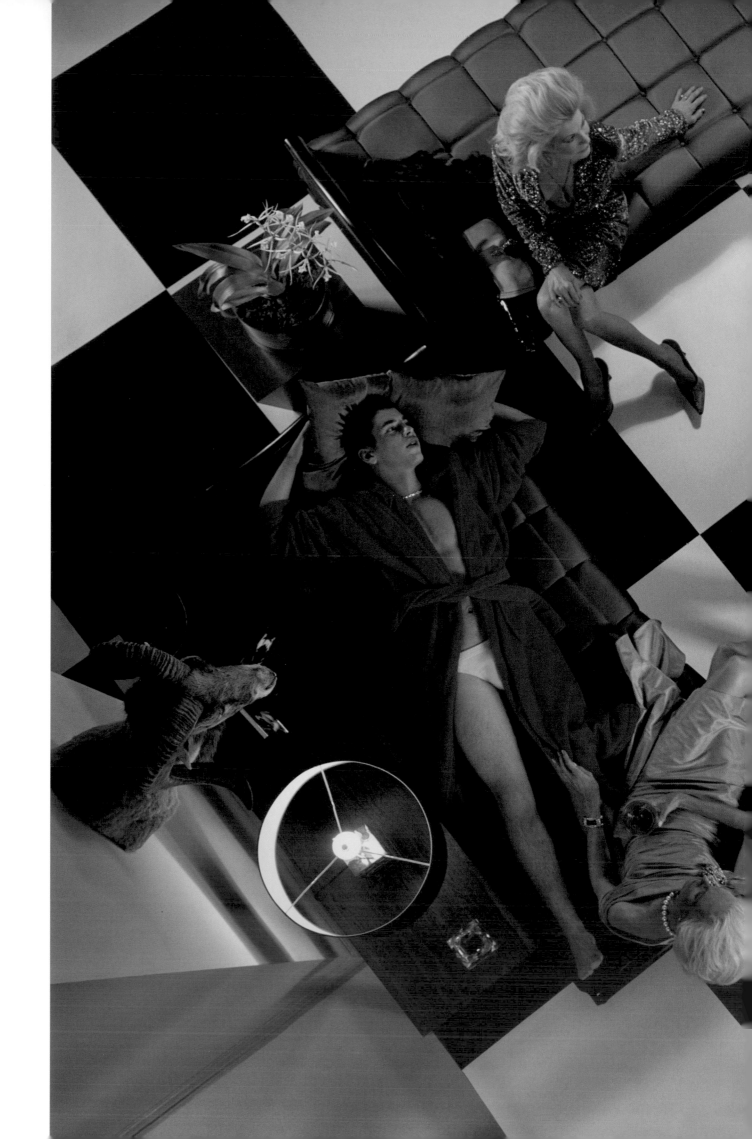

46

Philip-Lorca diCorcia, courtesy Pace MacGill, *W magazine.*

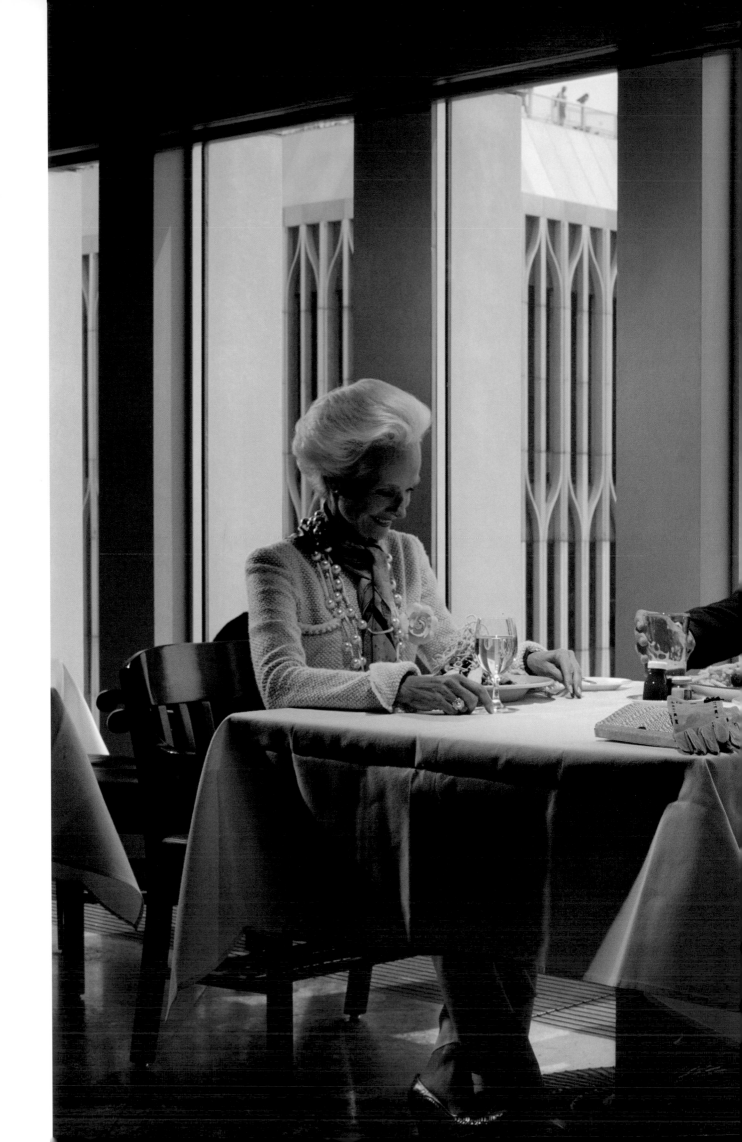

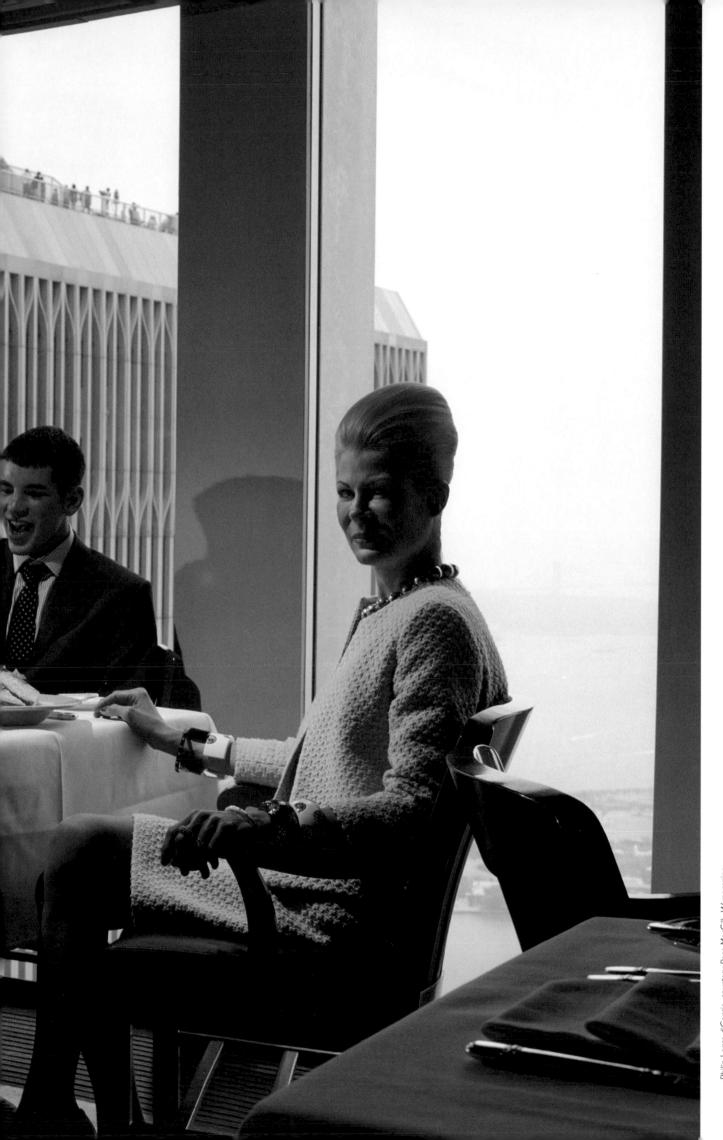

Philip-Lorca diCorcia, courtesy Pace MacGill, *W magazine*.

49

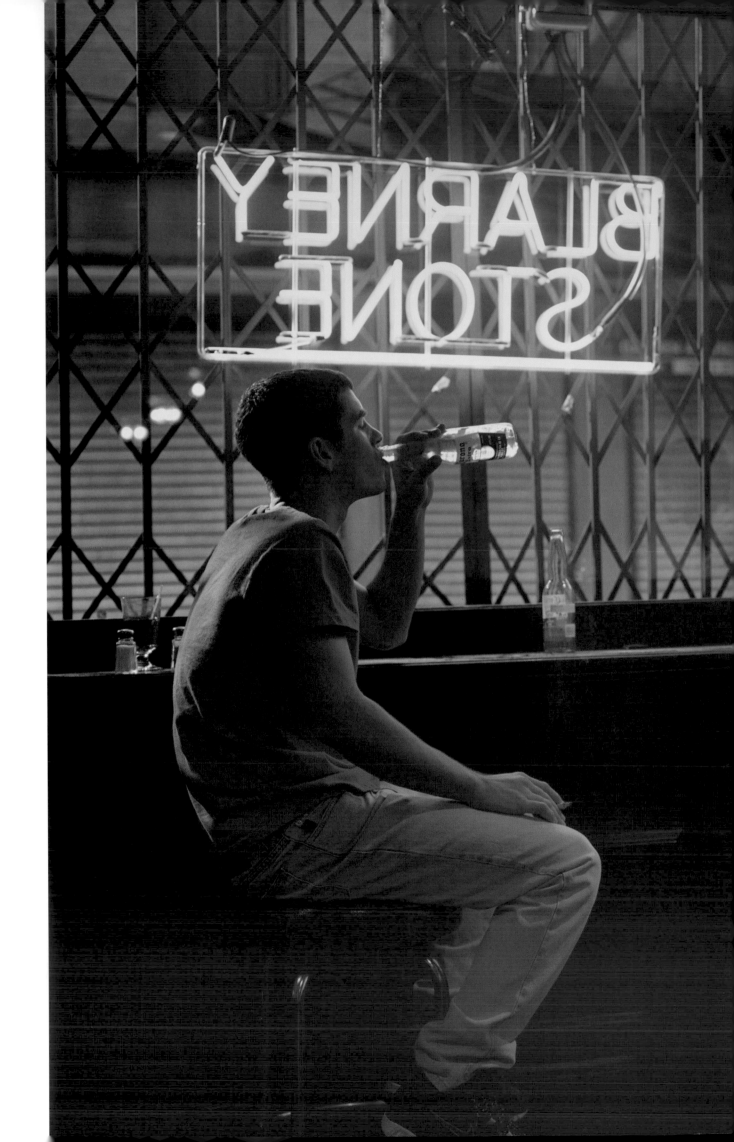

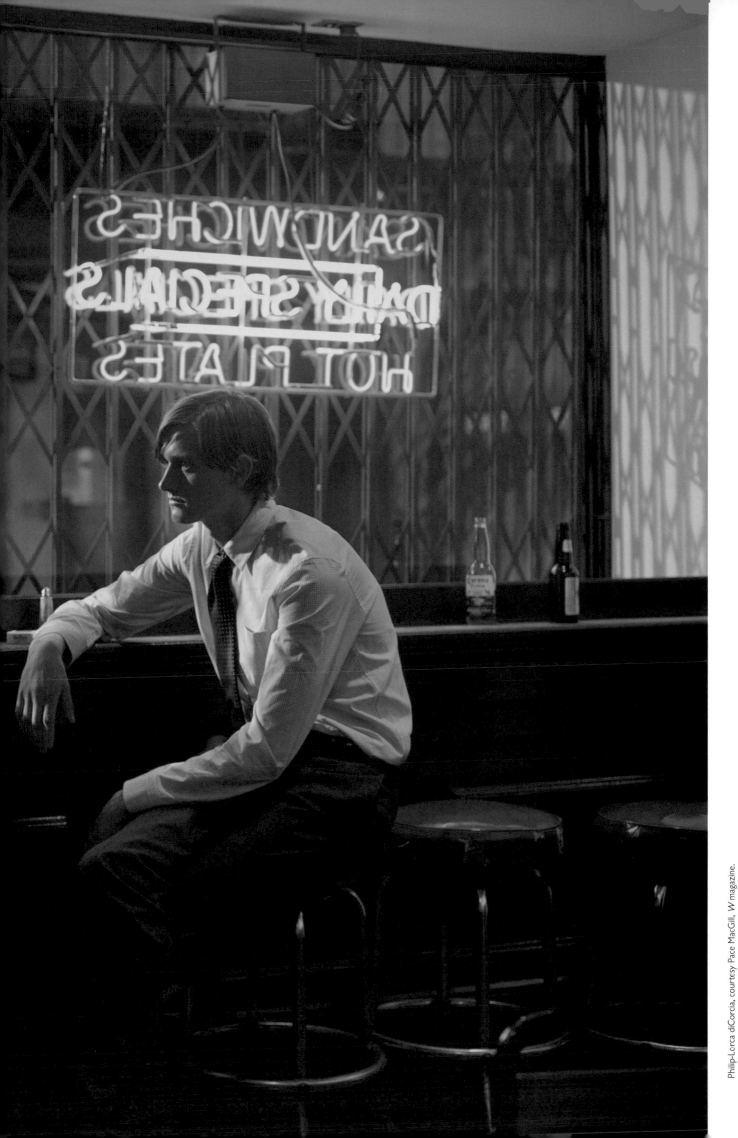

Philip-Lorca diCorcia, courtesy Pace MacGill, *W* magazine.

51

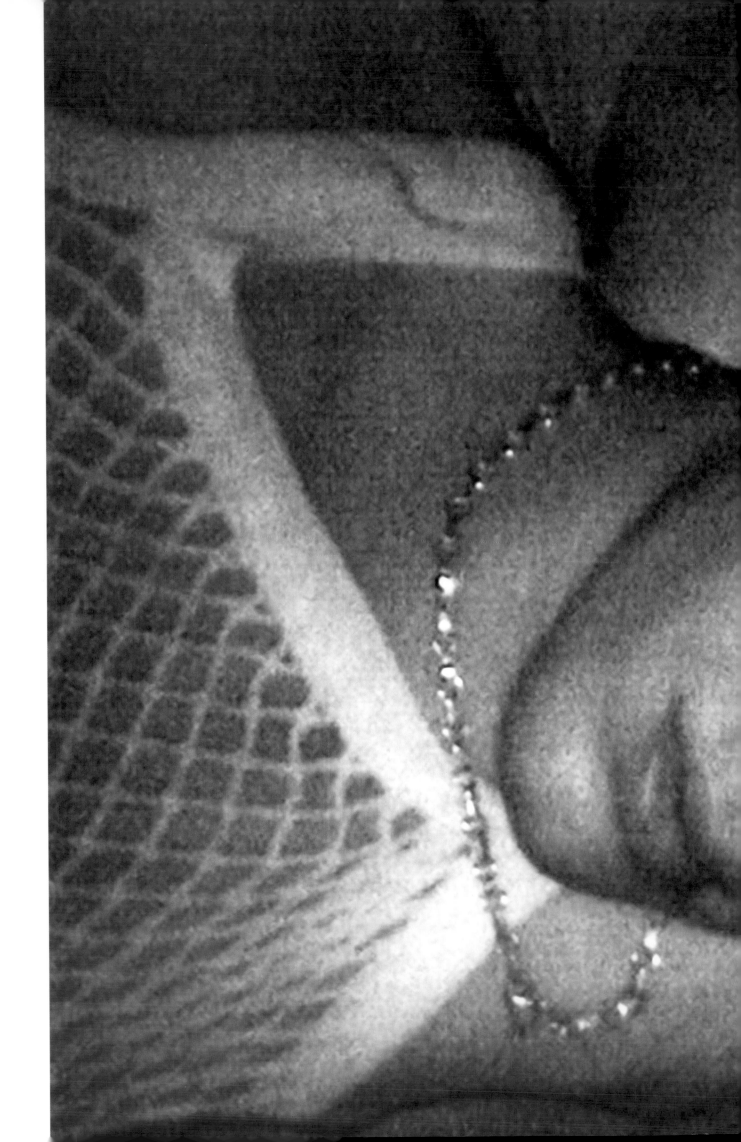

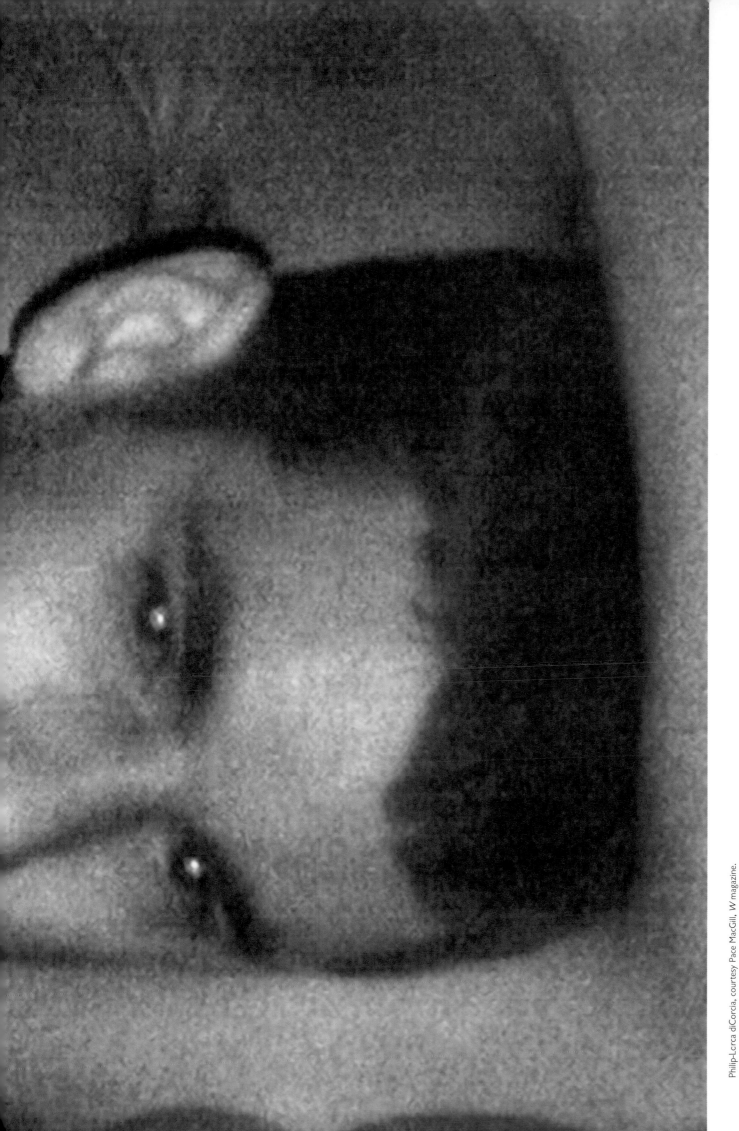

Philip-Lorca diCorcia, courtesy Pace MacGill, W magazine.

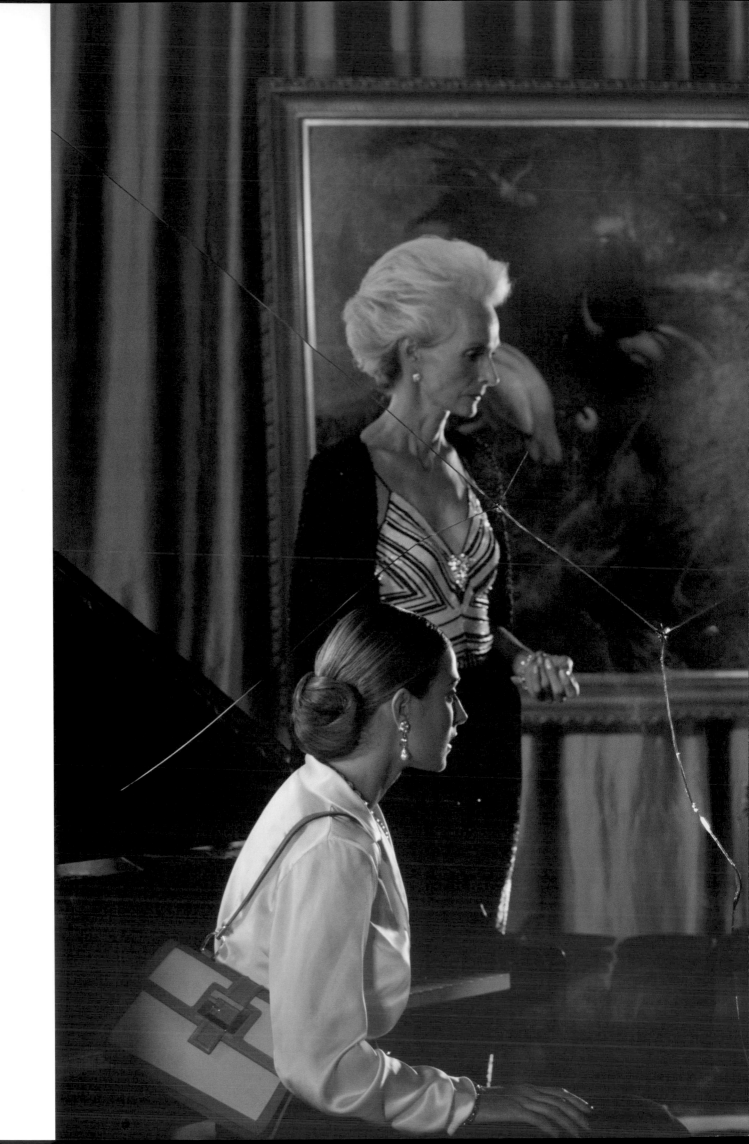

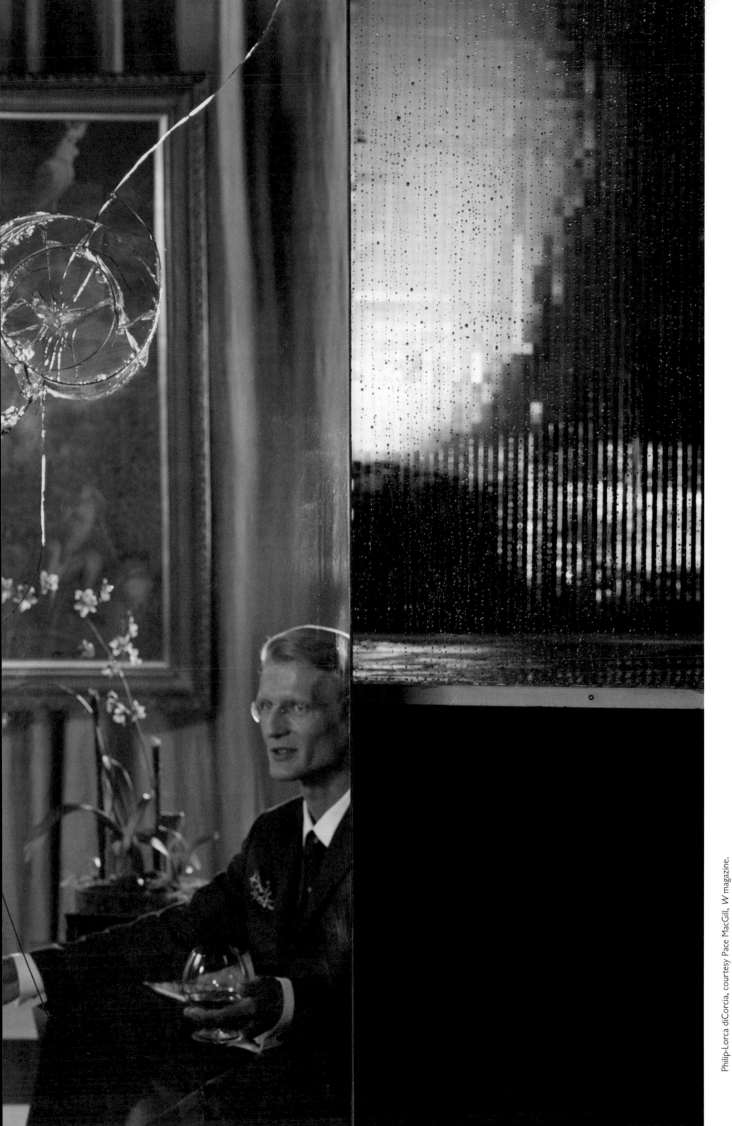

Philip-Lorca diCorcia, courtesy Pace MacGill, *W* magazine.

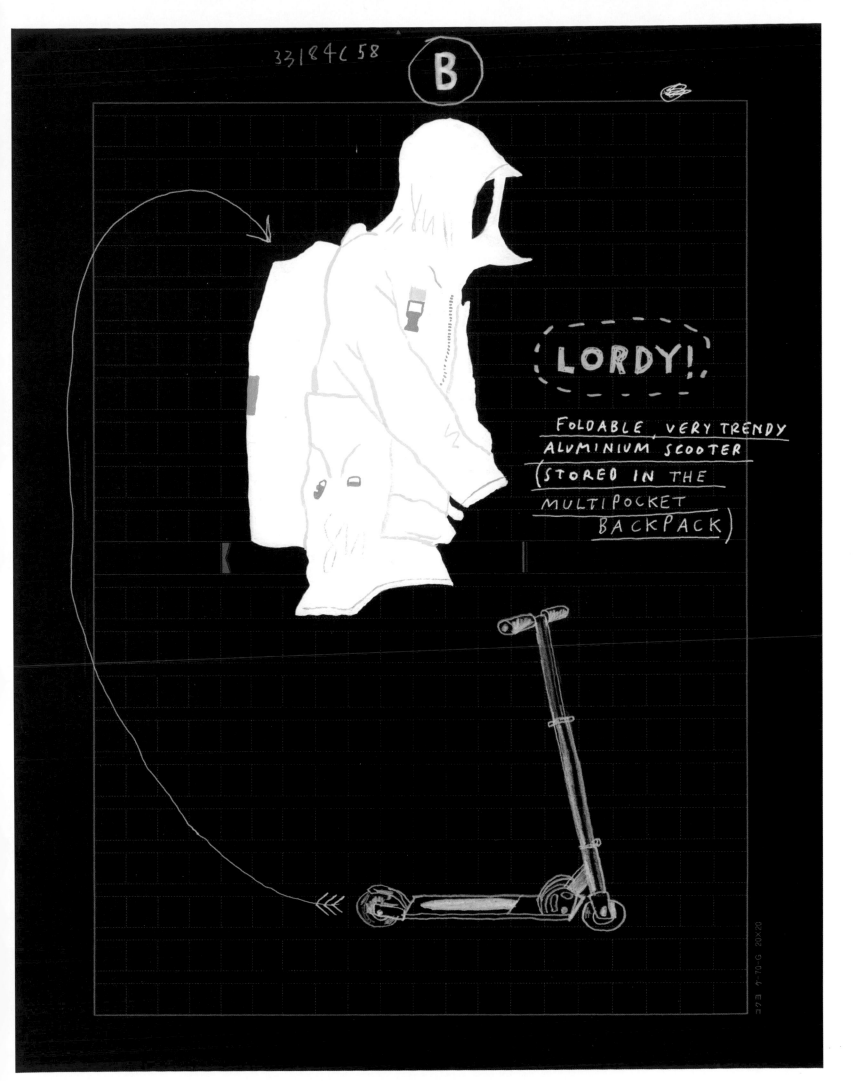

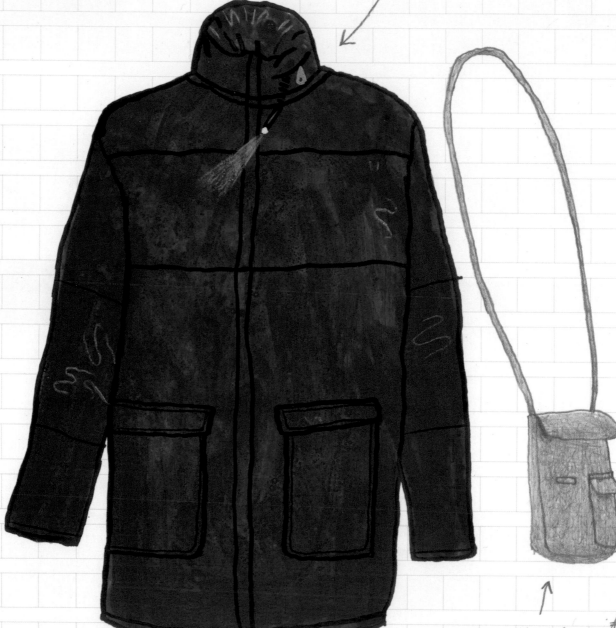

handy

READING LAMP

comes with it.
FOR BOOKS.

LIFE C151-G

20 × 20

Paul Davis, *Saturday Night* magazine.

REALLY: IT TURNS INTO A HAMMOCK!

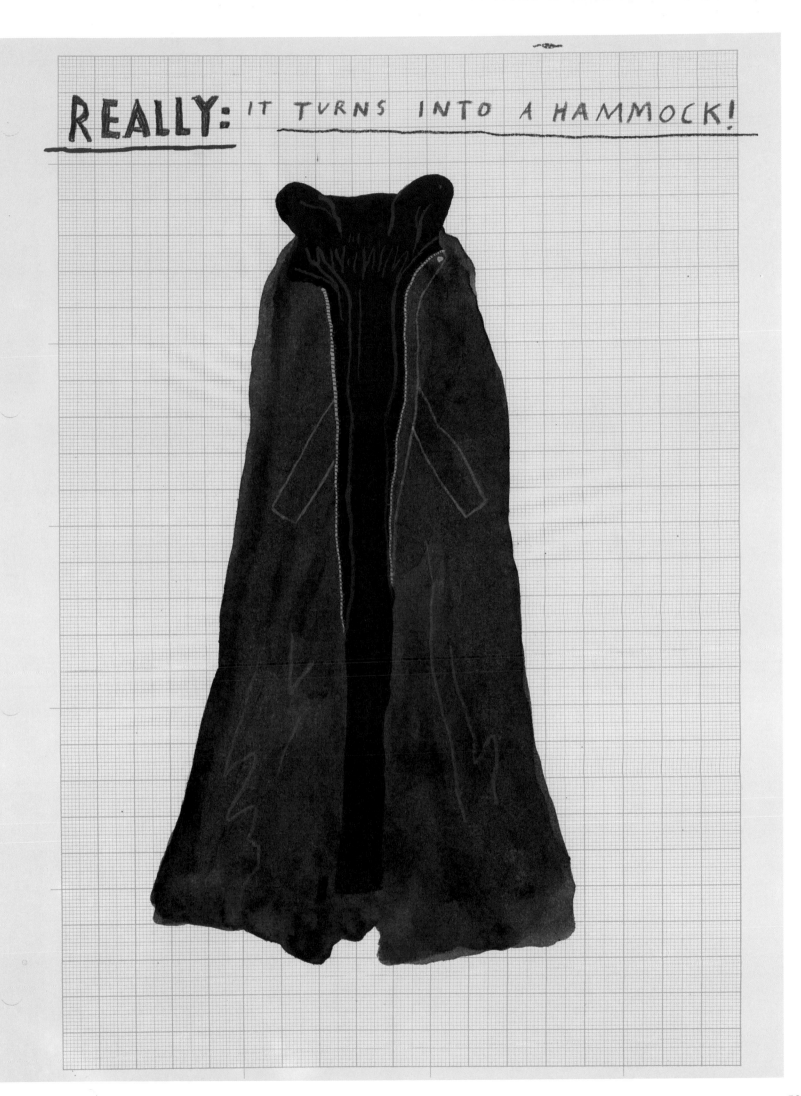

IT TURNS INTO A HAMMOCK!

Paul Davis, *Saturday Night* magazine.

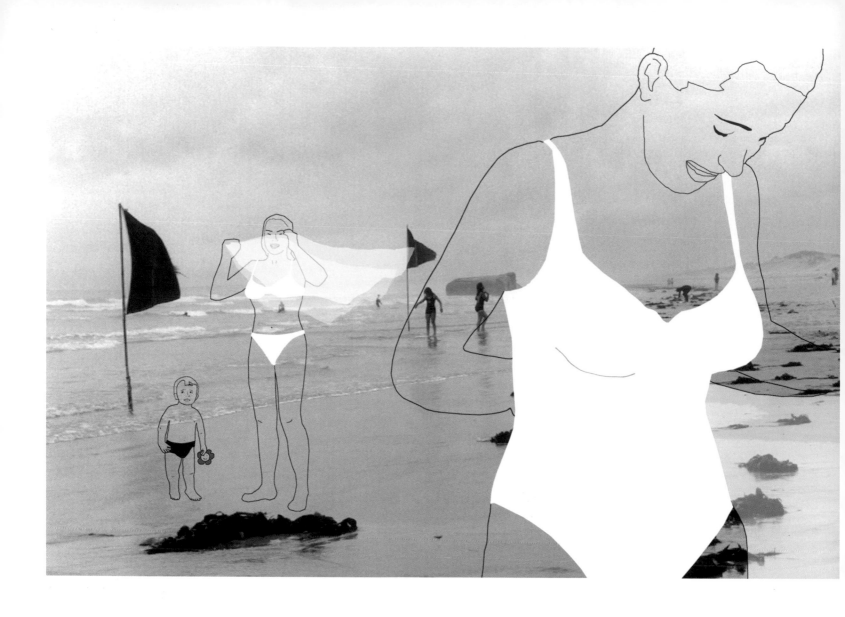

Morgane le Gall, *Alice.*

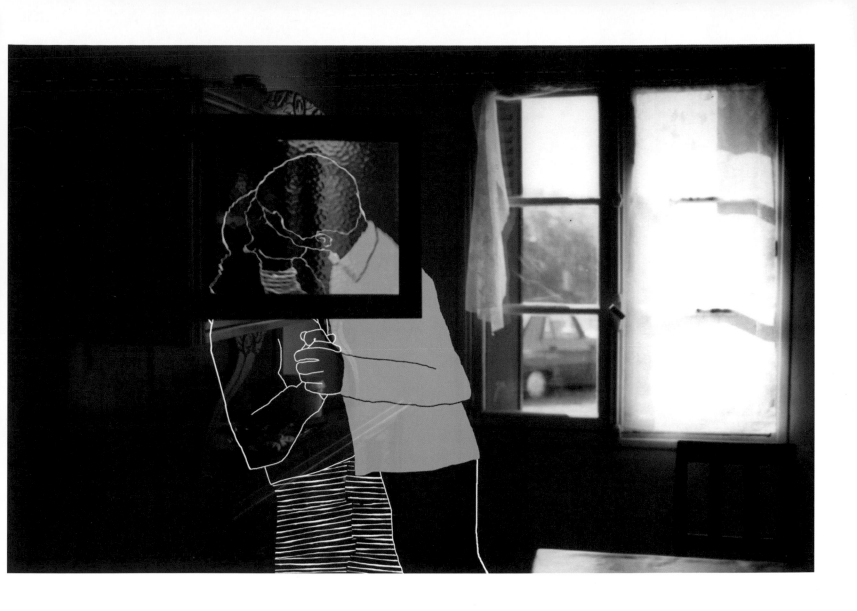

Morgane le Gall, Festival de la Mode, Hyères.

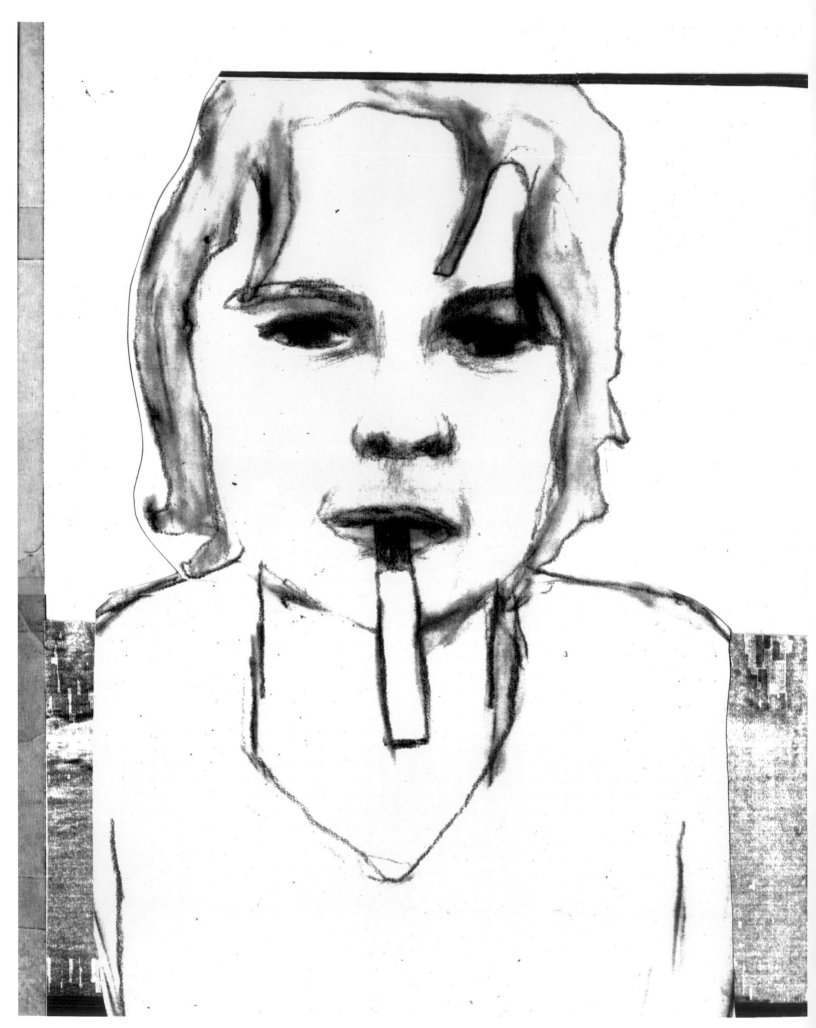

Graham Rounthwaite, *Everything but the Girl*, CD artwork, Virgin Records.

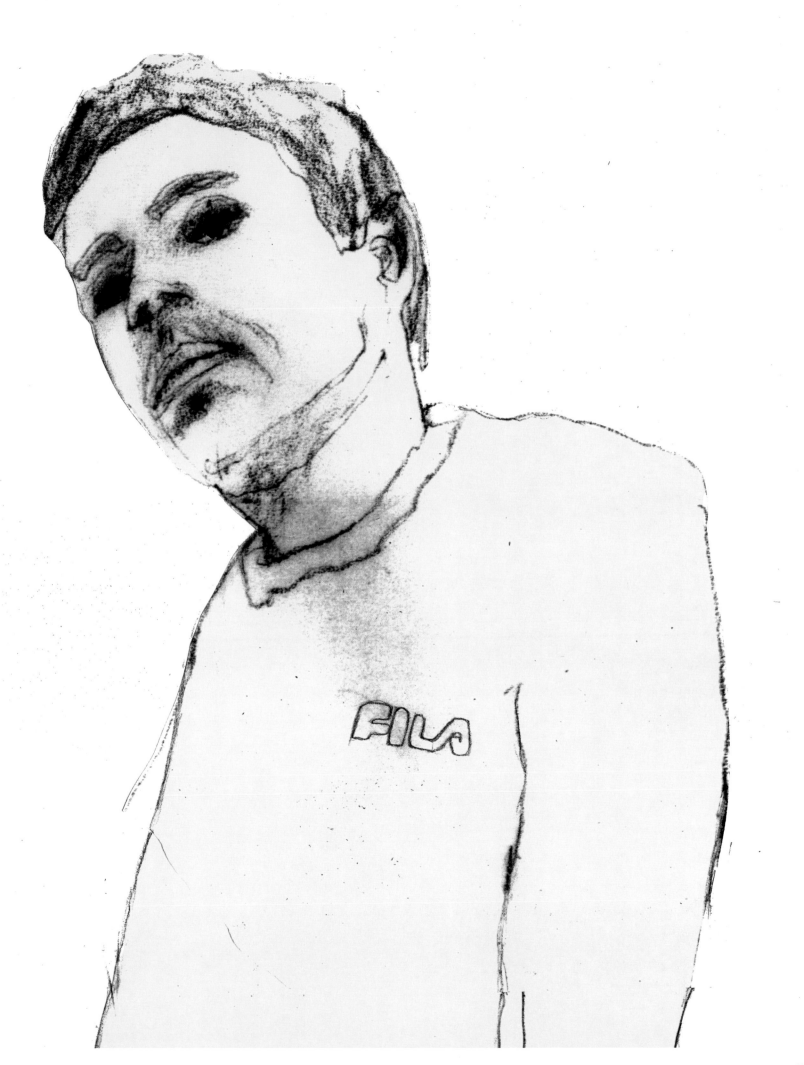

Graham Rounthwaite, *Everything but the Girl*, CD artwork, Virgin Records.

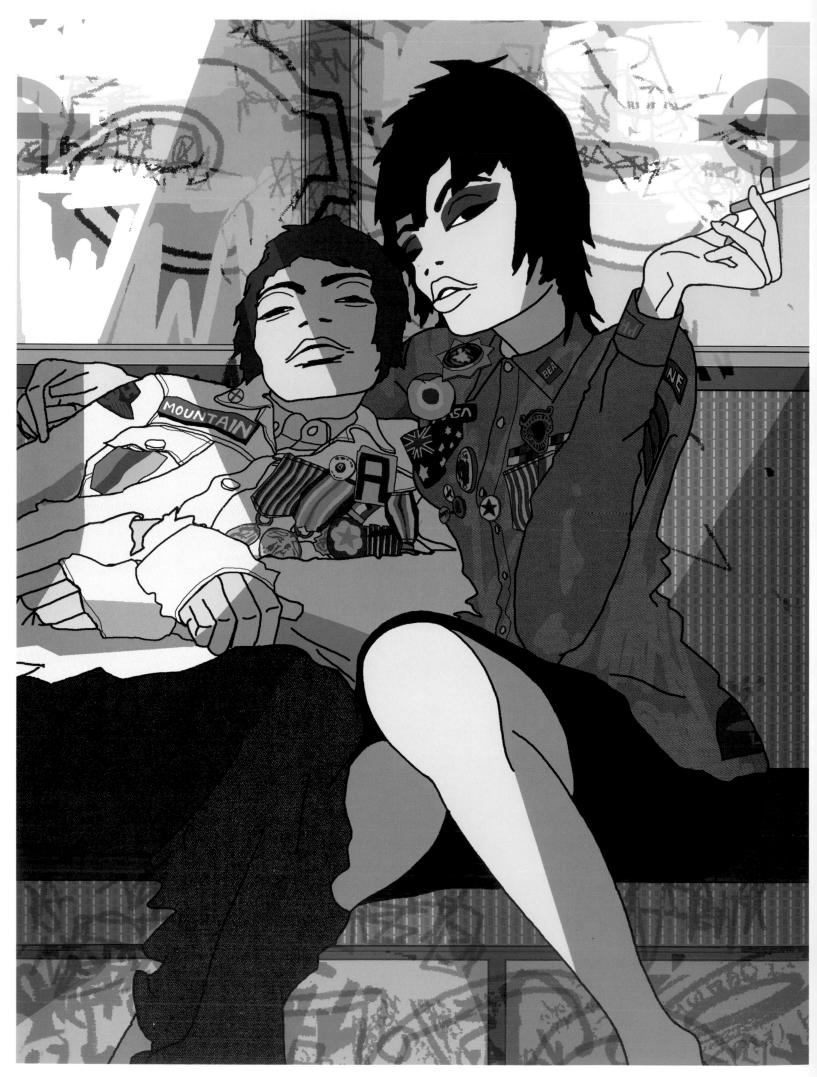

Graham Rounthwaite, Club 333, Off-Centre.

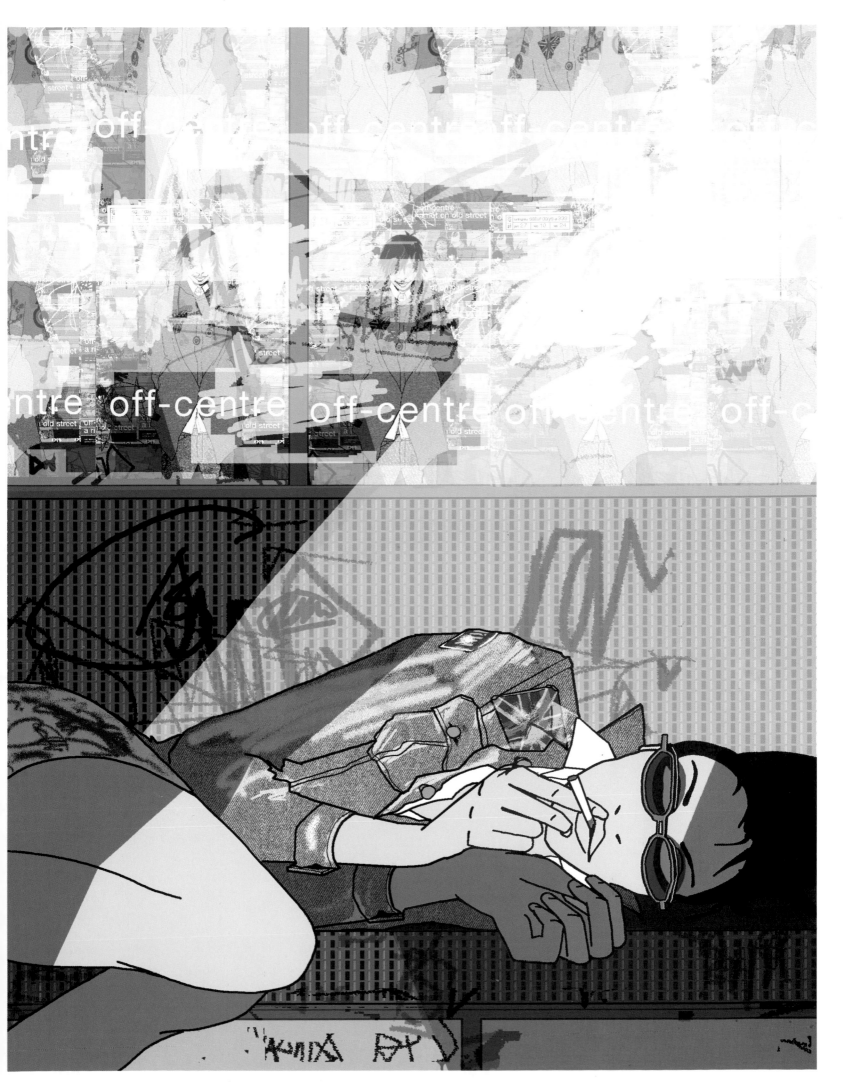

Graham Rounthwaite, Club 333, Off-Centre.

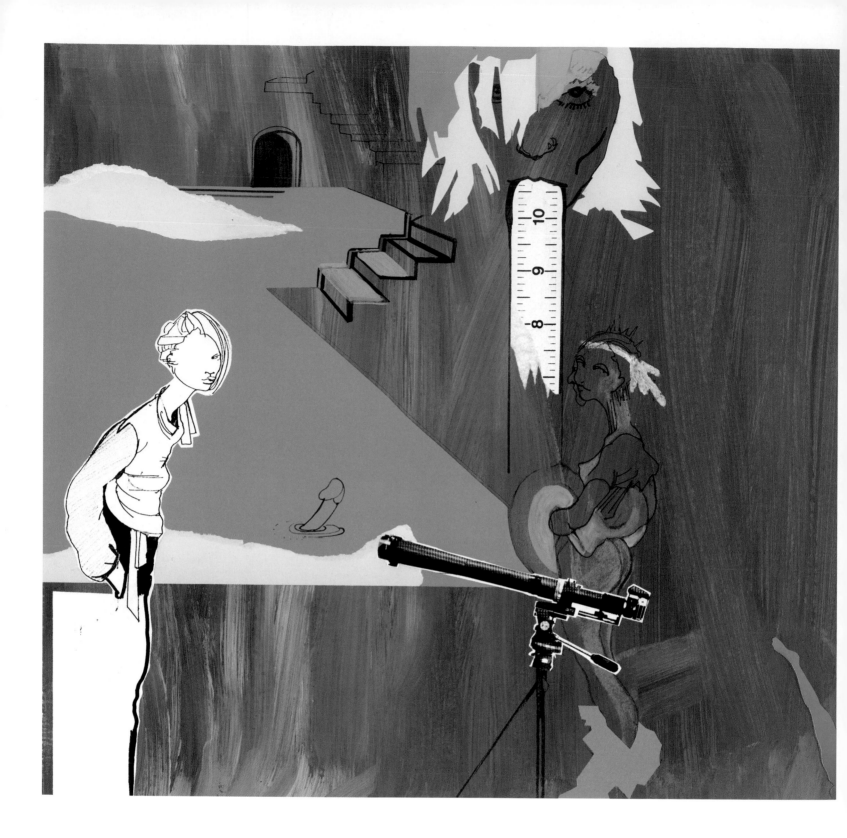

Julie Verhoeven, *Spoon*.

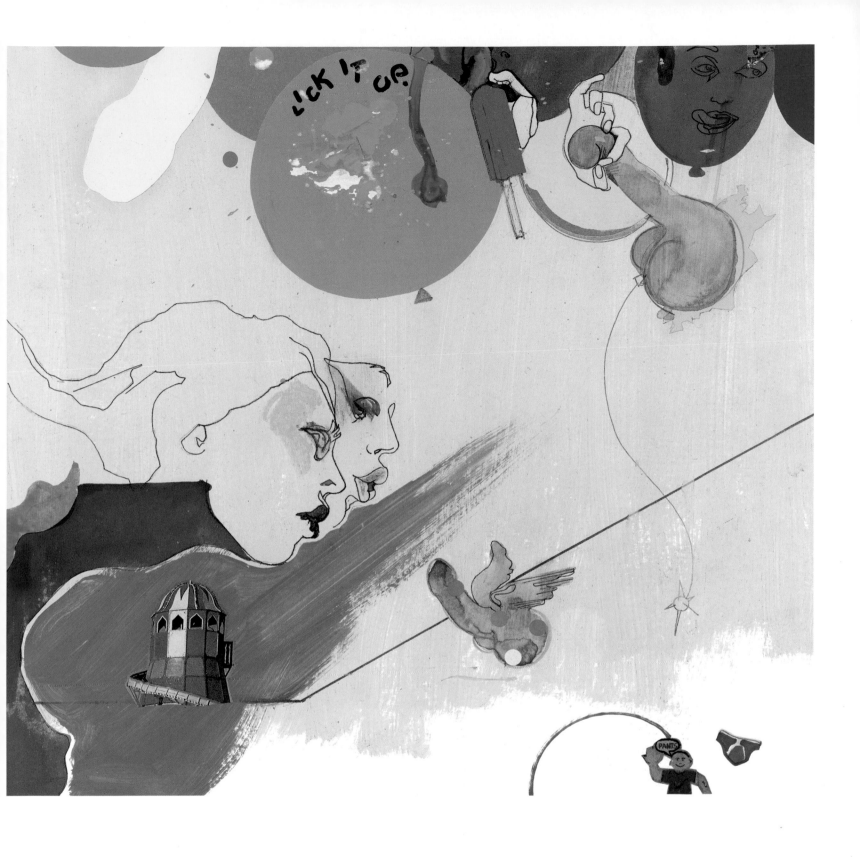

Julie Verhoeven, *Spoon.*

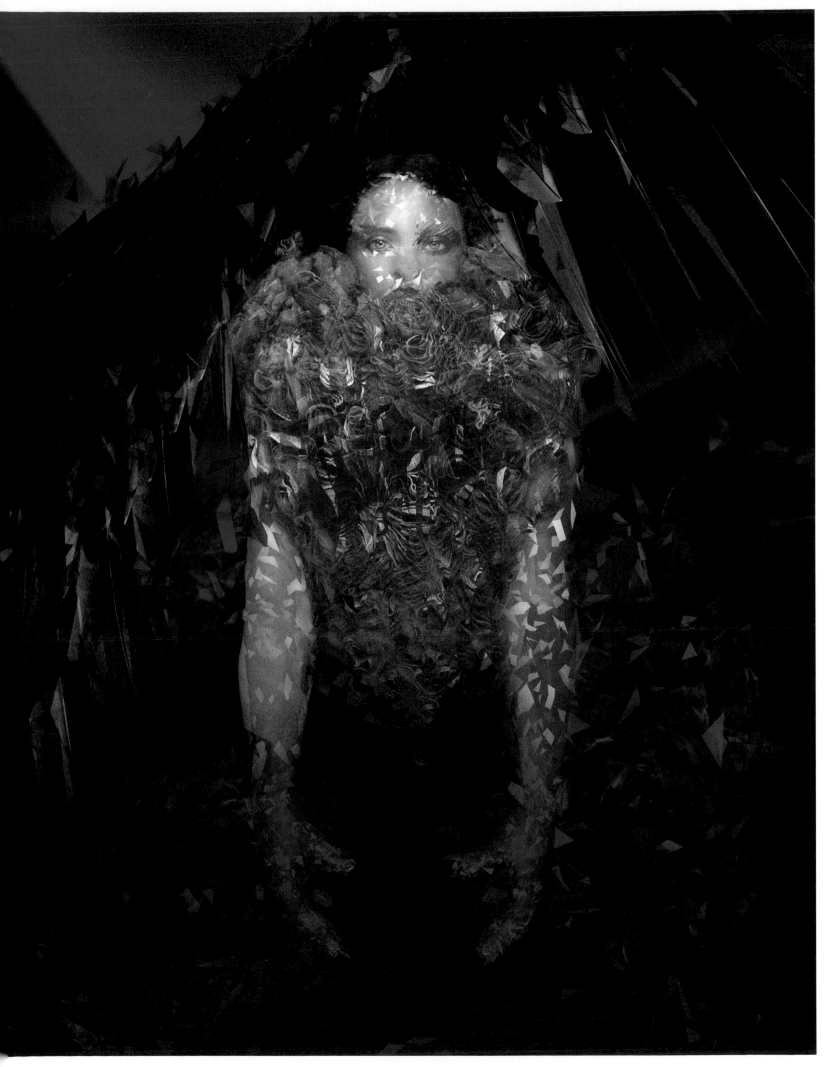

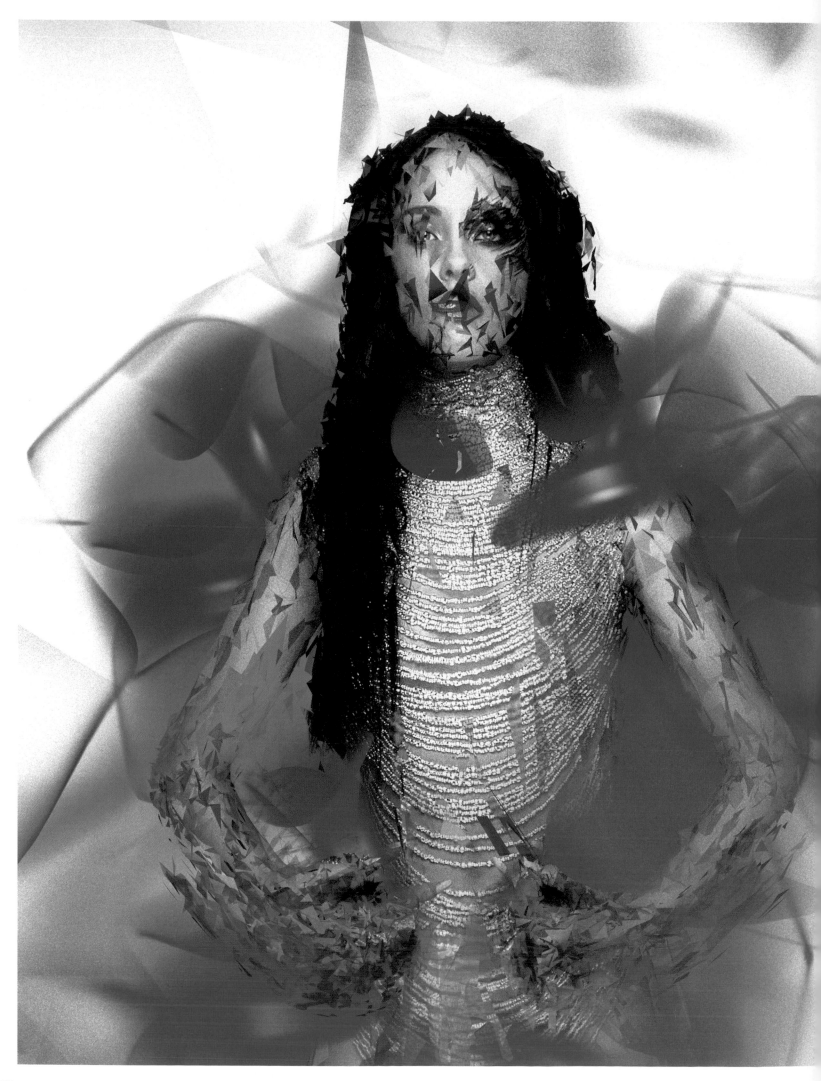

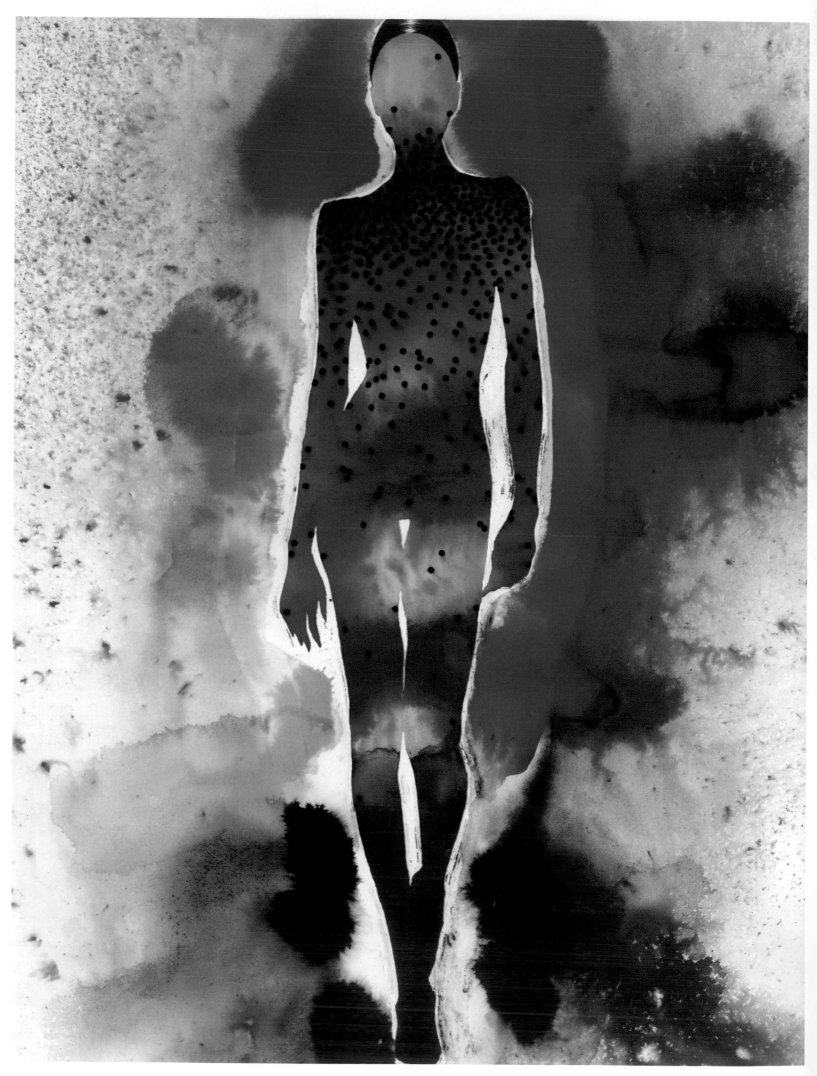

Kareem Iliya, CFDA Awards.

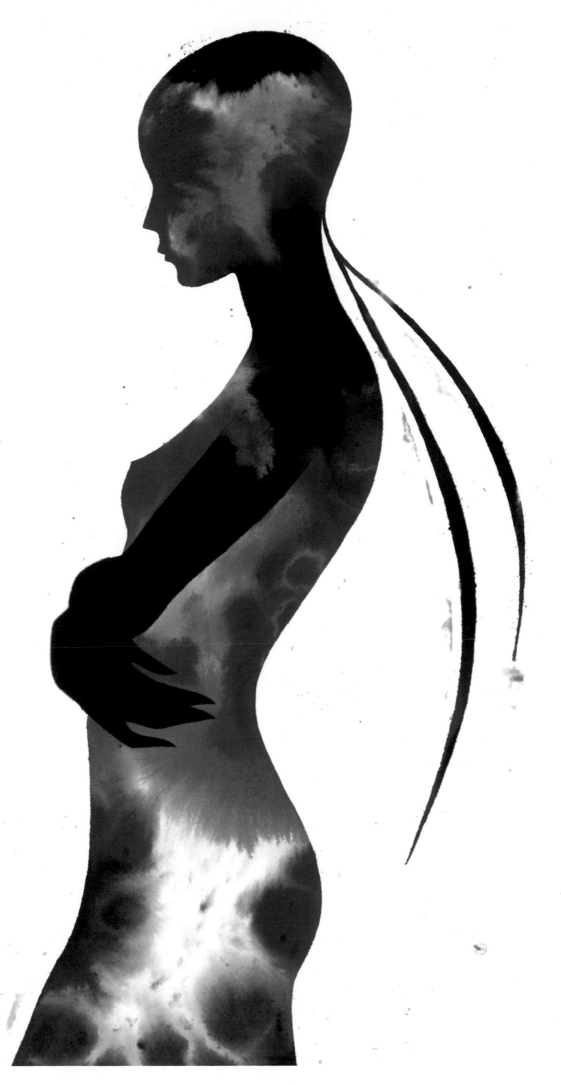

Kareem Iliya, Mayor Gallery.

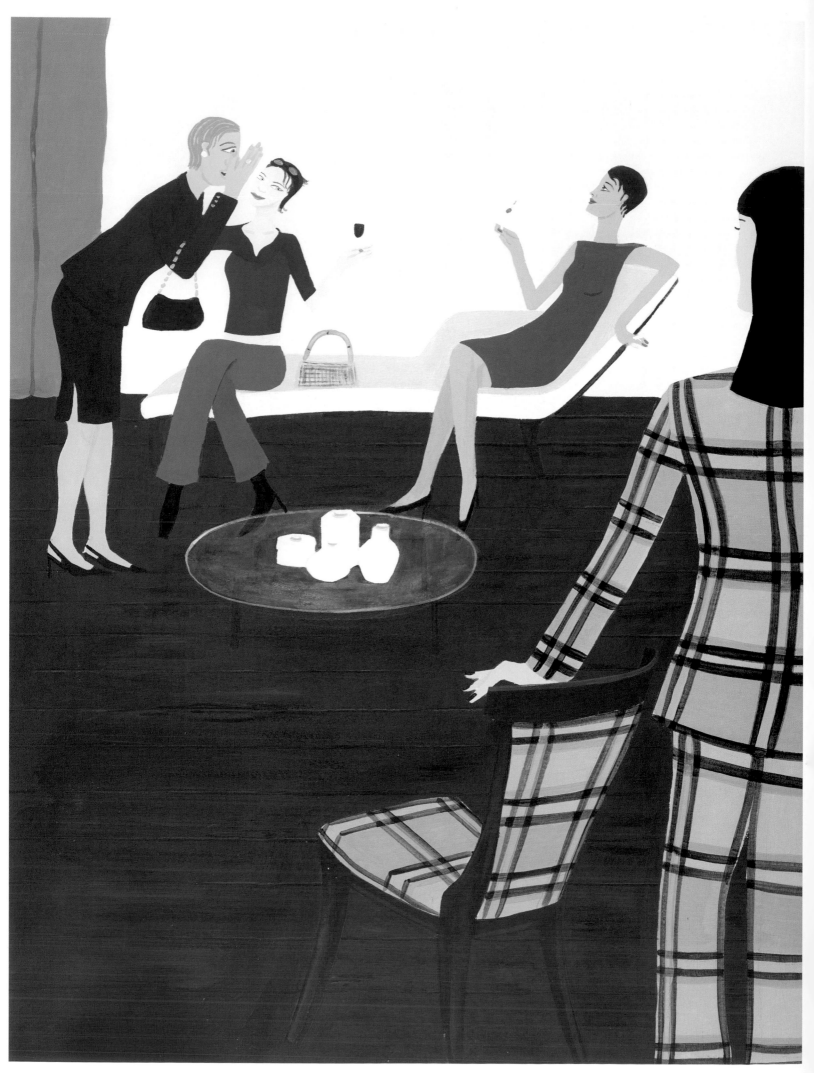

Claudia Pearson, Beacon Hill.

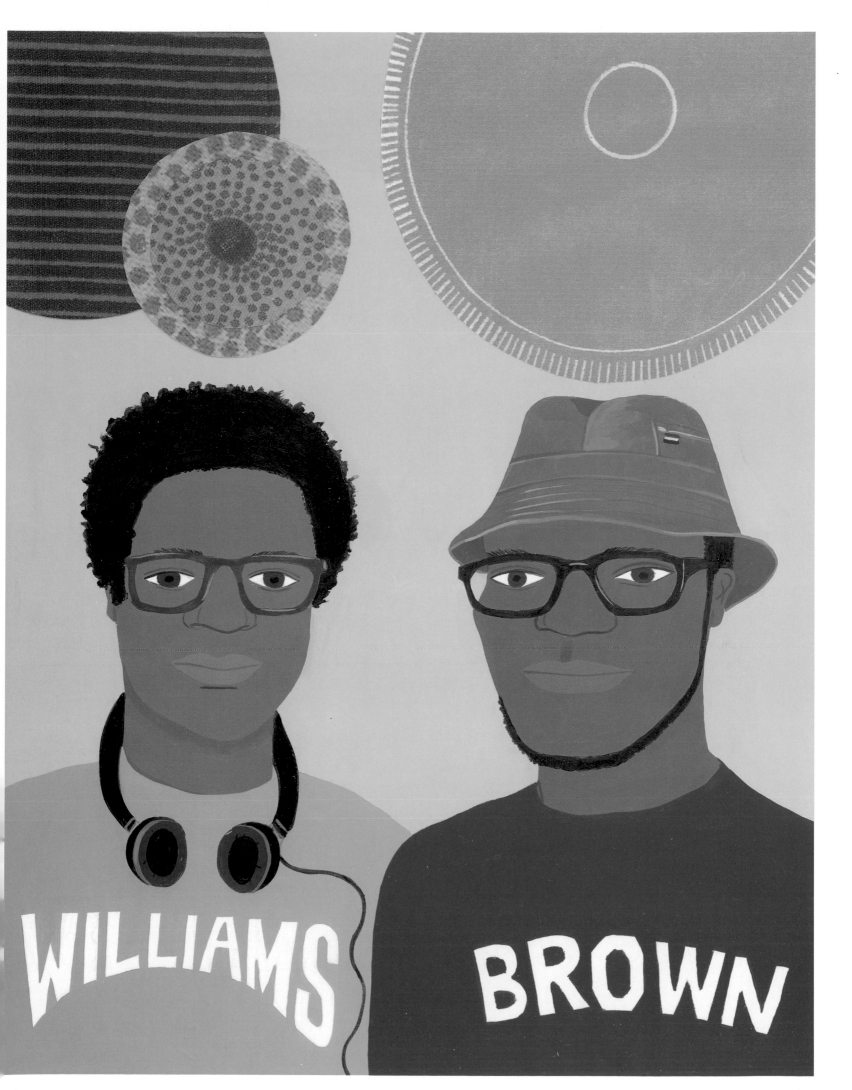

Claudia Pearson, Brown and Williams.

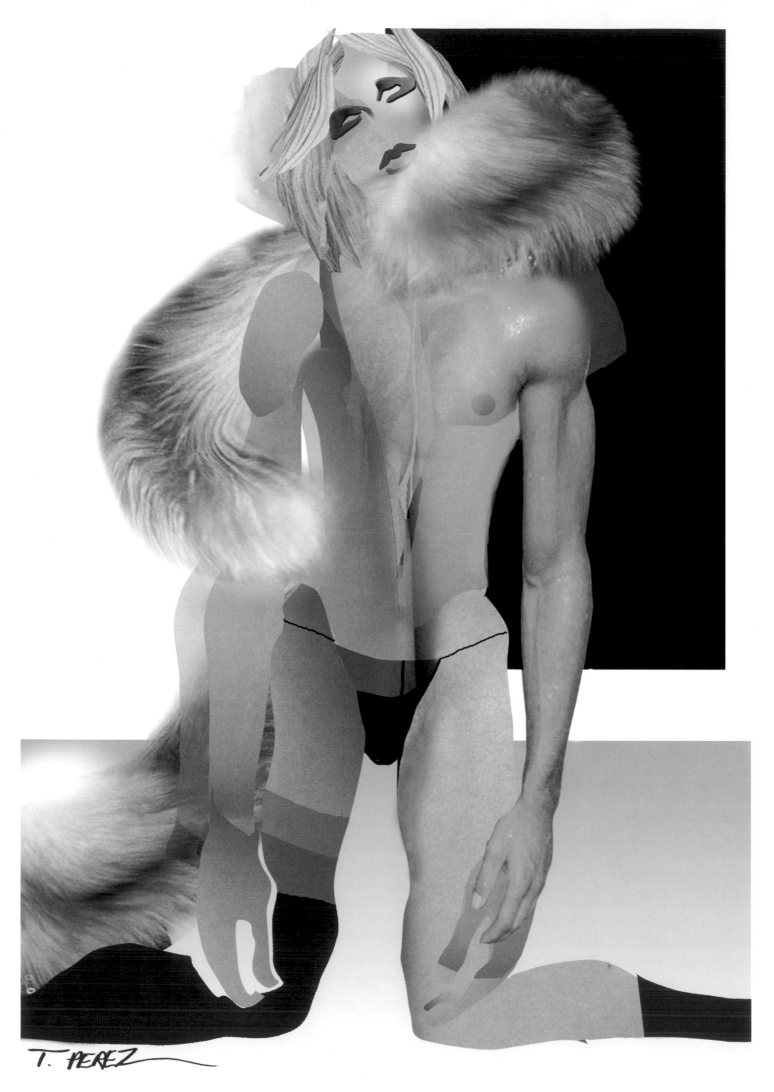

T. PEREZ

Thierry Perez, Fashion Illustration exhibition, National Gallery, London.

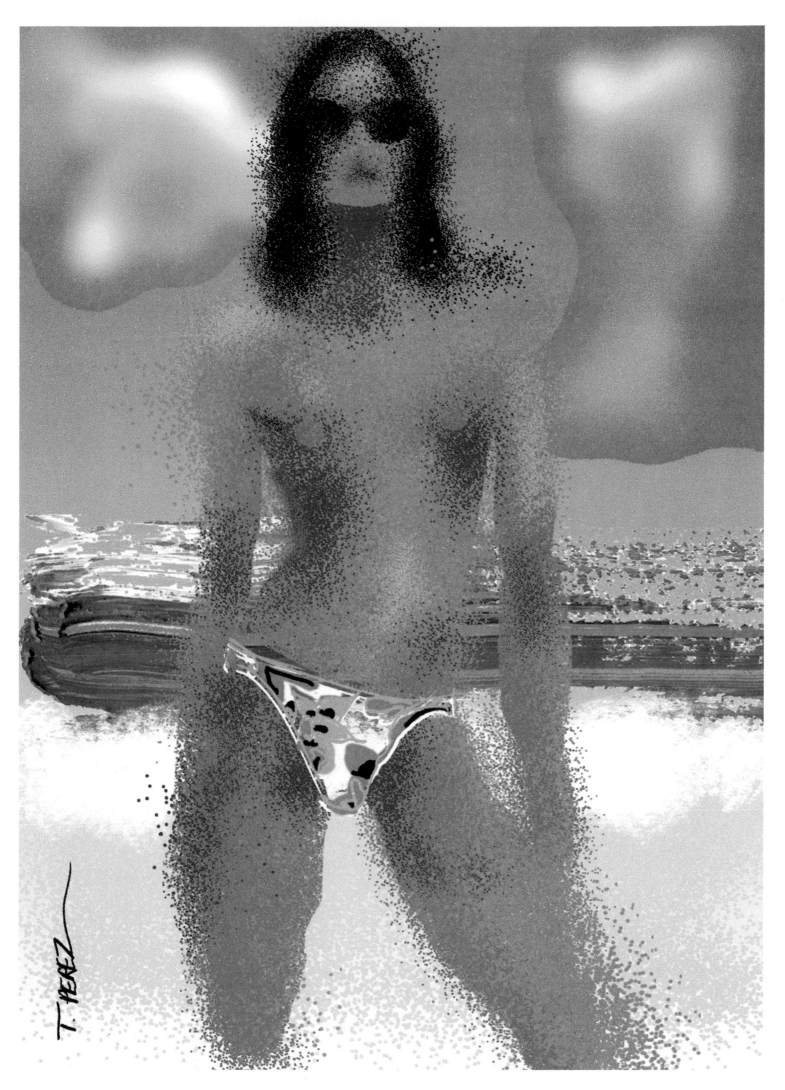

Thierry Perez, Fashion Illustration exhibition, National Gallery, London.

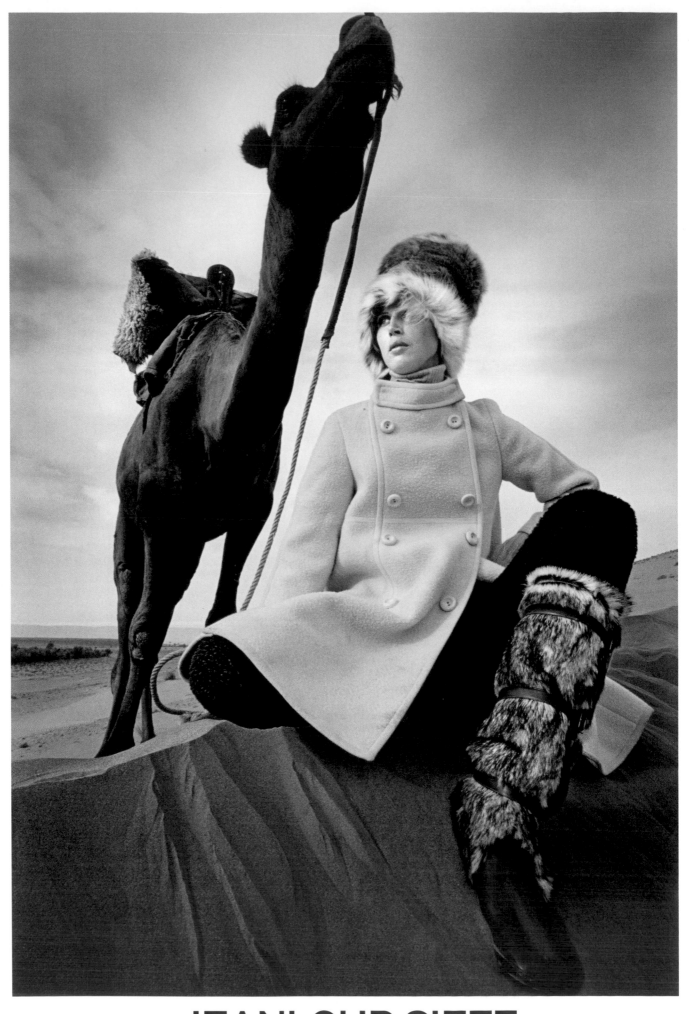

JEANLOUP SIEFF

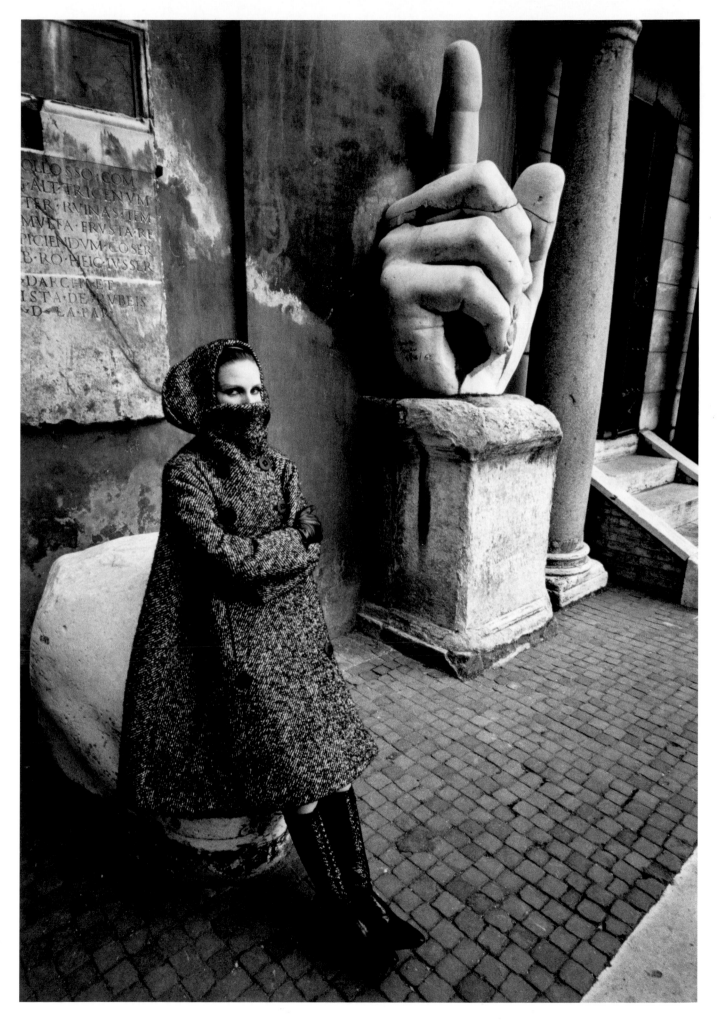

Opposite, *Vogue* magazine, Morocco, 1967.
Beyond Warzazat, in stifling heat, the model, red-hot under her thick furs, waits patiently for me to reach the end of my roll of film whilst thinking of her native Sweden.

Above, *Harper's Bazaar*, Rome, 1962.
I decided I would only take a 21mm lens for my Leica, which was in effect like playing heads or tails with my future at Harper's Bazaar. In spite of the distortion they liked the pictures, so, I stayed on!

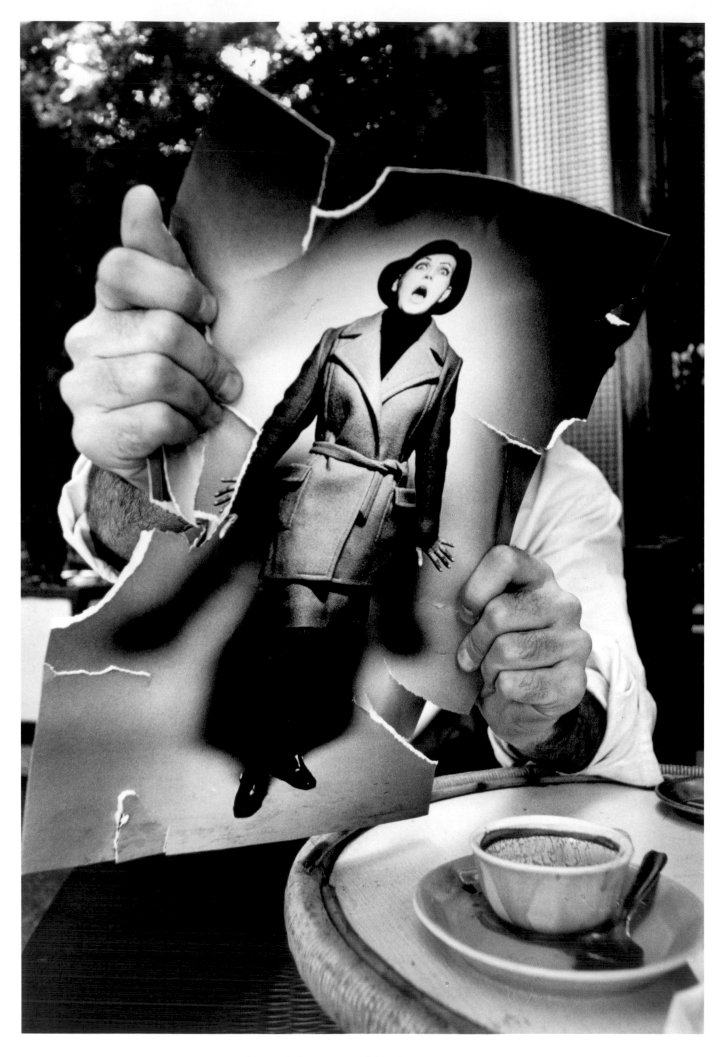

Pierre-André Boutang tearing a fashion photograph, Paris, 1966.
I had first photographed this model in a studio in order to retake the pictures in various other situations. Here, the model screams in horror as a friend tears the photograph in an iconoclastic gesture.

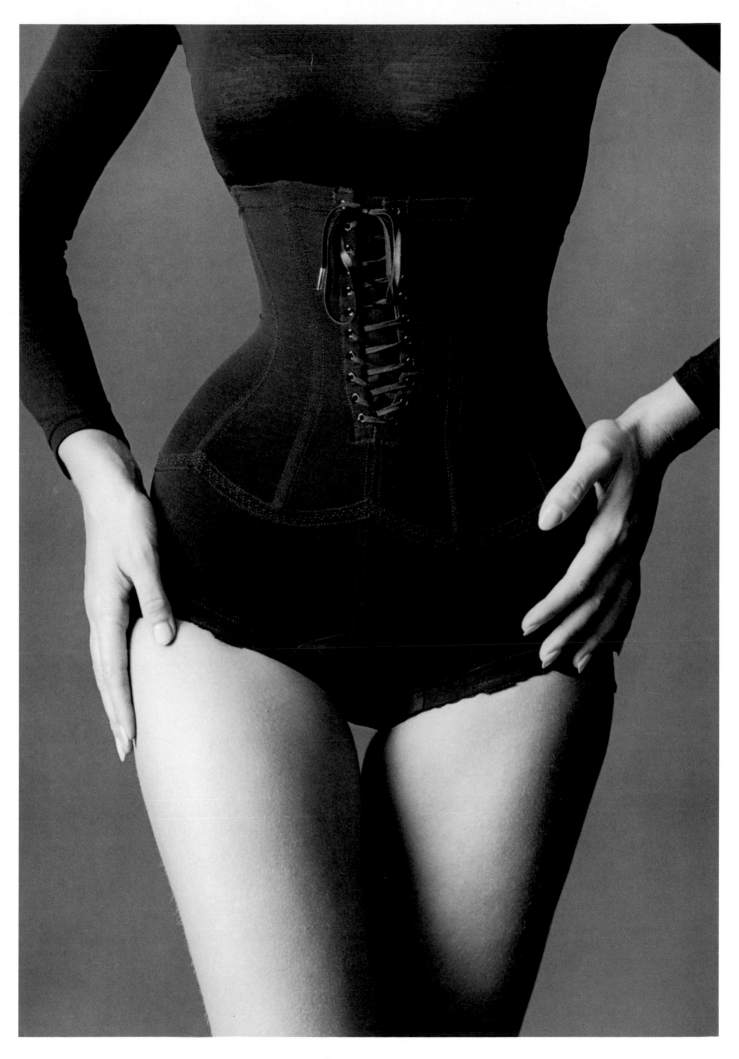

The Corset, New York, 1962.
It was the beautiful Anka, with her desperately tiny waist, who posed in this 1900s corset. In spite of her slim figure, she found it difficult to breathe.

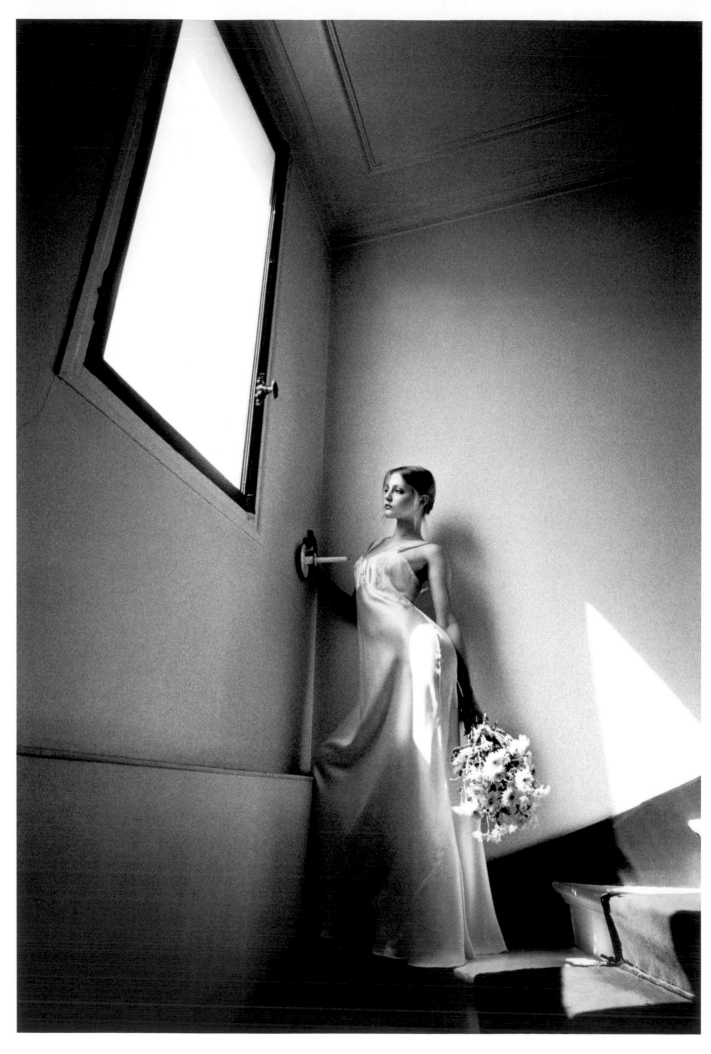

Vogue magazine, Ingrid Boulting, Paris, 1970.
I like her moon-like face and her child-like slenderness. I think she went off to America to work in films.

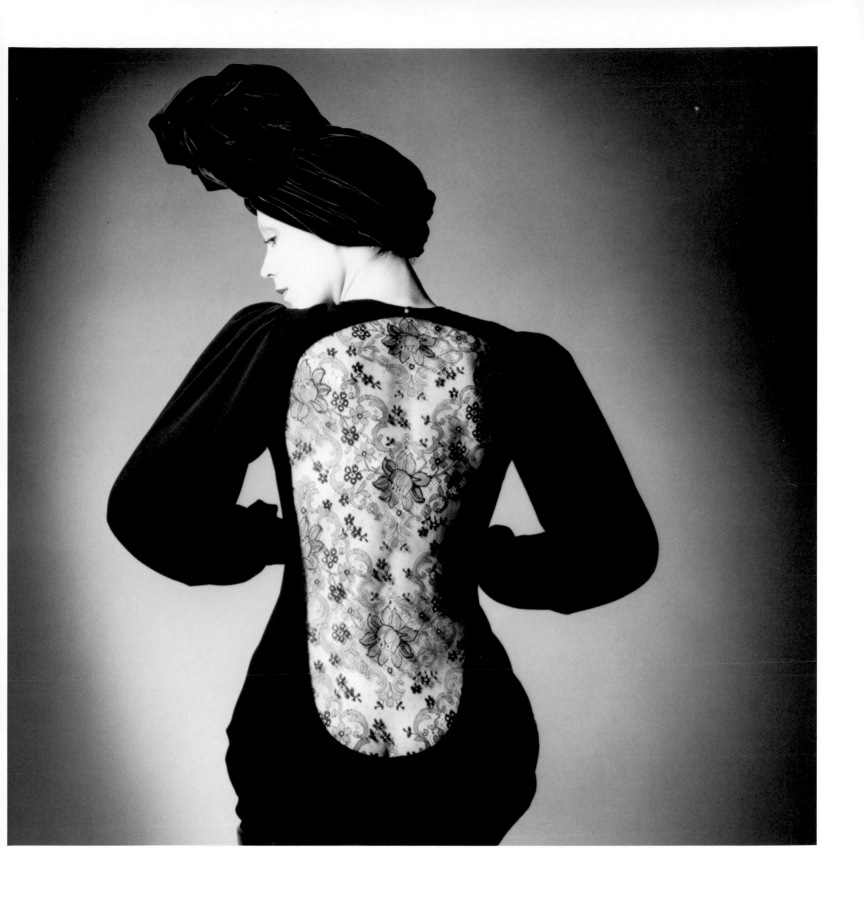

Vogue magazine, dress by Yves Saint Laurent, Paris, 1970.
Many people have asked me whether Catherine Deneuve posed for this picture. They can rest assured, it's not her.

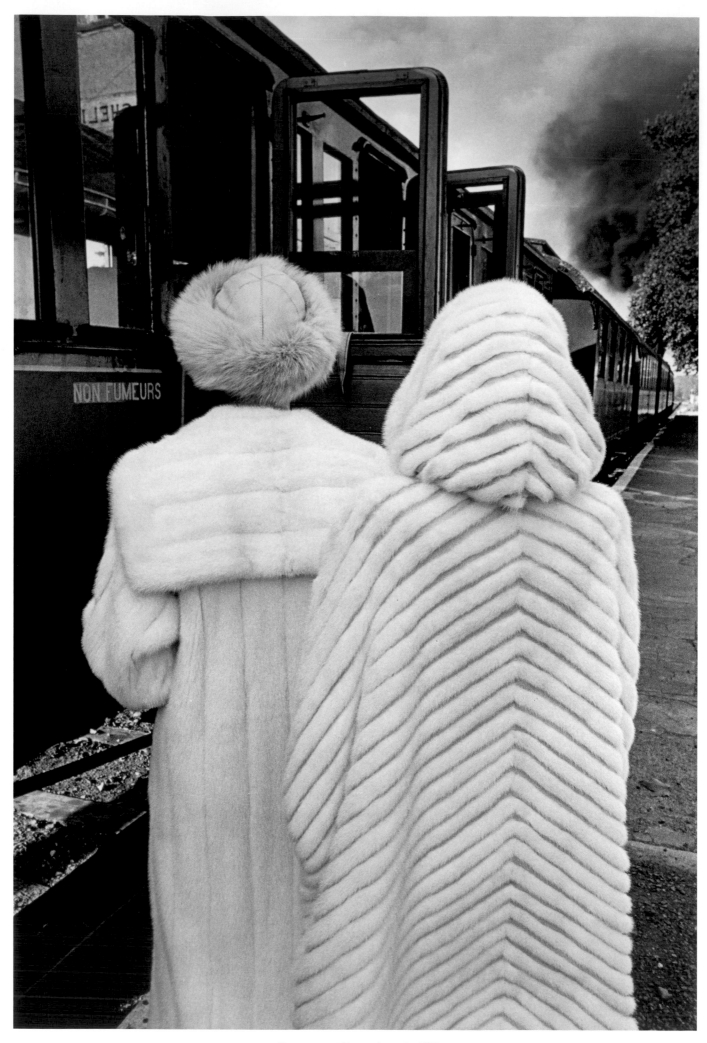

Two women watching a train pass by, 1978.
A fashion photograph taken in a small railway station in Touraine. Vintage train buffs had restored a locomotive and some coaches for a ten-kilometre journey.
A young woman covered with axle grease was driving it, singing.

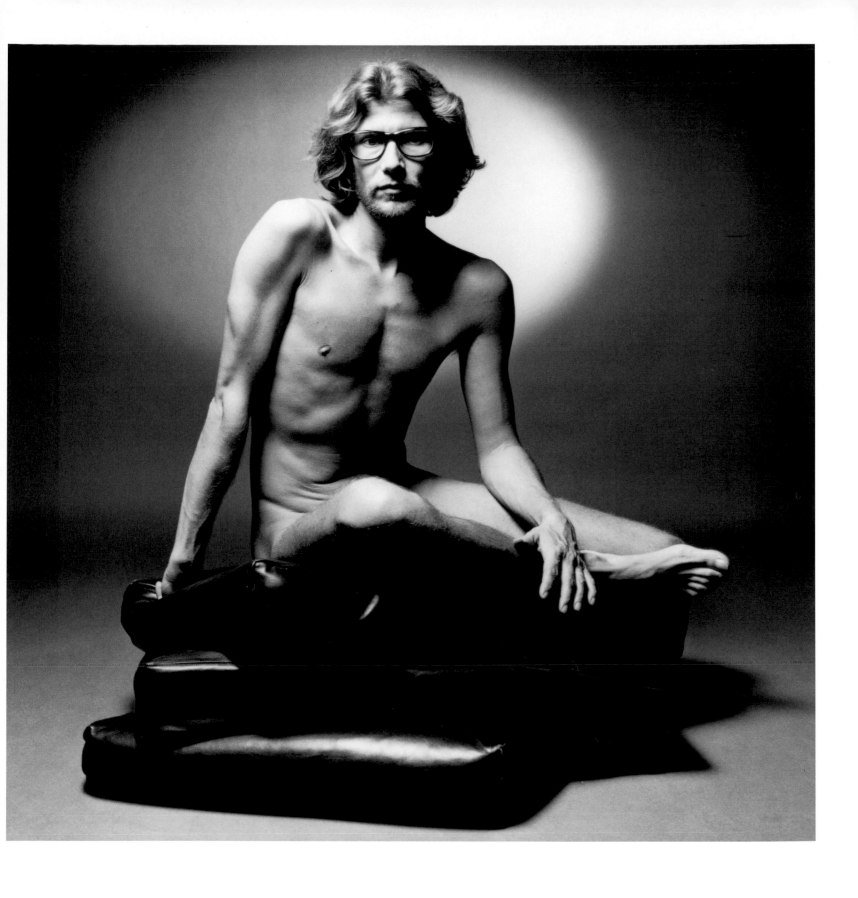

Yves Saint Laurent, couturier, Paris, 1971.
I wanted him to pose in the nude for the ads of his own eau de toilette and he looked like an inspired Christ, but one who was not perturbed by the merchants in the temple!

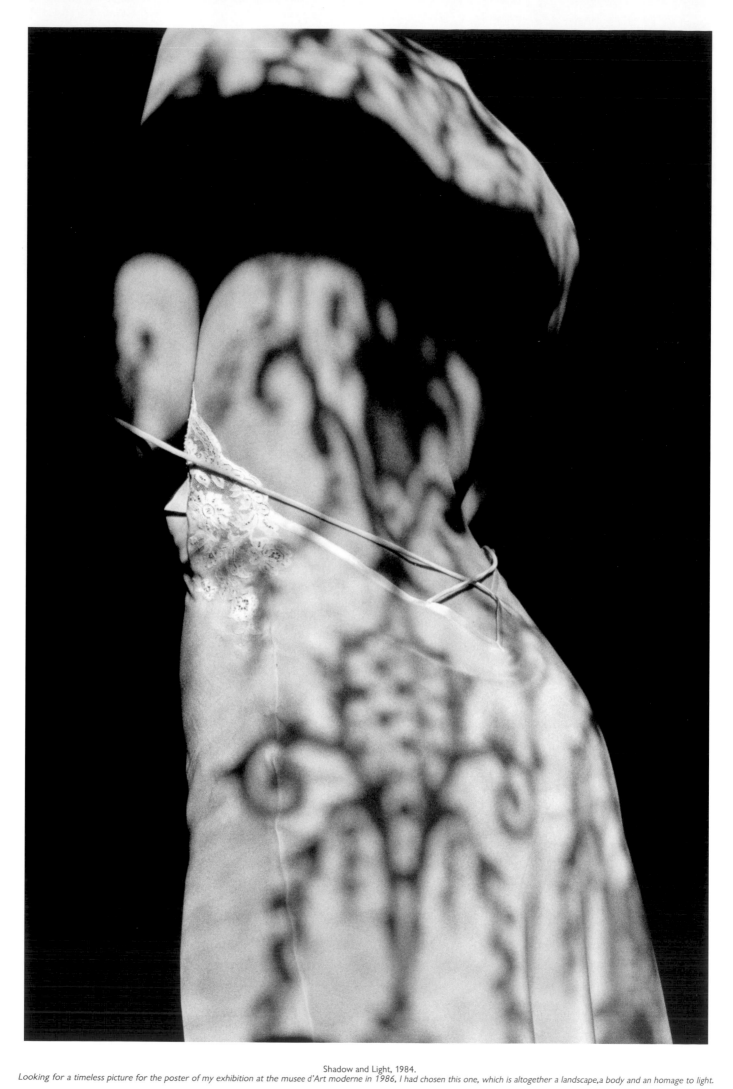

Shadow and Light, 1984.
Looking for a timeless picture for the poster of my exhibition at the musee d'Art moderne in 1986, I had chosen this one, which is altogether a landscape, a body and an homage to light.

Derrière dans un collant, Paris, 1981.

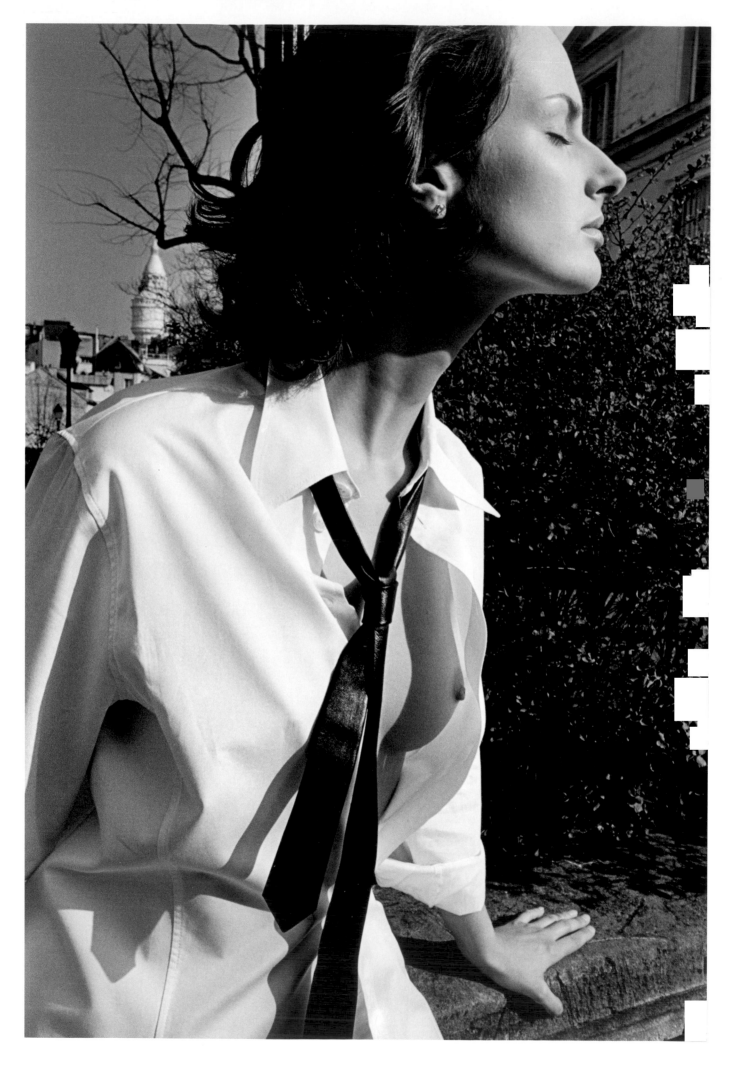

French *Elle* magazine, Phoebe, modele, Paris, 1995.

JEANLOUP SIEFF
1933–2000

EDITED BY TIGGY MACONOCHIE

LIGHT

When I was ten, I wanted to be an astronomer. Calculating the distances between earth and the planets and galaxies, I came across light for the first time: the distances were measured in light-years. Then I forgot about astronomy, and fell passionately in love with the theatre and cinema. I would be a director if it was the last thing I did!

My school years unfolded beneath the flickering light of the projector; this was my second encounter with my muse-to-be. The third came when I was fifteen and my girlfriend said, from under the sheets, 'Turn the light out.' Forewarned should have been forearmed, but nothing dawned on me till the day my uncle gave me a camera. Then there was light! Peering through the viewfinder at people and things, I realised that the common denominator of my passions was the vibration that gave them life.

Thence began my headlong pursuit of instruments that measured and lenses that transmitted light. I am still far from completing my quest. I have covered thousands of kilometres and met persons brilliant and lacklustre, I have wandered through sunbaked deserts and plunged into the gloom of my depressions only to emerge renewed by the flames of my passion.

LA LUMIÈRE

A dix ans je voulais être astronome. En calculant les distances nous séparant des planètes et des galaxies, je fis ma première rencontre avec elle: ces espaces se mesuraient en années-lumière! Puis j'oubliais cette vocation pour me passioner de théâtre et de cinéma: je serai metteur en scène ou rien!

Mes années de lycée furent éclairées par les écrans de cinéma. Ce fut ma deuxième rencontre avec celle qui deviendrait ma muse. La troisième fut, lorsque l'amie de mes quinze ans me dit, du fond d'un lit: «Eteins la lumière.» Tous ces signes auraient dû me mettre en garde, mais je ne me doutais de rien, jusqu'au jour où un oncle m'offrit un appareil photo. Ce fut l'illumination. Je découvris, en regardant les gens et les choses au travers du viseur, que le dénominateur commun de mes passions était cette vibration qui leur donnait vie, et enfin la lumière fut!

Alors commença ma course éperdue après les instruments qui la mesuraient et les objectifs qui la recevaient. Cette quête est loin d' être terminée. J'ai parcouru des milliers de kilomètres, j'ai rencontré des gens brillants et d'autres ternes, j'ai erré dans des déserts brûlés et je me suis enfoncé dans les nuits de mes dépressions pour ressurgir, intact, des feux de ma passion.

Jeanloup Sieff, the great French photographer, died in Paris on 20 September 2000. He was sixty-six.

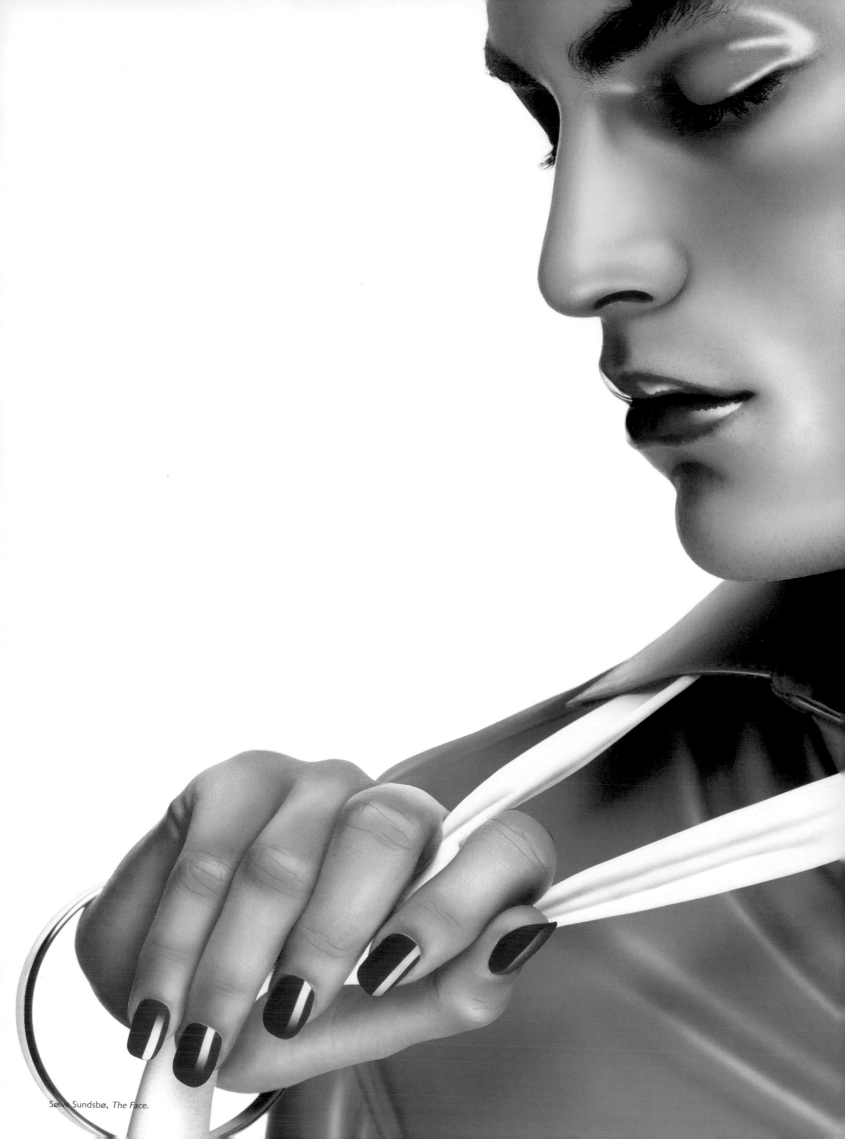

Sølve Sundsbø, *The Face.*

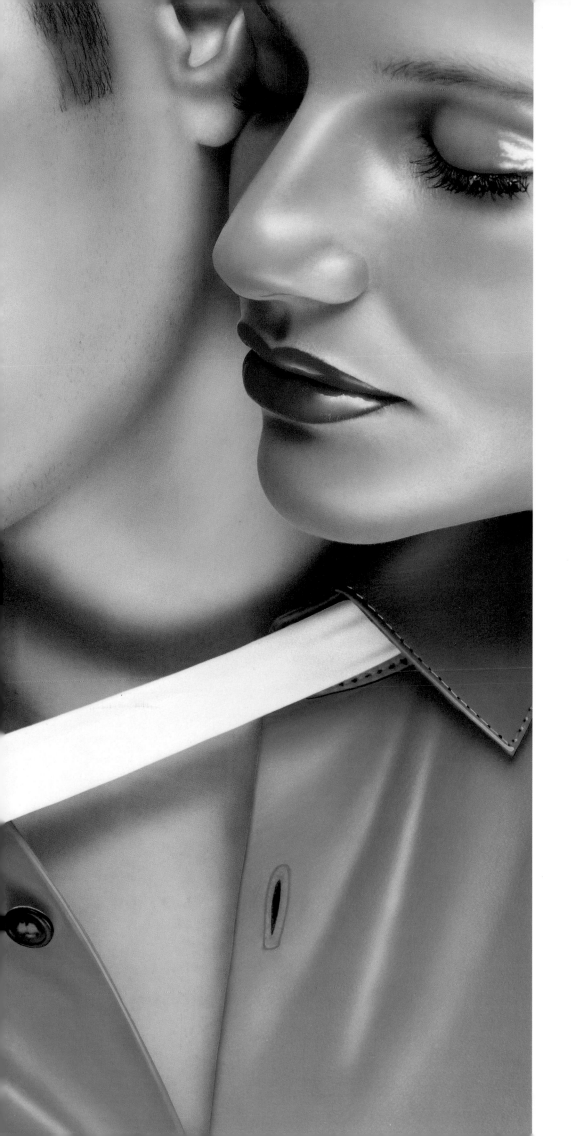

PORTFOLIO OF PHOTOGRAPHERS

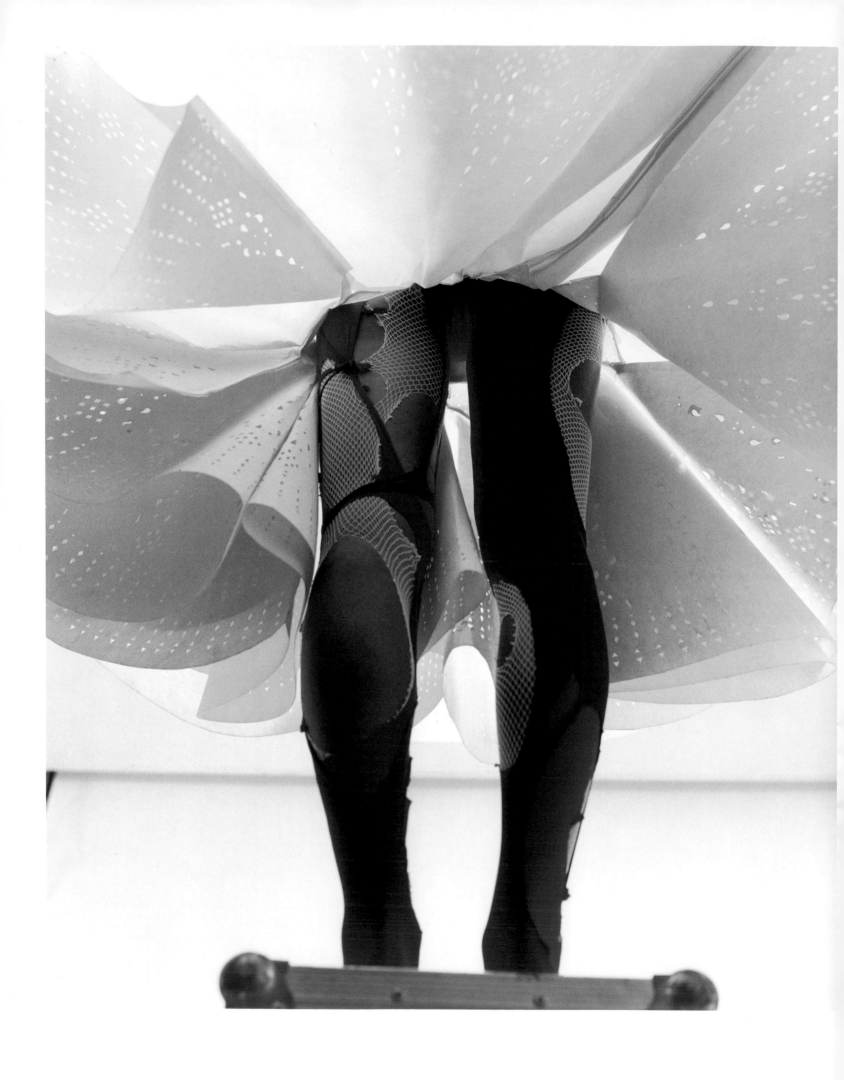

John Akehurst, *Big* magazine.

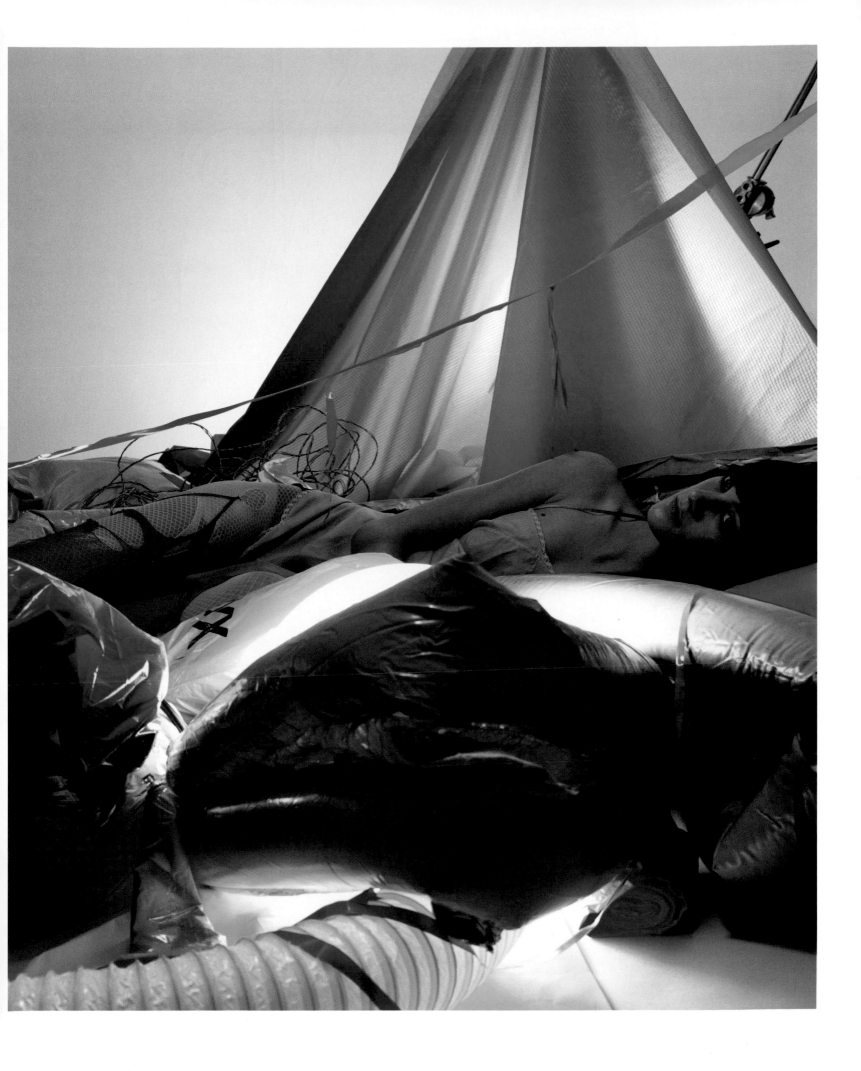

John Akehurst, *Big* magazine.

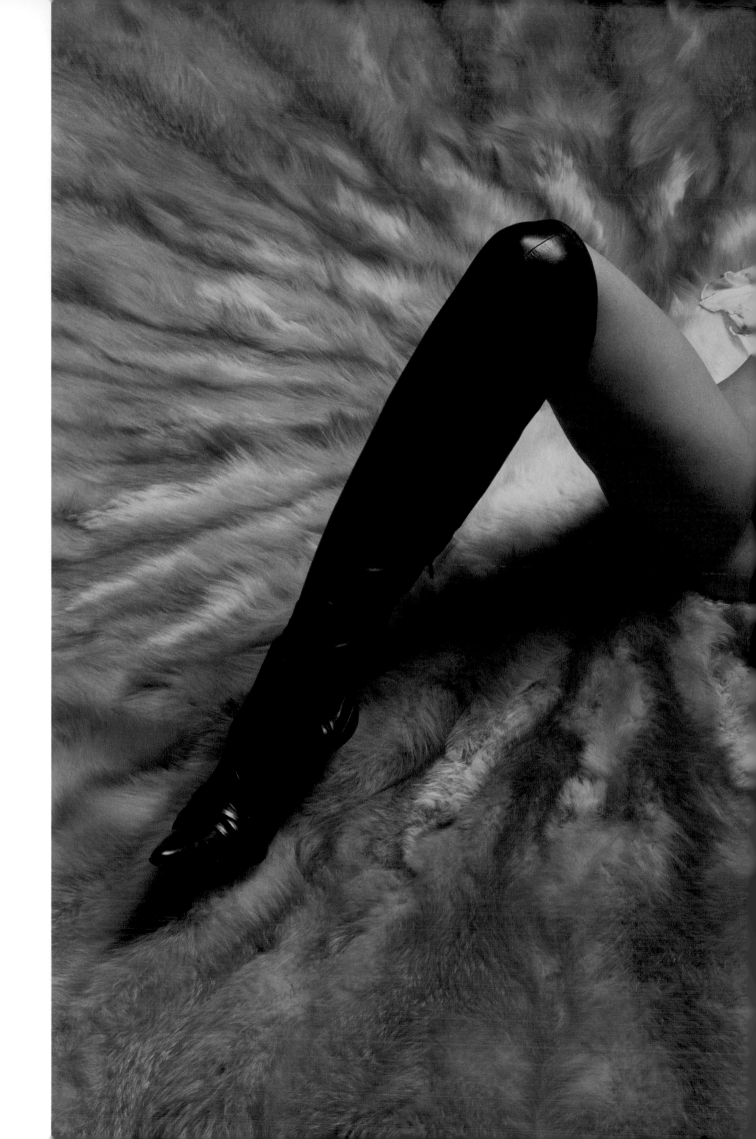

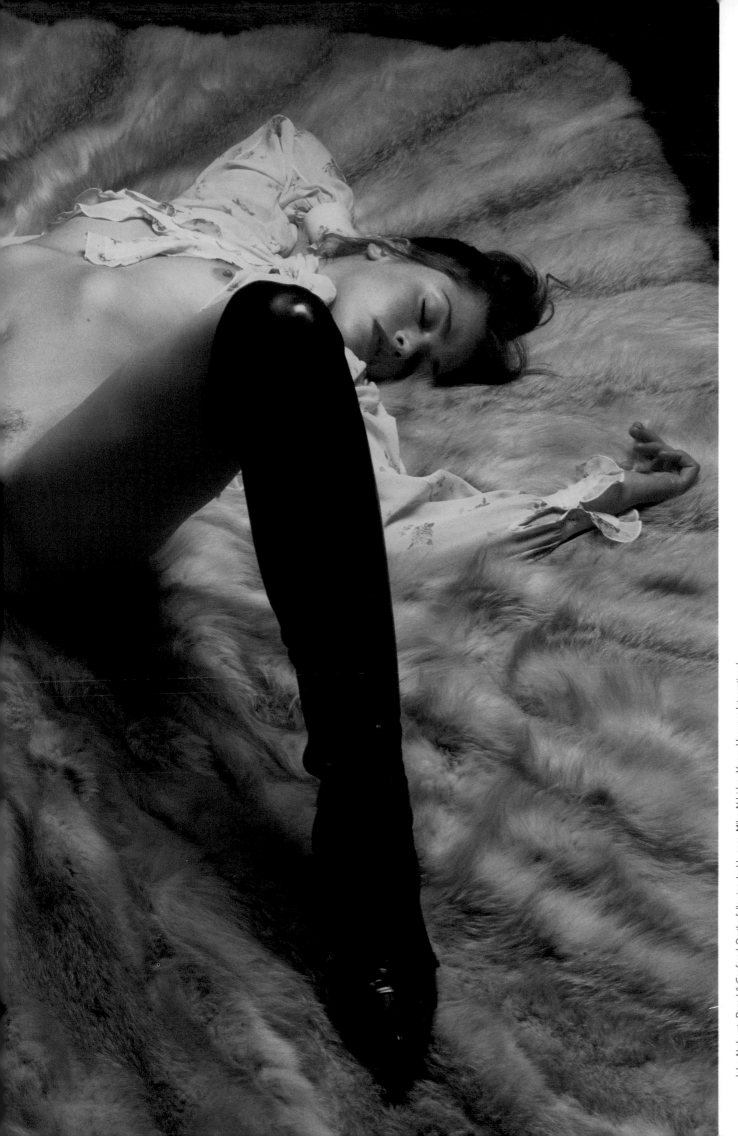

John Akehurst, *Dazed & Confused*. On the following double page: Miles Aldridge, *Vogue Hommes International*.

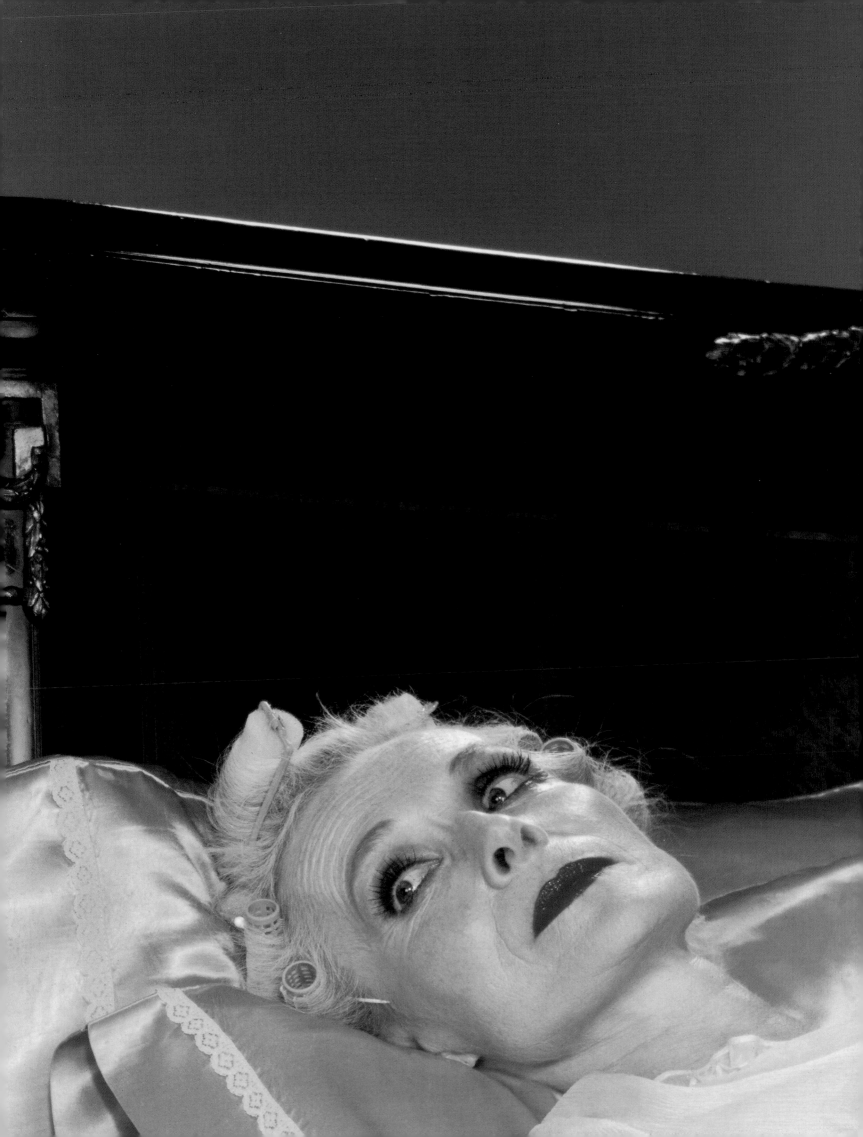

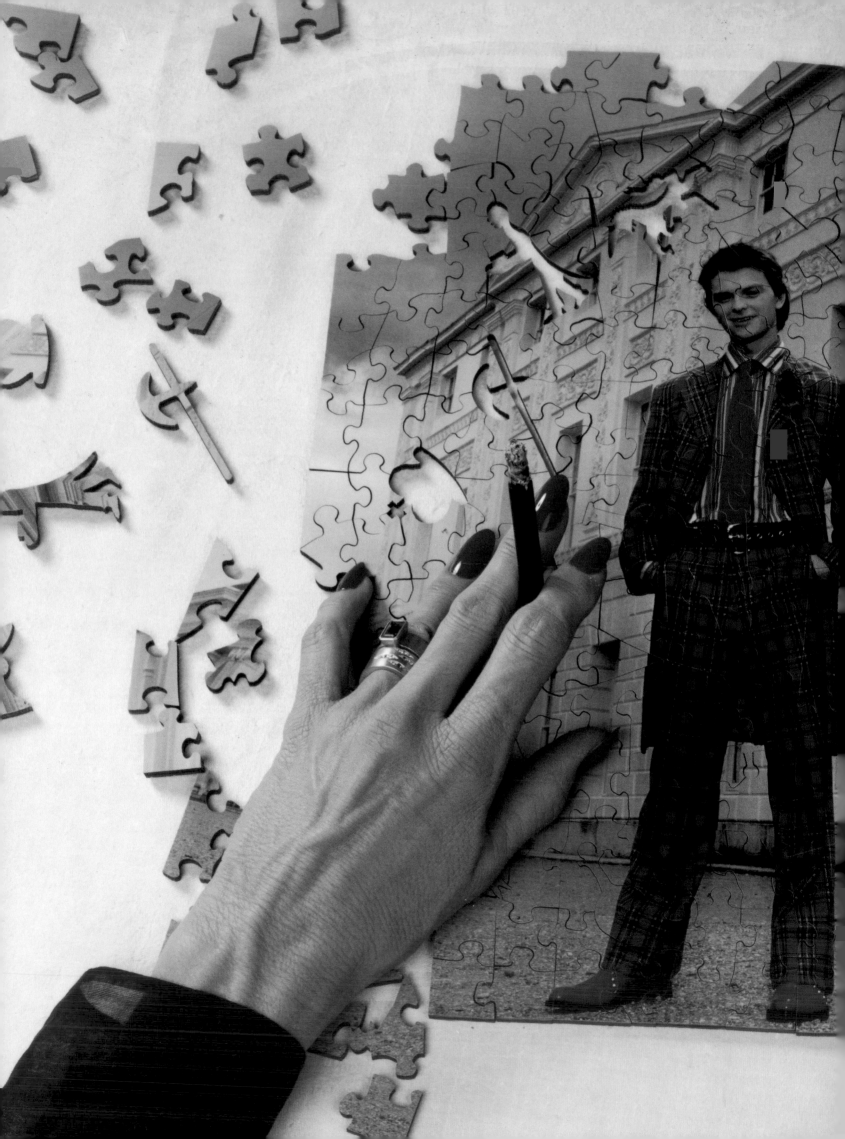

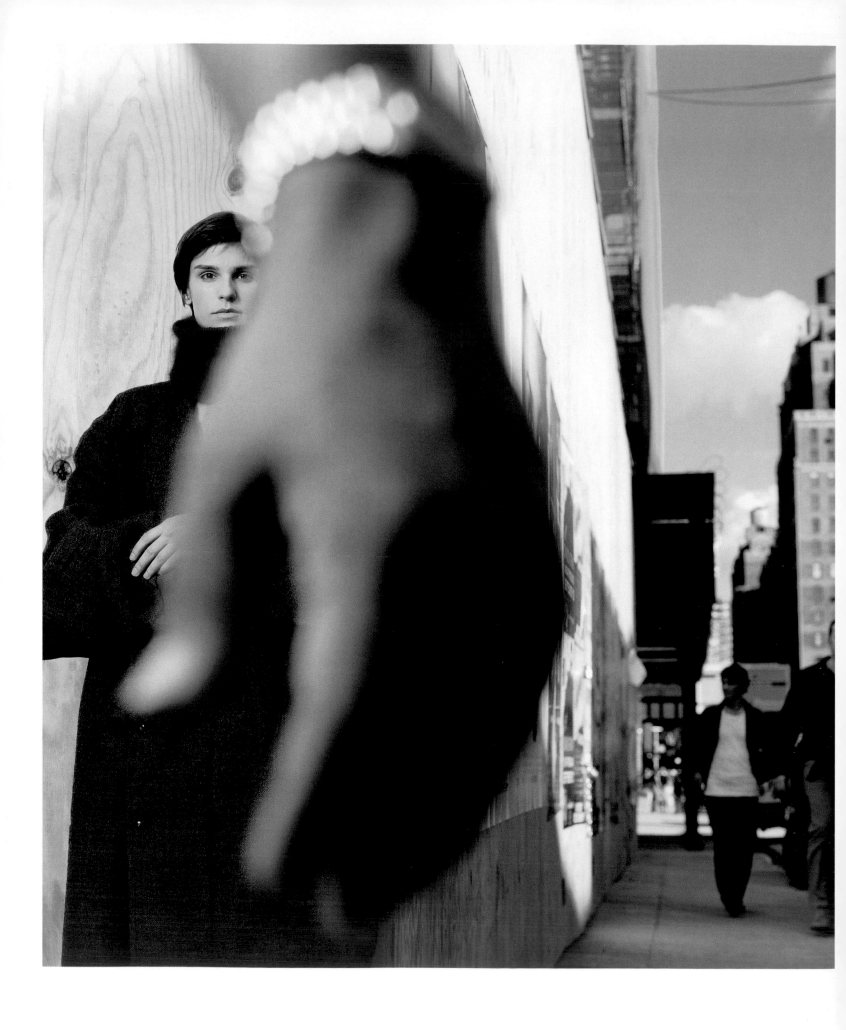

On the previous double page: Miles Aldridge, *Vogue Hommes International*. Above: Clang, *Rank* magazine.

Clang, *Rank* magazine.

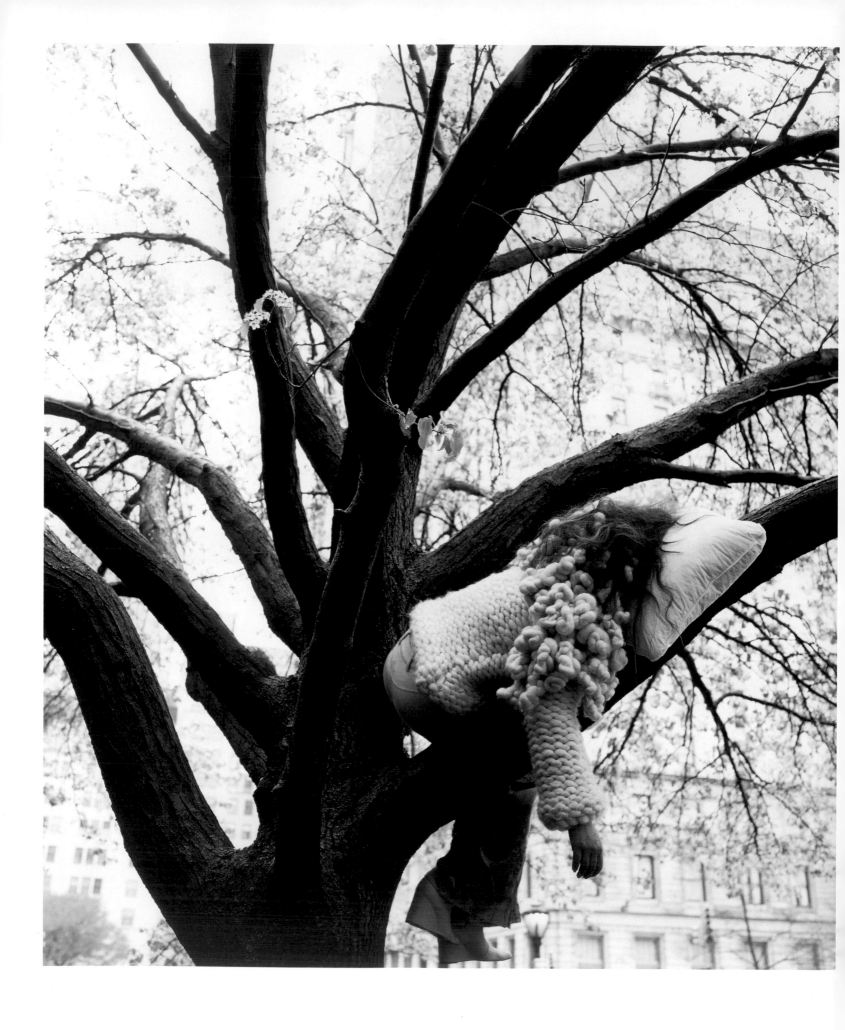

Clang, *Surface.*

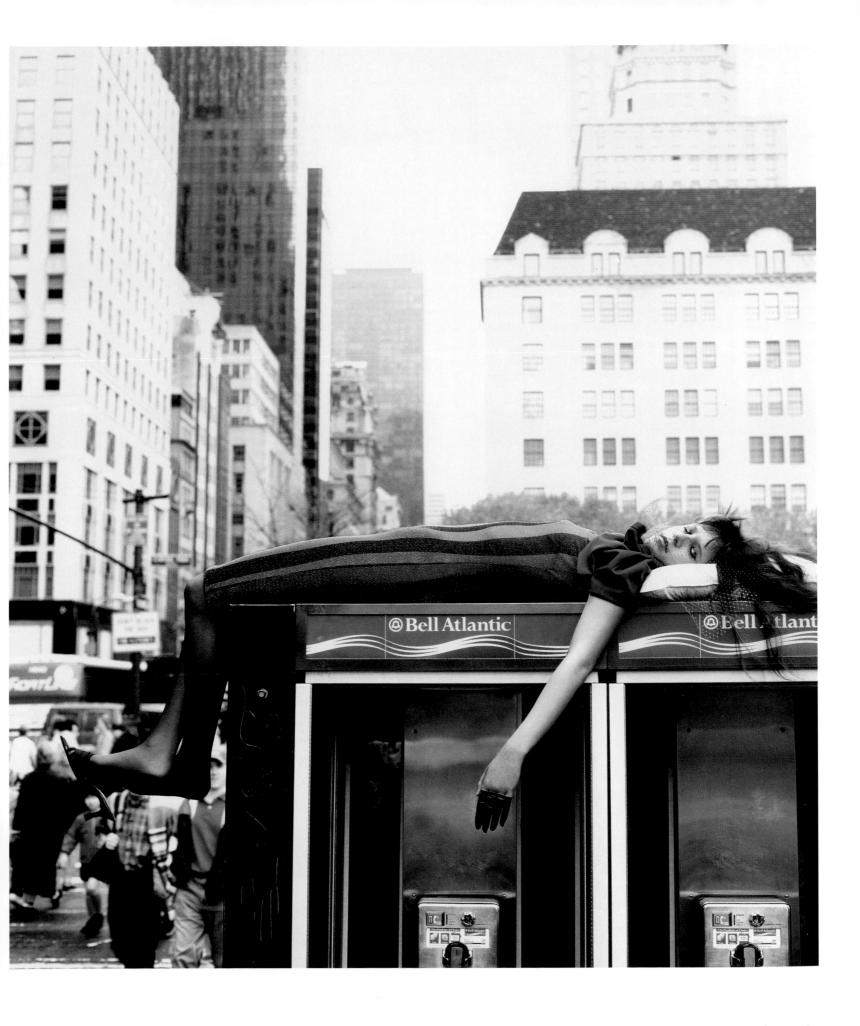

Clang, *Surface.*

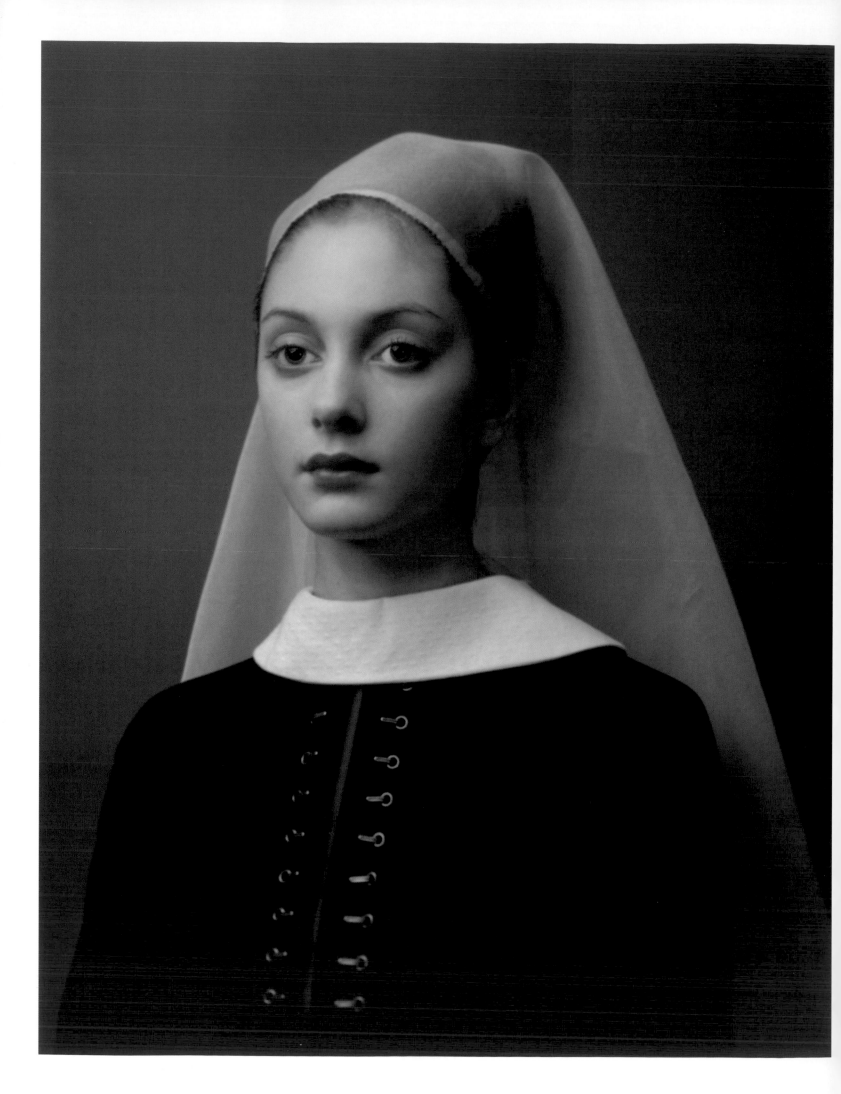

Karen Collins, *Soma* magazine.

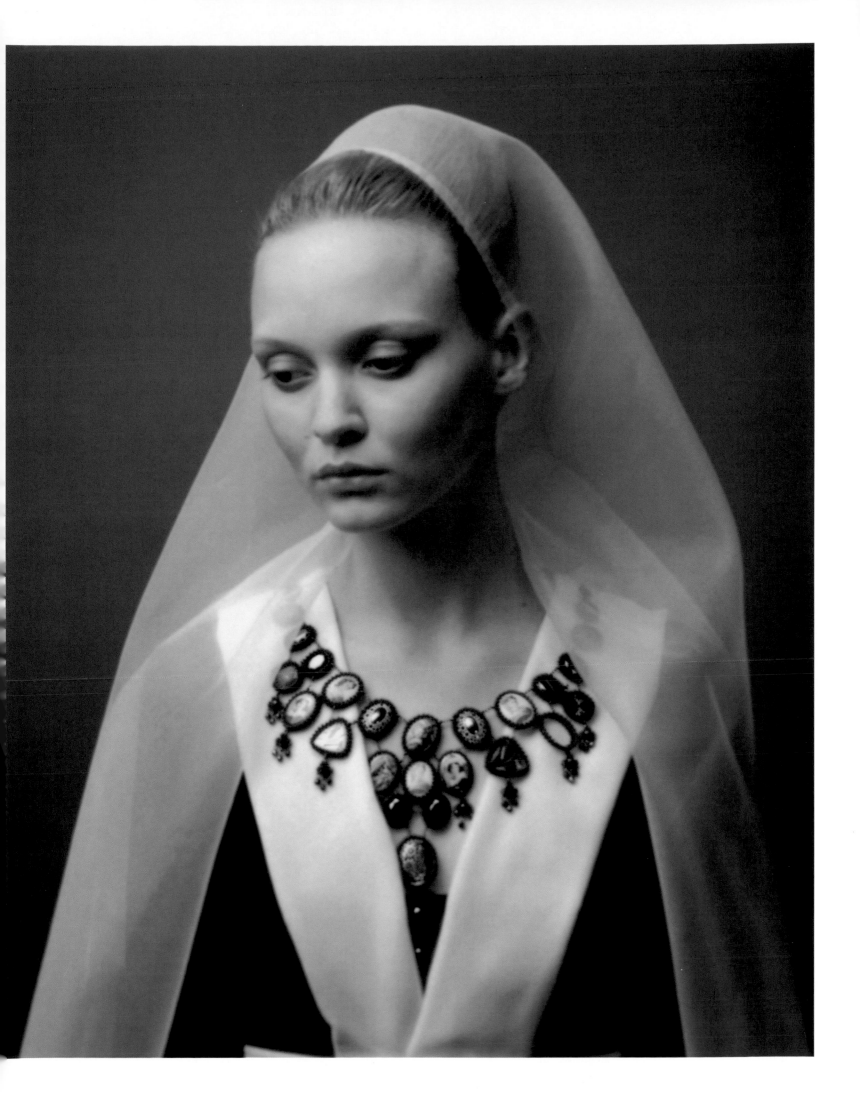

Karen Collins, *Soma* magazine.

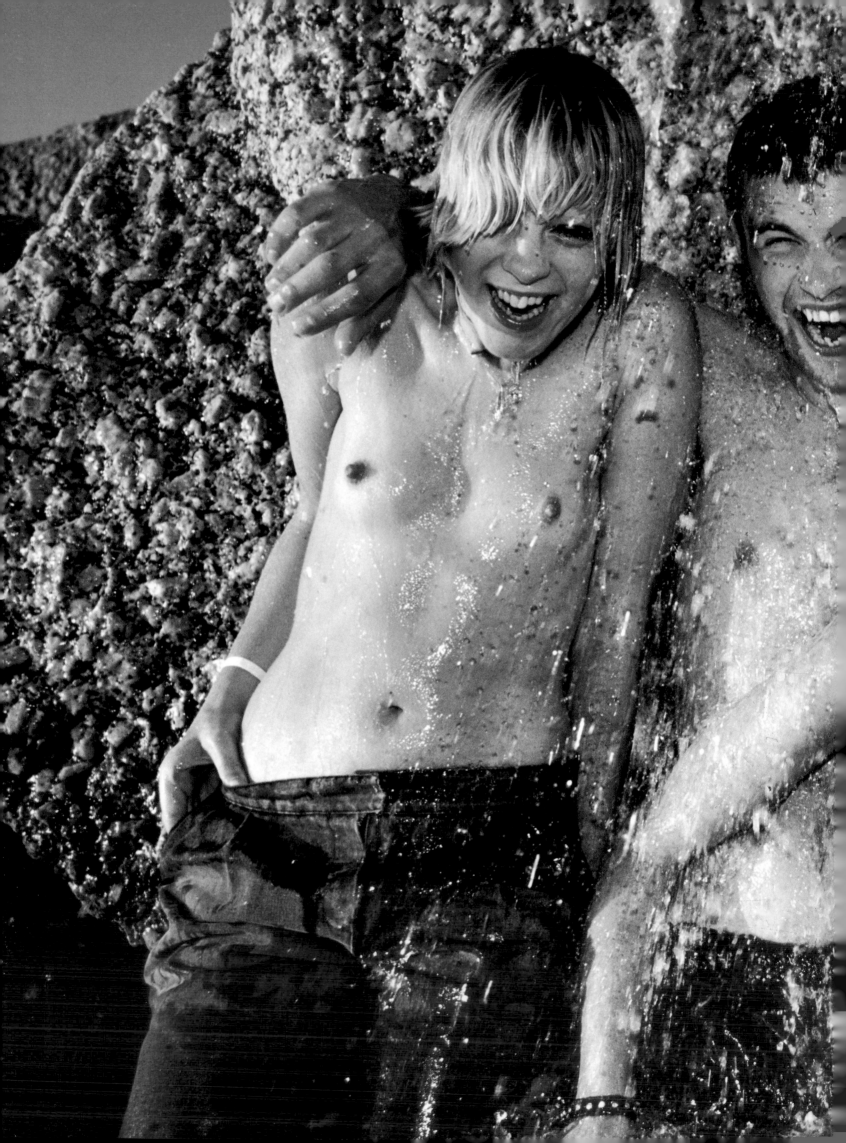

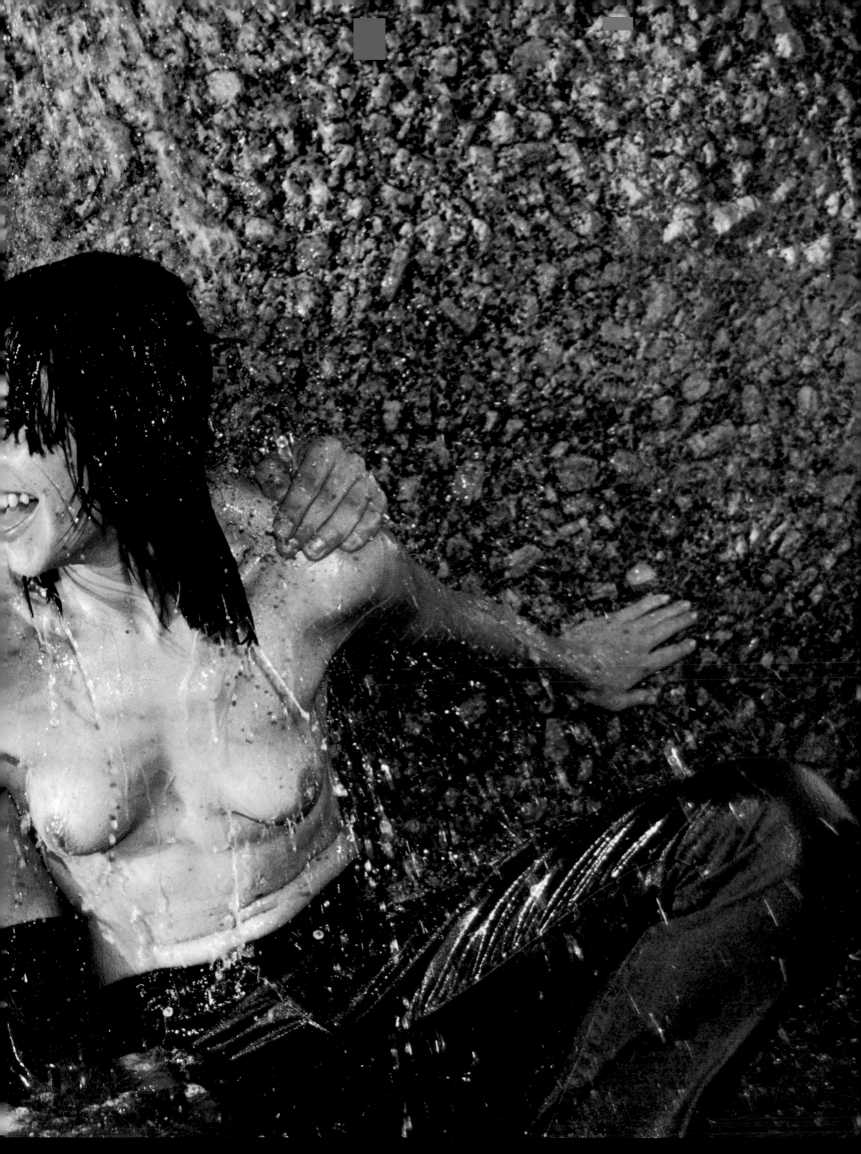

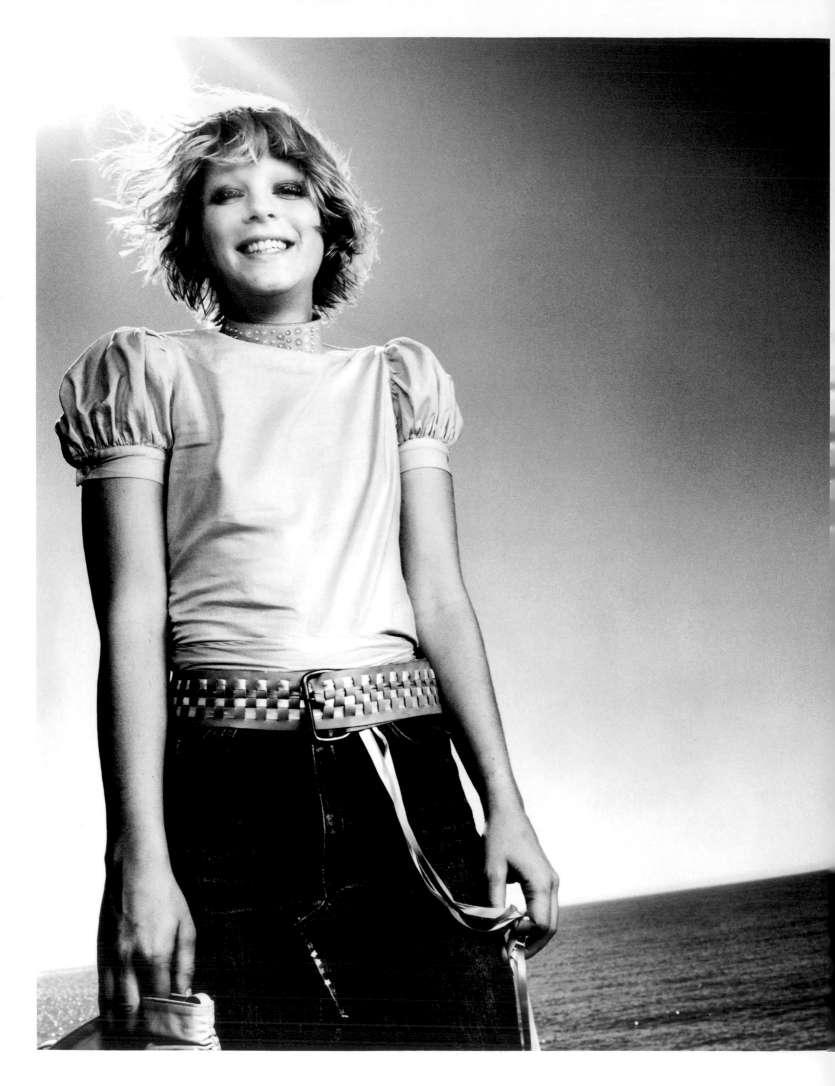

On the previous double page: Elaine Constantine, Waterfall, Italian *Vogue*, unpublished. Above: Elaine Constantine, Jo by the Sea, Italian *Vogue*, unpublished.

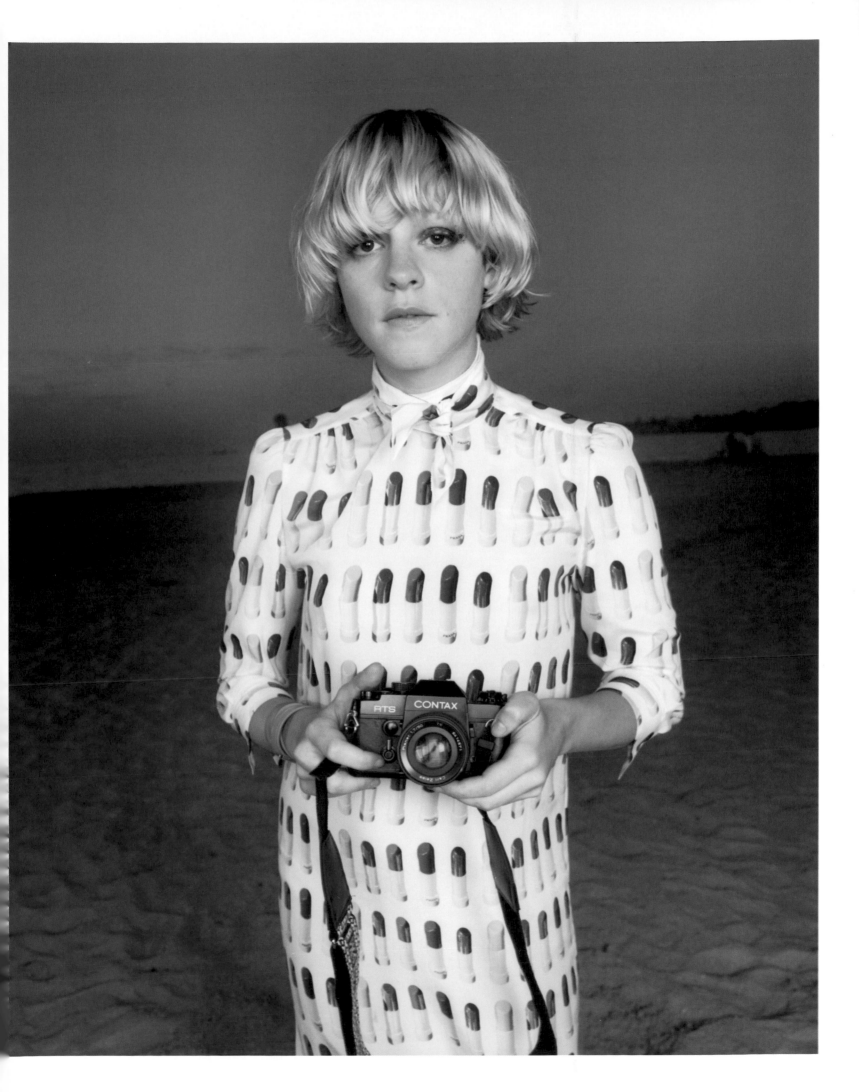

Elaine Constantine, Jo with Camera, Italian *Vogue*.

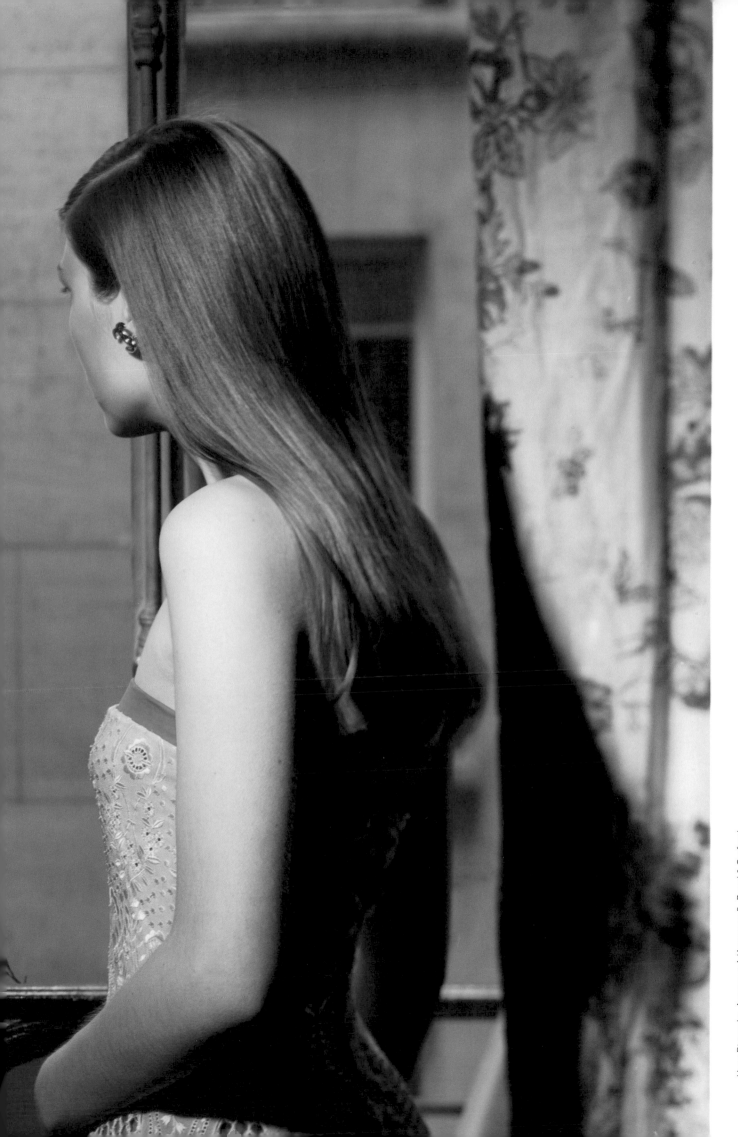

Horst Diergerdes, Apartment A/Apartment B, *Dazed & Confused*.

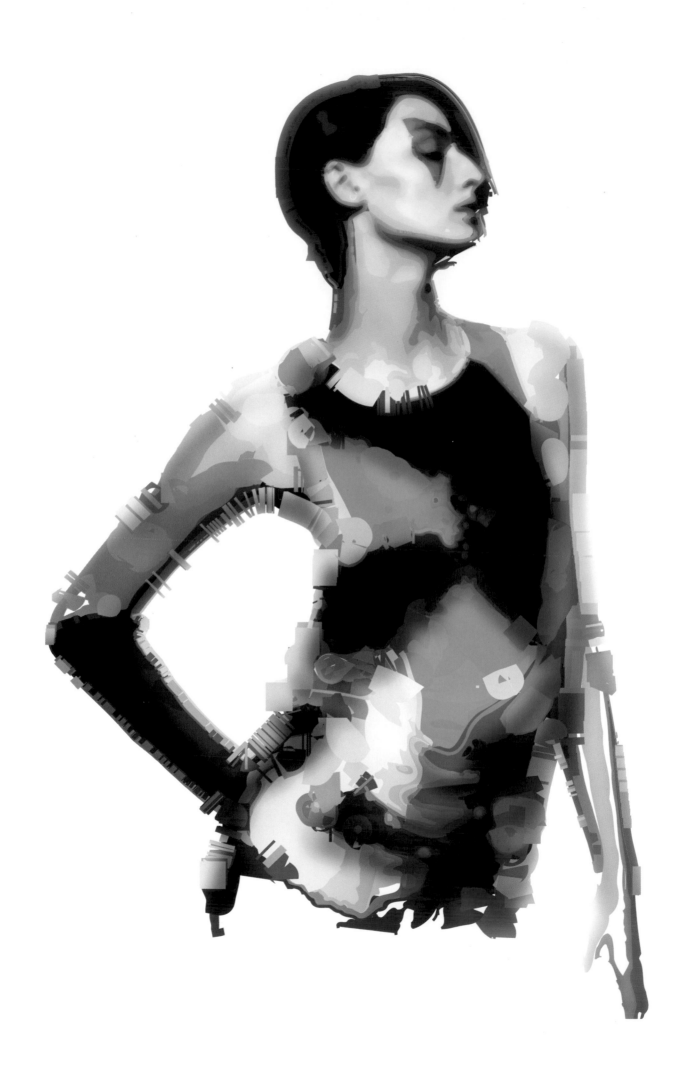

Warren du Preez and Nick Thornton-Jones, X-Girls, *Dazed & Confused.*

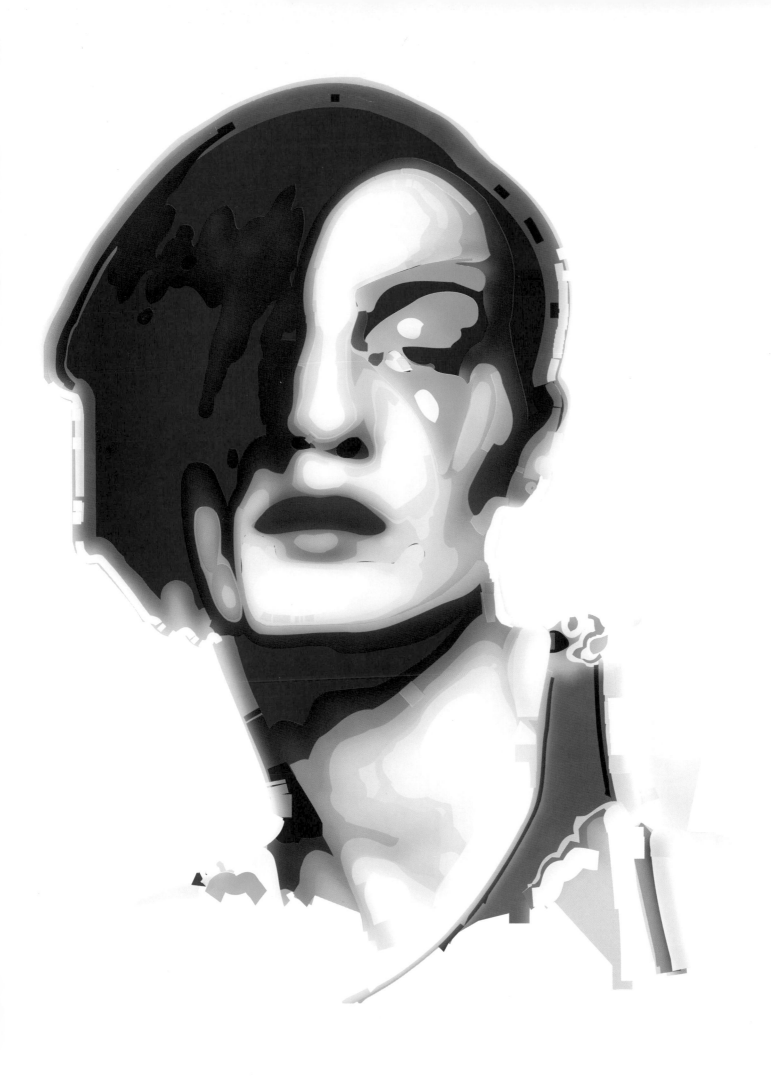

Warren du Preez and Nick Thornton-Jones, X-Girls, *Dazed & Confused.*

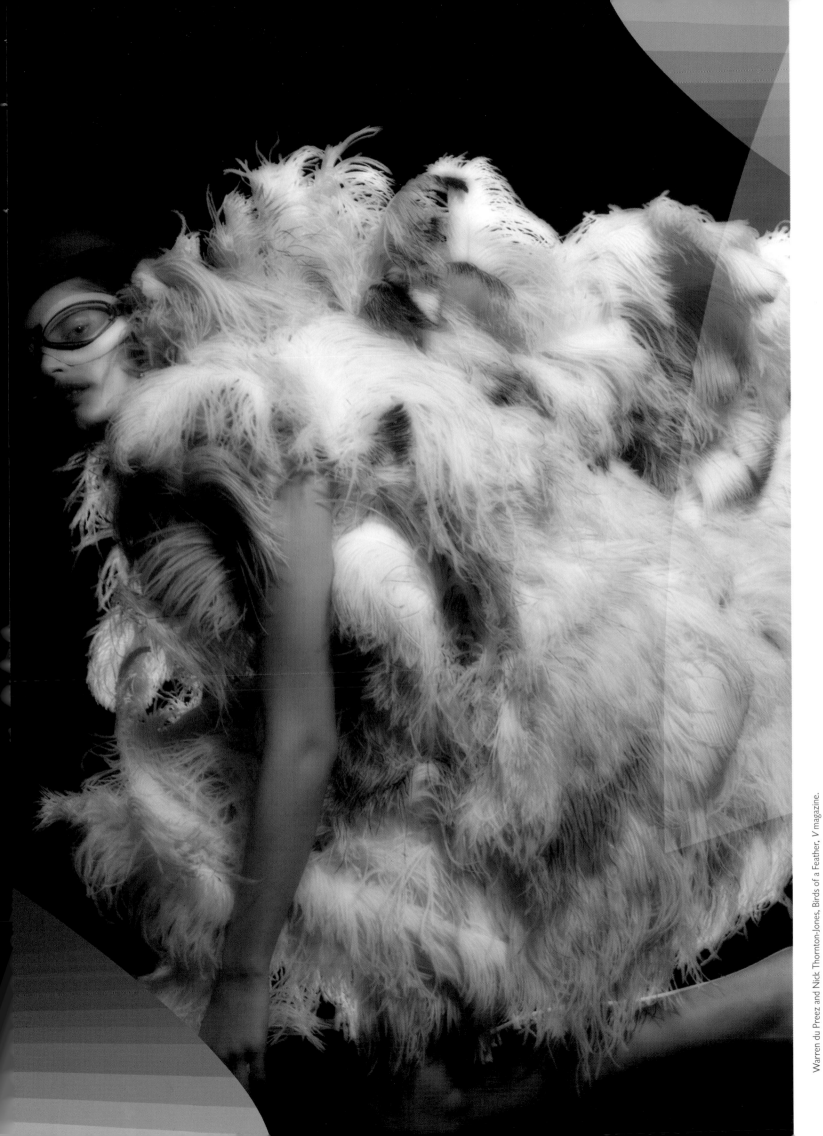

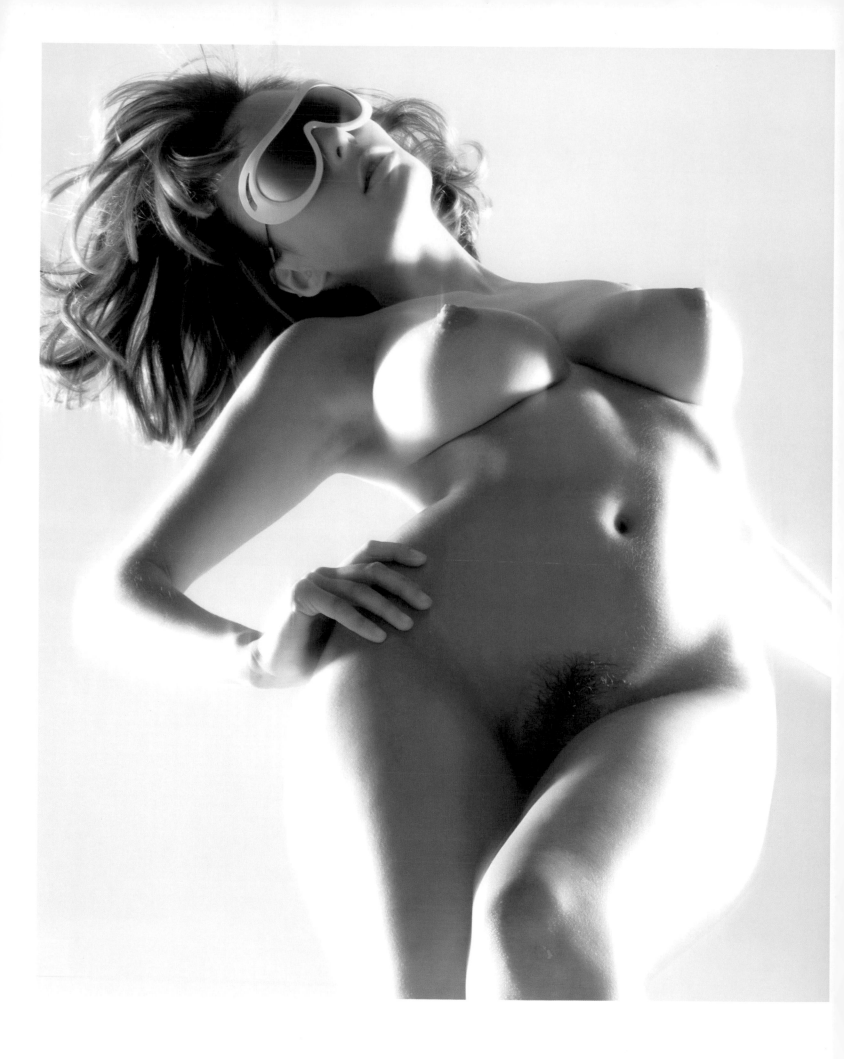

Sean Ellis, Korovamatic Nude, *The Face*.

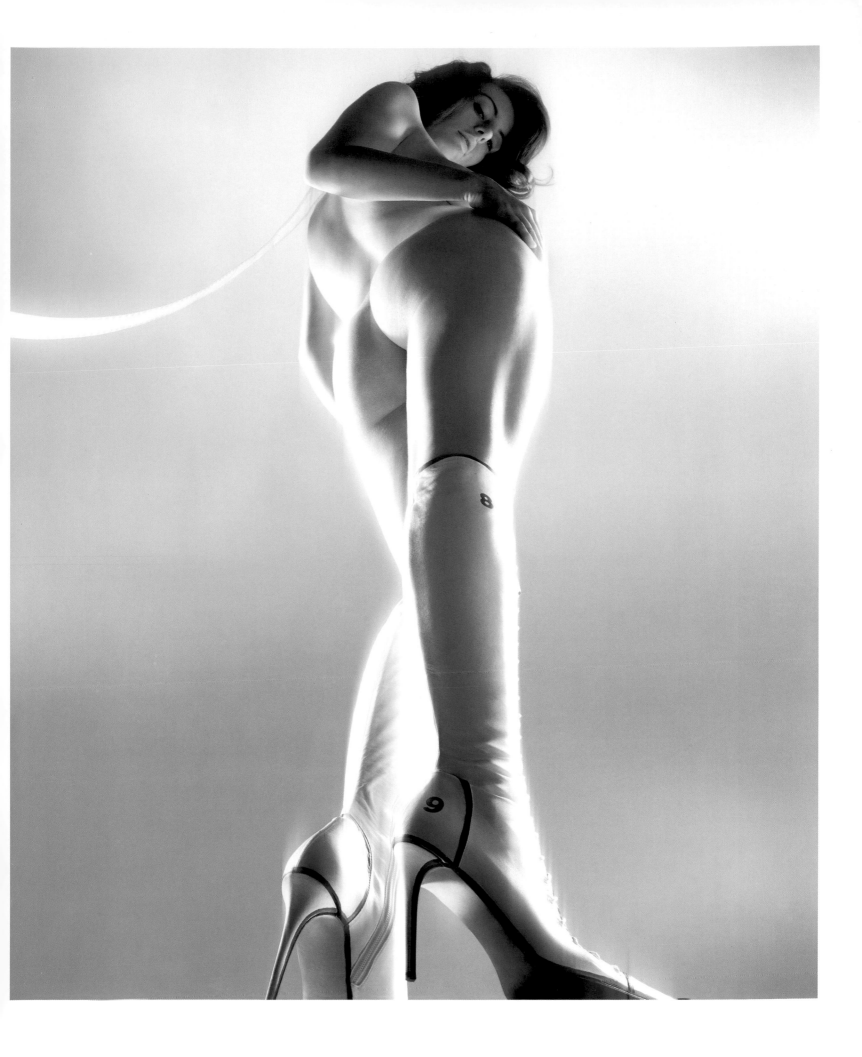

Sean Ellis, Korovamatic Nude, *The Face*.

Jerome Esch, Ex Gregis, *Spoon*. On the following double page: David Ferrua, *Jalouse*.

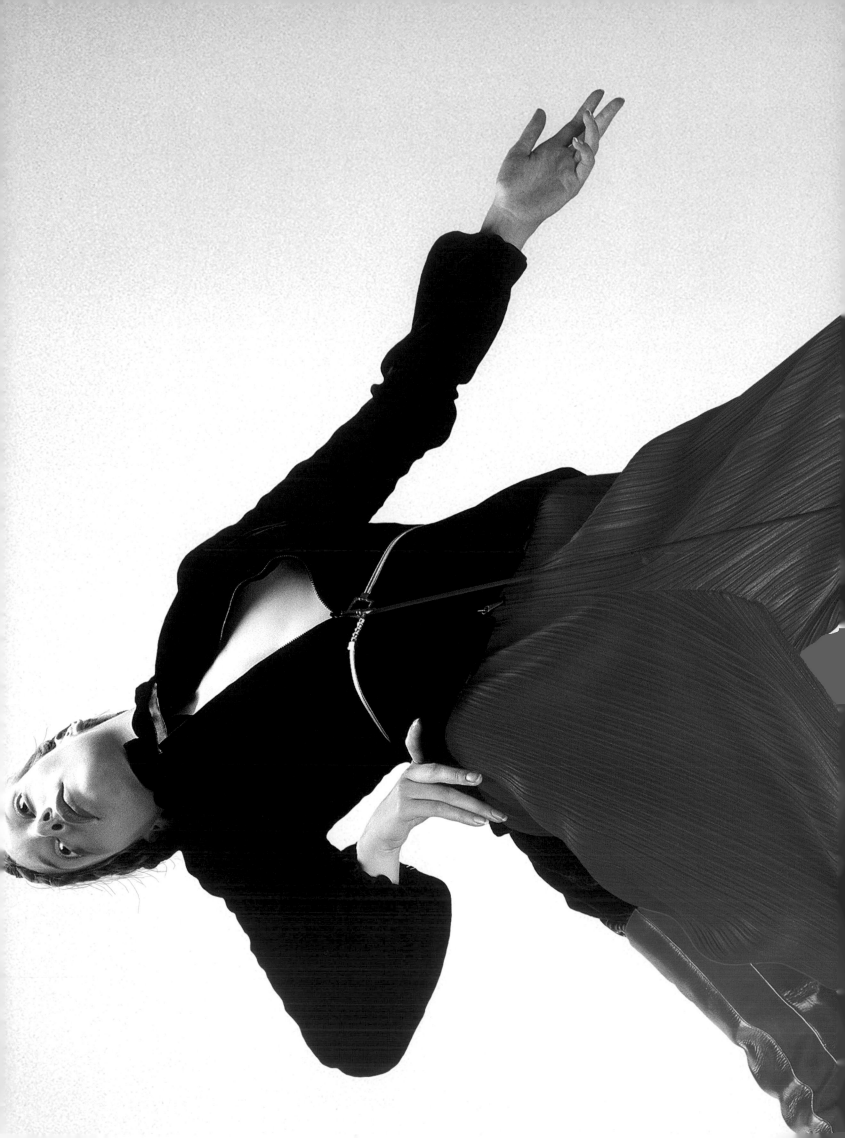

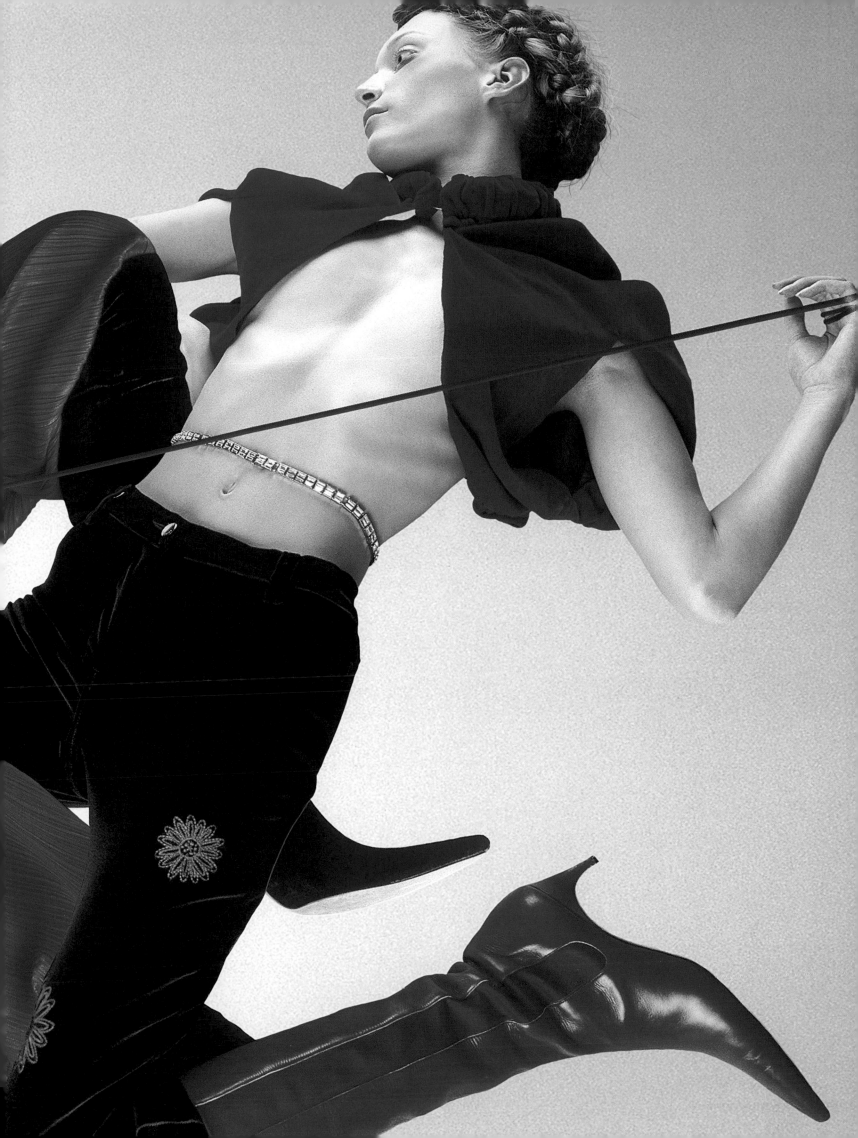

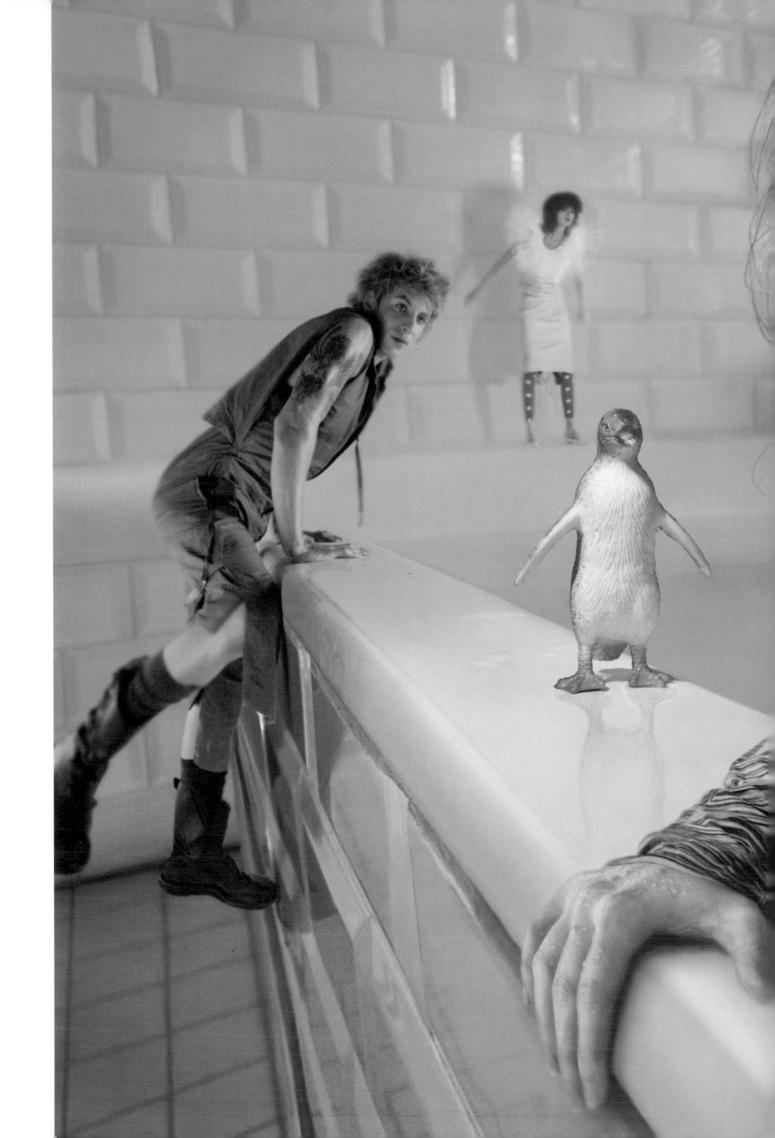

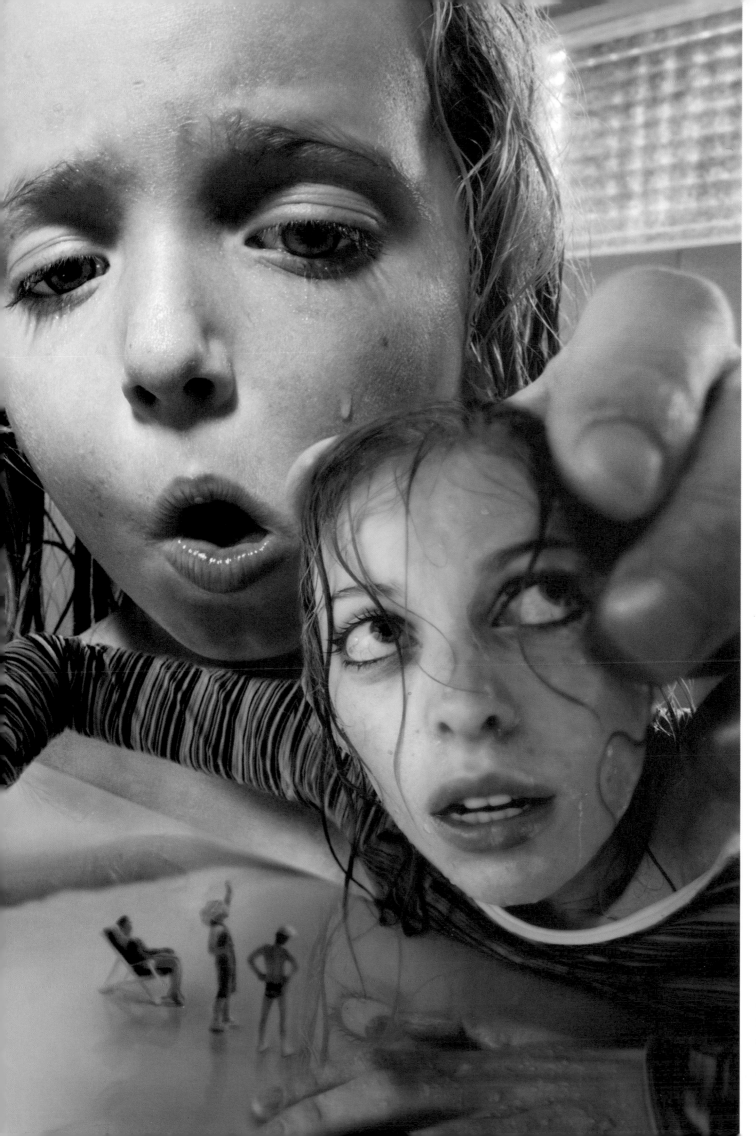

Andrea Giacobbe, Diesel.

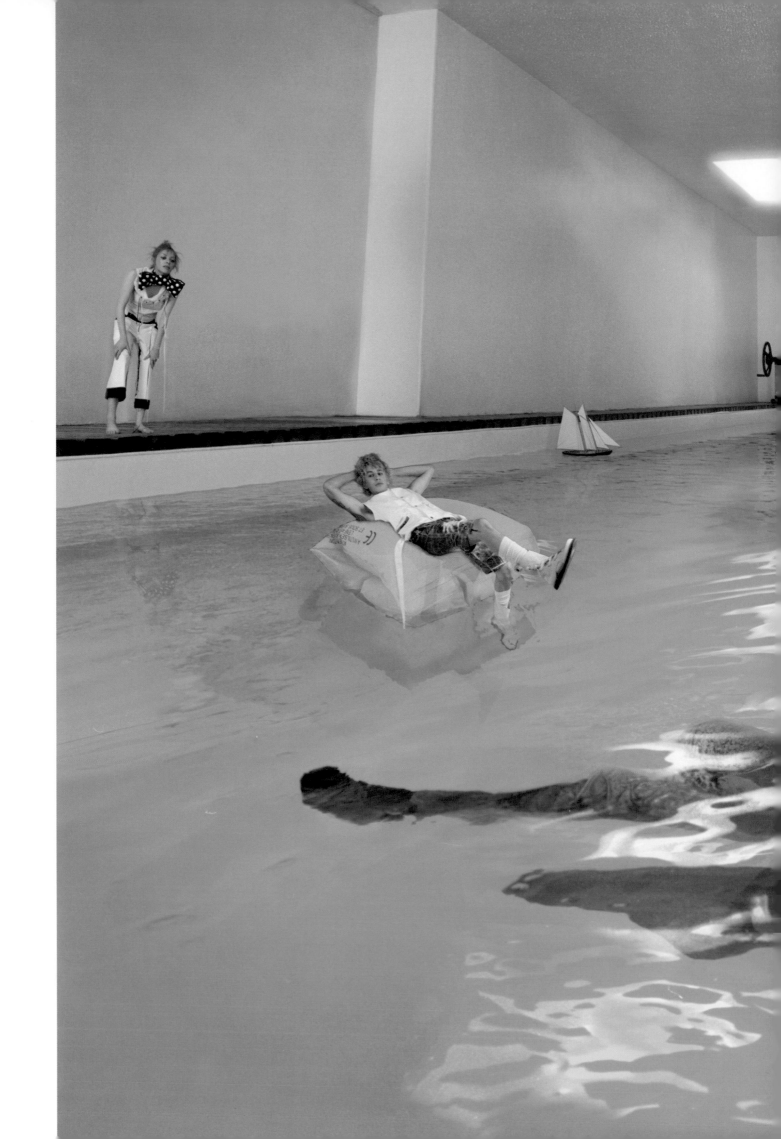

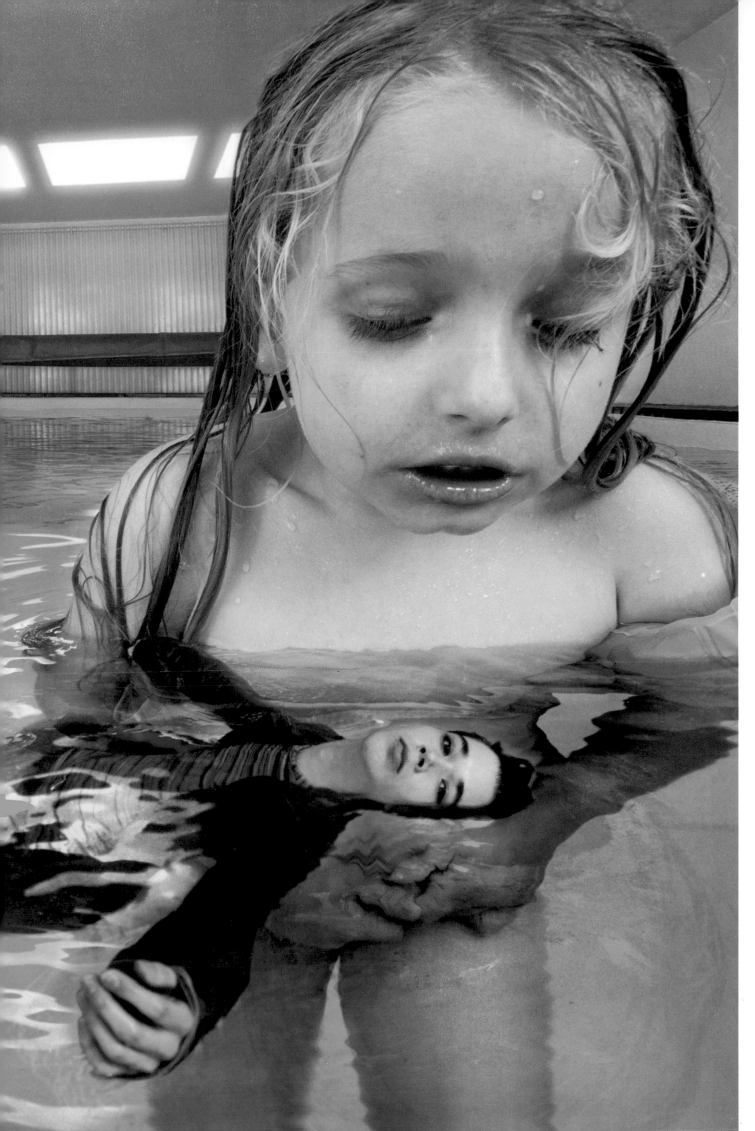

Andrea Giacobbe, Diesel. On the following double page: Andrea Giacobbe, *Dazed & Confused*.

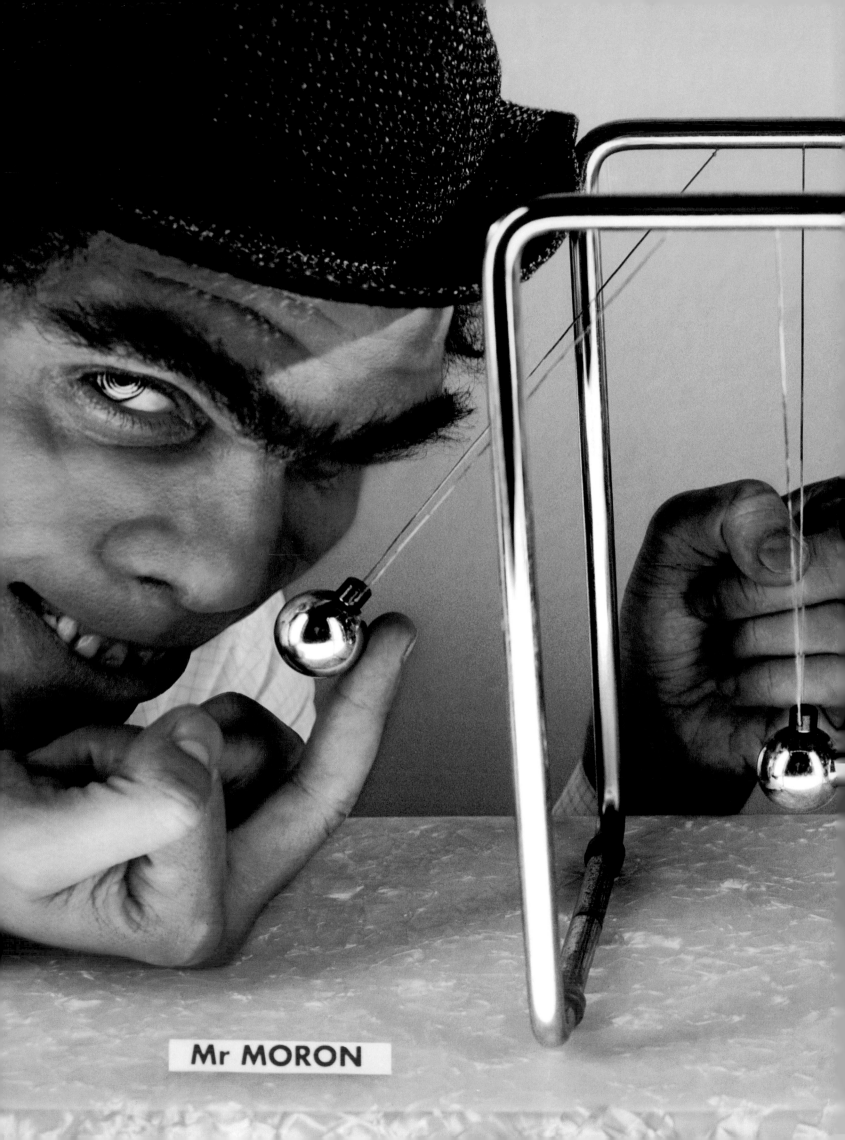

Mr MORON

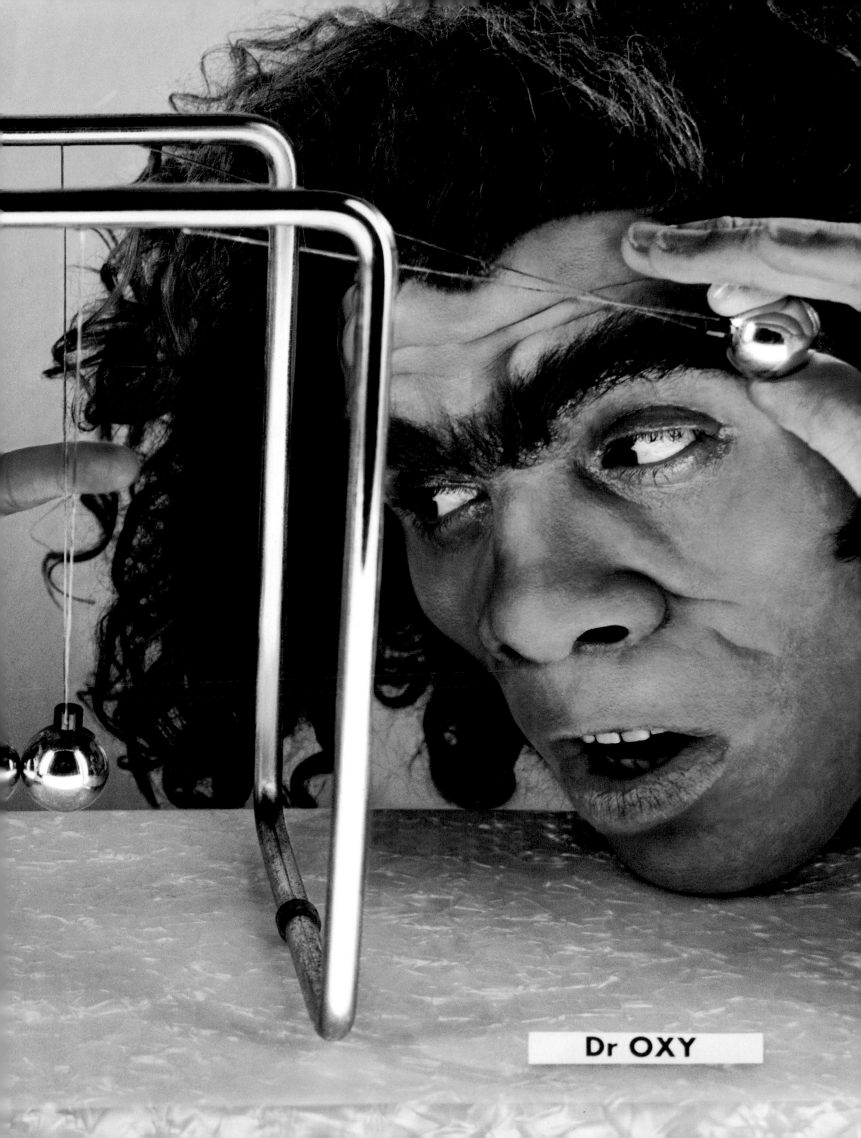

Dr OXY

Nathaniel Goldberg, *Numéro.*

Nathaniel Goldberg, *Numéro*.

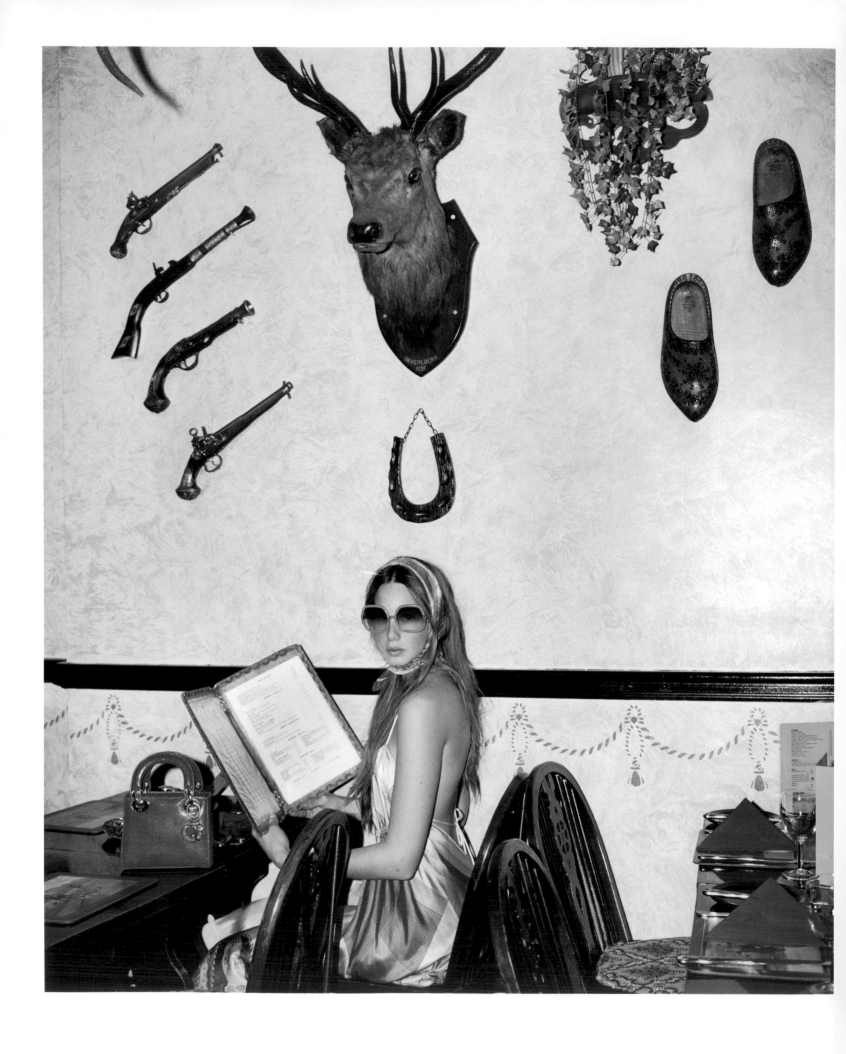

Frederike Helwig, *The Face*.

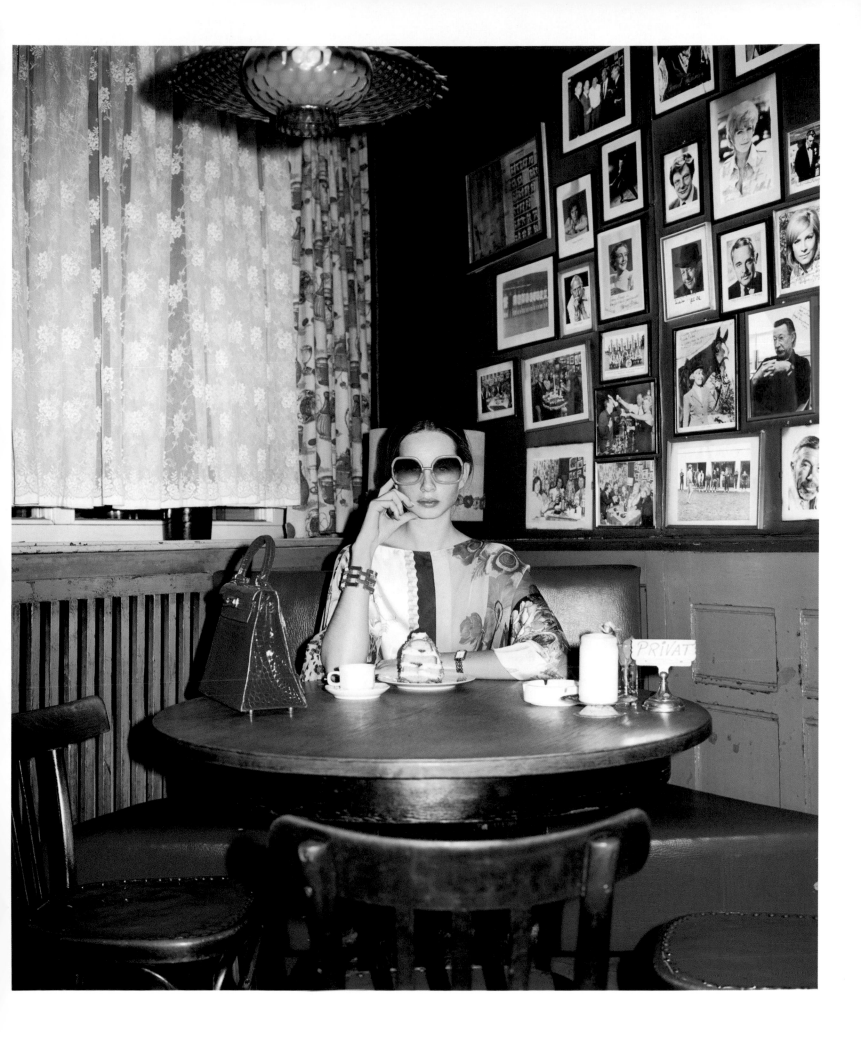

Frederike Helwig, *The Face.*

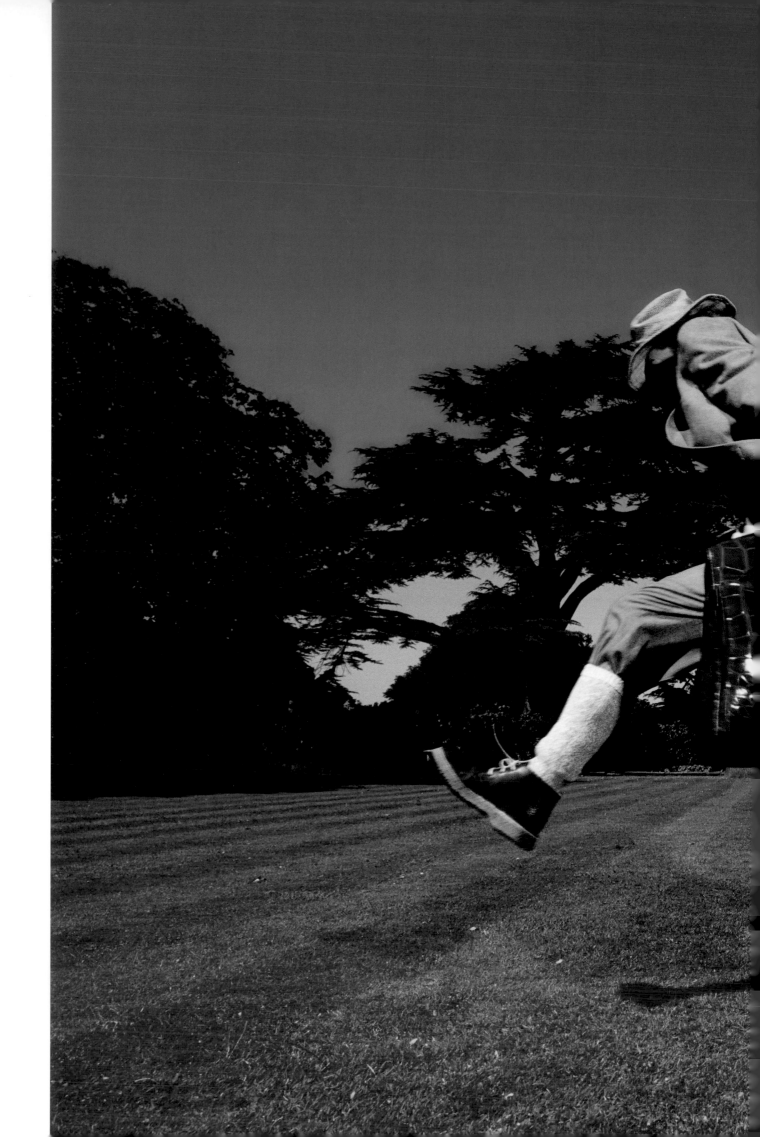

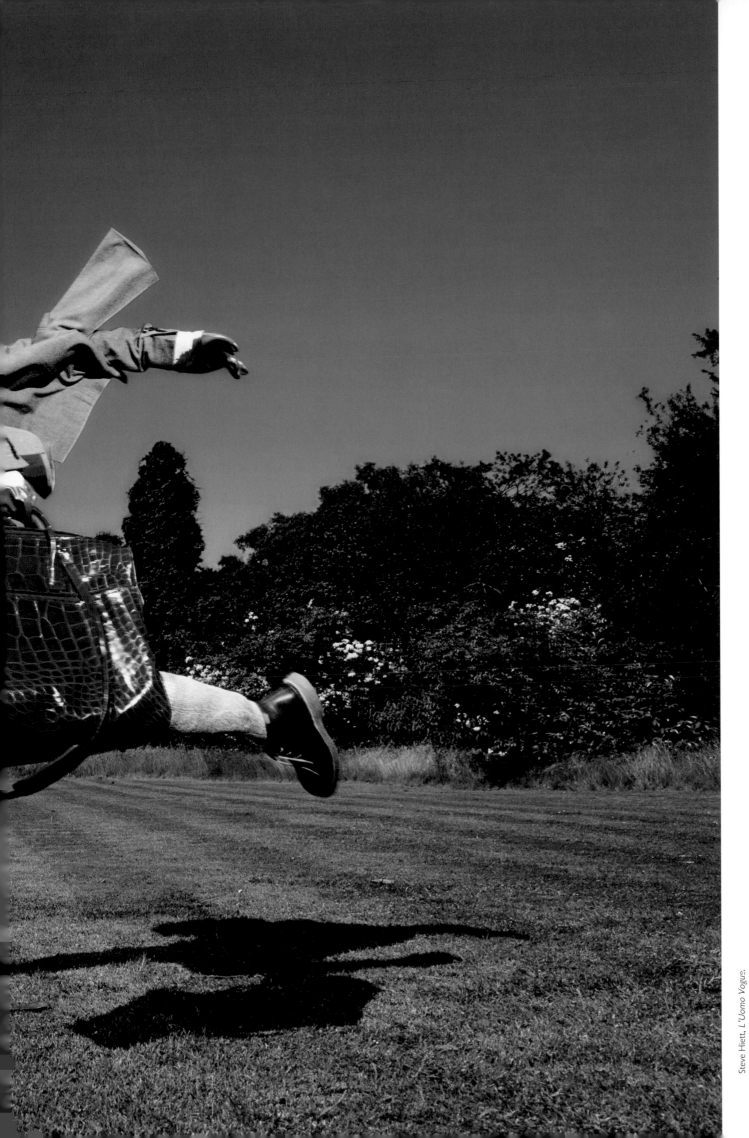

Steve Hiett, *L'Uomo Vogue*.

139

Bettina Komenda, *Liberation.*

Bettina Komenda, *Liberation.*

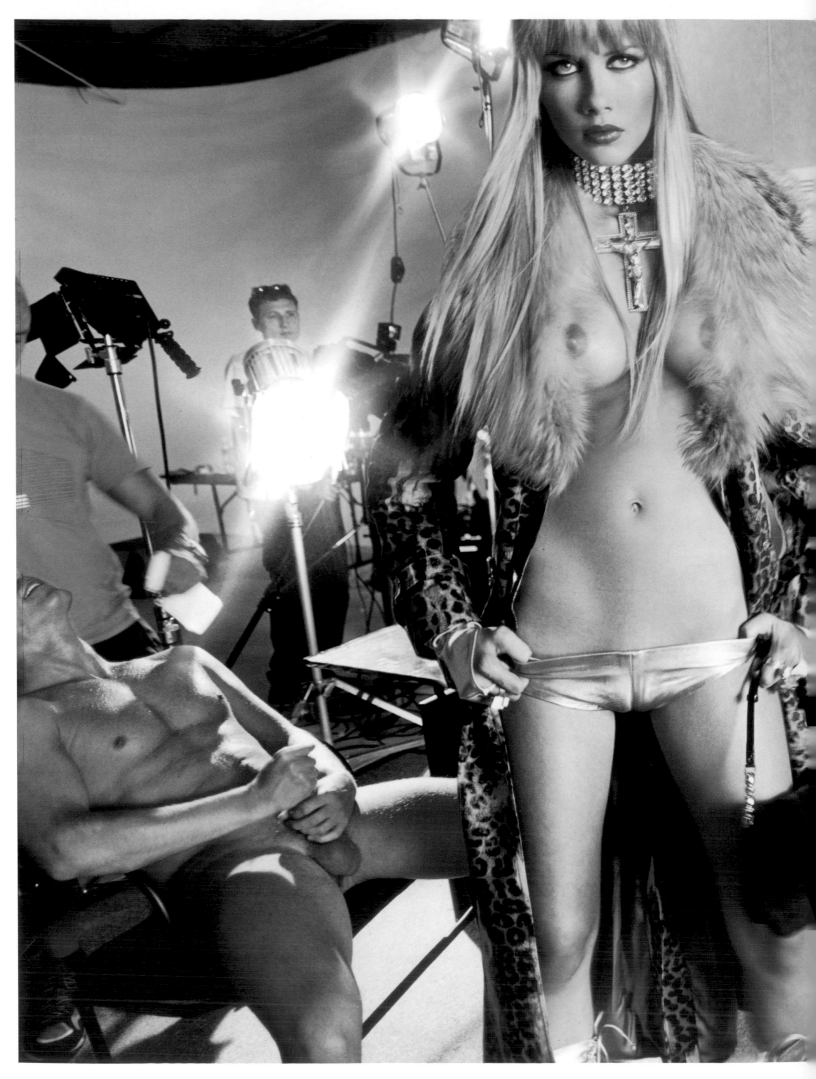

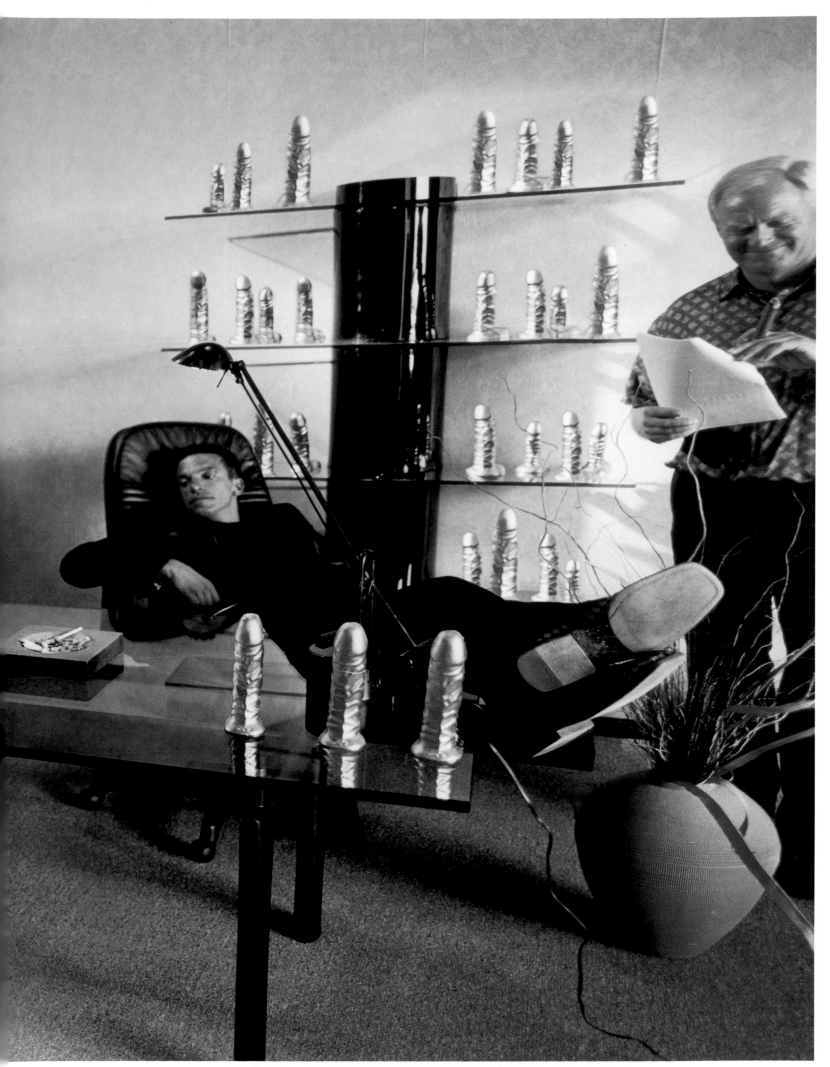

David LaChapelle, Savannah: The Life and Death of a Porn Diva, The Audition, *Arena*.

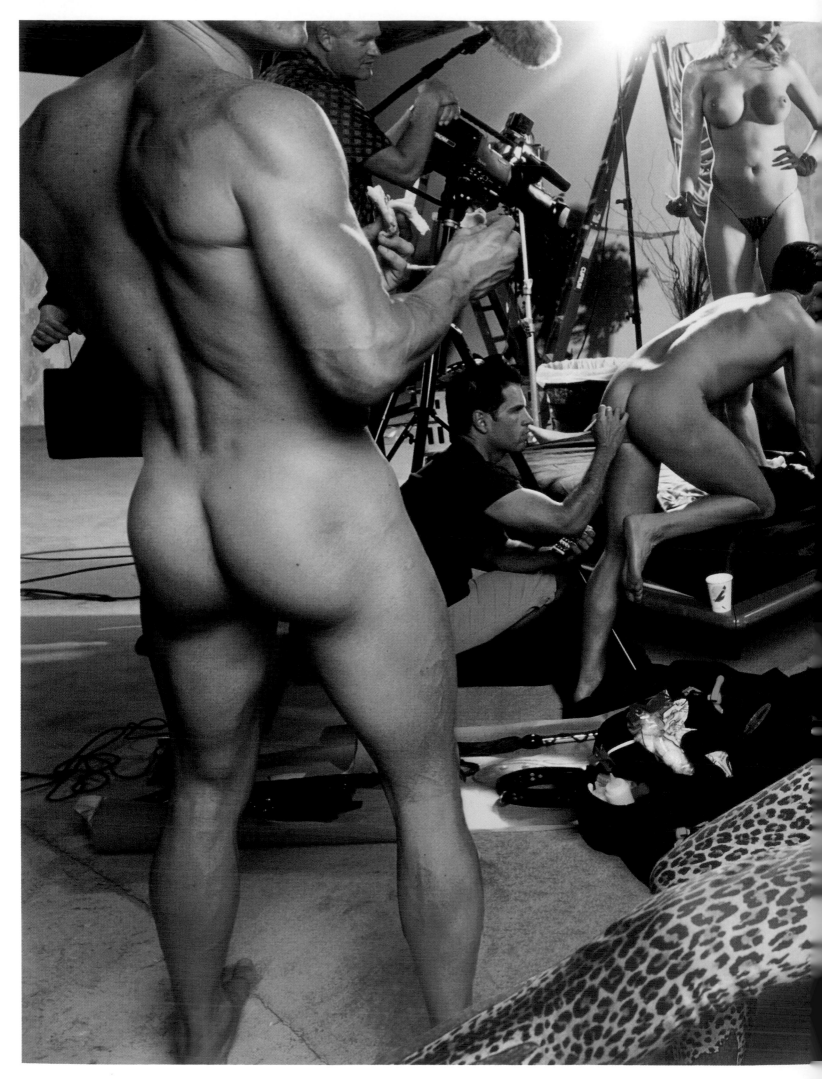

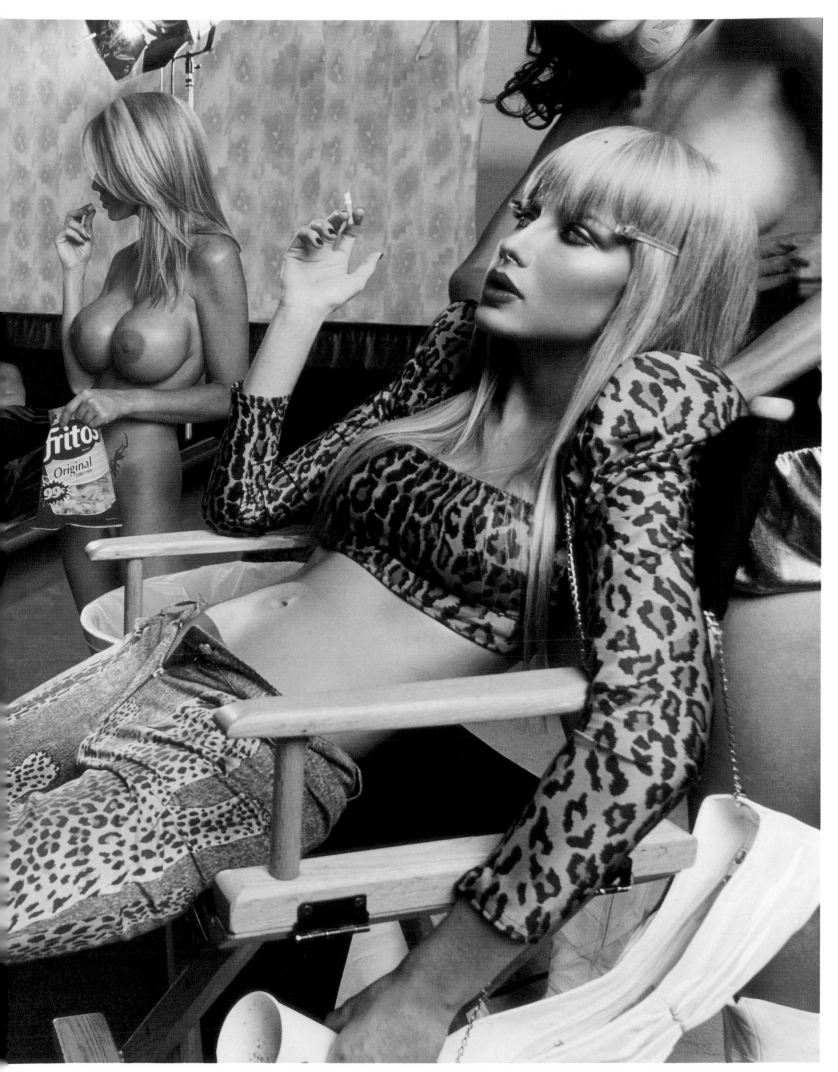

David LaChapelle, Savannah: The Life and Death of a Porn Diva, Poor Little Rich Girl, *Arena.*

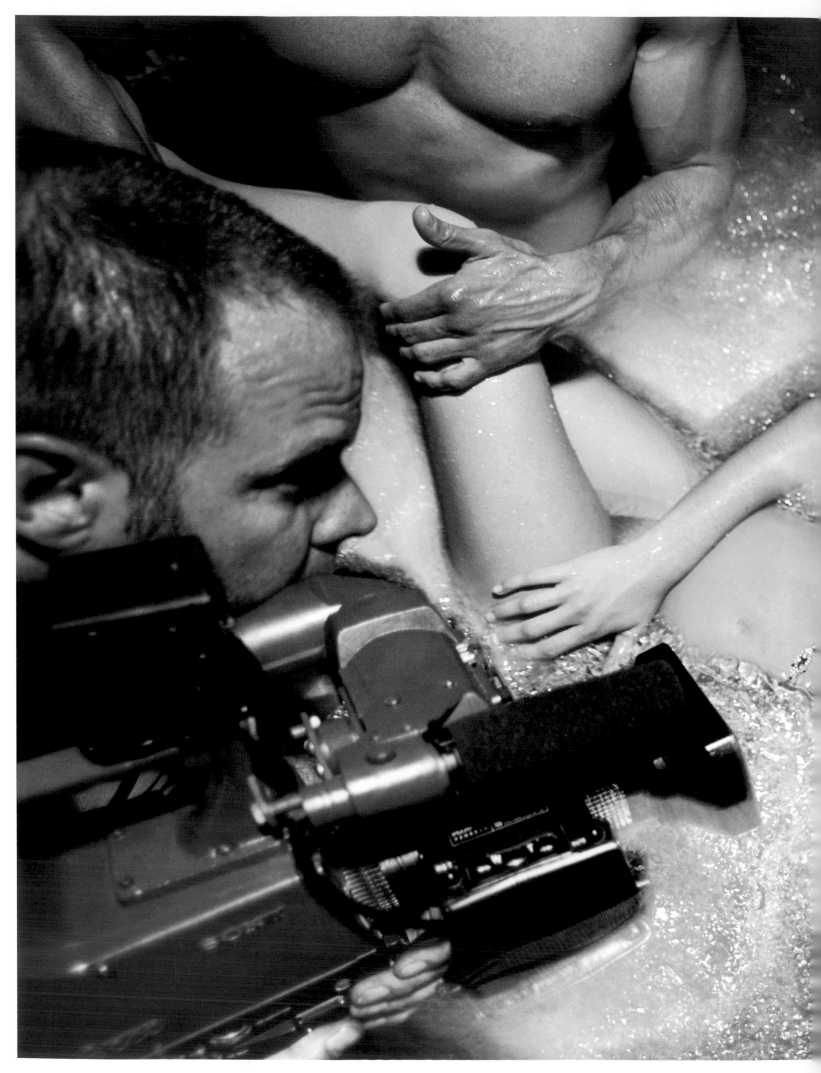

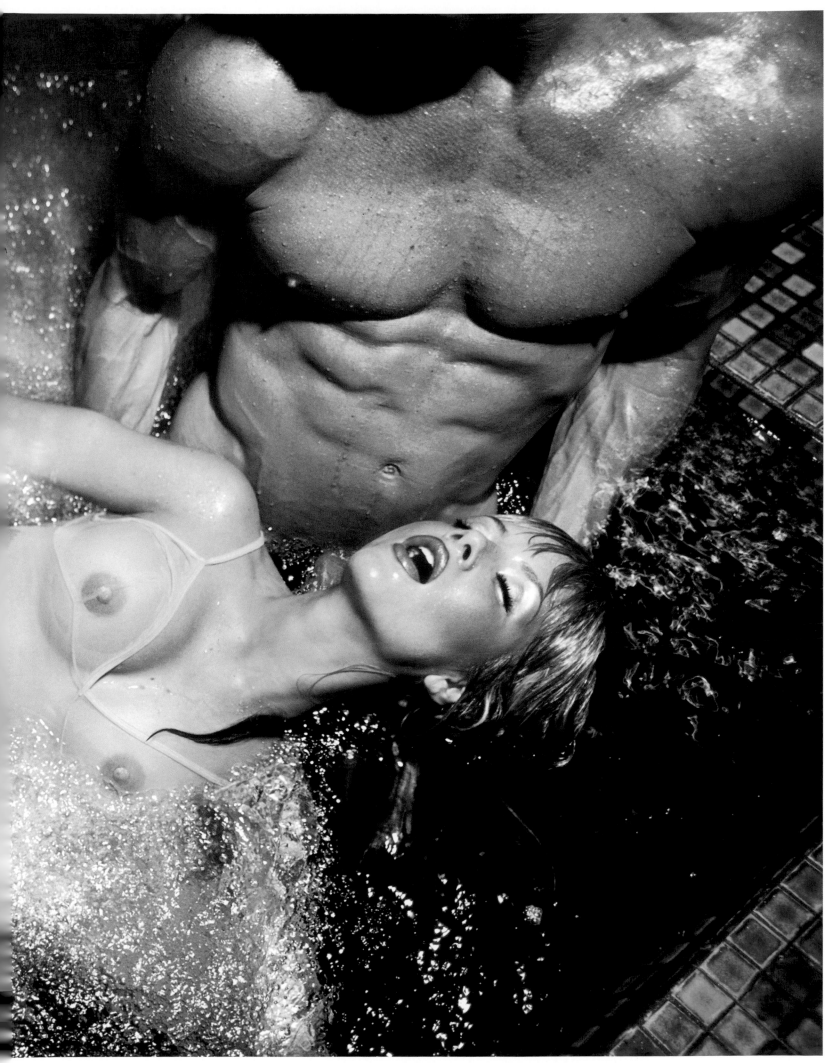

David LaChapelle, Savannah: The Life and Death of a Porn Diva, The Comeback, *Arena*.

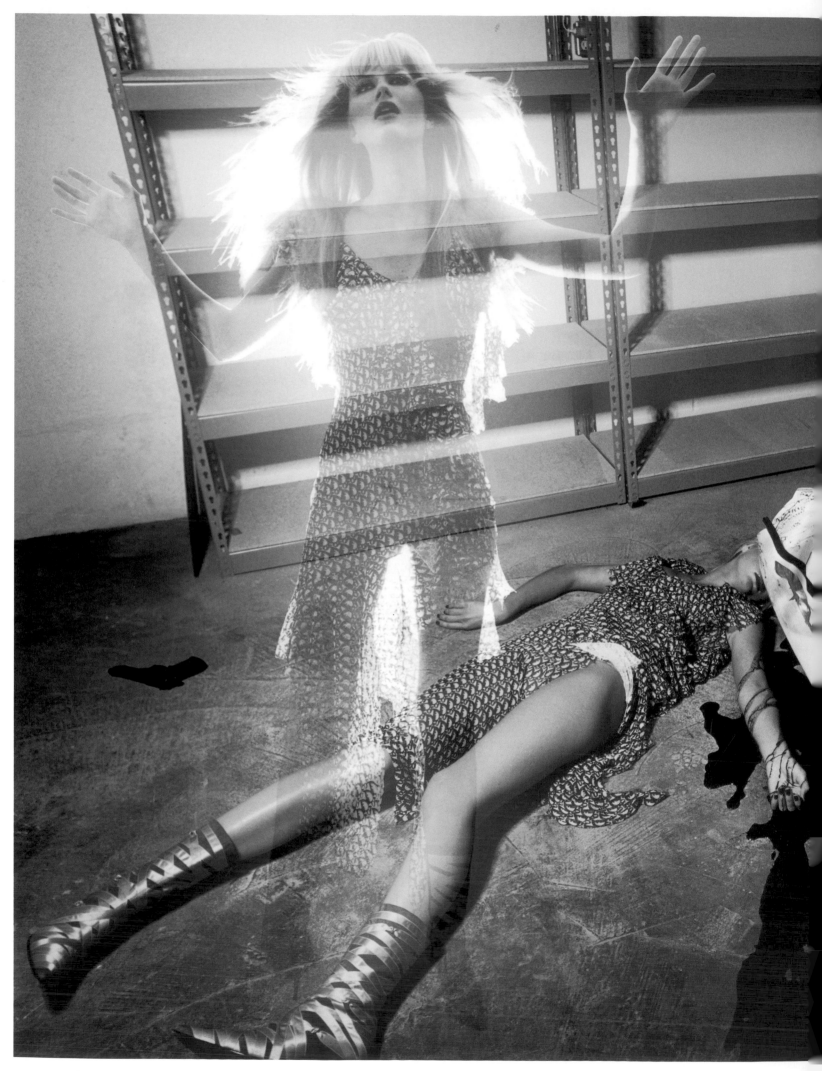

David LaChapelle, Savannah: The Life and Death of a Porn Diva, Resurrection, *Arena*.

Serge Leblon, *Dazed & Confused.*

Serge Leblon, *The Face.*

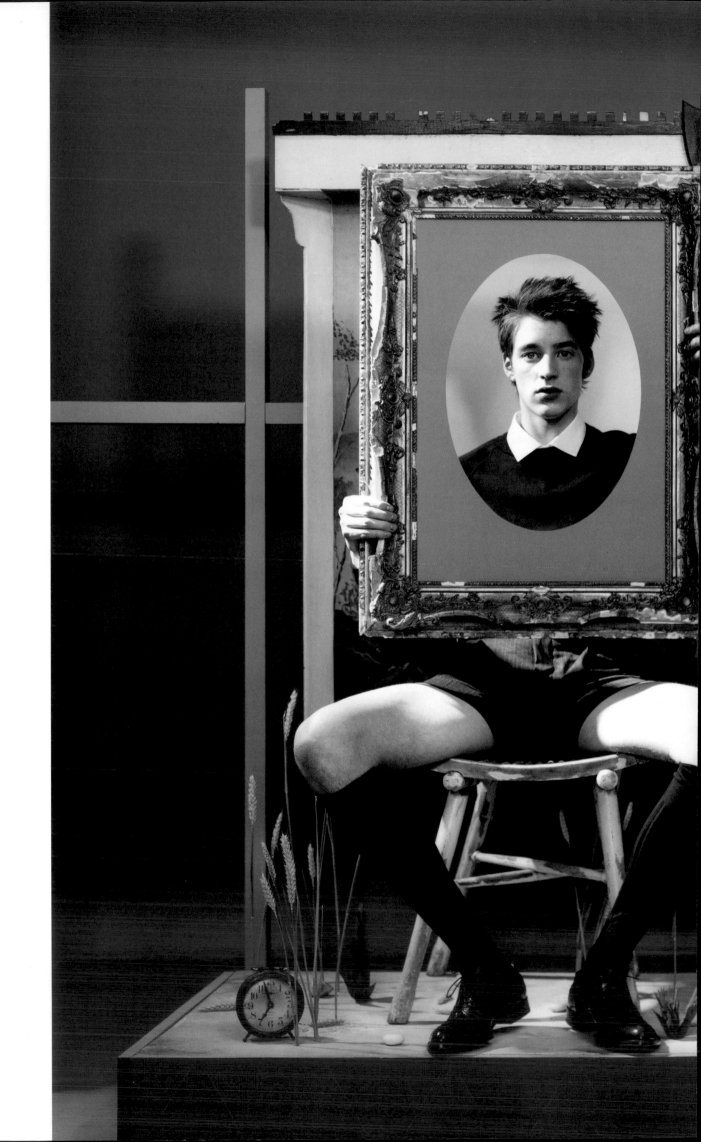

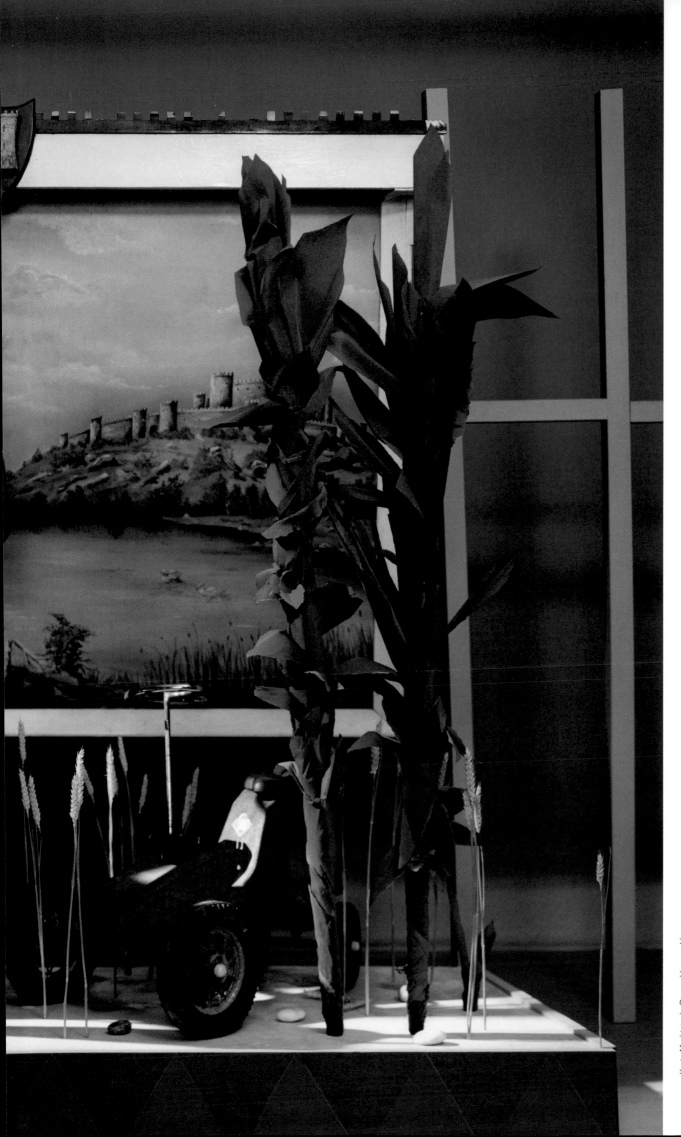

Kevin Mackintosh, Dream Heroes, *Upstreet.*

157

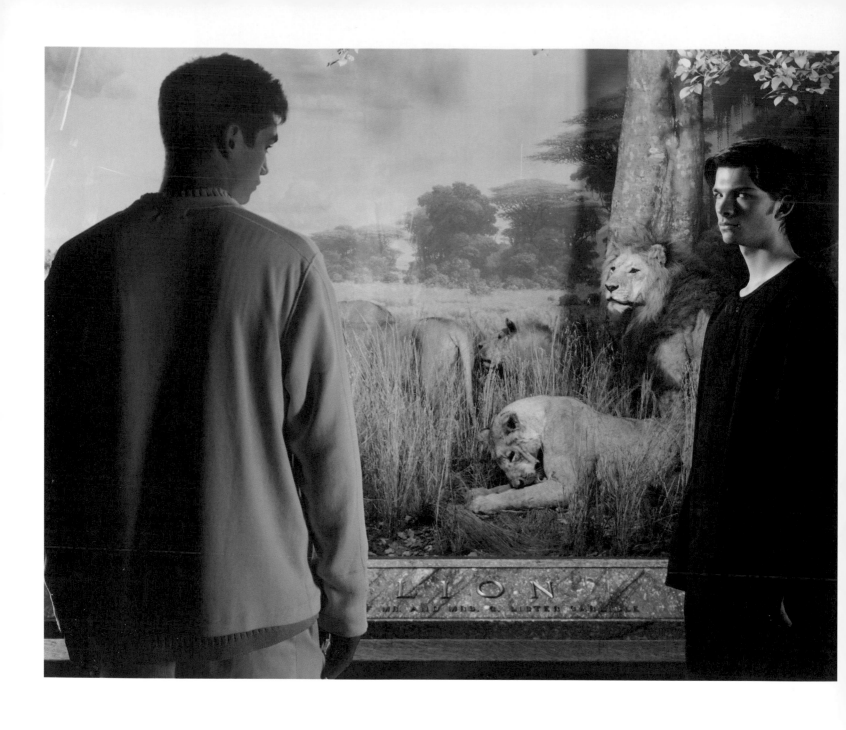

Marcus Mãm, *Flaunt.*

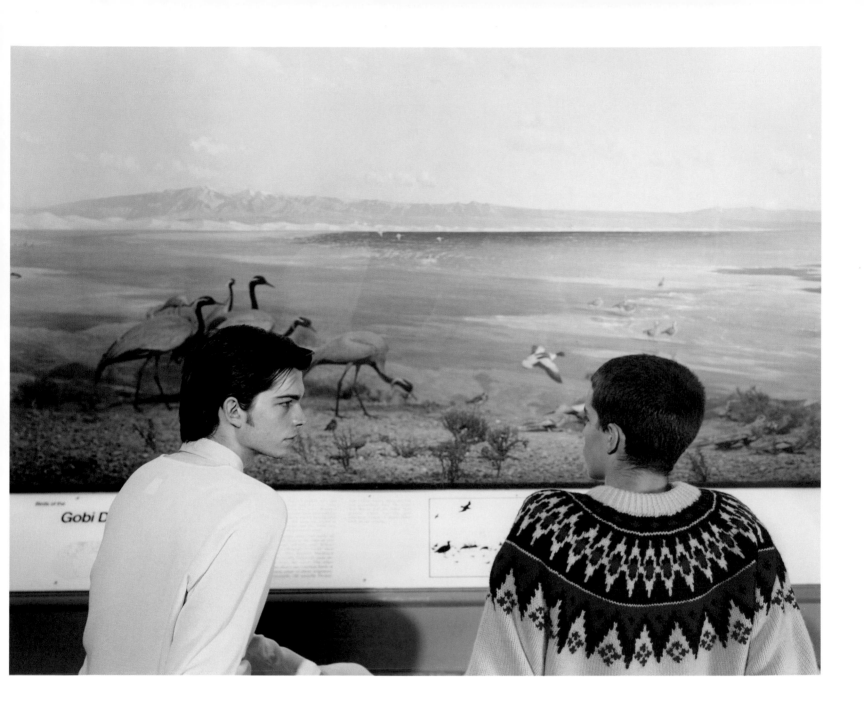

Marcus Mâm, *Flaunt.*

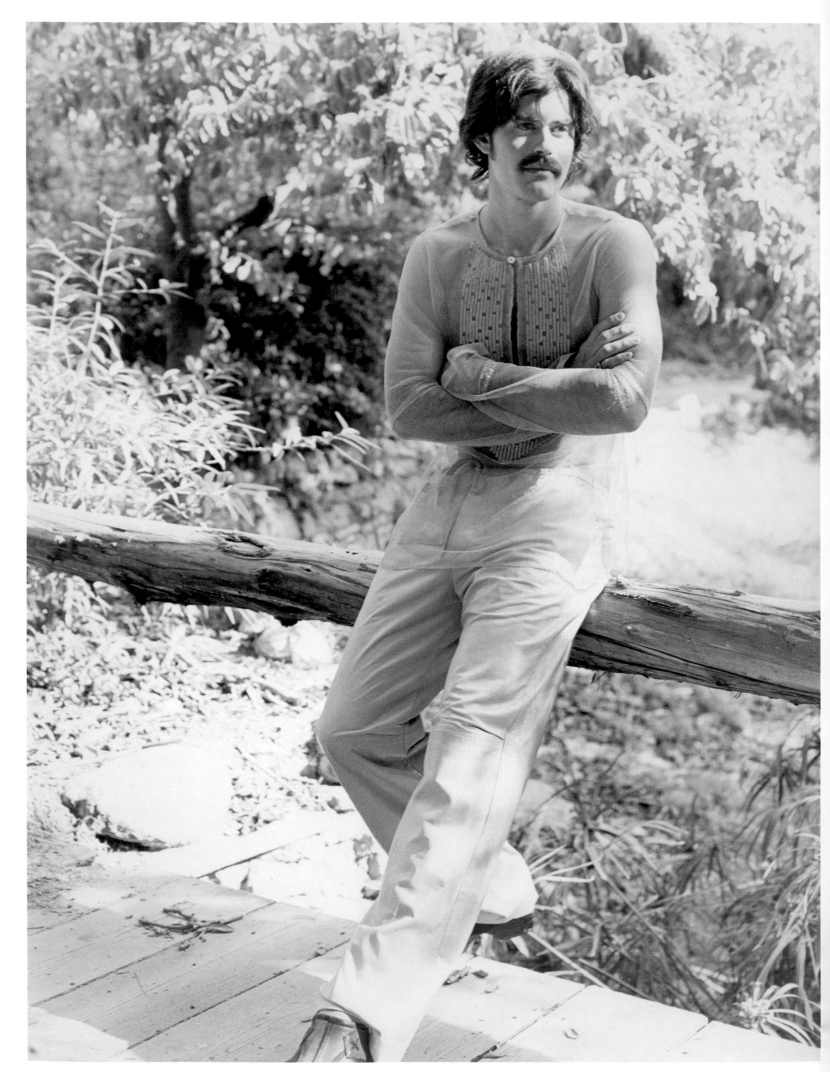

Melodie McDaniel, *Arena*.

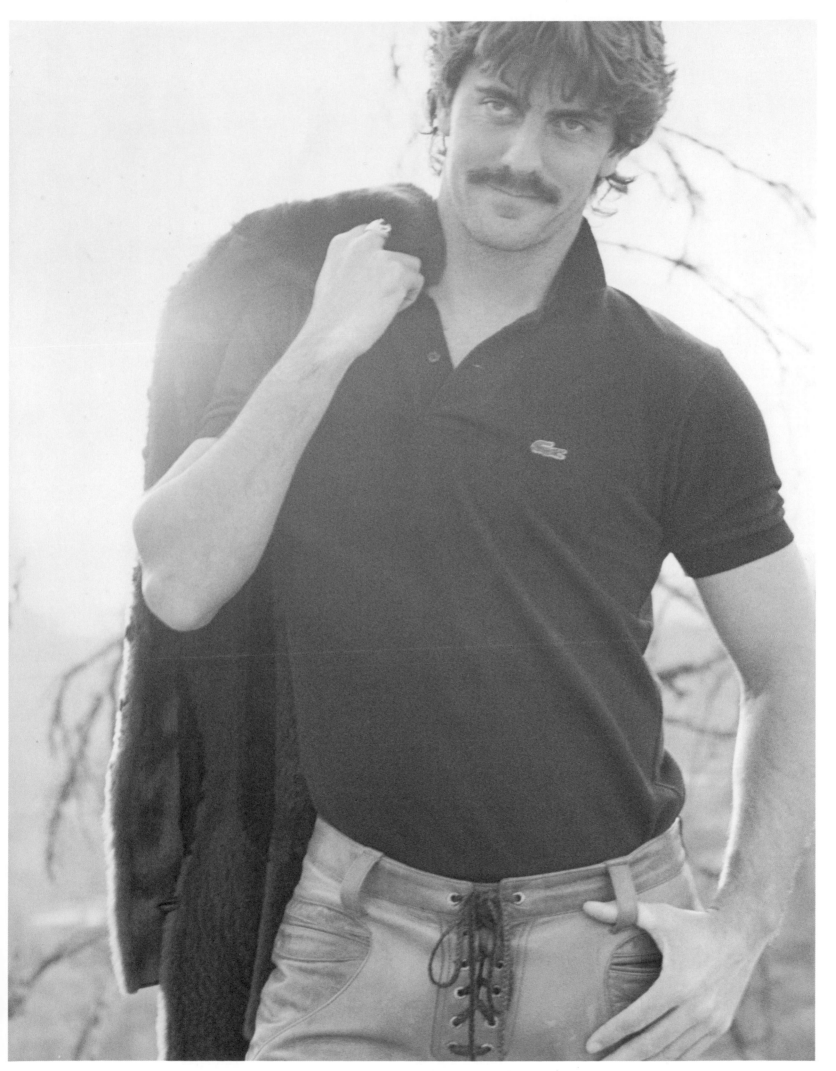

Melodie McDaniel, *Arena*.

Melodie McDaniel, *Arena*.

Melodie McDaniel, *Arena*.

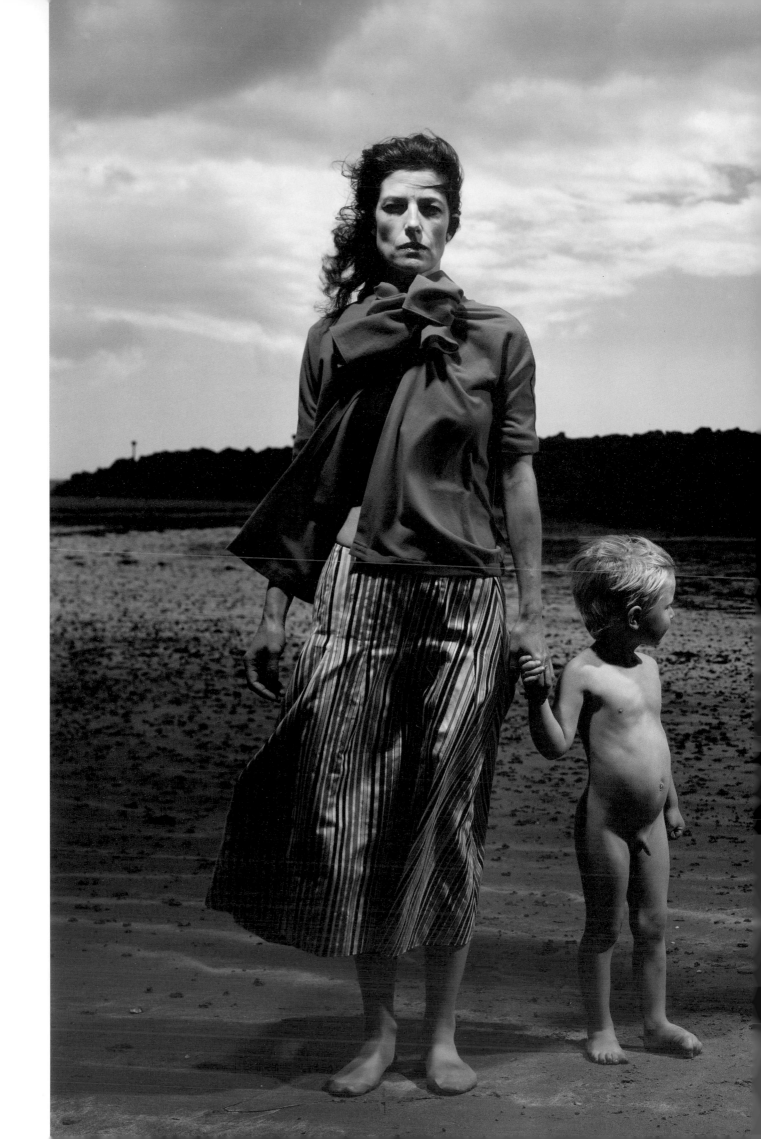

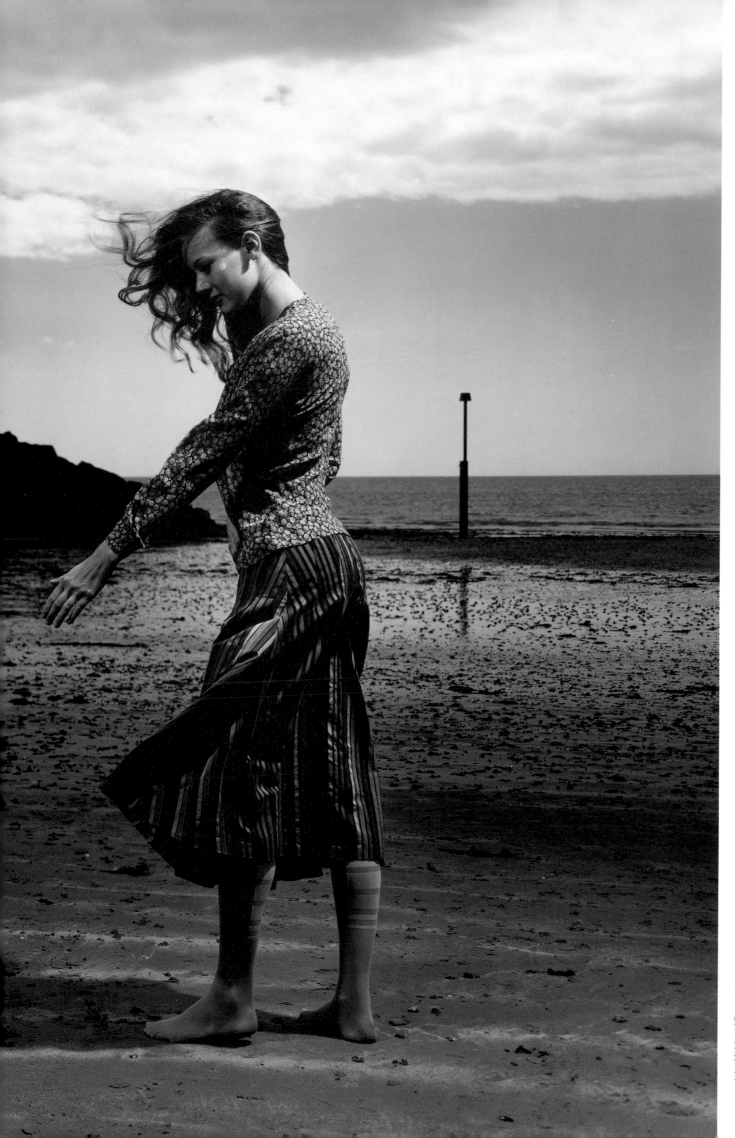

John Midgley, *AD* magazine.

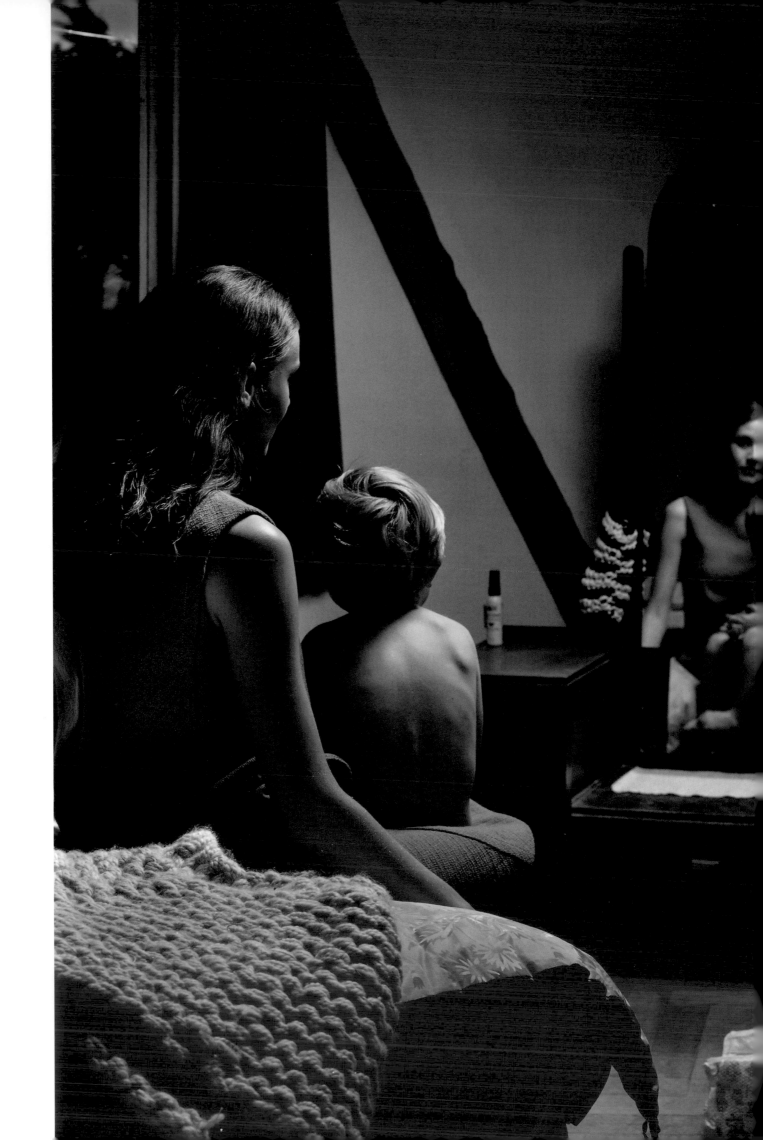

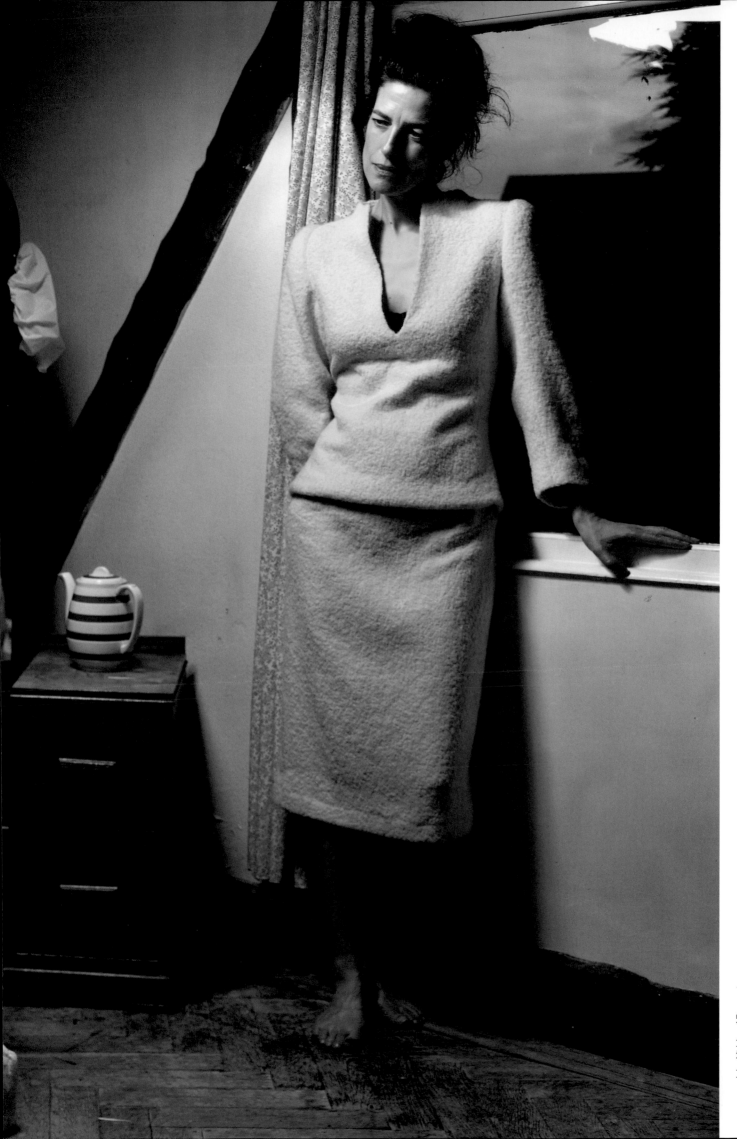

167

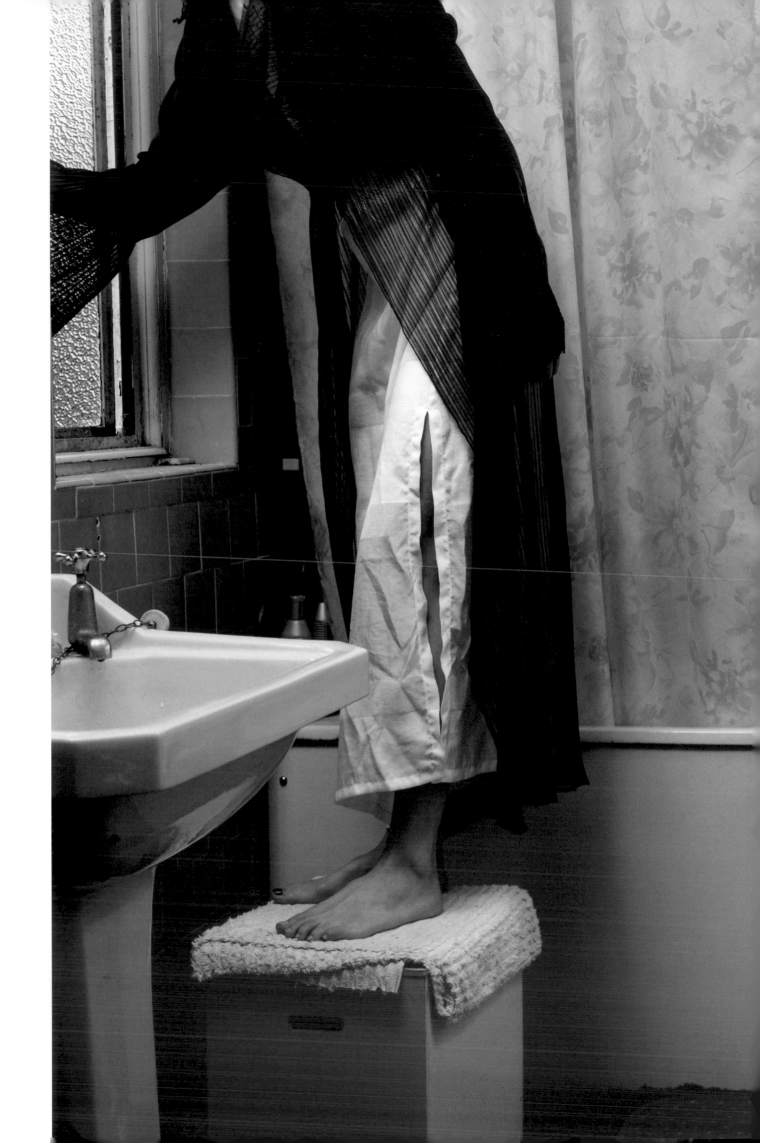

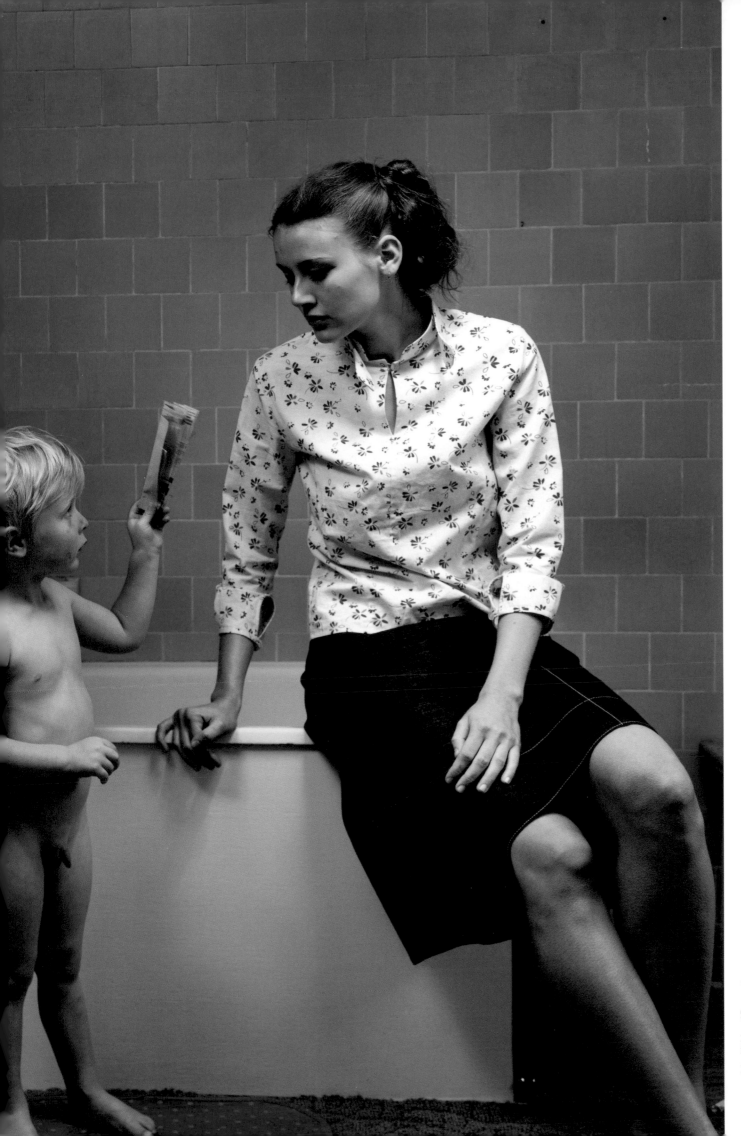

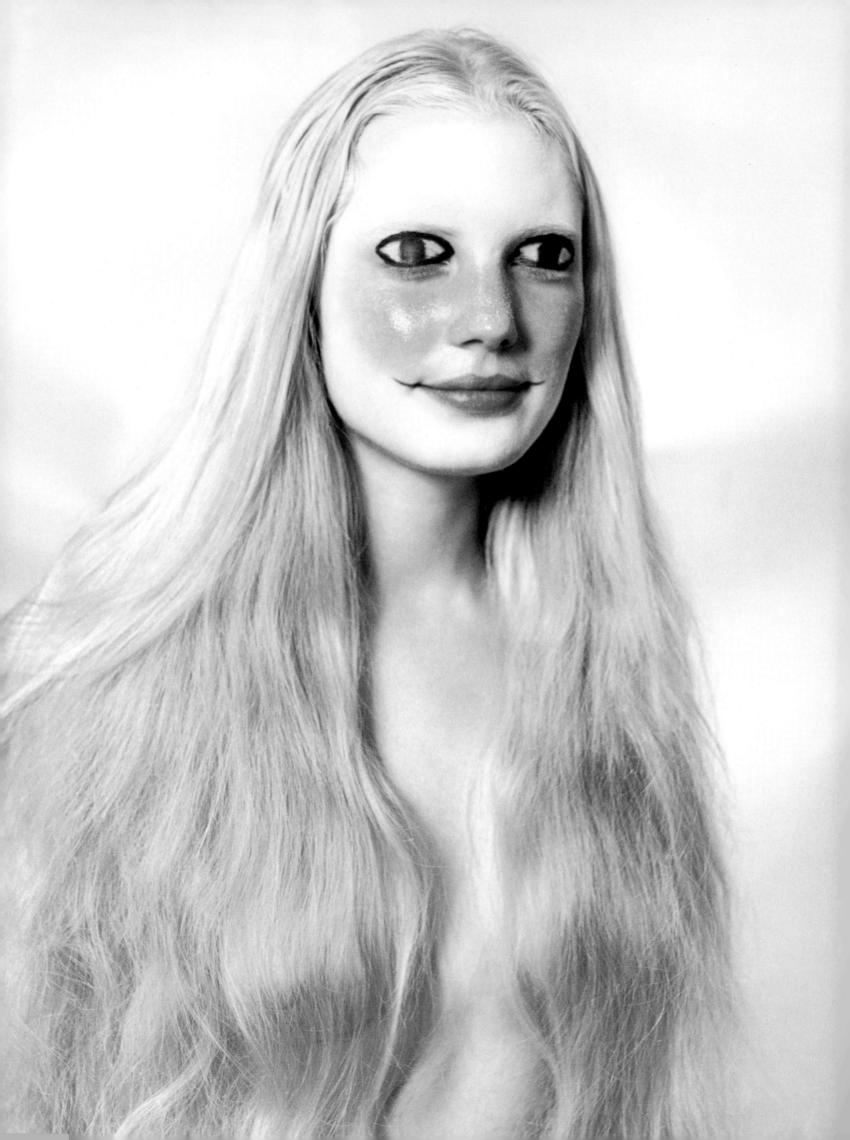

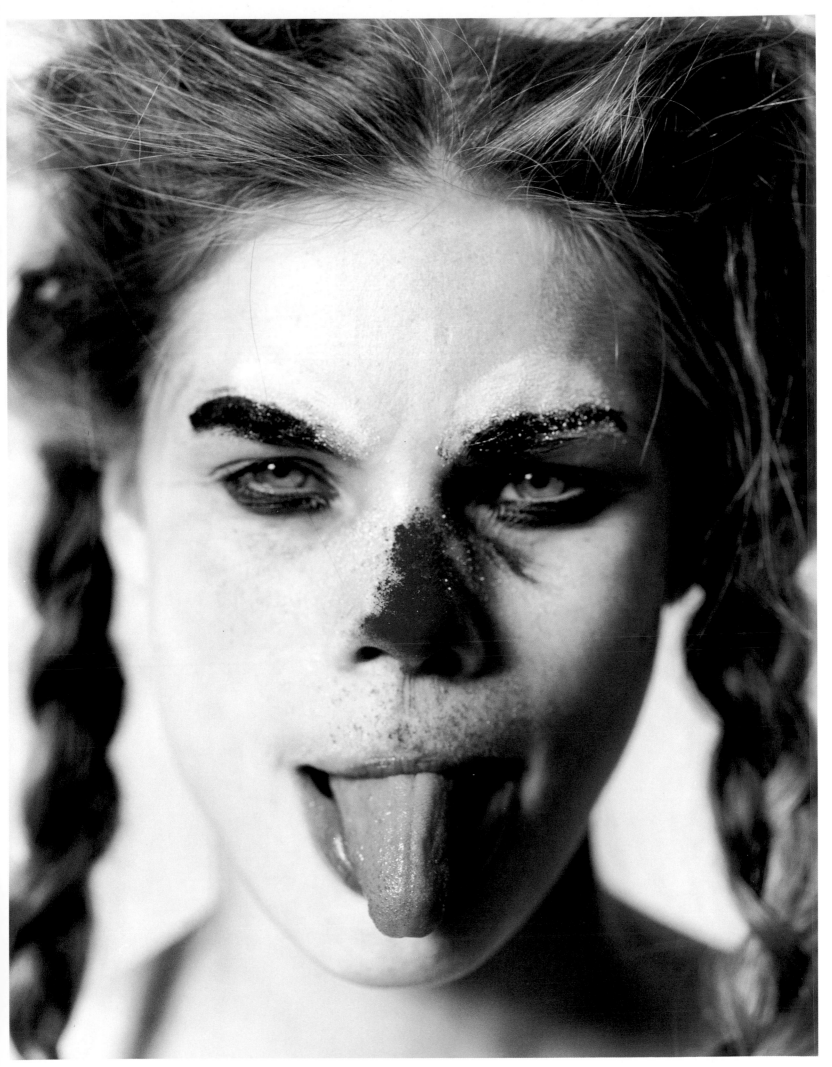

Michael Momy.

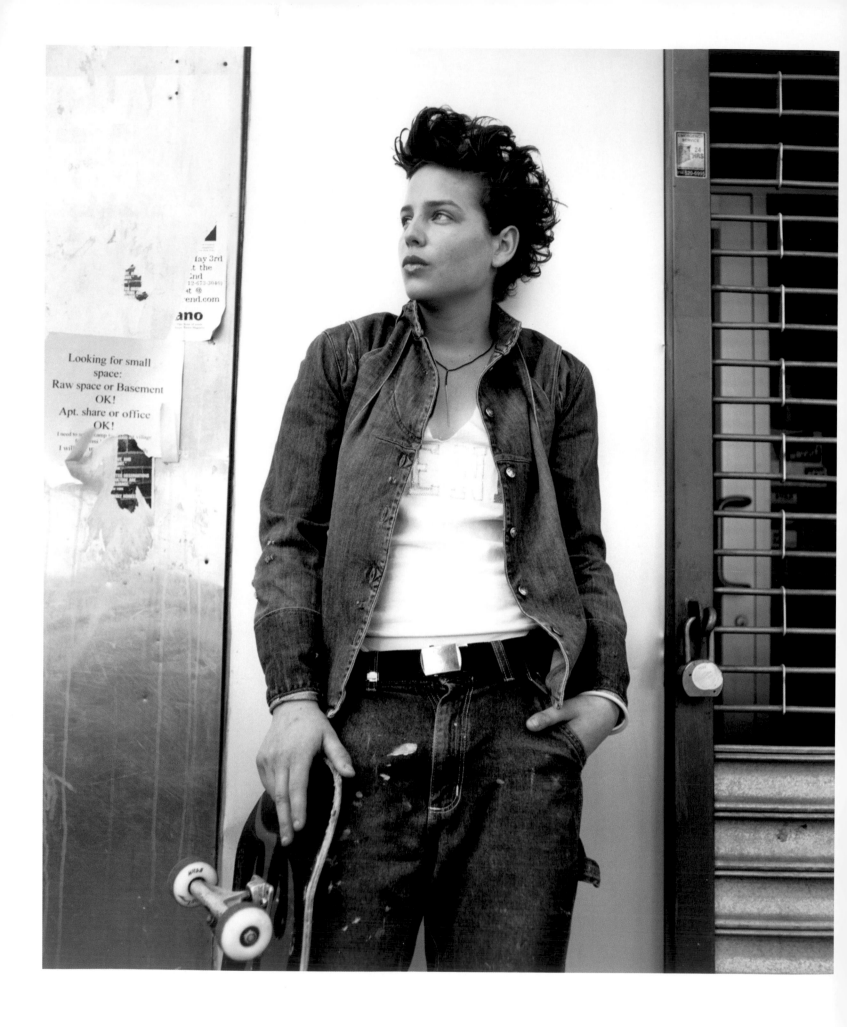

Platon, Chicks on Speed, *Nylon.*

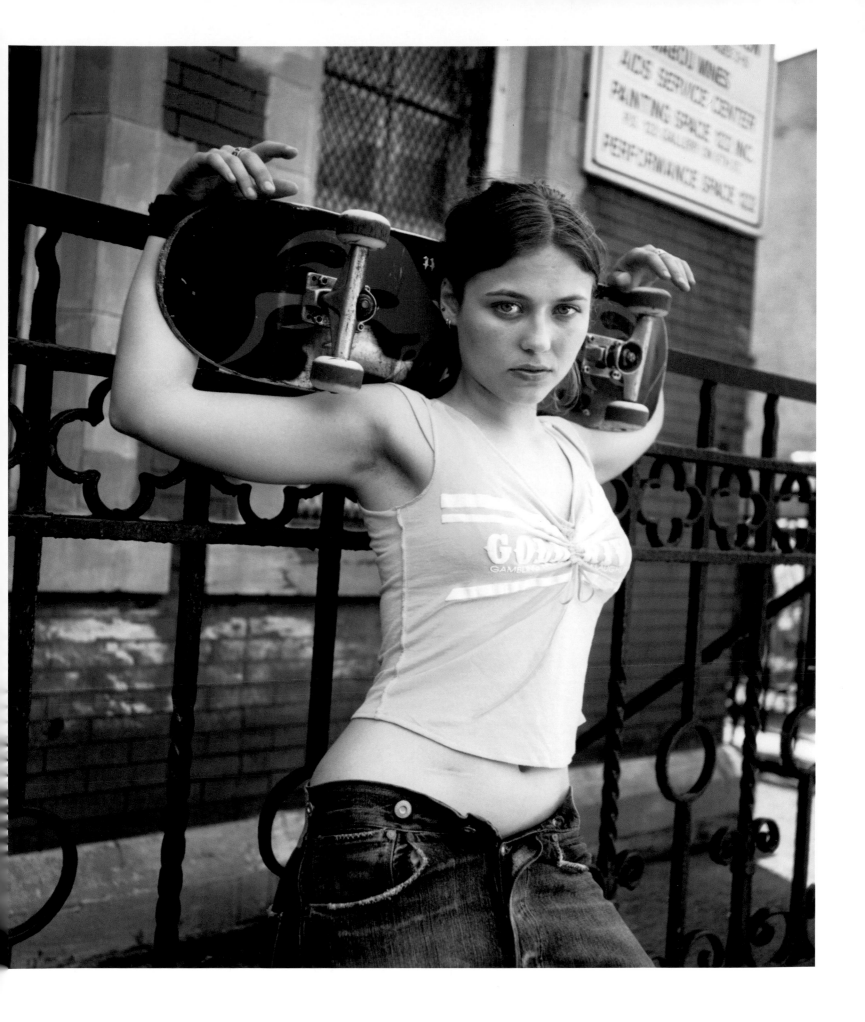

Platon, Chicks on Speed, *Nylon*.

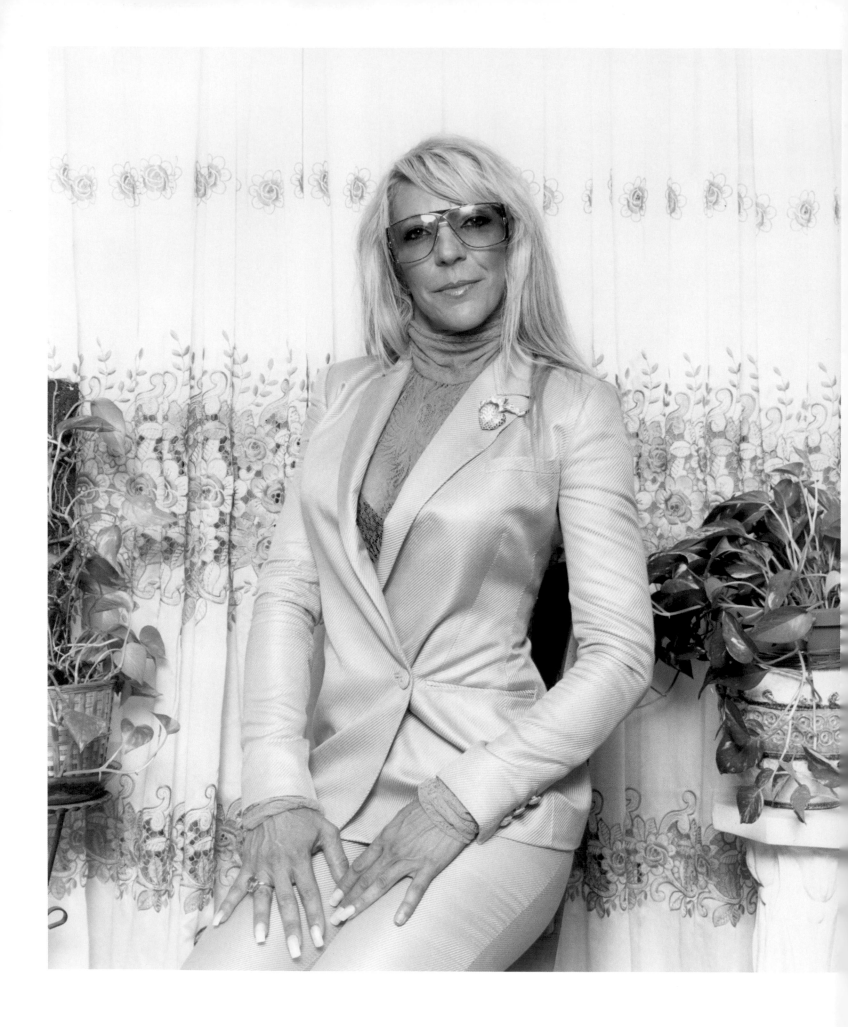

Platon, Good as Gold, *Nylon.*

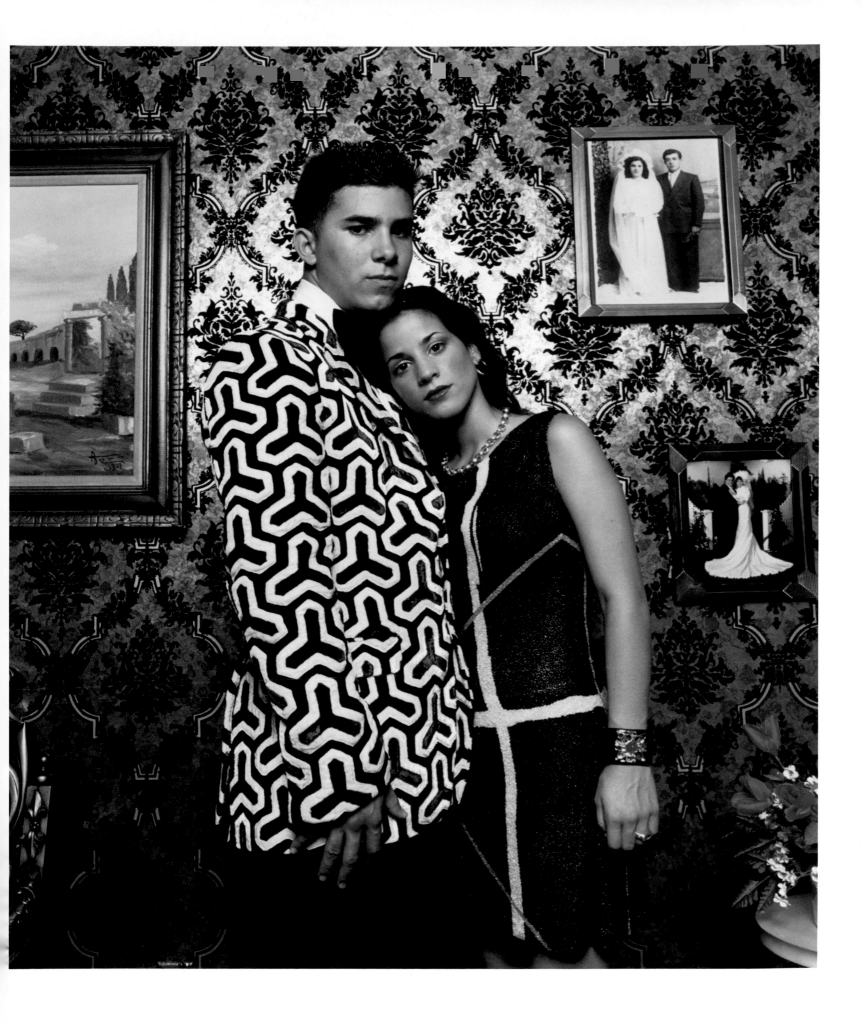

Platon, Good as Gold, *Nylon.*

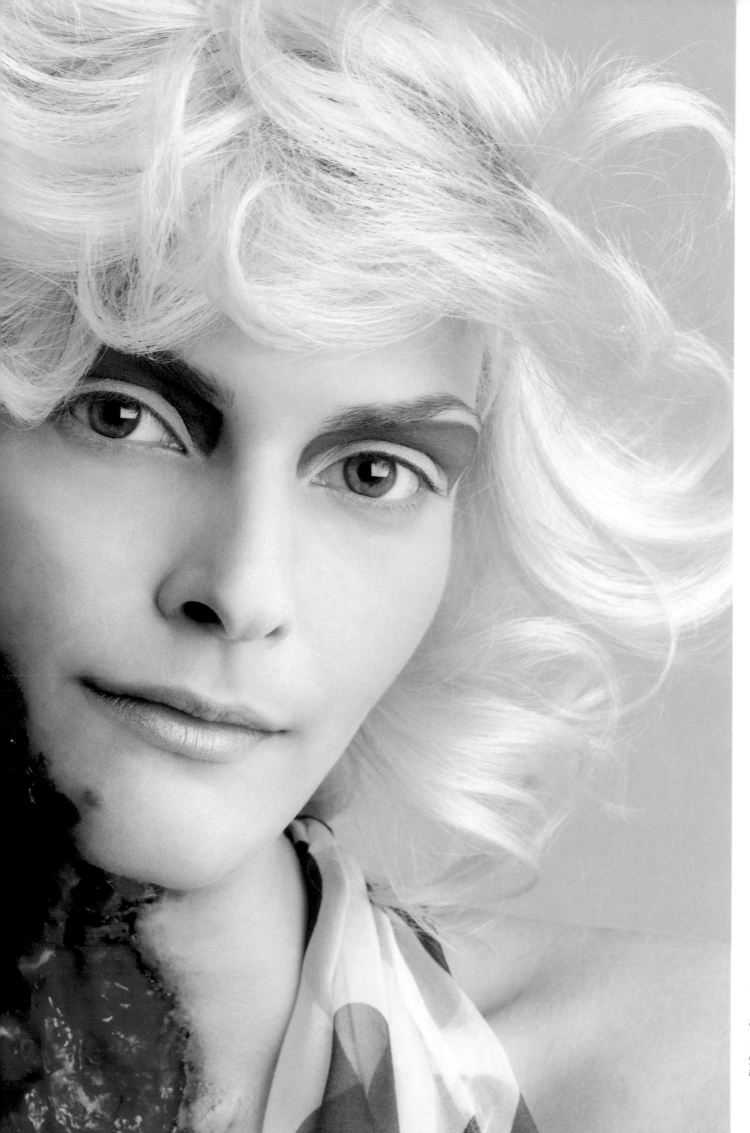

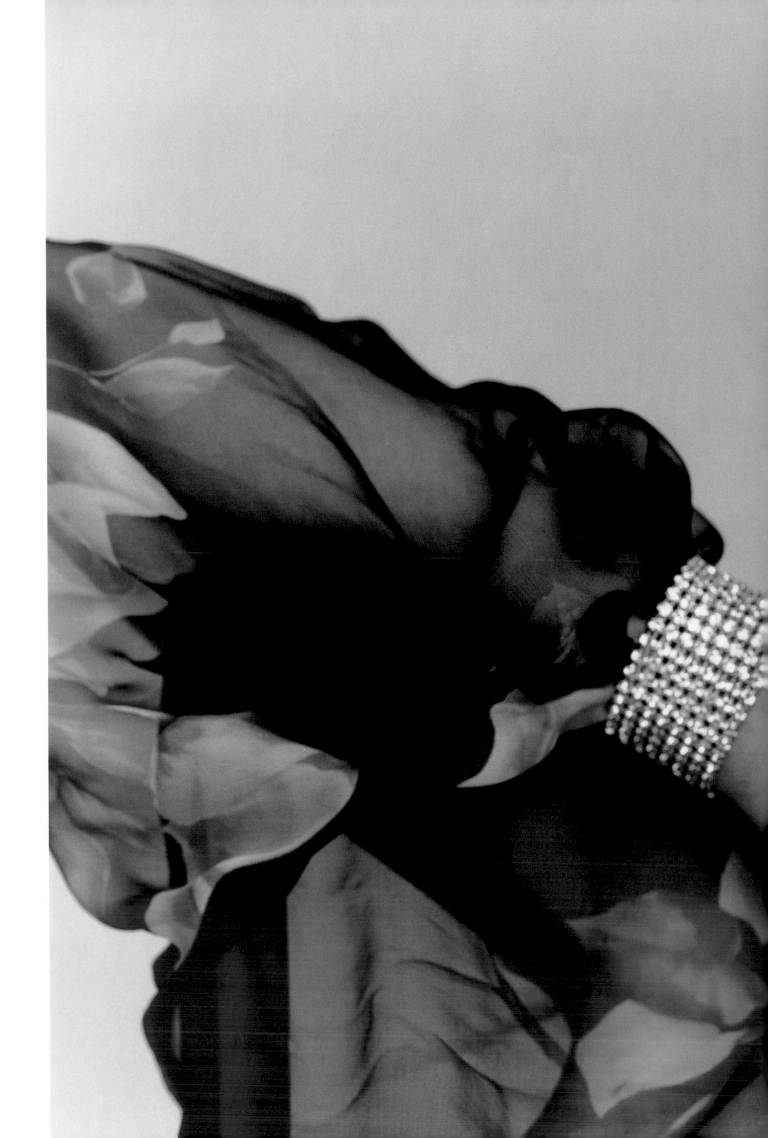

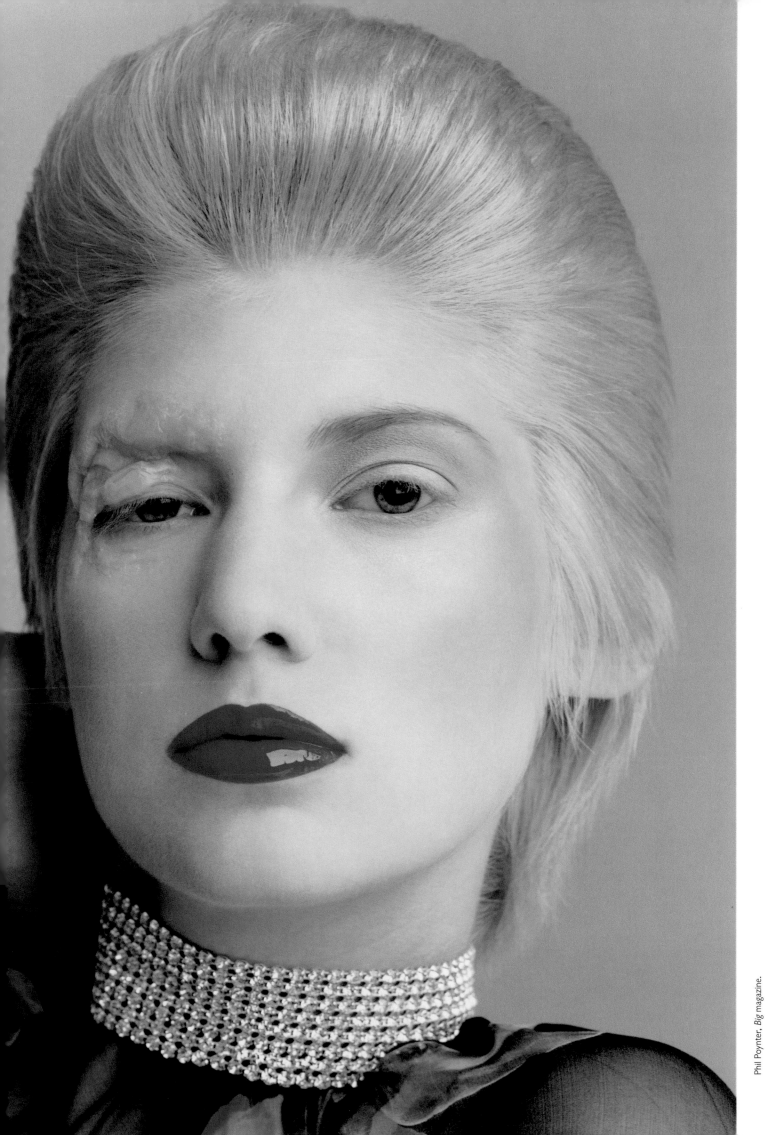

Phil Poynter, *Big* magazine.

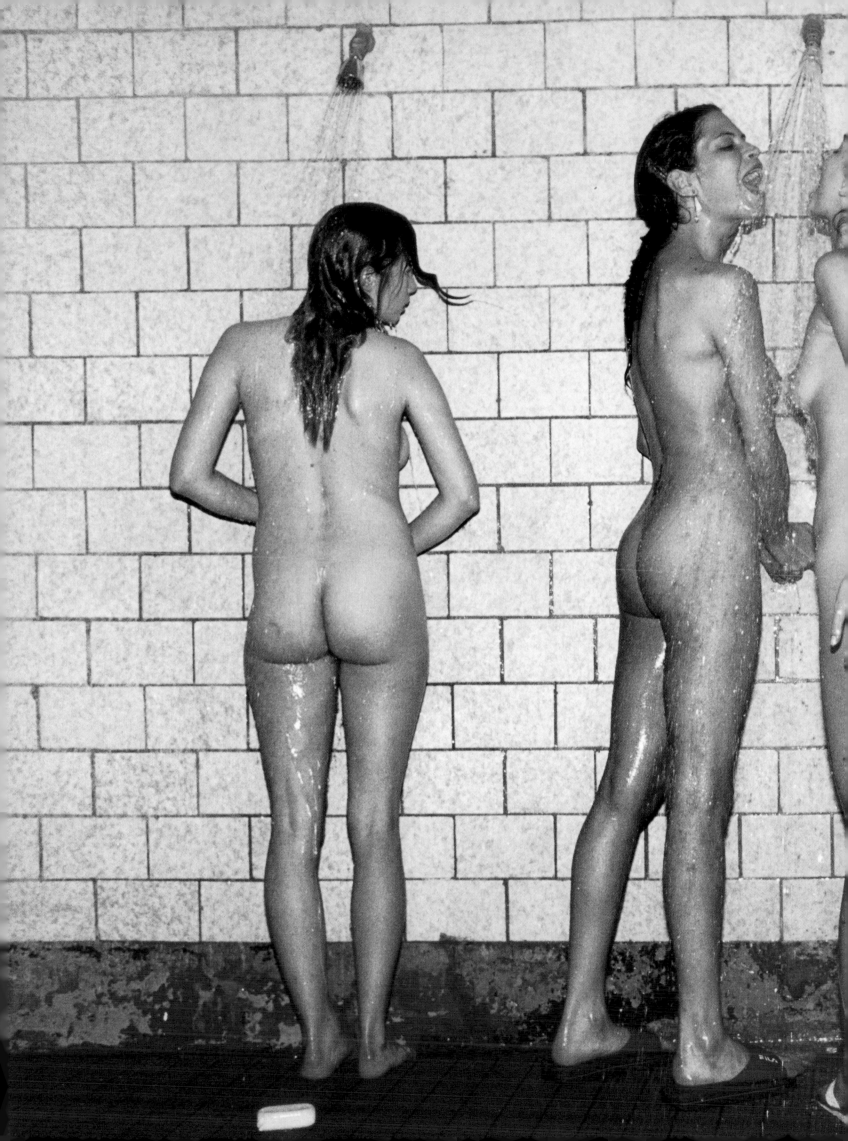

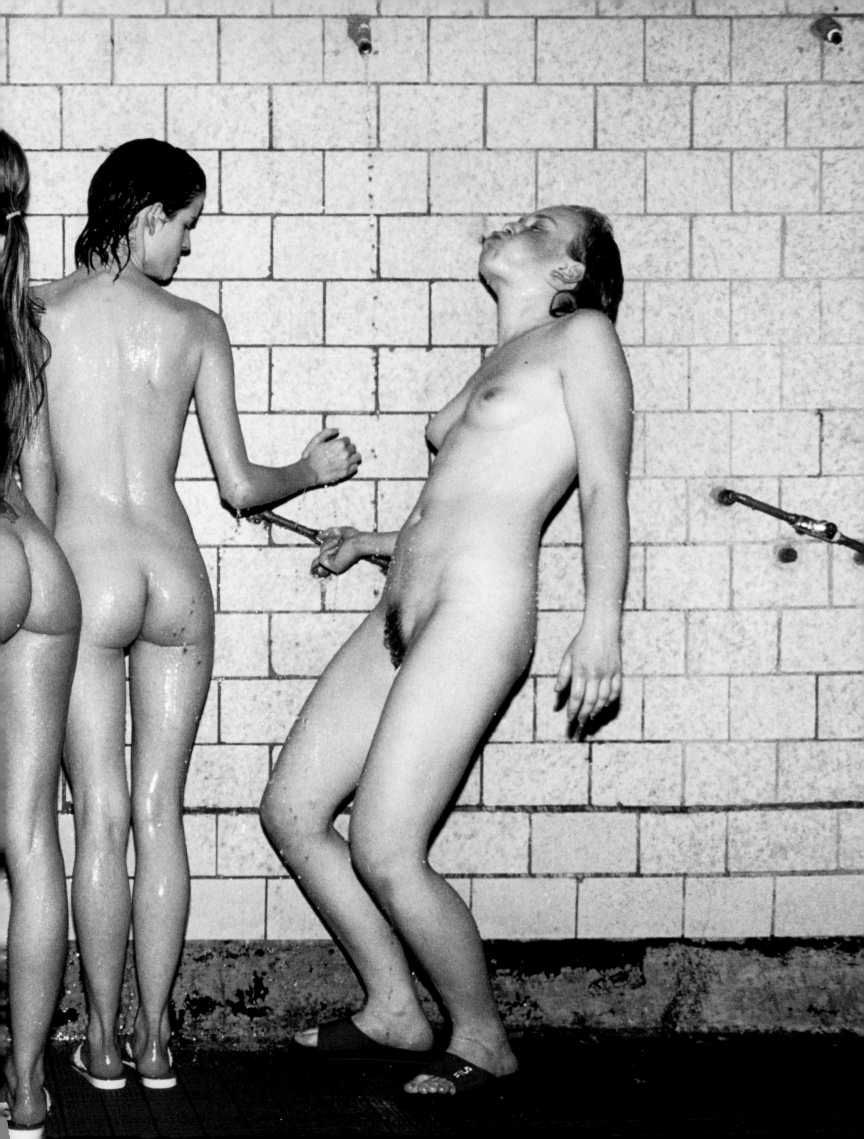

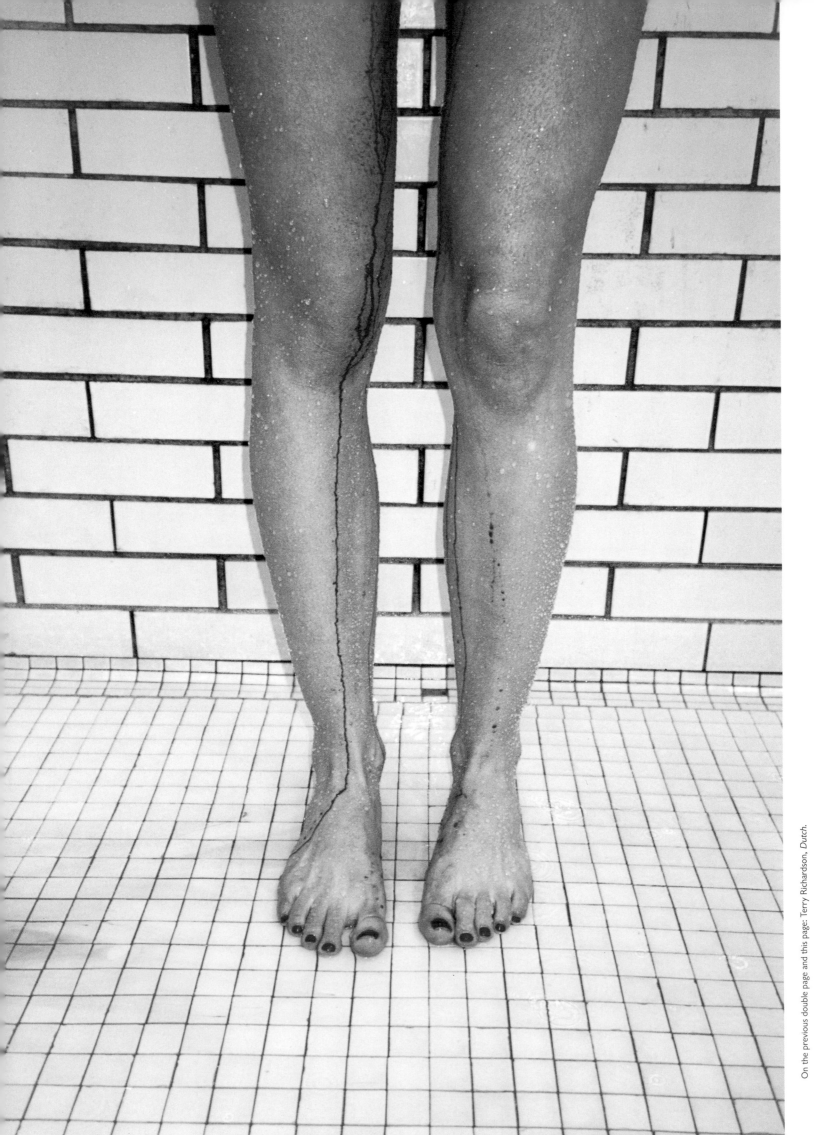

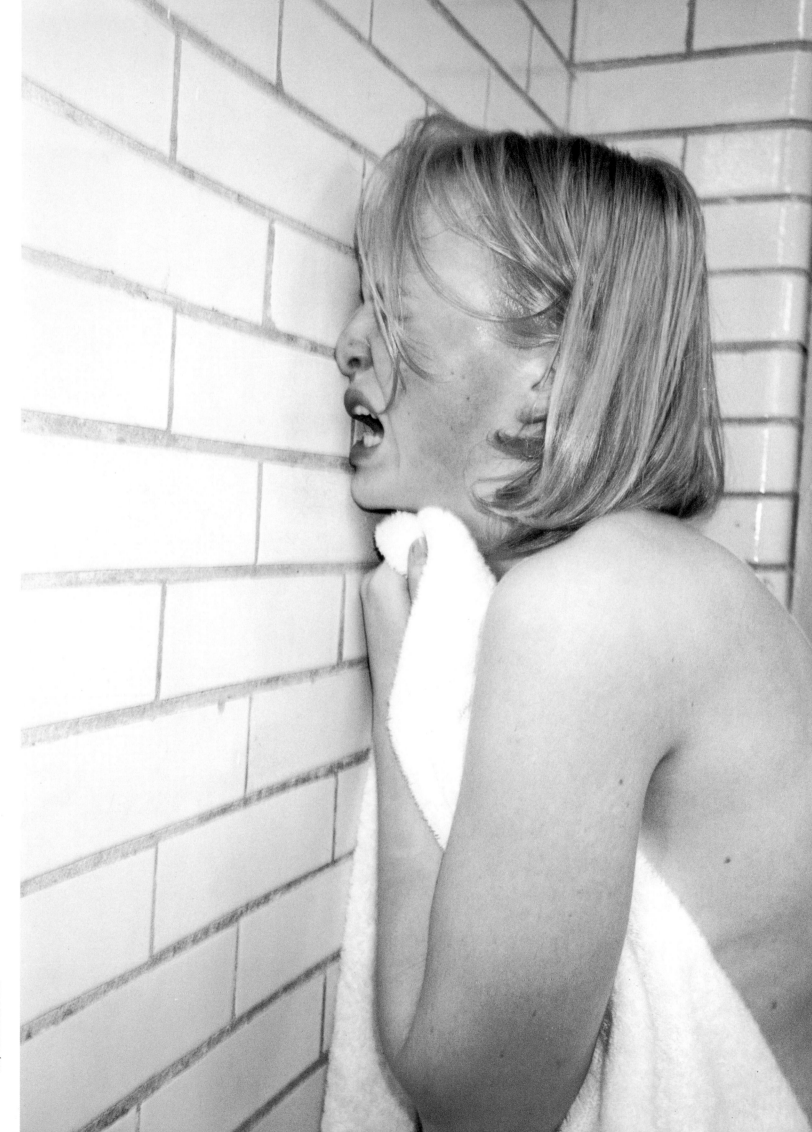

Terry Richardson, *Dutch.*

Christophe Rihet, *Jane.*

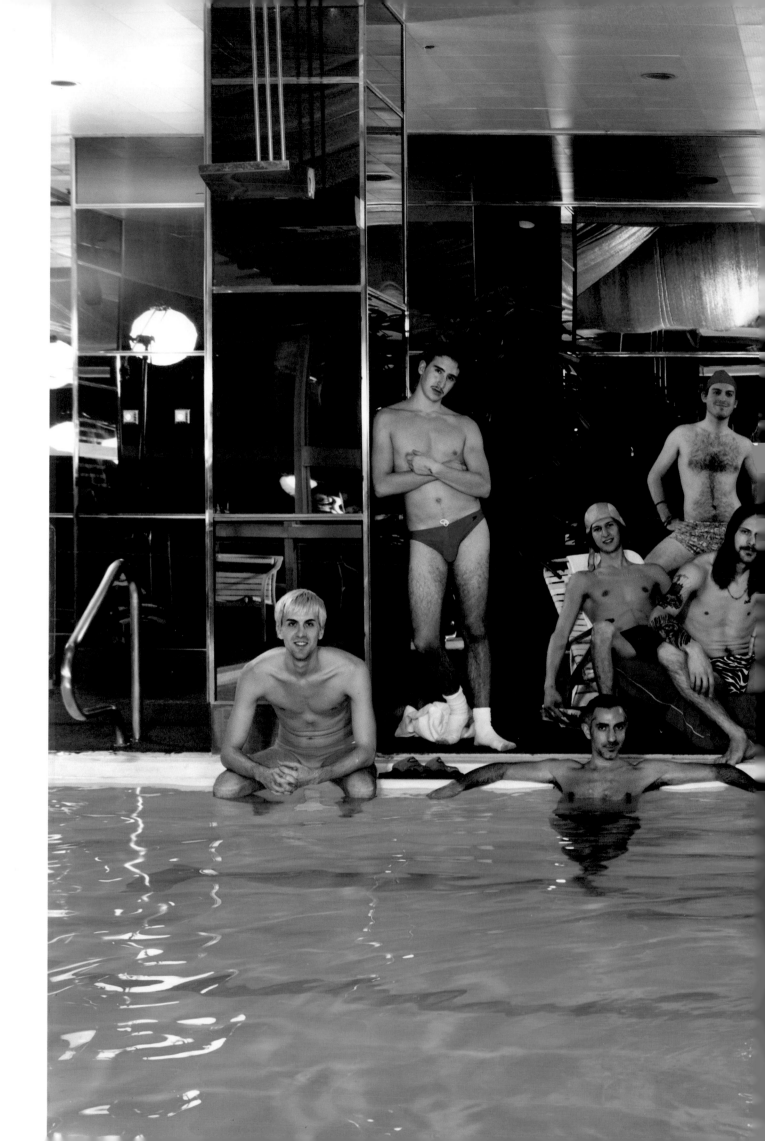

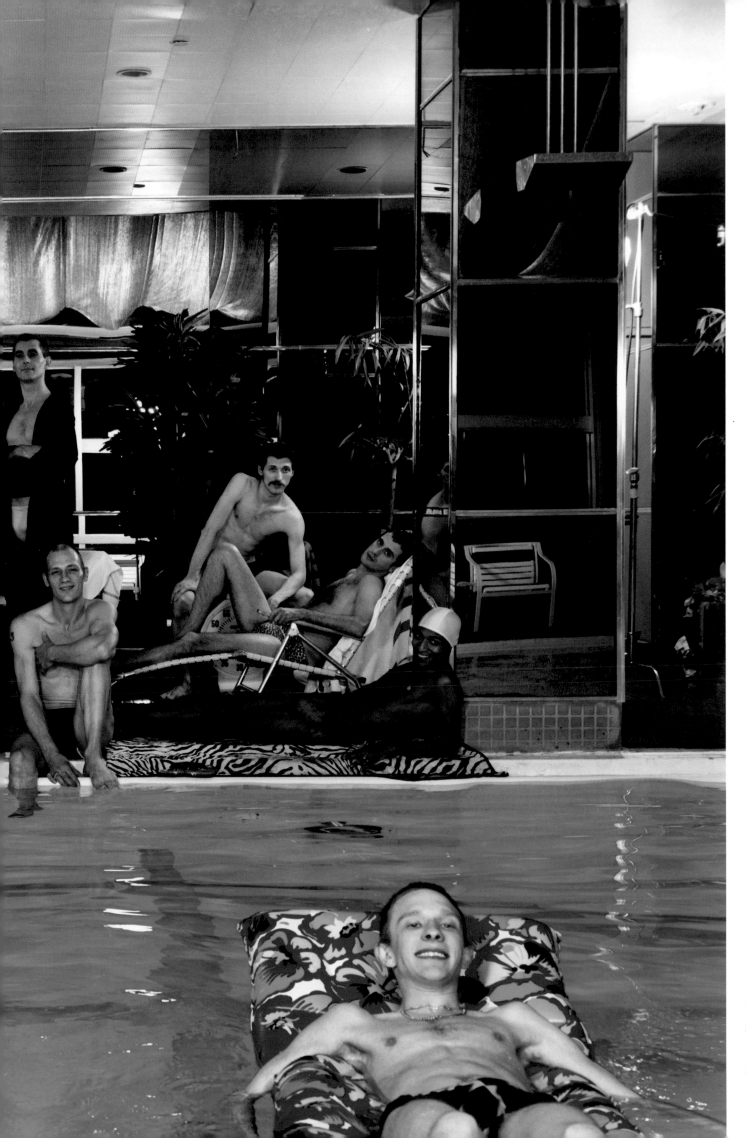

Christophe Rihet, *Jane*.

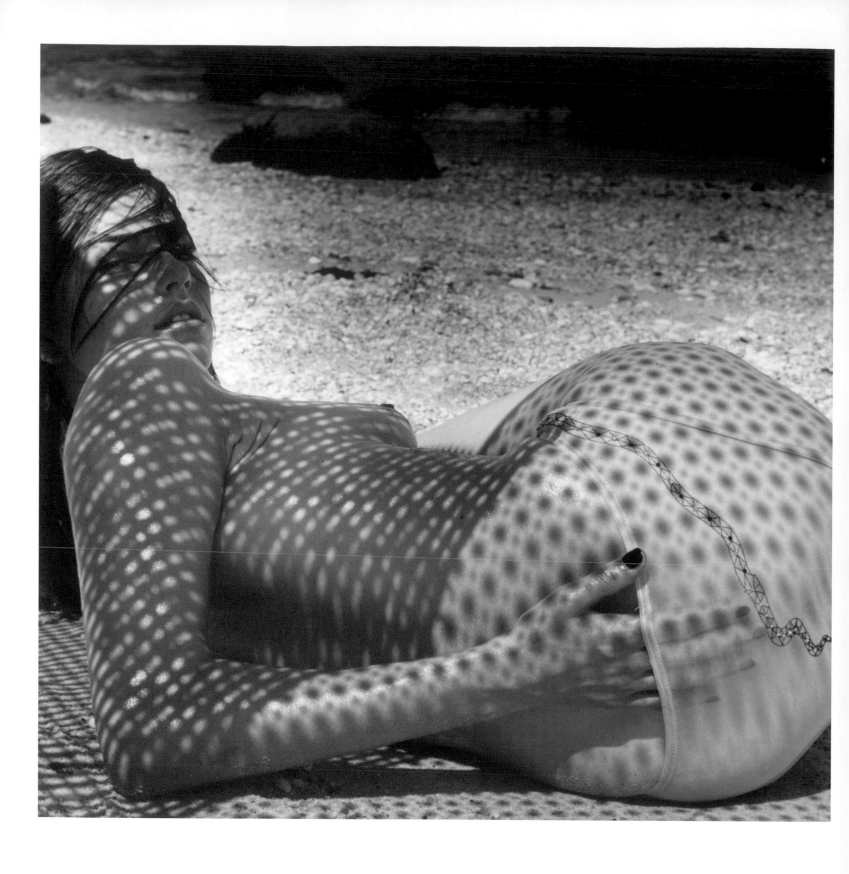

Luis Sanchis, *Pop.*

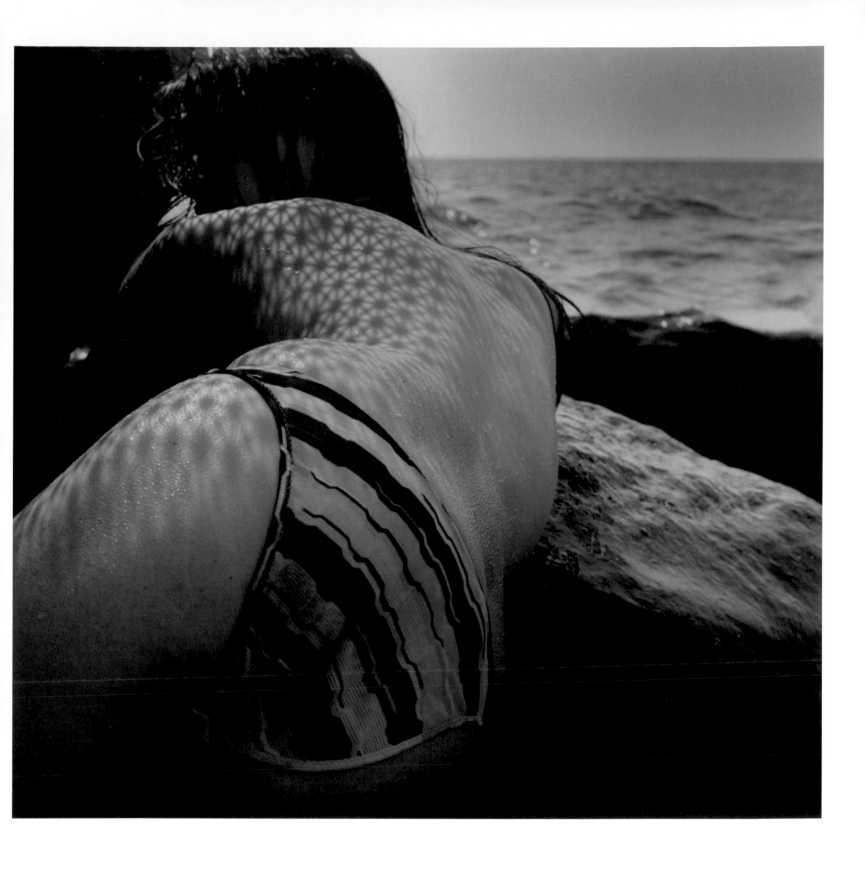

Luis Sanchis, *Pop.*

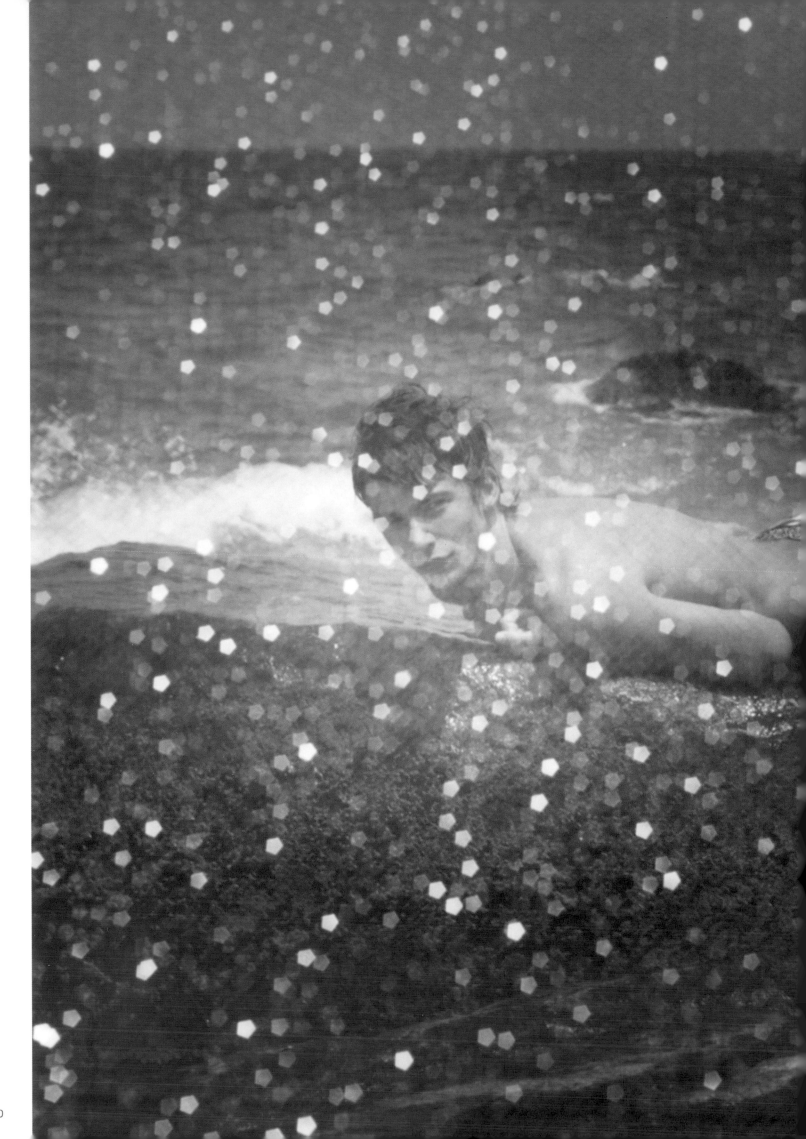

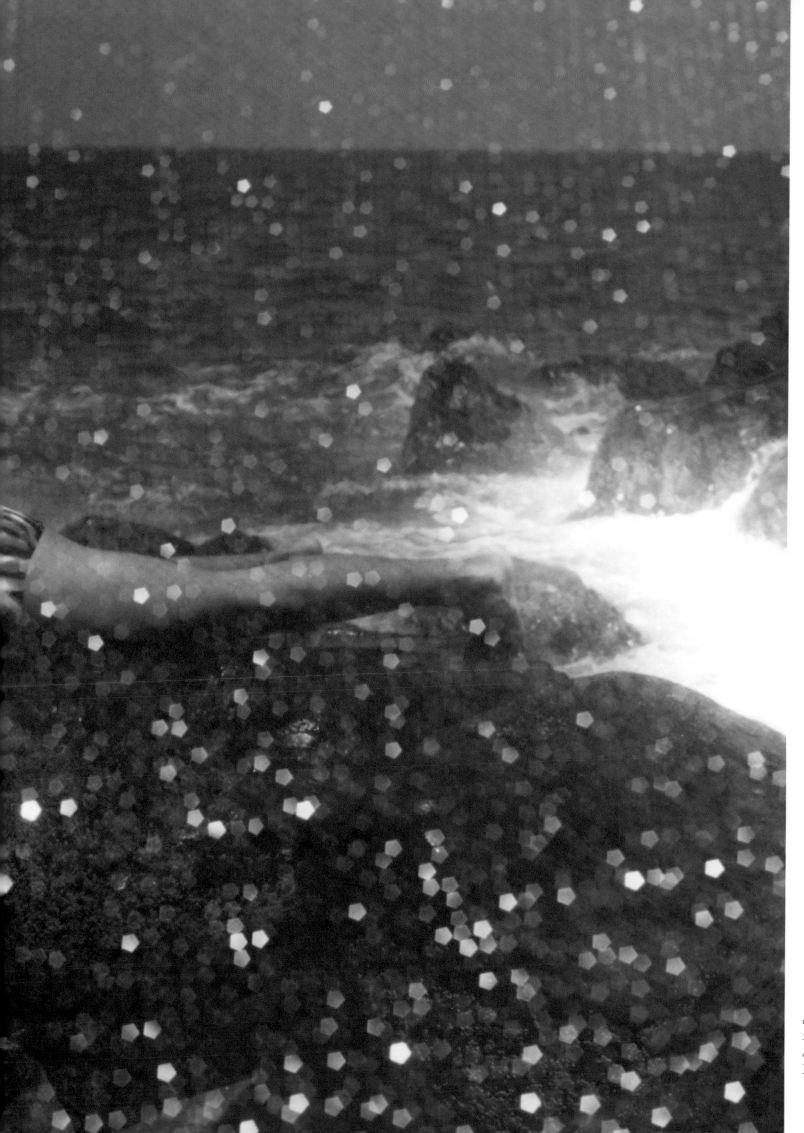

Luis Sanchis, *Pop.*

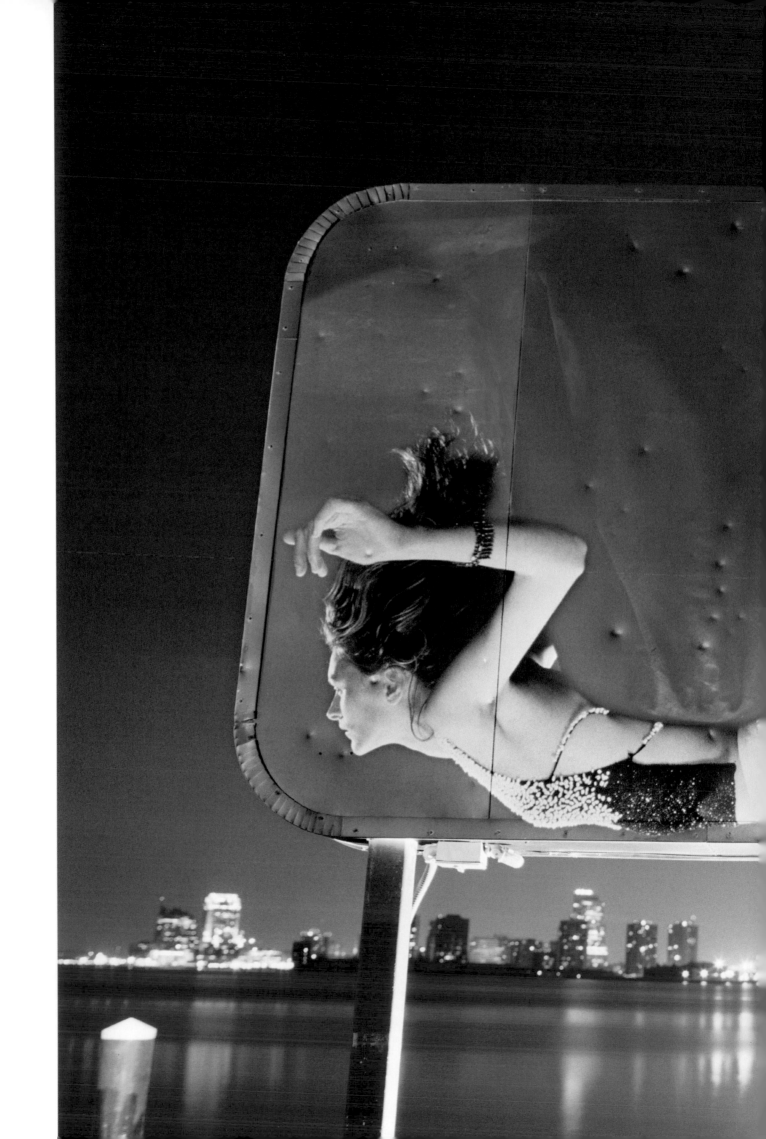

Sinisha, Flying, *Jalouse*.

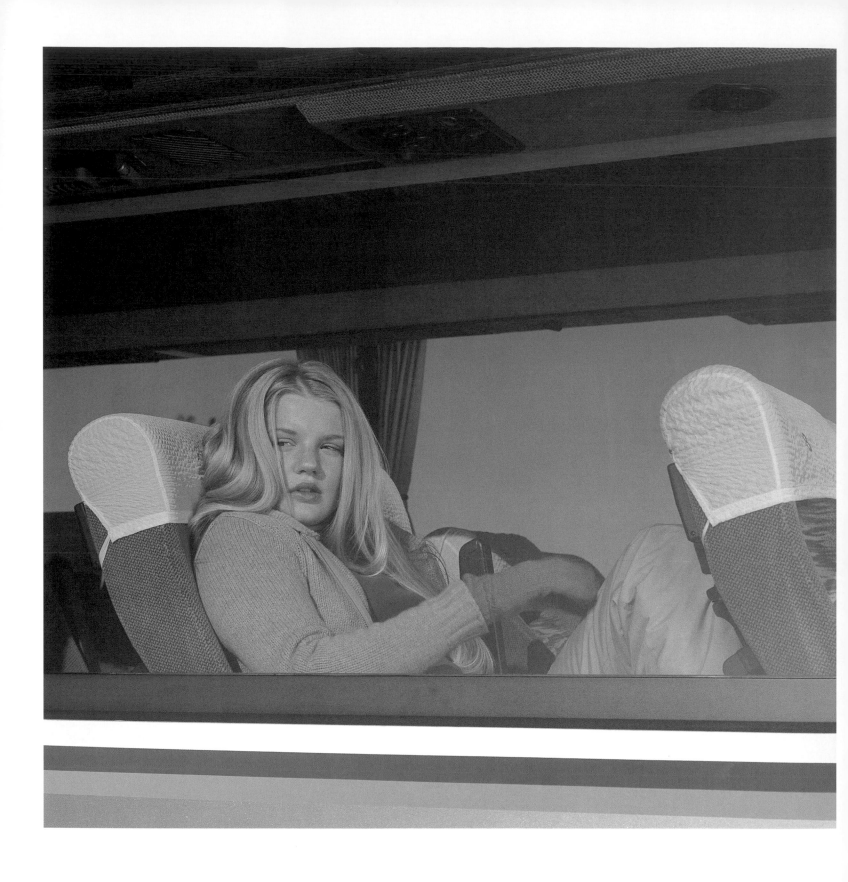

Oliver Spies, *Show* magazine.

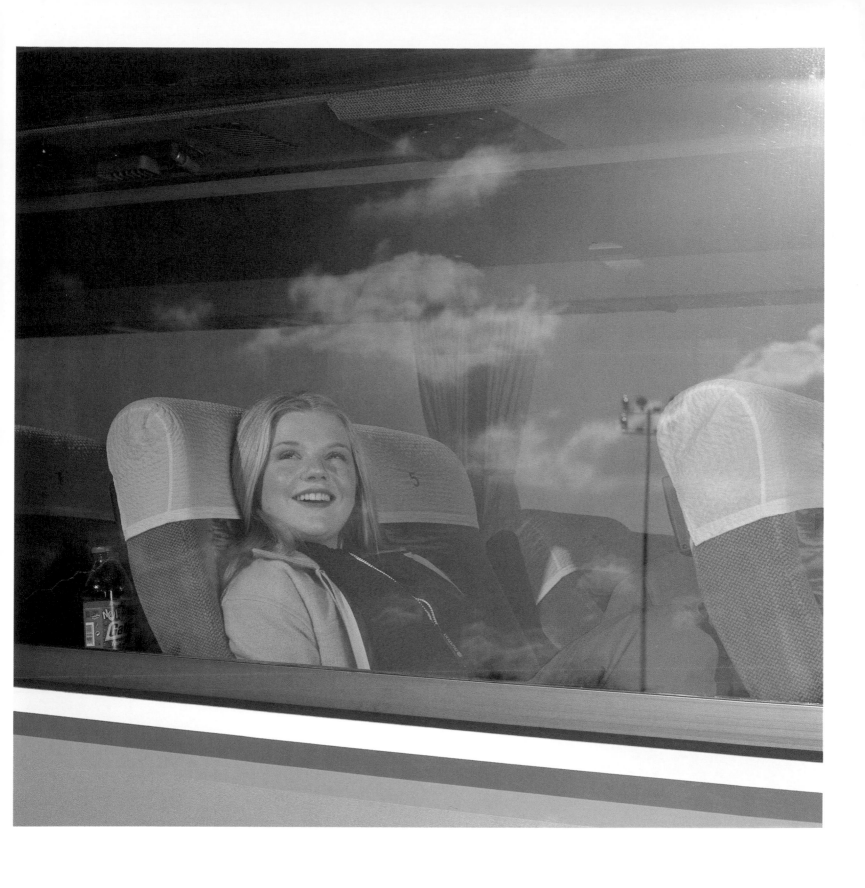

Oliver Spies, *Show* magazine.

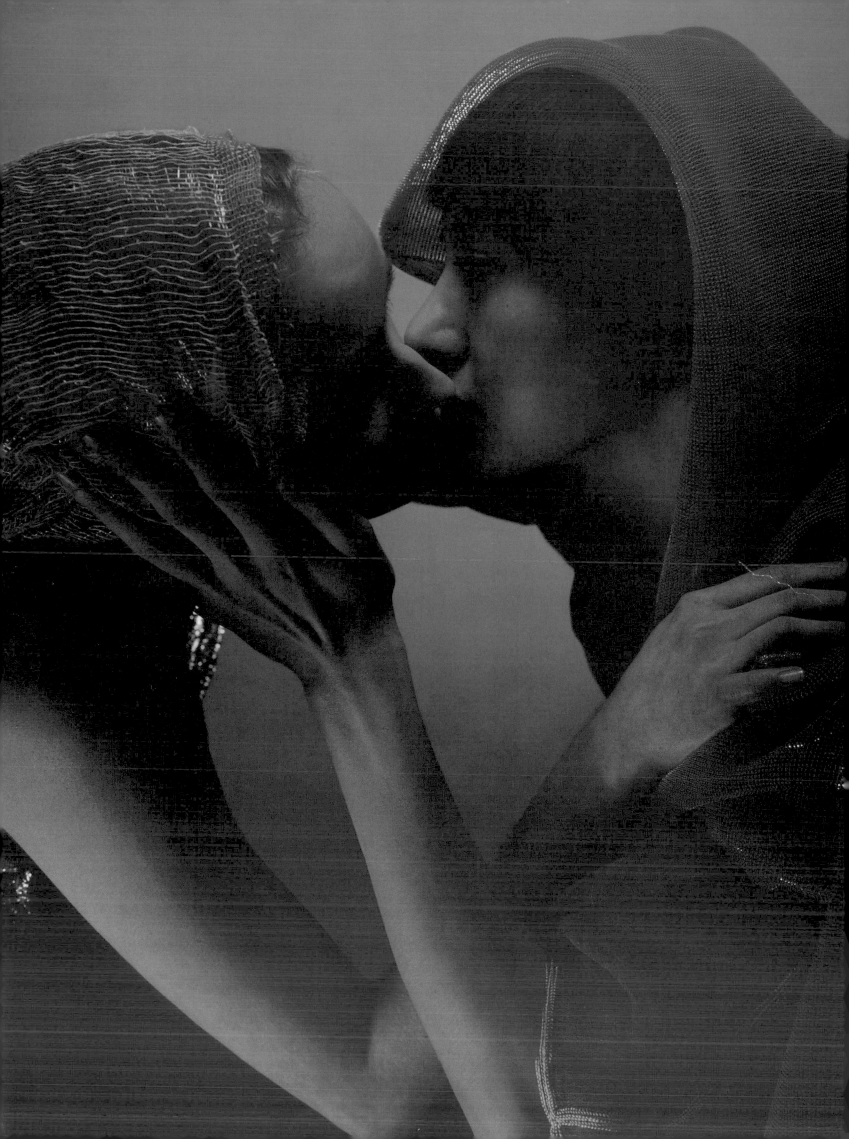

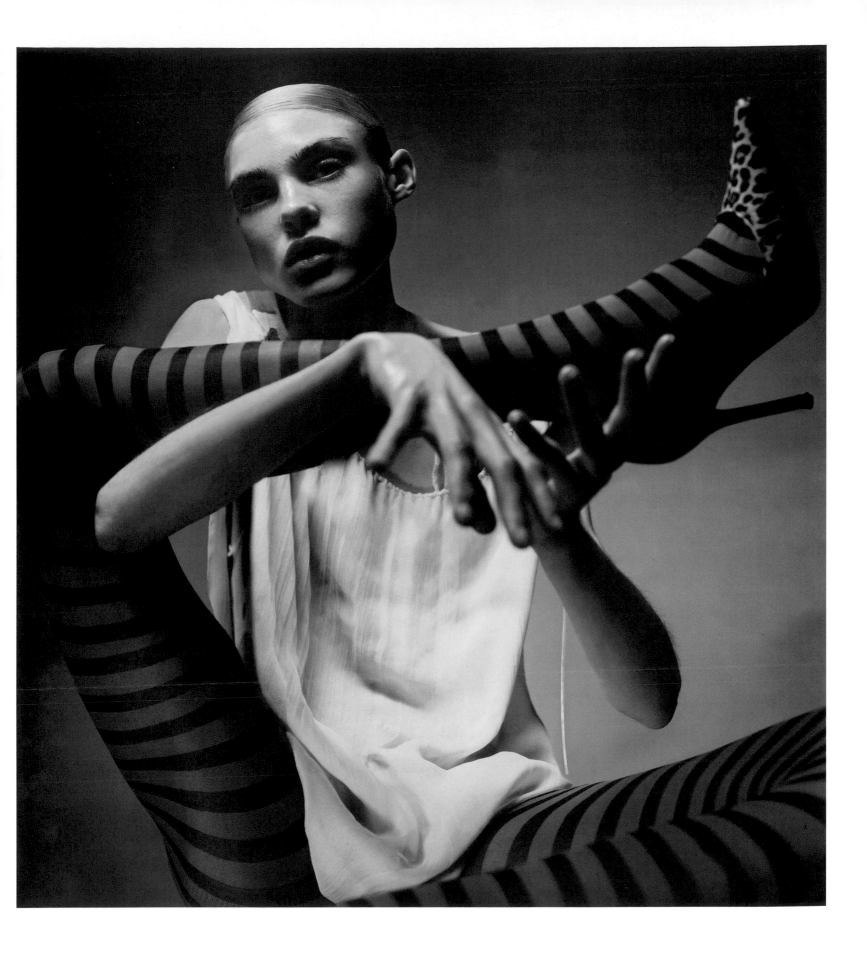

On these pages: Antonio Spinoza, left, Kiss, above, Contours, *Amica*.

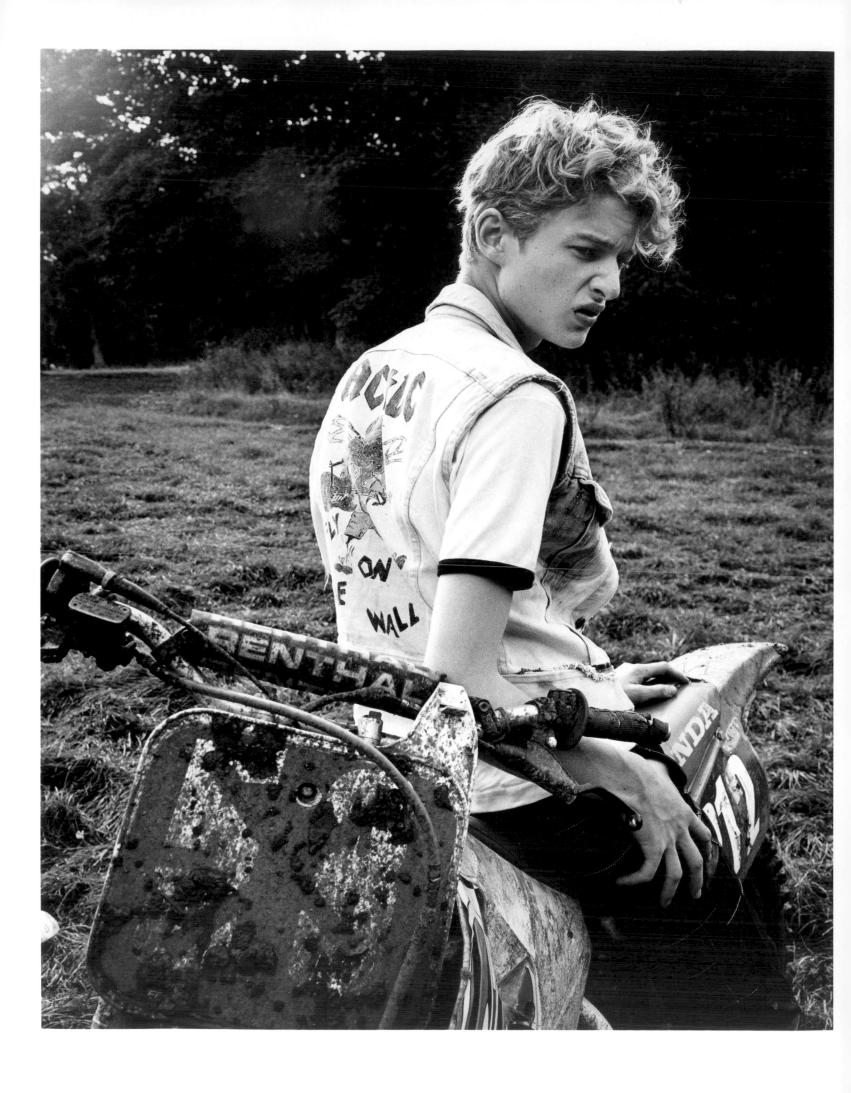

Steen Sundland, Rough Riders, *i-D.*

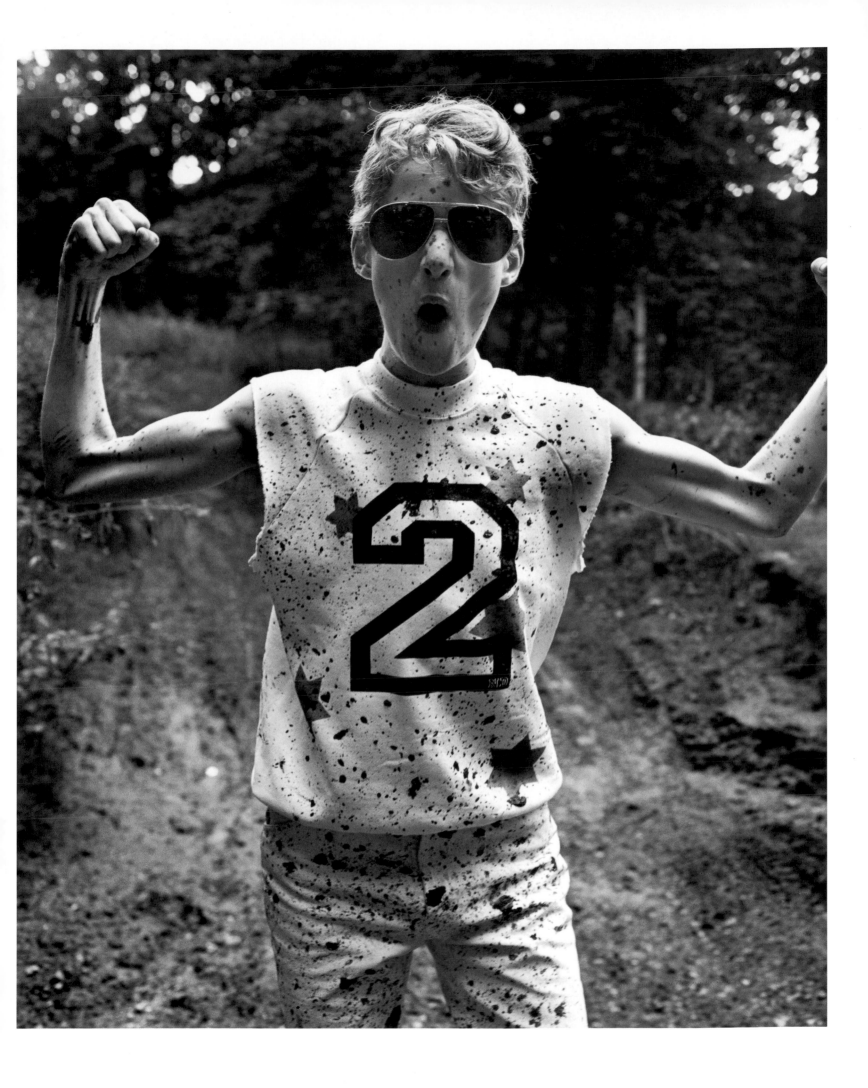

Steen Sundland, Rough Riders, *i-D*.

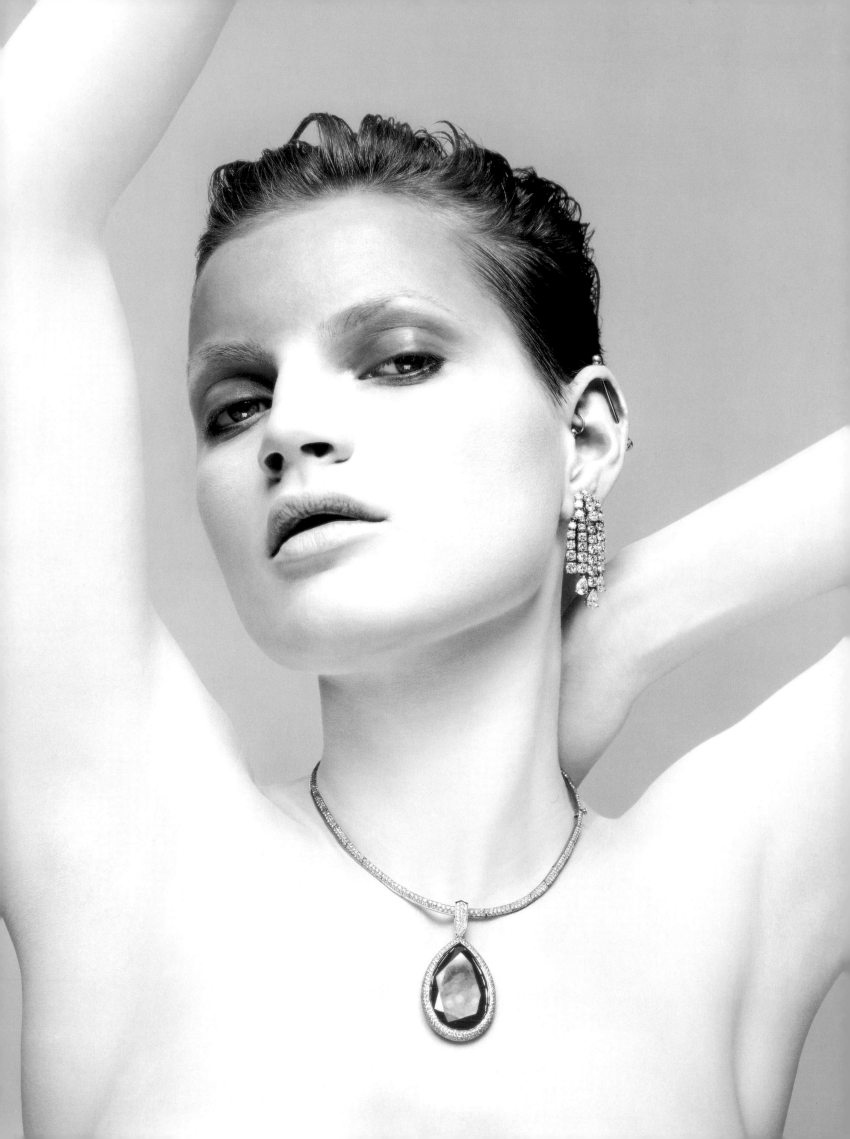

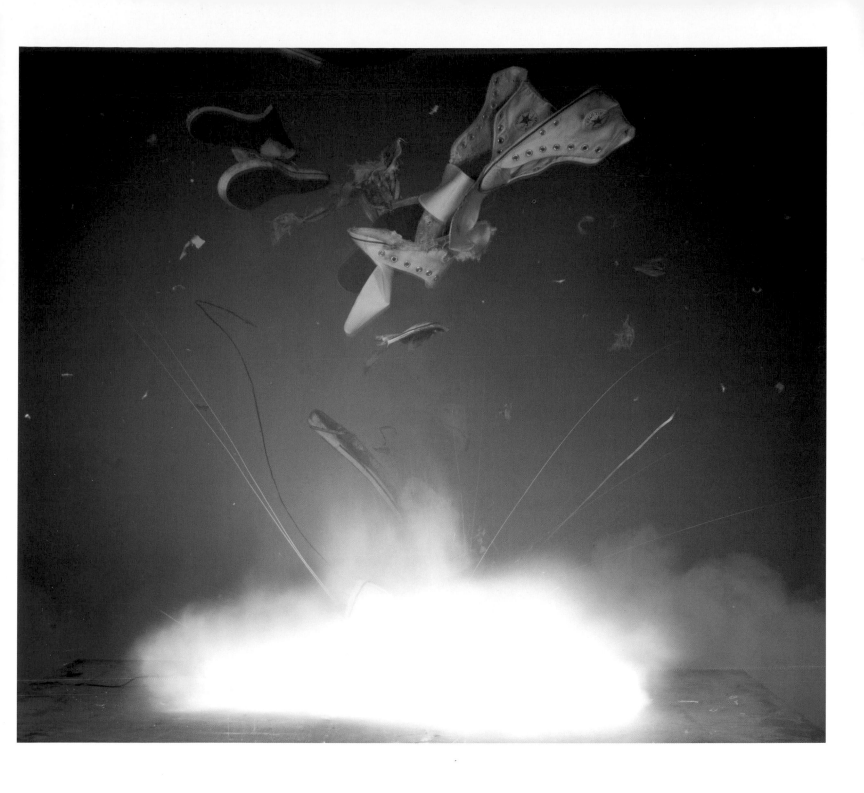

On these pages: Sølve Sundsbø, left, *Guinevere*, unpublished; above, Exploding Converse, *The Face*.

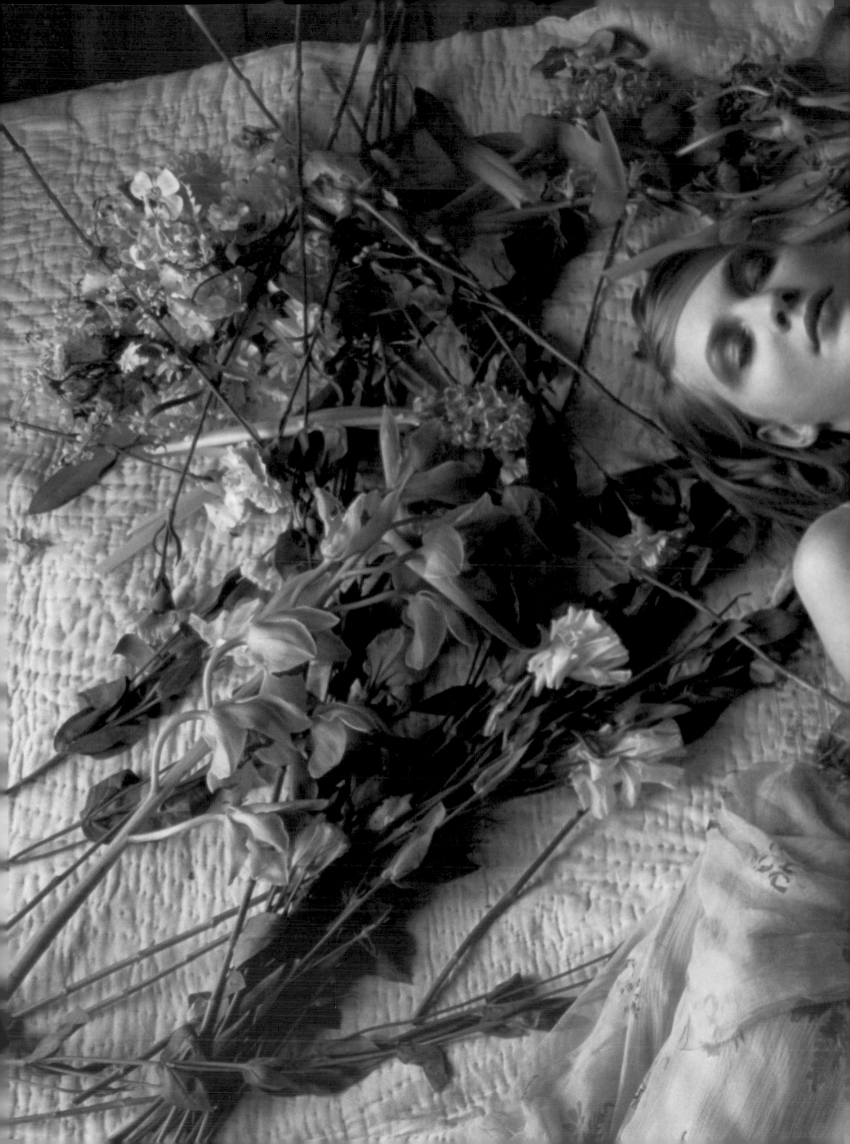

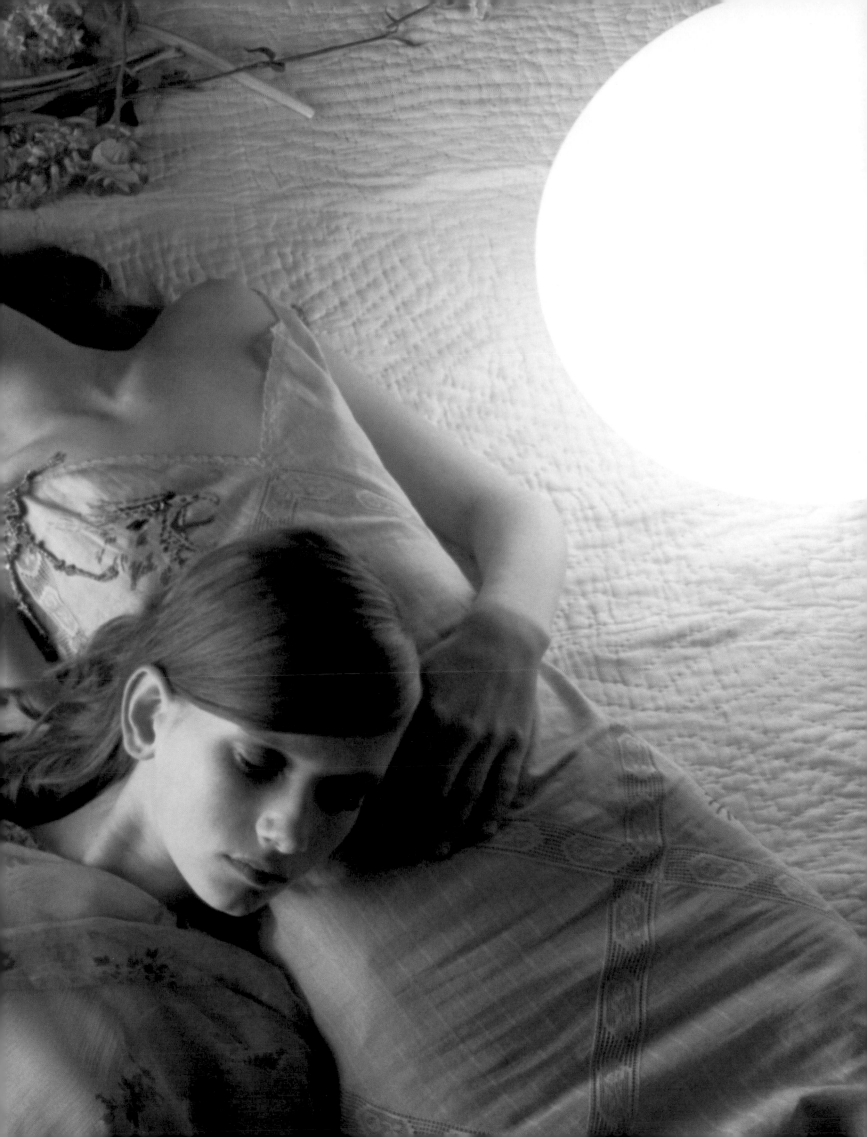

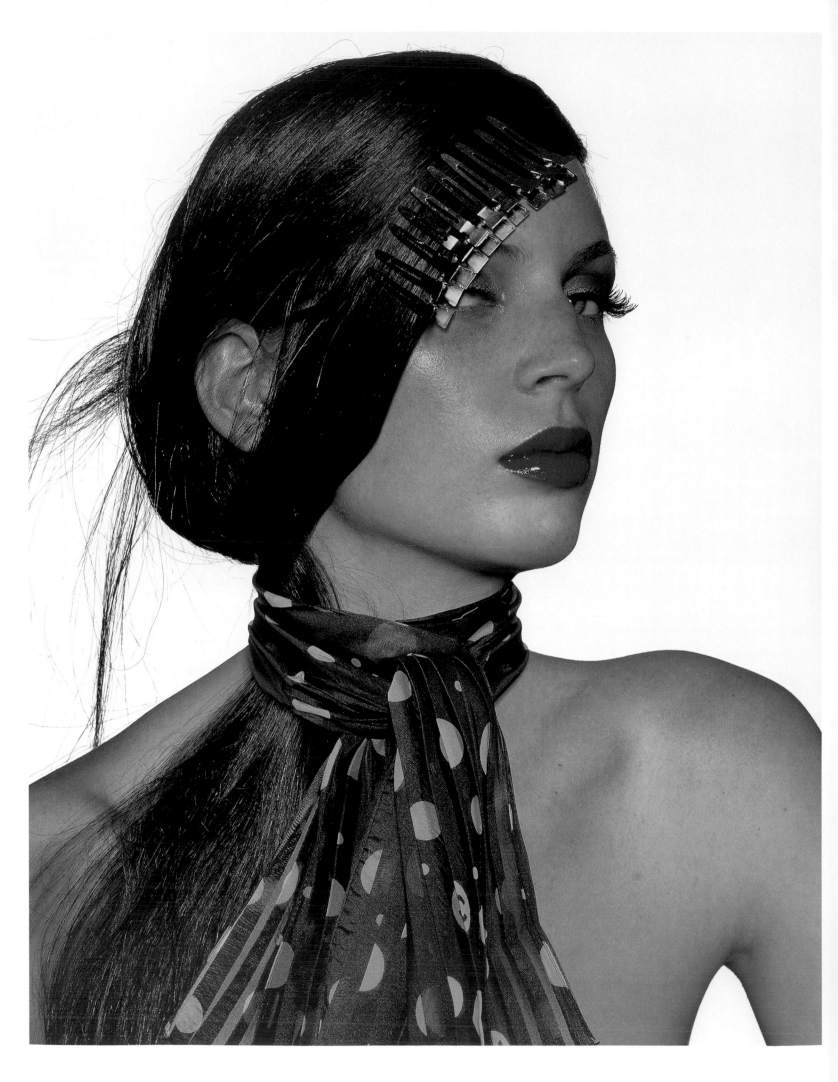

On the previous double page: Mike Thomas, Chintzy Chintzy Cheeriness, *The Face*. On this page: Donna Trope, Fake Fashion, *It* magazine.

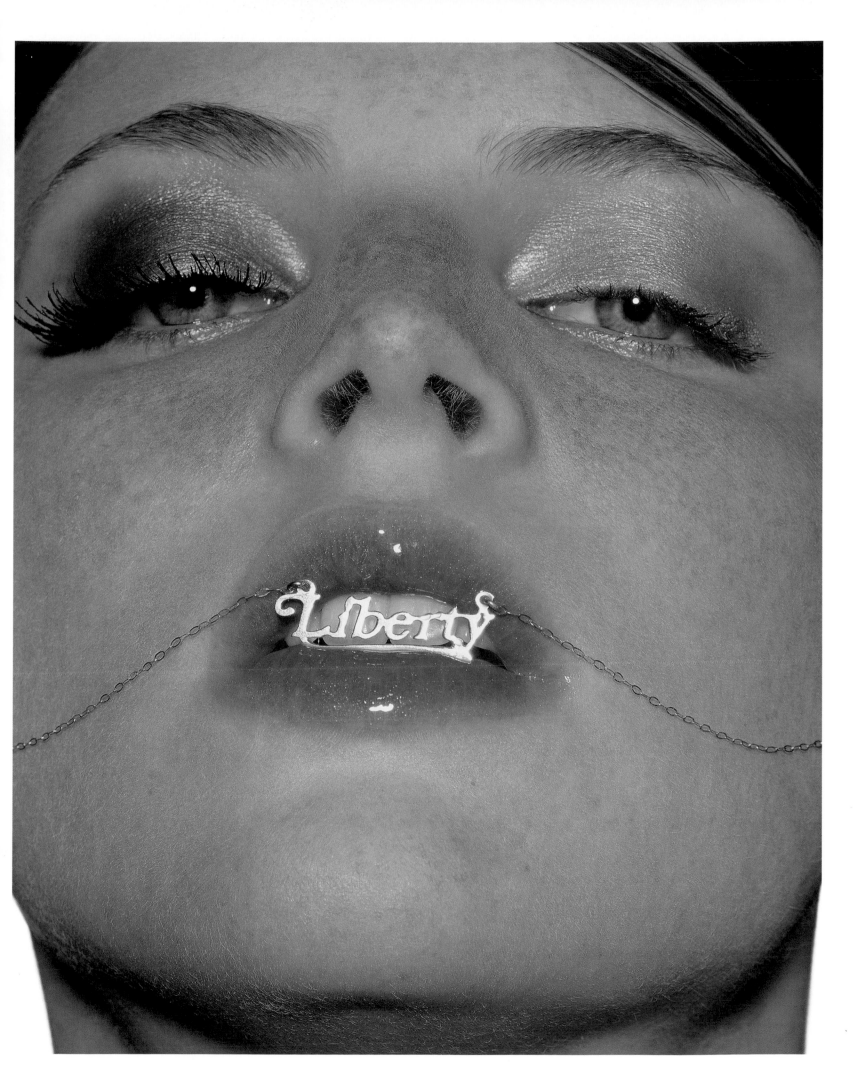

Donna Trope, Liberty in Mouth, *It* magazine.

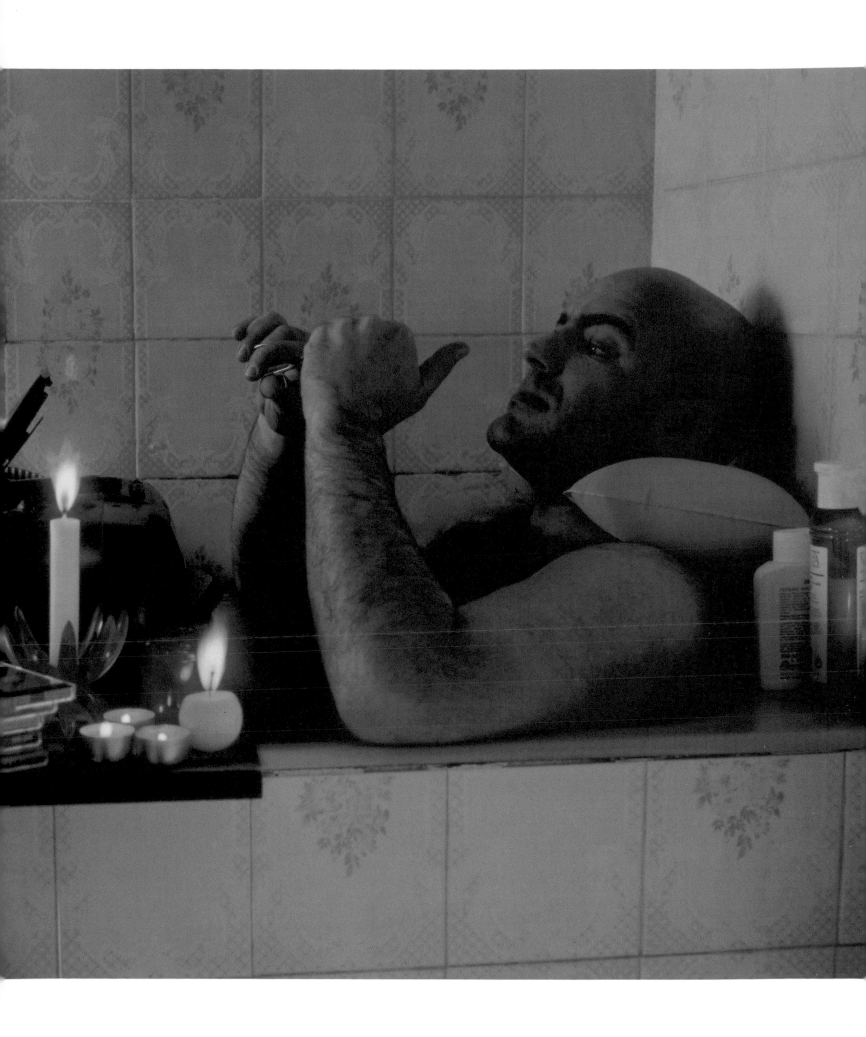

Javier Vallhonrat, *Big* magazine.

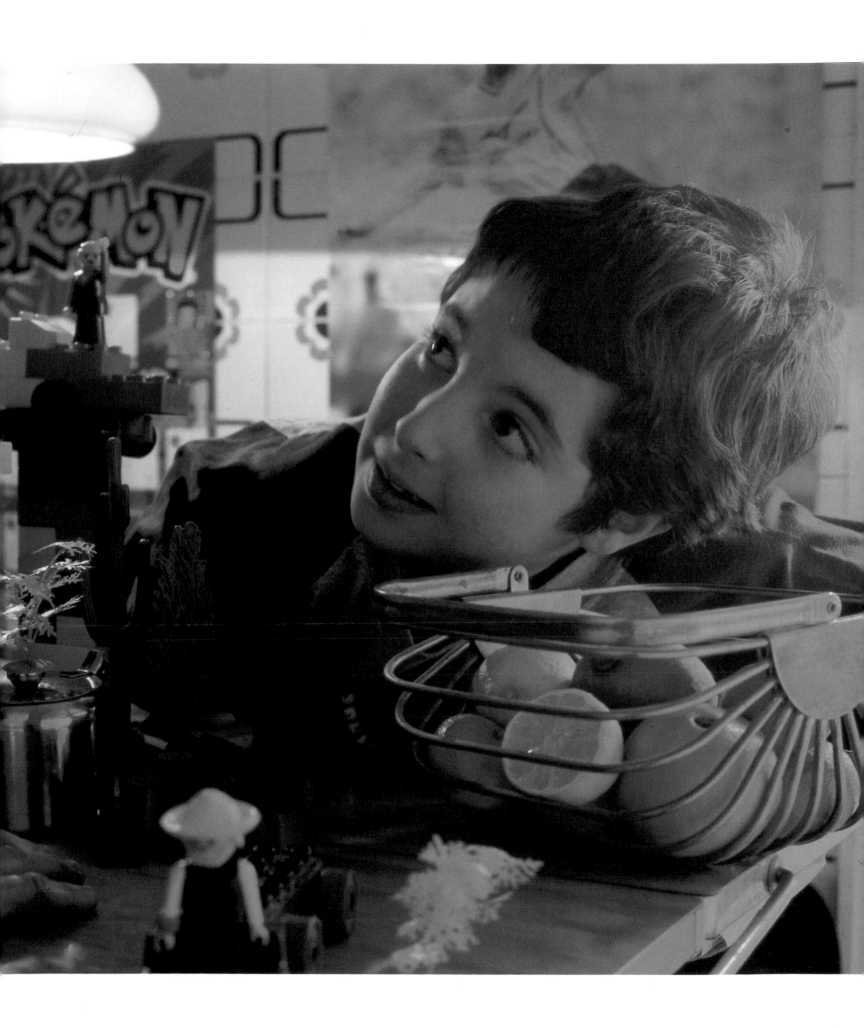

Javier Vallhonrat, *Big* magazine.

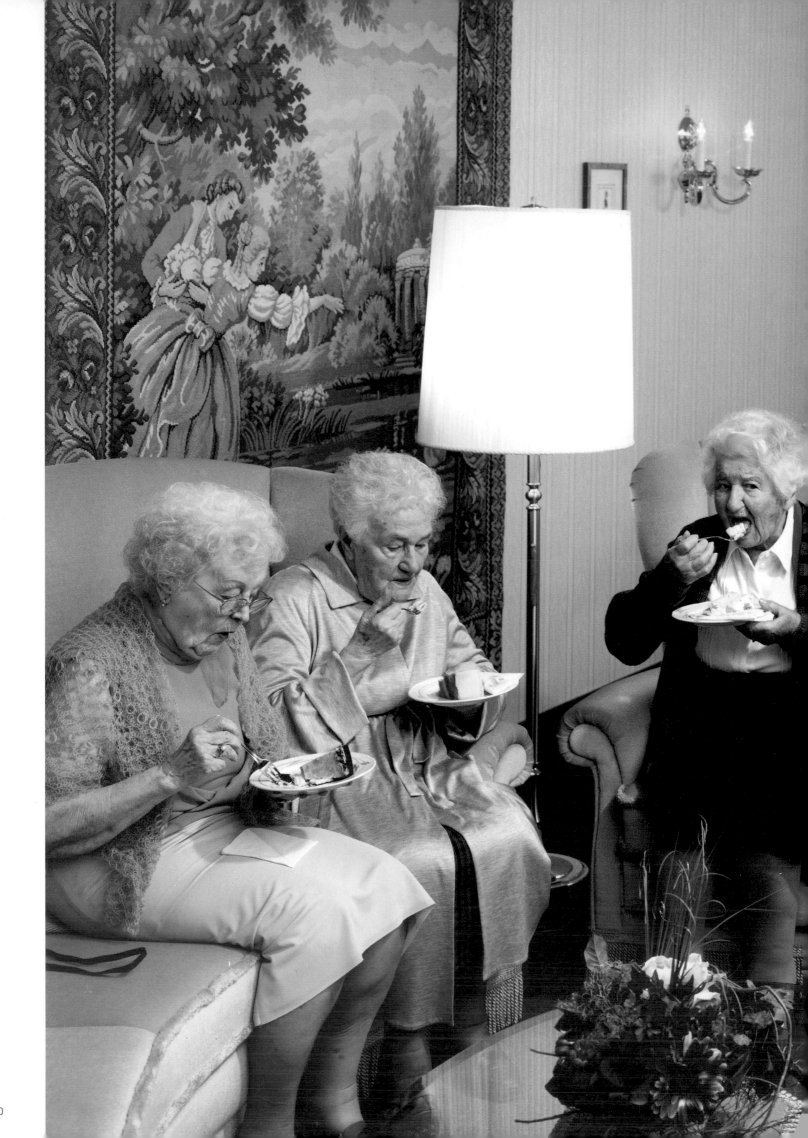

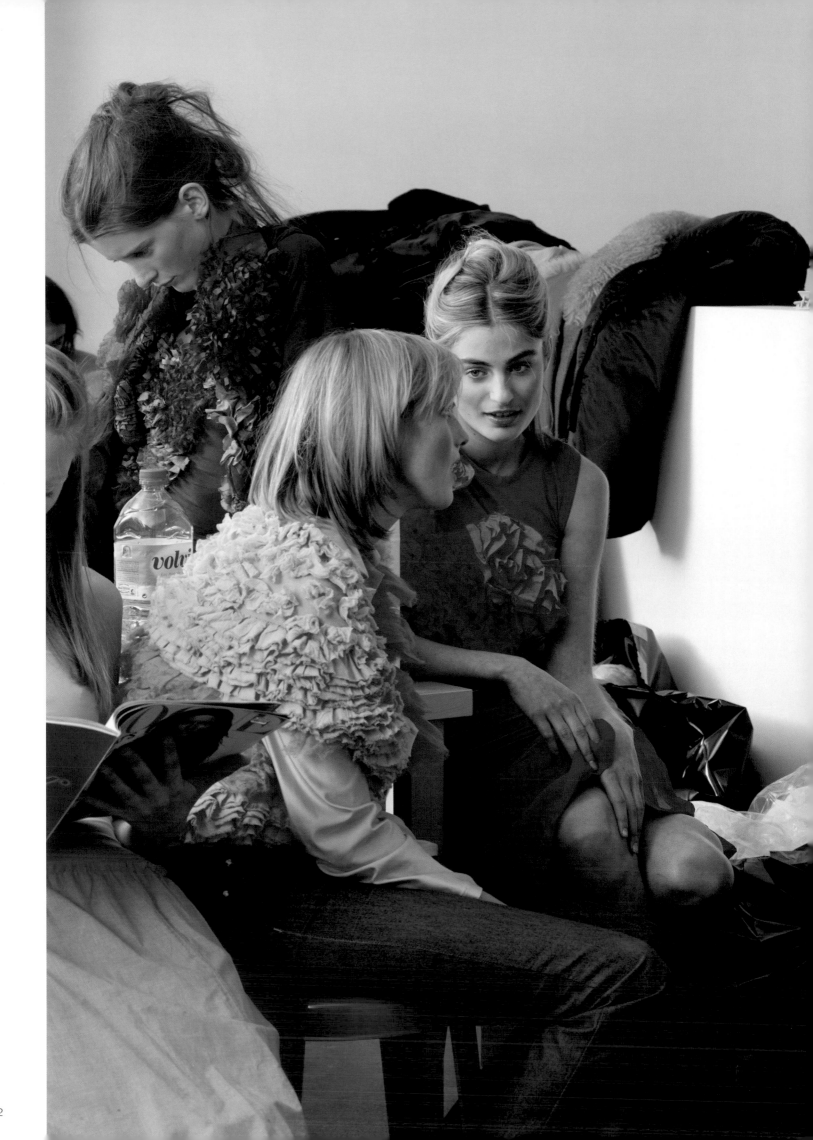

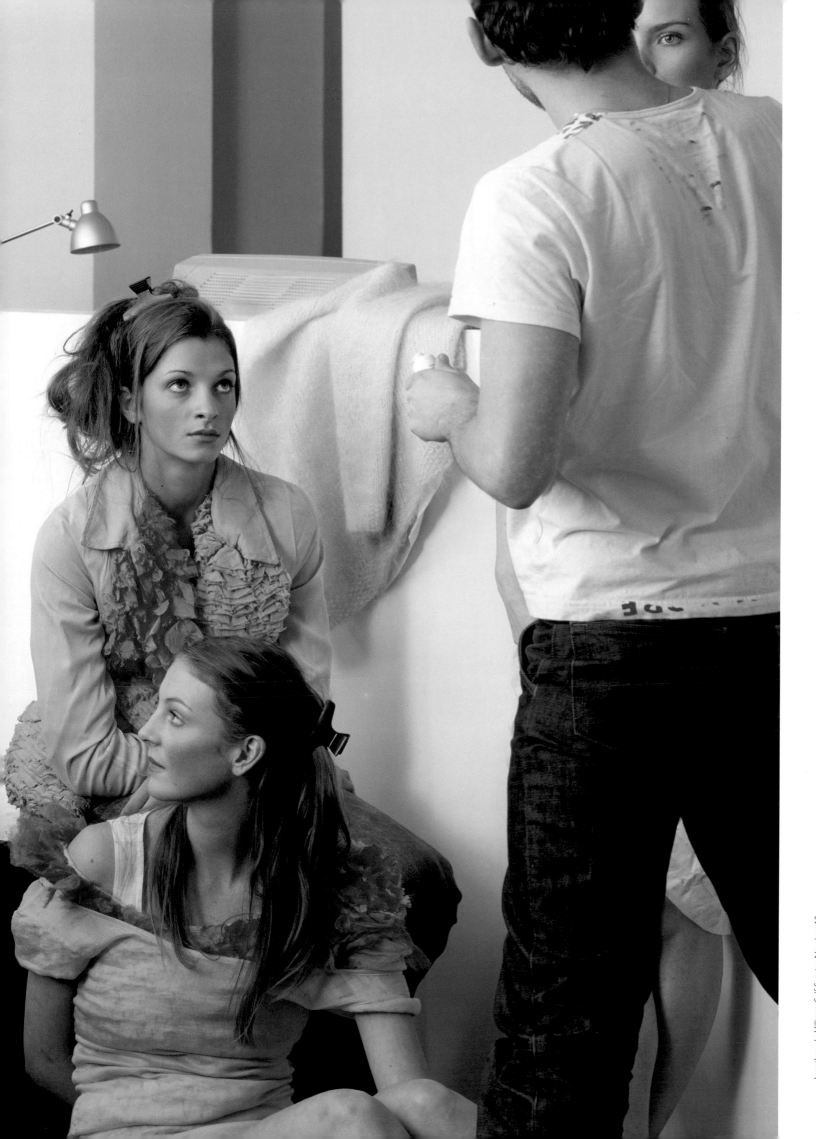

Jonathan de Villiers, *Self Service Number 12.*

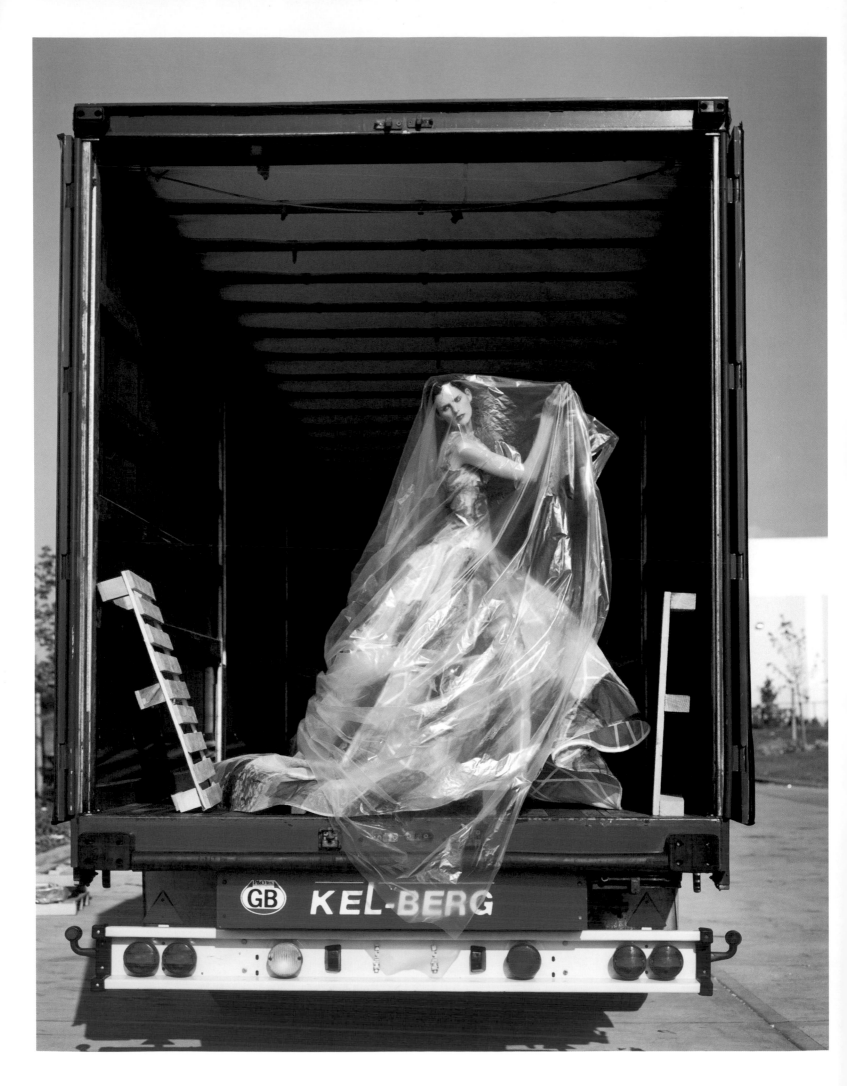

On these pages and the following double page: Tim Walker, Italian *Vogue*.

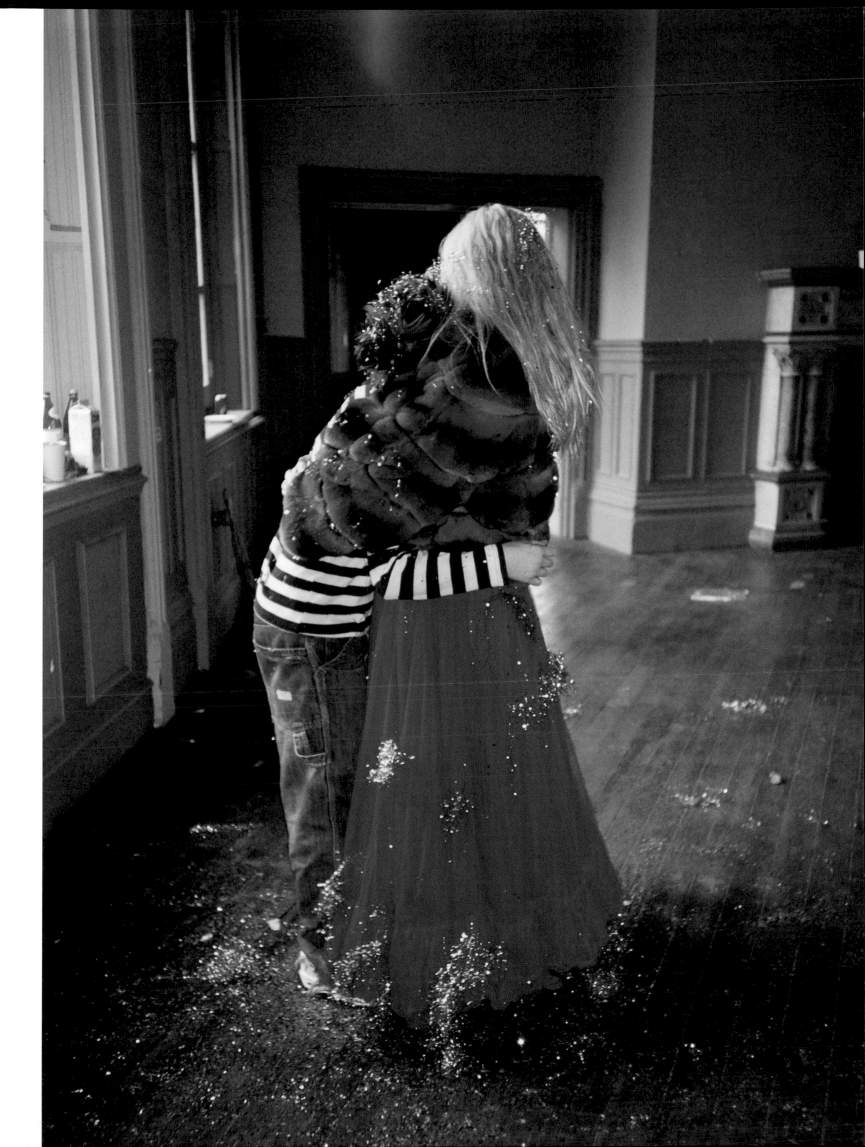

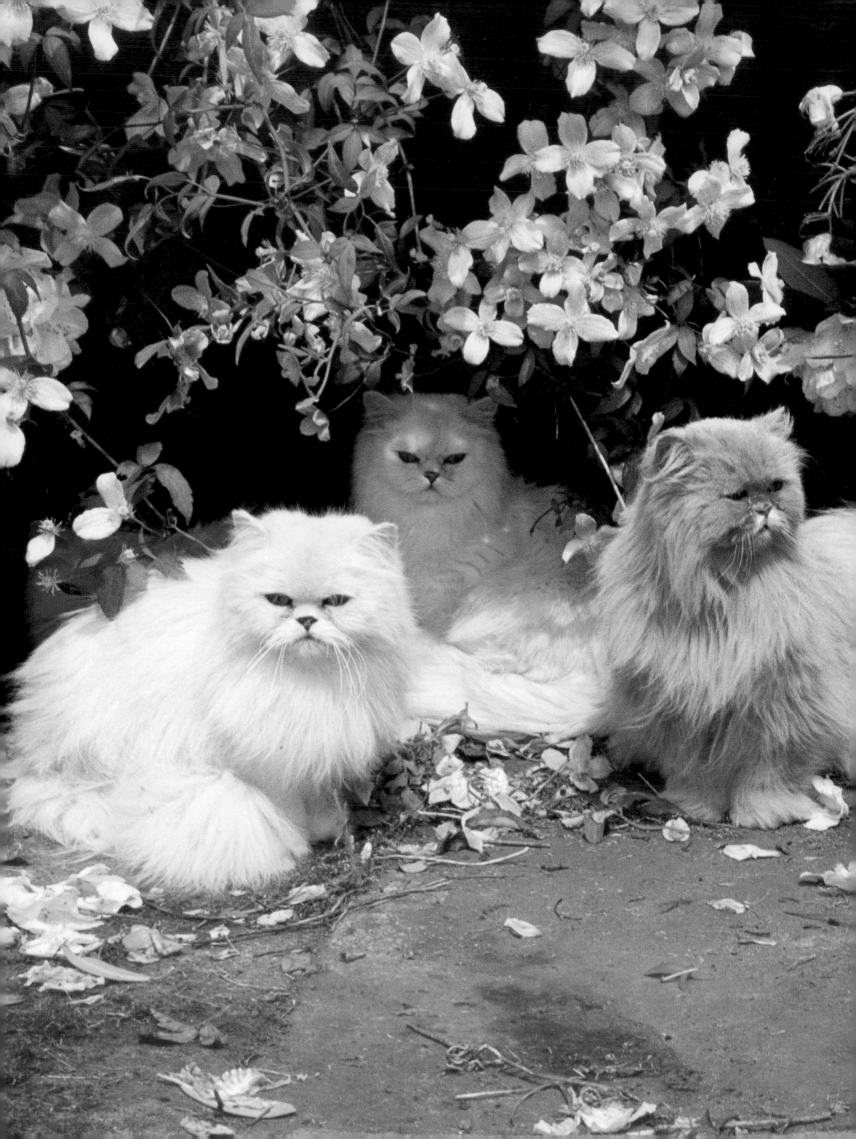

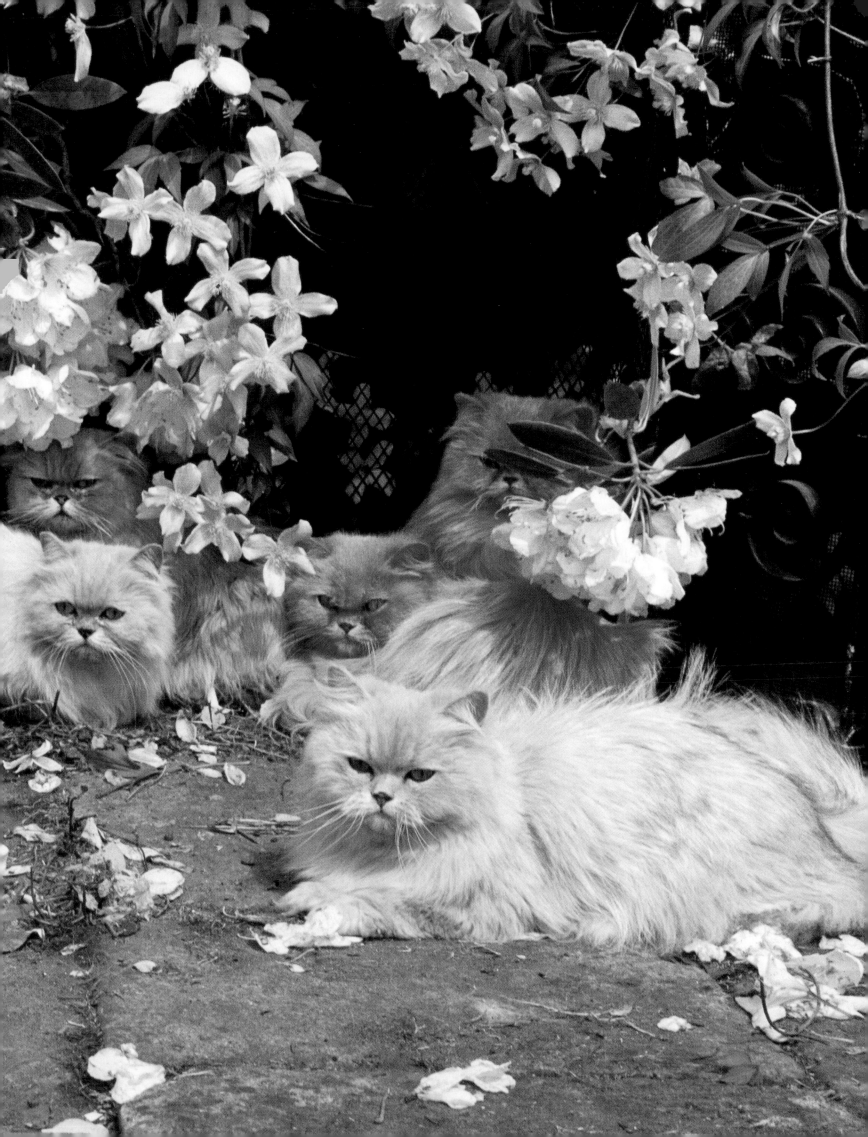

CAPTIONS

These credits have been supplied by the photographers, illustrators and their agents and are based solely on information they have supplied, and have been reproduced in good faith. The agent indicated in each case is the one with whom *Fashion Images de Mode* have dealt, but by no means does this imply that this is the artist's only agent. The editors and publishers disclaim all responsibility for any possible inaccuracies.

SØLVE SUNDSBØ SPECIAL VISUALS

Sølve Sundsbø at Claire Powell, The Face
Model: Liberty at Storm
Stylist: Katie Grand
Hair: Malcolm Edwards at Untitled
Make-up: Val Garland at Untitled.

Sølve Sundsbø at Claire Powell, The Face
Models: Tyson Ballou at Select and Rebecca Brennan at Take 2
Stylist: Simon Robins
Hair: Peter Gray at Untitled
Make-up: Maria Olsson at Untitled.

Sølve Sundsbø at Claire Powell, The Face
Model: Tyson Ballou at Select
Stylist: Simon Robins
Hair: Peter Gray at Untitled
Make-up: Maria Olsson at Untitled.

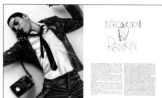

Sølve Sundsbø at Claire Powell, The Face
Model: Tyson Ballou at Select
Stylist: Simon Robins
Hair: Peter Gray at Untitled
Make-up: Maria Olsson at Untitled.

Sølve Sundsbø at Claire Powell, The Face
Model: Tyson Ballou at Select
Stylist: Simon Robins
Hair: Peter Gray at Untitled
Make-up: Maria Olsson at Untitled.

Sølve Sundsbø at Claire Powell, The Face
Model: Tyson Ballou at Select
Stylist: Simon Robins
Hair: Peter Gray at Untitled
Make-up: Maria Olsson at Untitled.

COVER
Sølve Sundsbø at Claire Powell, Pop magazine
Model: Liberty at Storm
Stylist: Simon Robins
Hair: Malcolm Edwards at Untitled
Make-up: Val Garland at Untitled.

ANDROGYNY
Pages 12/17: **Anette Aurell** at Art & Commerce, i-D
Models: Jan, Rafael, Gabriel, Eddy
Stylist: Annett Monheim at Streeters, NY
Hair: Leon Gorman at Atlantis.

ONE IN TEN
Pages 20/31: **Nick Knight**, Dazed & Confused
Stylist: Katy England
Hair: Sam McKnight
Make-up: Val Garland at Untitled
Production: Paul Hunwick
Photo assistants: Luke Thomas and Ben Dunbar.

NARRATIVE
Pages 36/55: **Philip-Lorca diCorcia**, courtesy Pace MacGill, W magazine
Stylist: Joe Zee
Hair: Serge Normont

Make-up: Virginia Young
Photo assistants: Julian Dufort and Keith Kliner
Set: Gerard Santos.

LIGHT
Pages 80/93: **Jeanloup Sieff**, courtesy of the estate of Jeanloup Sieff. Represented by Tiggy Maconochie, Maconochie Photography, London
© Jeanloup Sieff

PORTFOLIO
Page 96: **John Akehurst** at Camilla Lowther Management, Big magazine
Model: Mia
Stylist: Camille Bidault-Waddington
Hair: Alain Pichon at Untitled
Make-up: Mary Jane Frost at Blunt
Clothes: Alexander McQueen.

Page 97: **John Akehurst** at Camilla Lowther Management, Big magazine
Model: Mia
Stylist: Camille Bidault-Waddington
Hair: Alain Pichon at Untitled
Make-up: Mary Jane Frost at Blunt

Clothes: Vintage dress by Dolly Diamond, customized stockings by Fogal and Jonathan Aston.

Pages 98/99: **John Akehurst** at Camilla Lowther Management, Dazed & Confused
Model: Amahoa
Stylist: Charlotte Stockdale
Hair: Malcolm Edwards
Make-up: Charlotte Tilbury
Clothes: Boots by Olivier Theyskens, vintage Chanel top from Steinberg and Tolkien.

Pages 100/103: **Miles Aldridge** at Blanpied Rubini, Vogue Homme International
Models: Madame Schmit at Nathalie/Nathaniel, Mitsu at Untitled
Stylist: Stevie Stewart
Hair: Alain Pichon
Make-up: Julie Jacobs at Streeters, Alice Ghendrih at Lighthouse and Mira Hyde at Naked.

Page 104: **Clang** at Creative Management, Rank magazine
Model: Lisa Slemmer at Next
Stylist: Bryan

Hair and Make-up: Bryan
Marryshow at Independent
Clothes: Grey overcoat by
Martin Margiela, neck warmer
by Bottega Veneta.

Page 105: **Clang** at Creative
Management, Rank magazine
Model: Lisa Slemmer at Next
Stylist: Bryan
Hair and Make-up: Bryan
Marryshow at Independent
Clothes: Purple pleated dress
by Givenchy, tights by Danskin,
stilettos by Jean Paul Gaultier
Femme.

Page 106: **Clang** at Creative
Management, Surface magazine
Model: Kristin Chapman at
Q Model Management
Stylist: Karen Levitt
Hair: Bryan Marryshow
at Independent
Make-up: Gina Crozier
at Independent
Clothes: Alexander McQueen.

Page 107: **Clang** at Creative
Management, Day Dream,
Surface magazine
Model: Kristin Chapman
at Q Model Management
Stylist: Karen Levitt
Hair: Bryan Marryshow
at Independent
Make-up: Gina Crozier
at Independent
Clothes: Green and purple
striped dress and skirt around
neck by Dolce & Gabbana, finger
gloves by La Crasia, shoes by
Norman Smitherman.

Page 108: **Karen Collins** at Katy
Barker Agency, Soma magazine
Model: Danika at IMG
Stylist: Rushka Bergman at Katy
Barker Agency
Hair: Hynsoo at L'Atelier
Make-up: Lynn Russell at L'Atelier
Clothes: Jean Paul Gaultier black
dress with Vivienne Westwood
white cotton collar.

Page 109: **Karen Collins** at Katy
Barker Agency, Soma magazine
Model: Hana Hettesova at Elite
Stylist: Rushka Bergman at Katy

Barker Agency
Hair: Hynsoo at L'Atelier
Make-up: Lynn Russell at L'Atelier
Clothes: Trussardi dress,
Erickson Beamon necklace.

Pages 110/111: **Elaine
Constantine** at Marco Santucci,
Waterfall, Italian Vogue
(unpublished)
Models: Jo Reynolds, Will
Gritten, Lou
Stylist: Sofia Prantera
Hair: Neil Moodie
Make-up: Debbie Stone.

Page 112: **Elaine Constantine**
at Marco Santucci, Jo by the sea,
Italian Vogue (unpublished)
Model: Jo Reynolds
Stylist: Sofia Prantera
Hair: Neil Moodie
Make-up: Debbie Stone.

Page 113: **Elaine Constantine** at
Marco Santucci, Jo with camera,
Italian Vogue
Model: Jo Reynolds
Stylist: Sofia Prantera
Hair: Neil Moodie
Make-up: Debbie Stone
Clothes: Prada.

Pages 114/115: **Horst Diergerdes**
at Smile, Apartment A/
Apartment B, Dazed & Confused
Models: Mia at Select and
Charlotte B at Models One
Stylist: Alistair Mackie
Hair: Damien
Make-up: Val Garland at Untitled
Clothes: Embroided fringed
top by Chloé, green chiffon
dress by Yves Saint Laurent
Rive Gauche.

Pages 116/117: **Warren du
Preez and Nick Thornton-Jones**
at LEJ, X-Girls, Dazed & Confused
Model: Erin O'Connor
Stylist: Katy England
Hair: Alain Pichon at Untitled
Make-up: Sam Bryant at Untitled
Clothes: Stephen Sprouse.

Pages 118/119: **Warren du
Preez and Nick Thornton-Jones**
at LEJ, Birds of a Feather,
V magazine

Model: Nikki M at Storm
Stylist: Victoria Bartlett
Make-up: Wendy Rowe at Blunt
Clothes: Alexander McQueen.

Page 120: **Sean Ellis** at Kate Ellis,
Korovamatic Nude, The Face
Model: Tara O'Connor
Stylist: Charlotte Stockdale
Hair: Neil Moodie
Make-up: Lisa Butler
Clothes: Sunglasses by Chanel.

Page 121: **Sean Ellis** at Kate Ellis,
Korovamatic Nude, The Face
Model: Tara O'Connor
Stylist: Charlotte Stockdale
Hair: Neil Moodie
Make-up: Lisa Butler
Clothes: Boots by John Galliano,
ribbon by V V Rouleaux.

Pages 122/123: **Jerome Esch** at
Peter Sterling, Ex Gregis, Spoon
Stylist: Karine Chane Yin and
Patrice Fuma Courtis
Clothes: Bernard Willhelm,
Lagerfeld Galley and Balenciaga.

Pages 124/125: **David Ferrua**
at Michele Filomeno, Jalouse
Model: Leike
Stylist: Léa Baseden
Hair: Emanuele Fortugno
Make-up: Max Delorne
Clothes: Gucci, Pleats Please,
YSL, Chloé, Moschino Jeans
and Eric Bergère.

Pages 126/127: **Andrea
Giacobbe** at Art Department,
Diesel Style Lab.

Pages 128/129: **Andrea
Giacobbe** at Art Department,
Diesel Style Lab.

Pages 130/131: **Andrea
Giacobbe** at Art Department,
Dazed & Confused
Model: Andrea Giacobbe
Stylist: Vincent Gaspaillard
Hair: Karim Mitha
Make-up: Tatsu.

Page 132: **Nathaniel Goldberg**
at Katy Barker Agency, Numéro
Model: Brigitte Hall
Stylist: Paul Sinclaire

Hair: John Sahag
Make-up: Aaron de Mey.

Page 133: **Nathaniel Goldberg**
at Katy Barker Agency, Numéro
Model: Brigitte Hall
Stylist: Paul Sinclaire
Hair: John Sahag
Make-up: Aaron de Mey.

Pages 134/135: **Frederike
Helwig** at Z, The Face
Stylist: Nancy Rohde.

Pages 136/137: **Steve Hiett**
at Smile, Italian Vogue
Stylist: Anna Dela Russo.

Pages 138/139: **Steve Hiett**
at Smile, L'Uomo Vogue
Stylist: Anna Dela Russo
Make-up: Ruby Hammer.

Pages 140/141: **Steve Hiett**
at Smile, Italian Vogue
Stylist: Katy Grand
Make-up: Ruby Hammer.

Page 142: **Bettina Komenda**
at Blanpied Rubini, Liberation
Model: Rhea Anderson at Natalie
Stylist: Yasmine Eslatu
Hair: Zilia Beliaeua at Streeters
Make-up: Alice Gendrih
at Lighthouse.

Page 143: **Bettina Komenda**
at Blanpied Rubini, Liberation
Model: Rhea Anderson at Natalie
Stylist: Yasmine Eslatu
Hair: Zilia Beliaeua at Streeters
Make-up: Alice Gendrih
at Lighthouse.

Pages 144/145: **David
LaChapelle** at Creative
Exchange, Savannah: The Life
and Death of a Porn Diva,
The Audition, Arena
Model: Ana Claudia at Women
Stylist: Patti Wilson at Creative
Exchange
Hair: Renato Campora at L'Atelier
Make-up: Collier Strong
at Cloutier
Sets: Kristen Vallour.

Pages 146/147: **David
LaChapelle** at Creative

Exchange, Savannah: The Life and
Death of a Porn Diva, Poor Little
Rich Girl, Arena
Model: Ana Claudia at Women
Stylist: Patti Wilson at Creative
Exchange
Hair: Renato Campora at L'Atelier
Make-up: Collier Strong at
Cloutier
Sets: Kristen Vallour.

Pages 148/149: **David
LaChapelle** at Creative
Exchange, Savannah: The Life
and Death of a Porn Diva,
The Comeback, Arena
Model: Ana Claudia at Women
Stylist: Patti Wilson at Creative
Exchange
Hair: Renato Campora at L'Atelier
Make-up: Collier Strong
at Cloutier
Sets: Kristen Vallour.

Pages 150/151: **David
LaChapelle** at Creative
Exchange, Savannah: The Life
and Death of a Porn Diva,
Resurrection, Arena
Model: Ana Claudia at Women
Stylist: Patti Wilson at Creative
Exchange
Hair: Renato Campora at L'Atelier
Make-up: Collier Strong
at Cloutier
Sets: Kristen Vallour.

Pages 152/153: **Serge Leblon**
at MAP, Dazed & Confused
Stylist: Cathy Edwards
Hair: Bruno Silvani
Make-up: Peter Phillips
Clothes: Emma Cook.

Pages 154/155: **Serge Leblon**
at MAP, The Face
Model: Fanni
Stylist: Camille Bidault-
Waddington.

Pages 156/157: **Kevin
Mackintosh** at LEJ, Dream
Heroes, Upstreet magazine
Model: Joel Frampton
Stylist: Donamen
Make-up: Mira Hyde
at Terrie Tanaka
Clothes: Miu Miu
Sets: Daryl MacGregor.

Pages 158/159: **Marcus Mâm**
at MAO, Flaunt.

Page 160: **Melodie McDaniel**
at CLM, Arena
Model: Jacob Hooper
Stylist: John Harris
Hair: Davy Newkirk
Make-up: Davy Newkirk
Clothes: Costume National.

Page 161: **Melodie McDaniel**
at CLM, Arena
Model: Jim Mathlich
Stylist: John Harris
Hair: Davy Newkirk
Make-up: Davy Newkirk
Clothes: Henry Duart, Lacoste.

Page 162: **Melodie McDaniel**
at CLM, Arena
Model: Johnny
Stylist: John Harris
Hair: Davy Newkirk
Make-up: Davy Newkirk
Clothes: Marc Jacobs and
vintage.

Page 163: **Melodie McDaniel**
at CLM, Arena
Model: Patrick McKenzie at Next
Stylist: John Harris
Hair: Davy Newkirk
Make-up: Davy Newkirk
Clothes: Marc Jacobs, Valentino.

Pages 164/169: **John Midgley** at
Z, AD magazine
Model: Sue Larson at Models One
Stylist: Geriada Kefford
Hair: Joel Gonzalies
Make-up: Matthias von Hooght.

Pages 170/171: **Michel Momy**
at LEJ.

Pages 172/173: **Platon** at Art
Department, Chicks on Speed,
Nylon
Models: Amber, Jianca and Kelly
Stylist: Malcolm Beckford
Hair: Manuella for Arrojo Cutler
Make-up: Manuella for Arrojo
Cutler.

Pages 174/175: **Platon** at Art
Department, Good as Gold,
Nylon
Stylist: Havanna Laffitte

Hair: Marco Santini for Bumble and Bumble at Kramer & Kramer
Make-up: Molly R. Stern at Magnet
Clothes: Suit and blouse by Versace, sunglasses by Cazal, tuxedo by Gucci, dress by Loewe.

Pages 176/177:
Phil Poynter at Camilla Lowther Management, Big magazine
Stylist: Katy Grand
Hair: Malcolm Edwards
Make-up: Ellen Kastner-Delagog.

Pages 178/179: Phil Poynter at Camilla Lowther Management, Big magazine
Stylist: Katy Grand
Hair: Malcolm Edwards
Make-up: Ellen Kastner-Delagog
Retouching: Colin Hume at Shoemaker's Elves.

Pages 180/183: Terry Richardson at Katy Barker Agency, Dutch magazine.

Pages 184/187: Christophe Rihet, Camilla Lowther Management, Jane magazine.

Page 188: Luis Sanchis at Art and Commerce, Pop magazine
Model: Siobhan Snyder at Elite
Stylist: Simon Robbins
Hair: Malcolm Edwards
Make-up: Mary Jane Frost at Blunt.

Page 189: Luis Sanchis at Art and Commerce, Pop magazine
Model: Siobhan Snyder at Elite
Stylist: Simon Robbins
Hair: Malcolm Edwards
Make-up: Mary Jane Frost at Blunt.

Pages 190/191: Luis Sanchis at Art and Commerce, Pop magazine
Model: J.R. at Storm
Stylist: Simon Robbins
Hair: Malcolm Edwards
Make-up: Mary Jane Frost at Blunt.

Pages 192/193: Sinisha at Yannick Morisot, Flying, Jalouse
Model: Kim Iglinsky at Women
Stylist: Kim Brewster at Creative Exchange
Hair: Kevin Moon.

Pages 194/195: Oliver Spies at Michele Filomeno, Snow magazine
Models: Guidmar at Louisa Models, Kim Shara at PS Models
Stylist: Christine Baumann
Hair and make-up: Erol Koyu at Phoenix.

Page 196: Antonio Spinoza at Michele Filomeno, Kiss, unpublished
Models: Maya at Next, Olia at Vision
Stylist: Julian Monge
Hair: Cicci Swan
Make-up: Flavia Dalmeira
Clothes: Free-Expression, Julian Monge.

Page 197: Antonio Spinoza at Michele Filomeno, Contours, Amica
Model: Jonja at Vision
Stylist: Enrico Maria Volonte
Hair: Cicci Swan
Make-up: Rista Dimovitch
Clothes: Mila Shön, Emilio Cavalini, Dolce & Gabbana.

Pages 198/199: Steen Sundland at Management and Production, Rough Riders, i-D
Model: Francis at Models One
Stylist: James Sleaford
Hair: Jonathan Connerly.

Page 200: Sølve Sundsbø at Claire Powell, Guinevere
Model: Guinevere at IMG
Stylist: Monica Pillosio
Hair: Peter Gray at Untitled
Make-up: Maria Olsson at Untitled
Digital Manipulation: Metro Imaging.

Page 201: Sølve Sundsbø at Claire Powell, Exploding Converse
Digital Manipulation: Metro Imaging.

Pages 202/203: Mike Thomas at Creative Exchange, Chintzy Chintzy Cheeriness, The Face
Models: Karolina M at Next and Erika at Models One
Stylist: Susanne Deekin at Smile
Hair: Peter Grey at Untitled
Make-up: Sam Bryant at Untitled.

Page 204: Donna Trope at Eugenia Melian, Fake Fashion, It magazine
Model: Liberty Ross at Storm
Stylist: Sofia Neofitou
Hair: Kevin Ford at Naked
Make-up: Sharon Dowsett at Premier
Clothes: Chanel scarf.

Page 205: Donna Trope at Eugenia Melian, Liberty in Mouth, It magazine
Model: Liberty Ross at Storm
Stylist: Sofia Neofitou
Make-up: Sharon Dowsett at Premier.

Pages 206/207: Javier Vallhonrat Michele Filomeno, Yellow, Big magazine
Model: Justo de Arribas.

Pages 208/209: Javier Vallhonrat Michele Filomeno, Yellow, Big magazine
Model: Pablo Vallhonrat.

Pages 210/211: Jonathan de Villiers at Katy Barker Agency, Suddeutsche Zeitung.

Pages 212/213: Jonathan de Villiers at Katy Barker Agency, Self Service Number 12.

Page 214: Tim Walker at Camilla Lowther Management, Stella in Lorry, Italian Vogue
Model: Stella Tennant
Stylist: Grace Cobb
Hair: Julian le Bau
Make-up: Ruth Funnell.

Page 215: Tim Walker at Camilla Lowther Management, Italian Vogue
Models: Merlin and Kev
Stylist: Cathy Kauterine
Hair: Julian le Bau
Make-up: Lucia Pieroni
Clothes: Carlo Tieoli.

Pages 216/217: Tim Walker at Camilla Lowther Management, Pastel Cats, Italian Vogue.

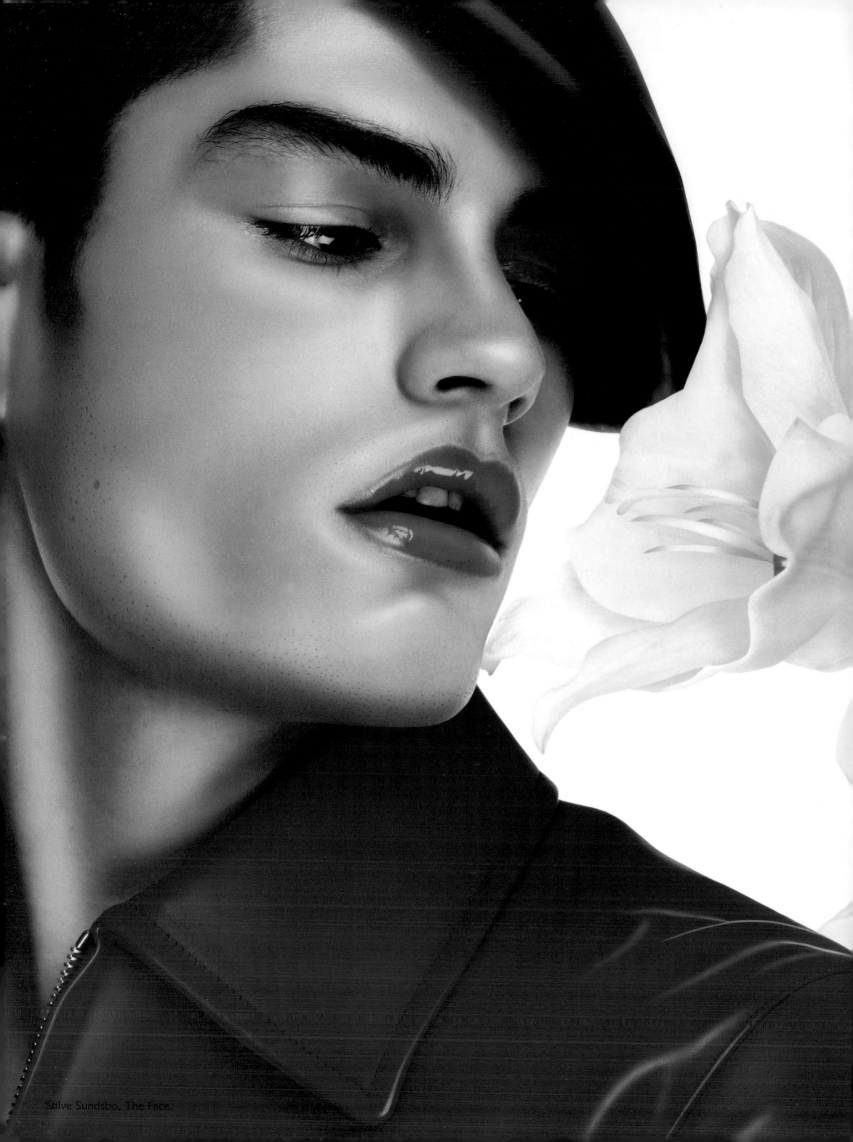

Sølve Sundsbø, The Face.

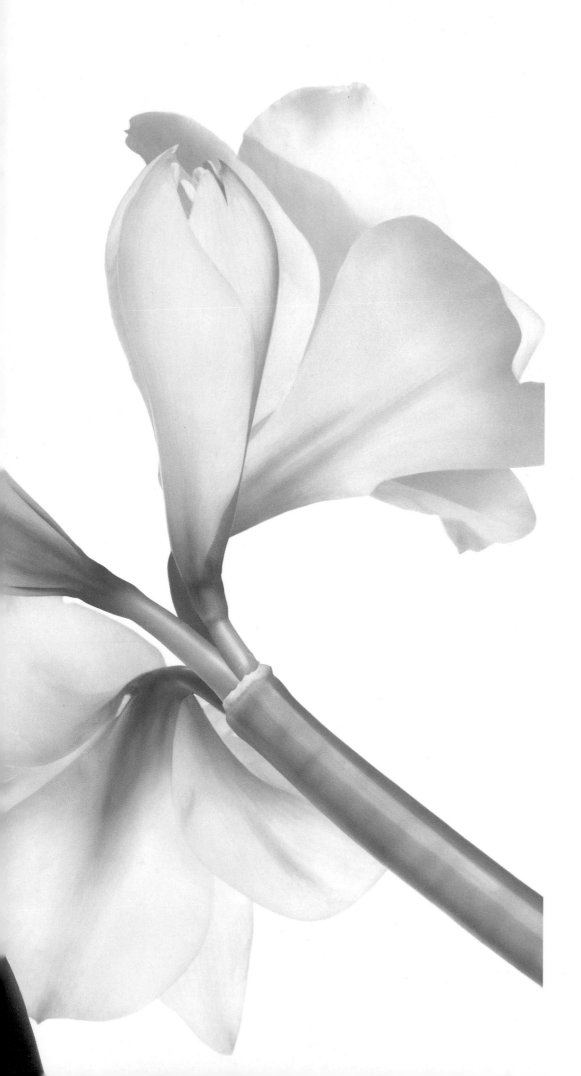

MANY THANKS TO

Tiggy Maconochie
Maitre Pascal Narboni
A.D.M.
Richard at Yannick Morisot
Sarah and Natalie at Smile
Julie Sims at MAP
Katy Barker
Kim Sion
Claire Powell
Steven Pranica
Eric and David at Blanpied Rubini
Huw at Mario Testino
Jessica Marx at Art and Commerce
Sharon at Marco Santucci
Patricia & Gabriel Trautmann
Anthony Allen
Eric Poupy
Leonie Edward-Jones
Eugenia Melian
Joe and Craig at Art Department
Dominic and Susanne
at Michele Filomeno
Camila and Jasmine Kharbanda
at Camilla Lowther Management
Dominic King and Derek Lacy at CXA
Ziggy, Tara, Joy and Olivia
at Z Photographic
Kayte and everyone
at Sean Ellis's studio
Belal at Phil Poynter
Phillippa at Nick Knight
Thanks also to Diana, Sarah, Ed,
Ronny, Susanne and Lisa
at Vision On
Alex, Alan and Nina
at Proud Galleries
Hector and all at Idea Generation
Omar, Hani, Zeina, Zaid and Imad
at the National Press.

Special visuals: Sølve Sundsbo
Editor: Lisa Lovatt-Smith
Art Direction and Design: Mathieu Trautmann assisted by Pierre-Marie Agin
Commercial Director: Nicole Bey-Lemaire
Photographic Coordination: Anne Tonialen
Translators/Proof-readers: Christine Davis, Anne Lepreux, Steve Piccolo
Vision On Creative Director: Kirk Teasdale
Vision On Project Manager: Briar Pacey
Vision On Production: Steve Savigear, Emily Moore, David Corbett and Paul McGuinness
Repro: Colourpath
Print: Printed in Poland by OZGraf SA

FASHION IMAGES DE MODE NO 6
First published in Great Britain in 2001 by Vision On Publishing Ltd
112–116 Old Street London EC1V 9BG
T +44 207 336 0766
F +44 207 336 0966
www.vobooks.com
info@vobooks.com

FOR FURTHER INFORMATION CONTACT:
Lisa Lovatt-Smith, Paseo La Floresta 1, La Floresta 08198, San Cugat, Barcelona
T +34 93 589 30 97
lovatt@retemail.es

VISION ON